Imperial Saint Petersburg

Imperial
SAINT PETERSBURG

from Peter the Great to Catherine II

Skira / Grimaldi Forum Monaco

Art Director
Marcello Francone

Graphic Design
Stefano Tosi

Editorial Coordination
Massimo Zanella
Alessandra Chioetto

Editing
Enza Sicuri

Layout
Serena Parini
Antonio Carminati

First published in Italy in 2004 by
Skira Editore S.p.A.
Palazzo Casati Stampa
via Torino 61
20123 Milano
Italy
www.skira.net

Printed and bound in Italy. First edition

ISBN 88-7624-016-0

Distributed in North America by Rizzoli
International Publications, Inc. through
St. Martin's Press, 175 Fifth Avenue,
New York, NY 10010.
Distributed elsewhere in the world by
Thames and Hudson Ltd., 181a High Holborn,
London WC1V 7QX, United Kingdom.

Imperial Saint Petersburg
from Peter the Great to Catherine II

17 July - 12 September 2004

10, avenue Princesse Grace,
MC 98000 Monaco
www.grimaldiforum.com

Grimaldi Forum Monaco

Jean-Claude Riey
President

Sylvie Biancheri
General Manager

Catherine Alestchenkoff
Director of Cultural Events

Guy Caruana
Building Director

Gérard Nouveau
Director of Events

Marc Rossi
Administrative and Financial Director

Hervé Zorgniotti
Director of Communication

and their staff

Lætitia de Massy, *Cultural Officer*
Thierry Vincent, *Registrar*
Katia Montironi, *Assistant*

Monaco

His Excellency Mr. Patrick Leclercq
Minister of State

Mr. Philippe Deslandes
Government Adviser for the Interior

Mr. Franck Biancheri
*Government Advisor for Economy
and Finance*

Mr. José Badia
*Government Adviser for Public Works
and Social Affairs*

Mr. Nicolay Orlov
*Honorary Consul of the Principality
of Monaco in St. Petersburg*

Mr. Claude Pallanca
Honorary Consul of Russia in Monaco

Mr. Oleg Choudinov
Consul of Russia in Marseille

Exhibition and Catalogue

Curator:
Brigitte de Montclos

Artistic Consultant:
Jean-Paul Desroches

Authors:
B. de Montclos
D.V. Lioubin
V.A. Fedorov
D.V. Lioubin
A. Soloviev
V.-I.T. Bogdan
E. Savinova
A. Alexeeva
L. Zavadskaïa
T.V. Rappe
M.N. Kossareva
T. Koudriavsteva
N. Serebriannaïa

Translations:
Translated from Russian into French
by Anita Davidenkoff, Anne Klimoff
and Barbara Schwahl
Translated from French into English
by Nancy G. Duncan Le Diascorn

Scenography:
François Payet
assisted by the Events Department
of the Grimaldi Forum Monaco

Exhibition Press Officer:
Micheline Bourgoin

Acknowledgments

We wish to express our deepest appreciation to all those institutions and individuals who, each in their own way, have helped guide this project to fruition.

The State Hermitage Museum, St. Petersburg

Mr. Mikhail Piotrovsky
Director of the State Hermitage Museum

Mr. Georges Vilinbakhov
First Deputy Director of the State Hermitage Museum, Scientific Adviser

Mr. Vladimir Matveev
Deputy Director of the State Hermitage, Exhibitions and Development

Mr. Viacheslav Fedorov
Director of the History of Russian Culture Department

Scientific Research Museum of the Russian Fine Arts Academy, St. Petersburg

Mr. Zourab K. Tseretely
President of the Scientific Research Museum of the Russian Fine Arts Academy, St. Petersburg

Mrs. Veronika-Irina Troyanovna Bogdan
Art History Ph.D, Deputy Director of the Scientific Research Museum of the Russian Fine Arts Academy, St. Petersburg

Mrs. E.I. Prassolova
Vice-Director of the Scientific Research Museum of the Russian Fine Arts Academy, St. Petersburg

Fine Arts Museum, Nancy (France)

Mrs. Chavanne
Curator of Cultural Heritage, Head of the Fine Arts Museum, Nancy

Mrs. Sophie Harent
Deputy Curator, Head of the Graphic Arts Collection

We extend our warmest thanks to all those who have contributed to this catalogue:

P. Akexandrov
I.S. Artemeva
N.I. Birioukova
T.B. Bouchmina
A. Bychkov
I.V. Charovskaïa
E.V. Deriabina
I.G. Etoeva
M.P. Garlova
I.I. Goudymenko
N.I. Gouseva
V. Gradov
N.I. Gritsaï
G. B. Iastrebinski
V. Kascheev
T.T. Korchounova
M.N. Kosareva
O.G. Kostioug
I.G. Kotelnikova
T.V. Koudriavtseva
T.K. Koustodieva
I.N. Kouznetsov
L. Kovaleva
S.A. Letine
D.V. Lioubin
L. Loginova
M.N. Lopato
O.N. Maltseva
V.I. Matveev
N. Mavrodina
G.A. Mirolioubova
E.I. Moïseenko
S.A. Nilov
K.A. Orlova
I.N. Oukhanova
A.G. Pobedinskaïa
G.A. Printseva
T.B. Rappe
N.K. Serebriannaïa
T. Semenova
I.A. Sokolova
E.A. Tarasova
V.A. Tchernychev
S.V. Tomsinski
I.E. Vilenski
L.A. Zavadskaïa

Olga Ilmenkova, Dmitri Schvidkovski, L.I. Kondratenko, Alexandra Loujina, Lioubov Evdokimova, J.B. Rybakova, S.N. Griva, L.N. Prokhorova, T.I. Rybakova

We would like to express our debt to all those who have contributed to this exhibition in a variety of ways:
Mr. Ivan Saoutov, Mrs. Iana Tchoumakova, Mrs. Tatiana Potashinskaia,
Mr. Denis Caget, Mrs. Corinne de Vilmorin, Foundation Joseph Brodsky

As the tri-centennial celebrations come to an end, the Principality of Monaco wishes to pay special honor to an exceptional city whose cultural and spiritual influence rapidly extended beyond Russia's borders to reach the Mediterranean coast: St. Petersburg, truly a challenge to Nature but also to society, revealed by its creator Peter I and glorified by Catherine II.

With some six hundred exceptional loans from the Hermitage Museum and the St. Petersburg Fine Arts Academy, the exhibition put on by the Monaco Grimaldi Forum is a forceful illustration of the brilliance of this legendary city whose history is a constant reminder of the genius of its empresses and emperors.

A history which bears witness to the wealth of cultural links woven between Russia and the Principality of Monaco since the 19th century and which were sealed in 1911 when Diaghilev's famous Russian Ballet was brought to Monte-Carlo to the thunderous success it had already known in Paris.

I am pleased today to write a new page in the cultural register of our two countries in welcoming the Hermitage Museum and the Fine Arts Academy. I would like to thank all the Russian institutions and authorities who helped bring this project to fruition and I am delighted about this collaboration which has kept the flame of friendship burning between Russia and the Principality of Monaco for more than a century.

Nostalgia for the Empire

Russia in history has at least two faces. One of these is turned towards Europe and this is the one embodied in St. Petersburg. This city's topography, architecture, climate and traditions contain a sort of code, laid down by Peter the Great, that is reproduced throughout Russia via St. Petersburg. St. Petersburg is the carrier of both the language and the vocabulary of the Russian culture that took shape after Peter the Great and became, through literature and military victories, such a major element in European culture in general.

Peter founded the city to embody his dream of Russia becoming a great power. He laid down all the preconditions for this. It was Catherine the Great, a German who, in terms of spirit and goals, was the most Russian ruler throughout the existence of the Russian Empire, who actually brought this dream to life. It was Peter who founded the Empire and it survived until the last Emperor gave St. Petersburg the new name of Petrograd. Then the Empire declined and fell. The Bolsheviks tried to revive it on the basis of a new ideology, but were only partially successful in this. The Empire is no more, but the nation, in its efforts to realize itself, is returning to its roots. Some people see these in Moscow; others in the Empire.

The Hermitage was engendered by and testifies to the imperial state. It is a symbol of the political and cultural foundations of the Russian Empire and its legacy. To a certain degree, it reproduces the Russian national idea. In the mirror of the Hermitage, Russia reflects as a world power, turned towards Europe in both spirit and mind. This is no absolute choice, but this is what is embodied in our wonderful museum, its architecture, collections and scientific traditions. The Hermitage is a symbol of Russia being open to the world, about which Dostoïevsky wrote with such perception.

This is a philosophy of history and culture embodied in all events at the Hermitage, in all its exhibitions, festivals, concerts, books and journals. Through its collection of international and Russian art, the Hermitage tells about Russia itself. It tells of those who gathered the collections and those who made donations, of the specific Russian taste for European art. It tells of Russian patronage of art, which united both Russian and European traditions. This gave birth to a new Russian art and new Russian artistic production. That is how Russian Baroque, Russian Empire, Russian classicism and the wonderful creations of the Tula masters, who magically transformed metal, emerged. That is how Russian imperial

*porcelain, imperial crystal, imperial stone carving factories came into being.
It was the birth of Russian avant-garde and Russian constructivism. Much more will yet
emerge from this typically Russian merging of spirit, style, craftsmanship and inspiration.*

*All this is manifested in the artistic collections that constitute the Hermitage today.
Our exhibition presents only a small period in Russian cultural history. Yet it embodies
the constantly reproduced code that at least explains how and why Russia rejected and then
vanquished Napoleon and his ideological world dominance. This culture is one of beauty,
pleasure and – enormous power. This is what the Hermitage described and describes to this
day. It does so through the marvelous masterpieces, never forgetting that it is the memory
of mankind and the memory of Russia. It is the Hermitage that brings the two together.*

*We are delighted to be able to tell all this through very specific items and articles. But we would
like to think that the deep meaning of our national traditions in the cultural sphere were visible
behind these.*

Prof. Mikhail Piotrovsky
Director of The State Hermitage Museum

Contents

15 From the ancient Moscovy to the New Russia
B. de Montclos

39 A city to be built, a society to emerge
B. de Montclos

63 St. Petersburg seen through engravings
D.V. Lioubin

81 Peter the Great
V.A. Fedorov

103 St. Petersburg, Imperial City
D.V. Lioubin

129 Catherine II, the "Sémiramis du Nord"
A. Soloviev

149 The Architectural Models from the Russian
Fine Arts Academy
V.I. Bogdan
E. Savinova, A. Alexeeva

173 Russian gold- and silver-work in the 18th century
L. Zavadskaïa

201 Catherine II and the European Decorative Arts
T.V. Rappe

221 Tula, the city of master craftsmen
M.N. Kosareva

241 Decorative Arts during the era of Catherine II
T.V. Koudriavtseva

265 Catherine II, the Collector
N. Serebriannaïa

Appendix

295 Comparative Chronology

301 List of works

315 Bibliography

From the ancient Moscovy
to the New Russia

"*During the reign of Michael and his son,*

our ancestors who although they saw

the many advantages involved in borrowing

certain foreign customs yet still held on to

the idea that the pious Russian man was the

most accomplished of all citizens in the world

and that Holy Russia the first among

all countries."

Nikolai Karamzin
*Notes on the New and the Old Russia (Note sur l'ancienne
et la nouvelle Russie),* Berlin 1861

With St. Petersburg's tri-centennial festivities just over, it is most fitting to have this great event to conclude the magnificent history of a city without comparison, Russian without being so, but not Occidental either, the very example of a city which sets one to dreaming because it is made not only of bricks and stones but also of myths and legends.

St. Petersburg, built upon the marshy lands of the Neva delta, is the symbol of a challenge thrown out by Peter I to nature, but also to society. The young Czar quickly understood the necessity of an access to the sea which would open up his immense country so closed within its own ossified traditions. Strengthened by the knowledge he had acquired empirically through contact with the foreigners he had met in Moscow, Peter knew to whom he should go to build a port: the Dutch engineers capable of mastering a marshland. He also knew that he had the necessary abilities for coordinating and supervising the work. Peter had been brought up according to the traditions of Christian faith adopted in 988 by Vladimir de Kiev. The Russian church, which had separated from the church of Rome in 1054, and had been autocephalous since 1589, remained all-powerful, enslaving not only the people but the ruling power. And this despite the fact that it had been shaken by the schism provoked by the Patriarch Nikon's demand between 1654 and 1660 to return to the primitive texts. Peter thus followed the practices of a church where the gestures, the prayers, the ritual, that is to say all the exterior signs of the religion, bestowed to the believer divine grace and a relationship with God. The people used those signs as incantations which explains the lasting quality of a system which had scarcely evolved for centuries. The holy image had been unaltered since the great creations of the monk Andreï Roublev in the 15th century. The style of icons as well as choice of themes had not changed. The icon

in which the Holy Trinity, represented by three angels appearing to Abraham and his wife Sarah, who live in the forest of Mambre, is a good example. The 17th century painter did not vary from the original motifs: and so we find, in the background, the lord's residence, the tree which evokes the forest and, in the foreground, the three angels around the table with the one who represents Christ in the center (fig. 1). In the same way, the holy or royal doors which in a Russian church separate the nave from the sanctuary adhered to the ancient tradition. They are located in the center of the iconostasis, this wooden partition covered with holy images which faces the congregation. Most of the time the doors are also decorated with holy images, icons representing the Good News which led the way to God. This is why the Annunciation and the four Evangelists are frequently shown. However in the 17th century, the doors began to be decorated with sumptuous gilded sculptures, inspired by secular examples. This is the case for the royal doors of the Simonov monastery (fig. I). The singing, the incense which is given off from censors made of precious metals (fig. II), the mystery which is produced by the iconostasis behind which officiates the priest, the extraordinary richness of the liturgical robes, traditionally reproduced according to the same rules over centuries: all of this magically fills the obscurity of the churches. And in response to popular fervor, sculpted representation of saints such as *Nicolas de Mojaïsk* (fig. III) who is said to have saved the city from the Tartars by appearing in the sky with a sword in his hands, came to figure in the churches, or that of the *Christ, bound* (fig. IV) to which chapels were dedicated. The women would embroider images repeating the themes of the icons onto pieces of silk which would then be used as altar frontals (fig. V). The same fervor can be found in the work of the gold- and silversmiths in the Patriarch's cross which depicts the twelve main annual festivals, and in the most

1
Icon *"The Trinity*
of the Old Testament",
Northern Russia, 1705

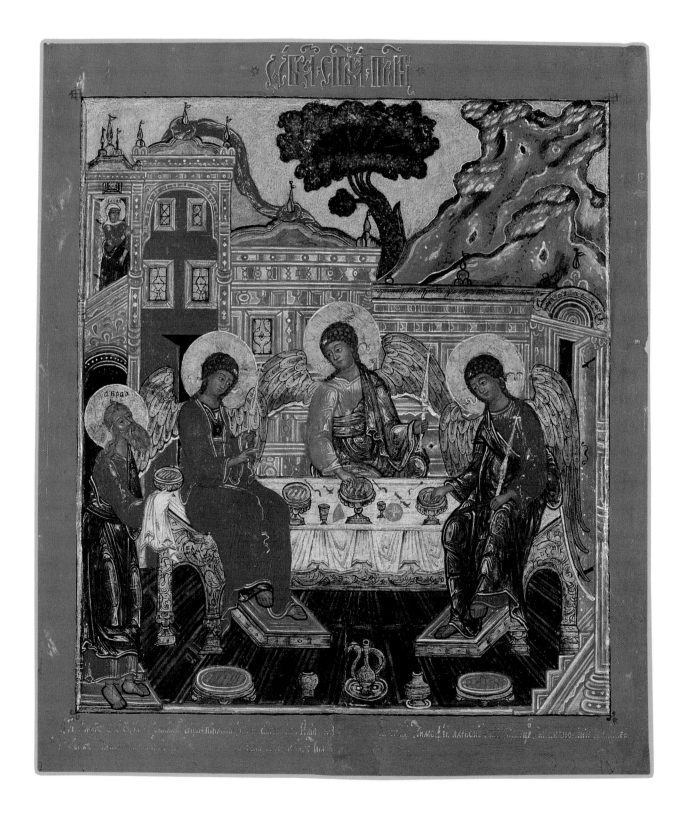

2
Reliquary cross,
Moscow, 1654
recto and *verso*

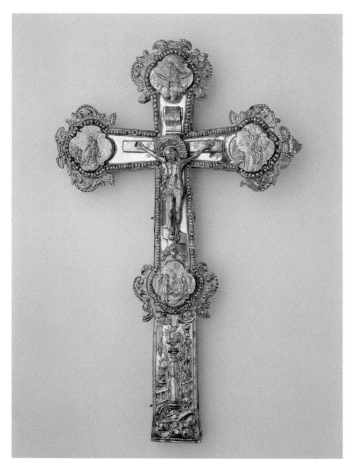
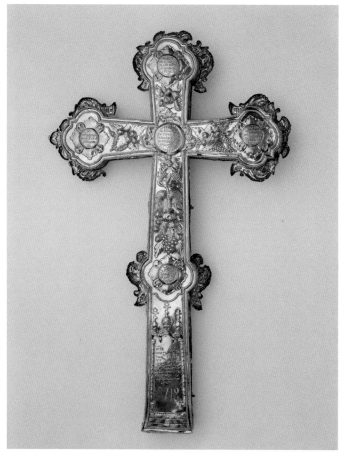

venerated icons of the Virgin, grouped around the traditional representation of the crucifixion (fig. VI). The small portable triptychs (fig. VII) on which figured the *deisis* (fig. VIII), that is, Christ between the Virgin and St. John the Precursor, are pieces of colored enamels on copper, very popular in private homes. A particularly meticulous decoration was given to the cross reliquaries in vermeil: on one side was the crucifixion, and on the other, places of worship were evoked through the use of gilded onion domes in relief (fig. 2). But the all-powerful Russian Church had ambitions of temporal power far surpassing the inspiring iconography of prayer. Beginning with the election of Michael Romanov to the throne of Russia in 1613, the Czar governed with his advisor who just hap-

pened to be the Patriarch Philarete, his father. For Alexis, his son and successor, faith and power were equal and the one did not exist without the other. It was this political role of the church which Peter was to regulate by making the Church subordinate to the State. And it was for this that he was given the reproving name of "Antichrist," as well as that of "Reformer." When the Patriarch Adrien died in 1700, the Czar in fact left his seat vacant for twenty years. And in 1721 Peter I promulgated a new organization for the church: a synodal body made of up ten priests subordinated to a lay official. From that point on, the Czar was the sole supreme head of Russia.

A new society was about to be born.

B. de Montclos

I
Holy doors of the Simonov
Monastery iconostasis,
Moscow, 17th century

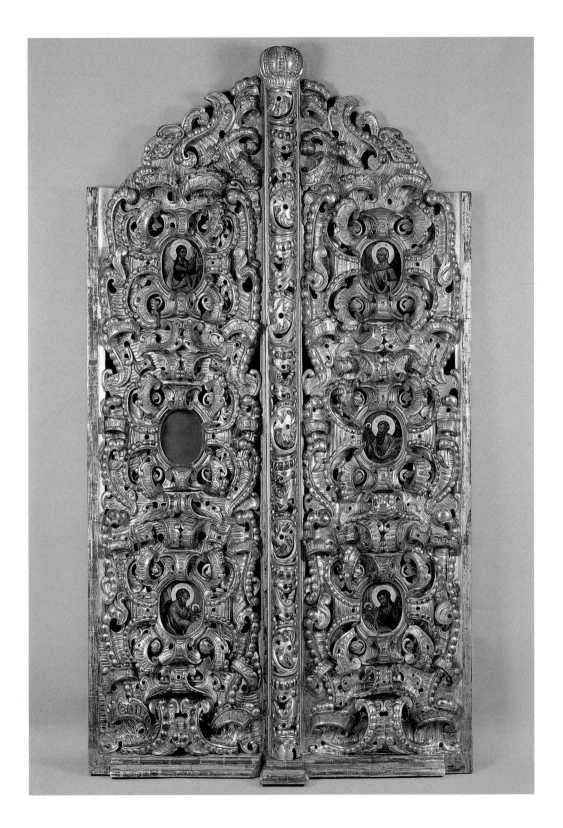

II
Censor,
Moscow, 1649

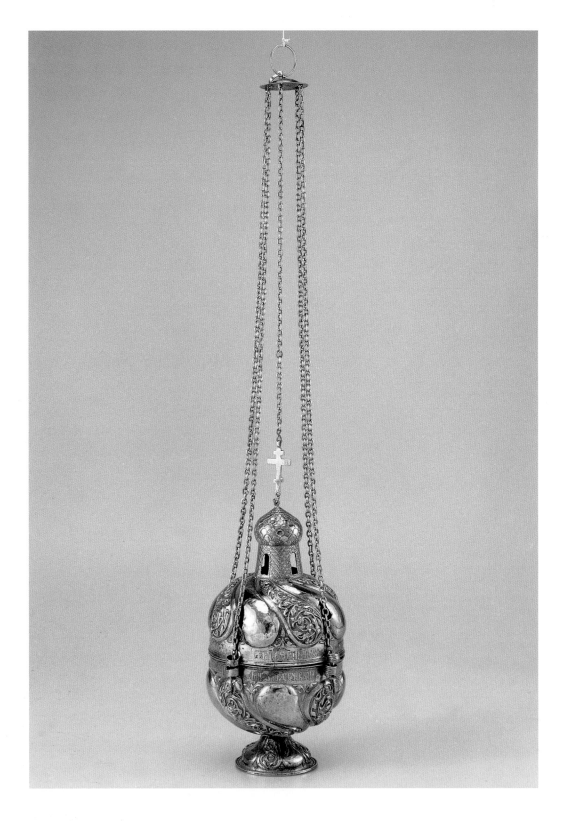

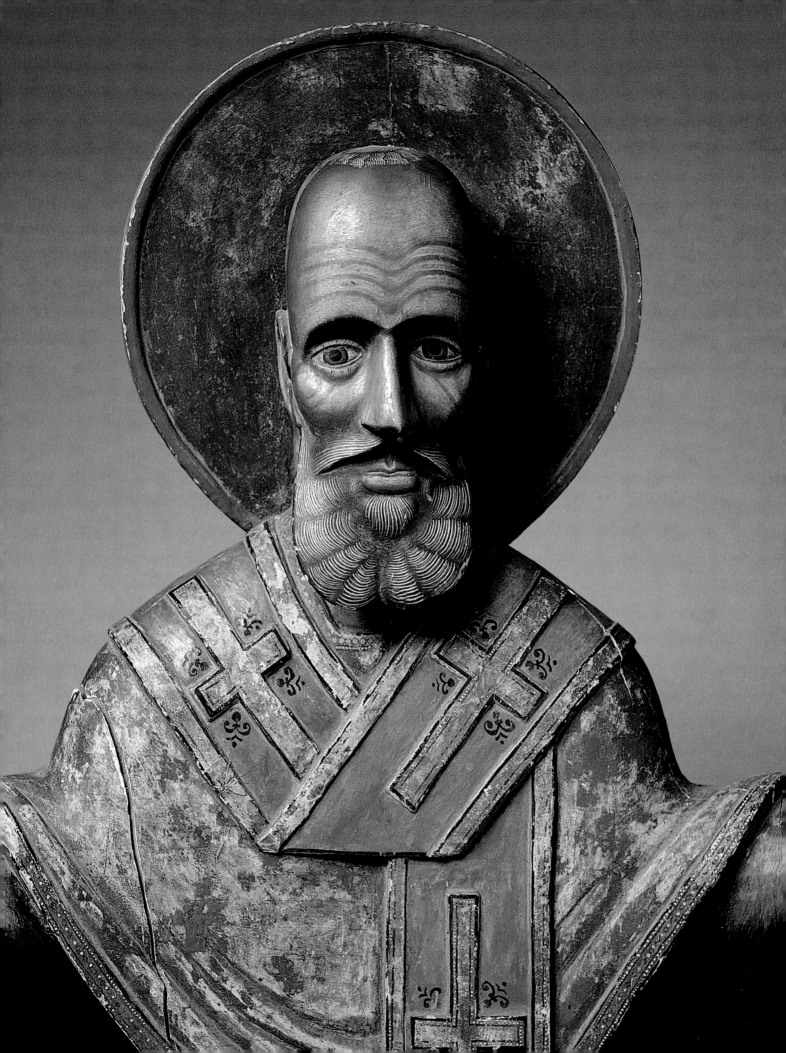

III
St. Nicolas of Mojaisk,
Russia, 18th century

IV
Christ, bound,
Russia, 18th century

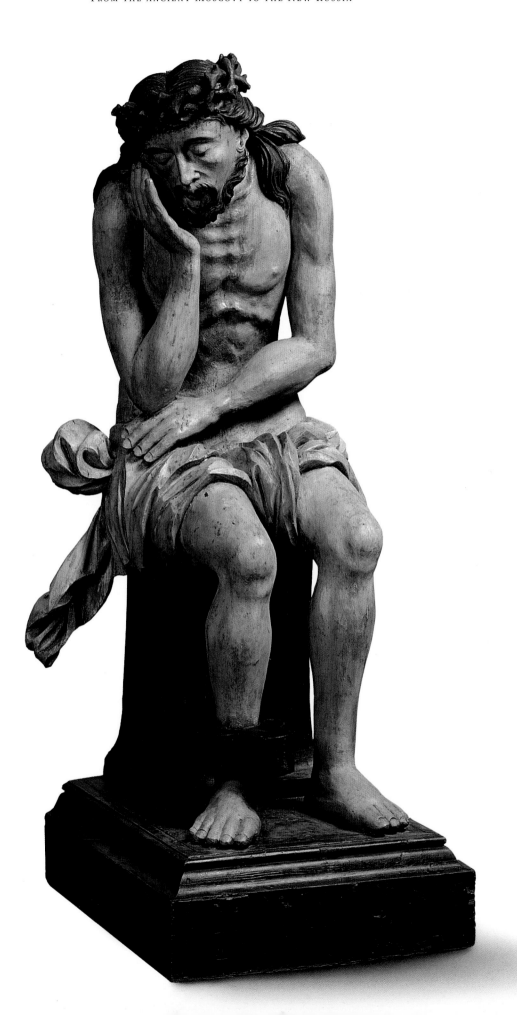

V
Altar frontal, "Three Saints"
(St. John, St. Nicolas and the
venerable Cyrille Belozersky),
Russia, 17th century

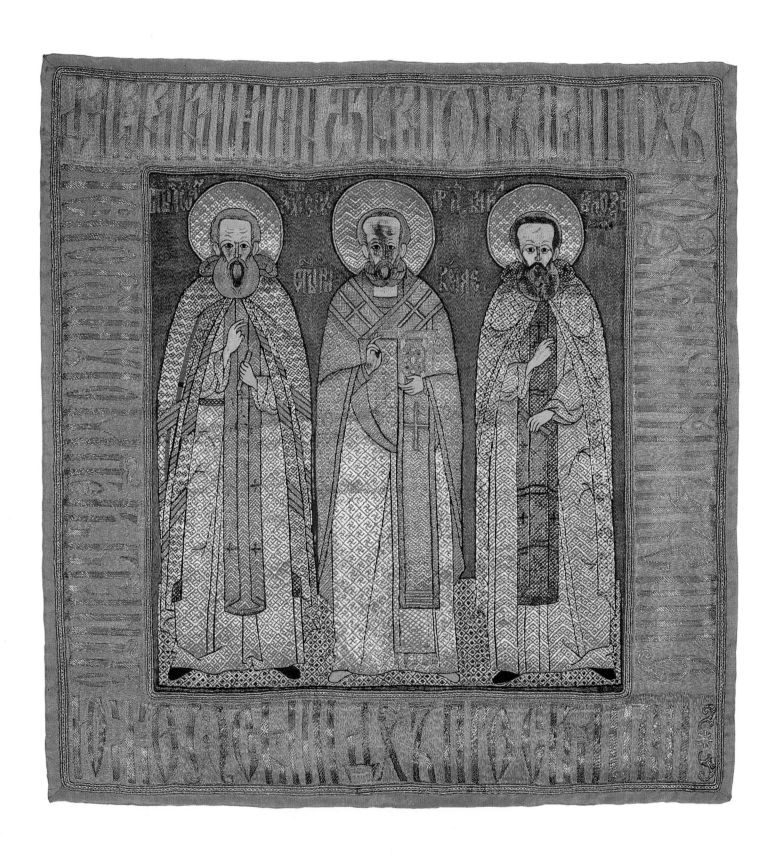

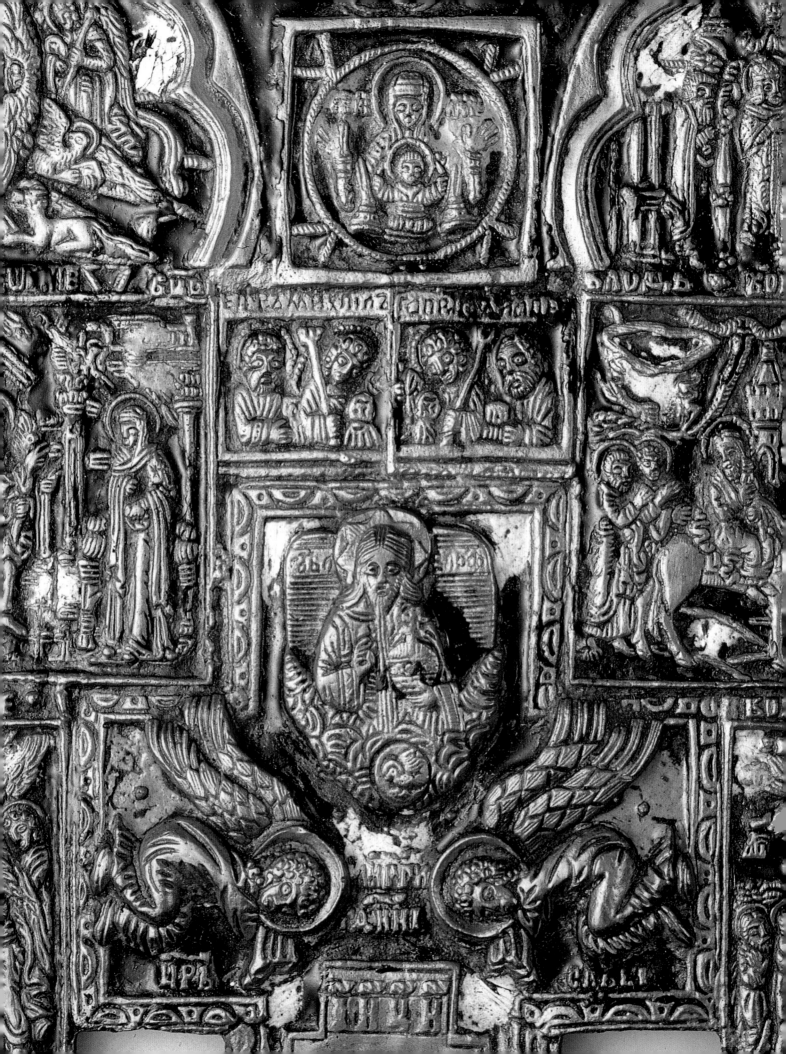

VI
Patriarchal altar cross,
Russia, 18ᵗʰ century

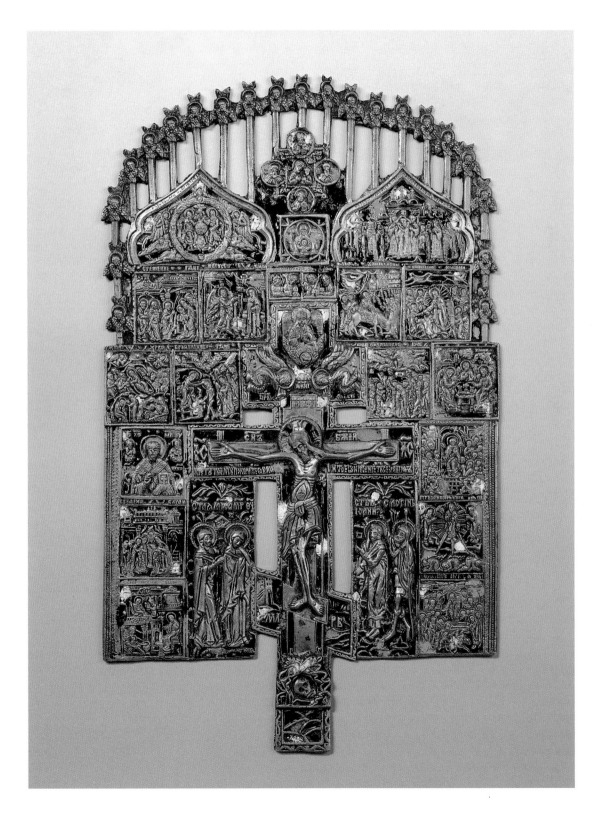

VII
Triptych,
Moscow, end of 17th century

Page 32
Detail

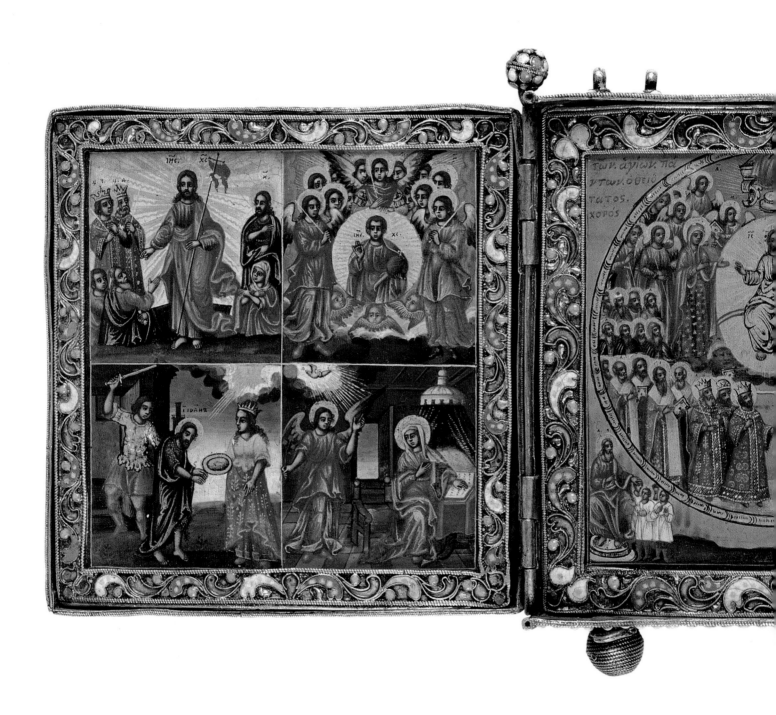

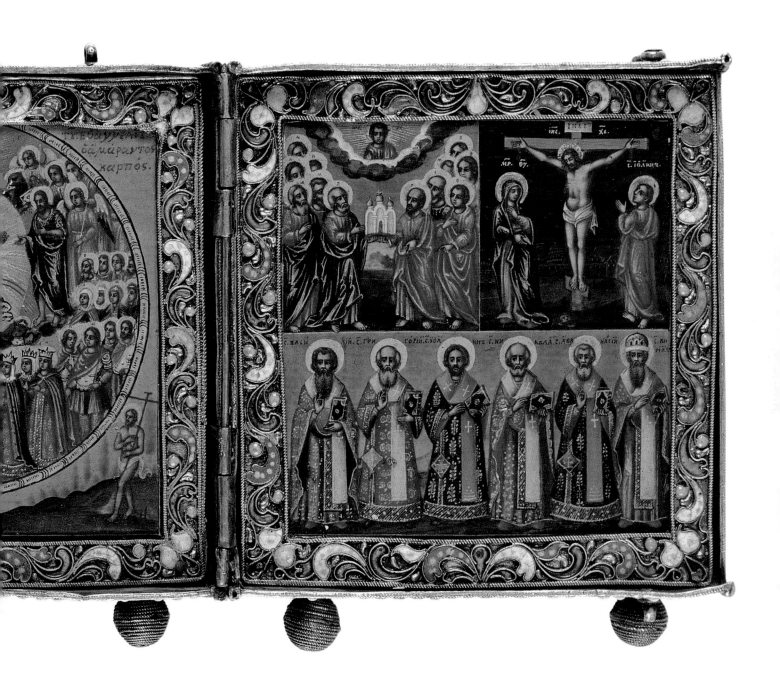

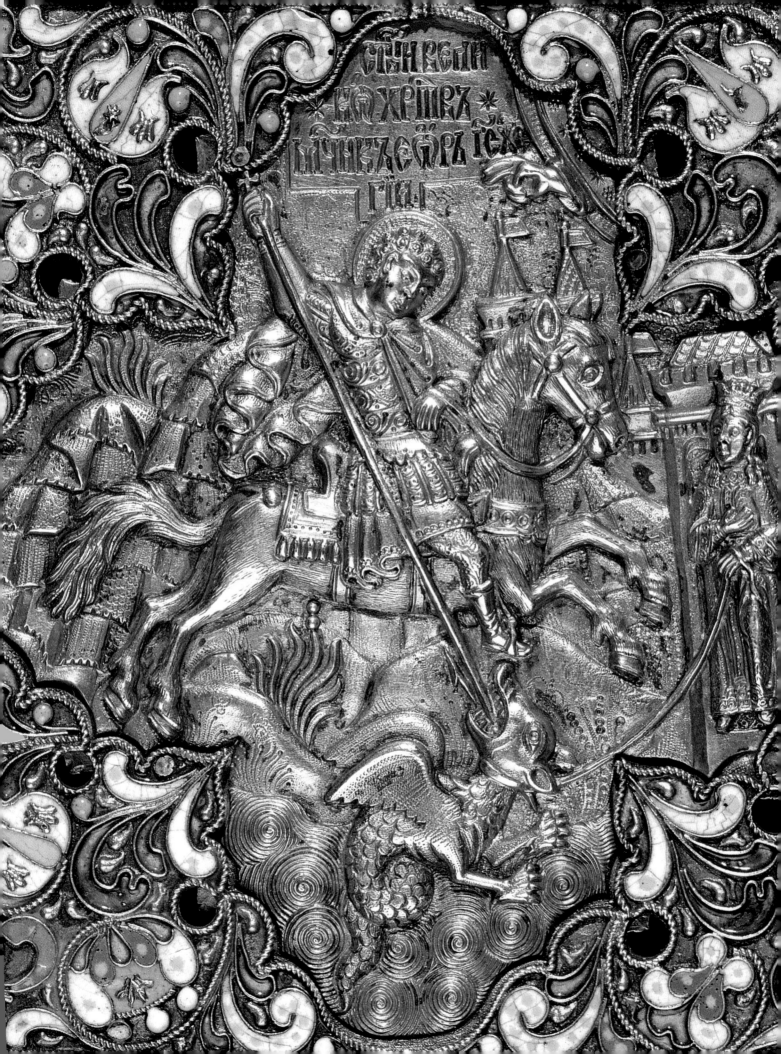

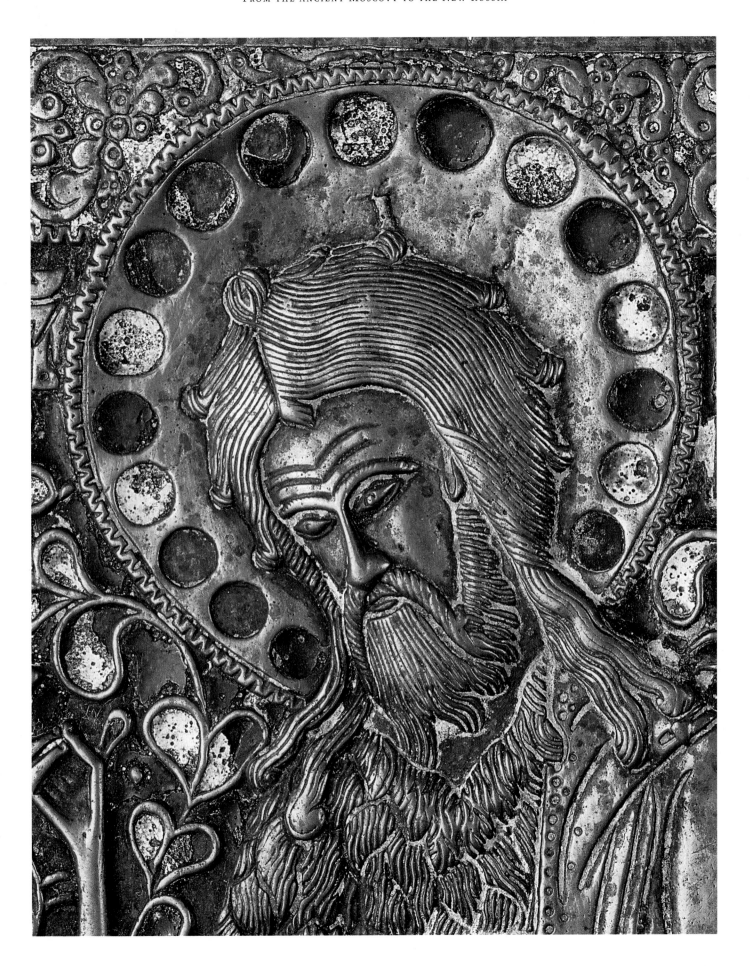

VIII
Triptych "Deisis",
Russia, 18th century

Page 33
Detail

IX
Icon *"The Prophet Elijah
ascending in the flames"*,
Russia, end of 17th century

X
Icon diptych *"The Miracle of
Saint-George vanquishing the dragon
and The Miracle of Flor and Lavr"*,
Northern Russia,
end 17th century–beginning
of 18th century

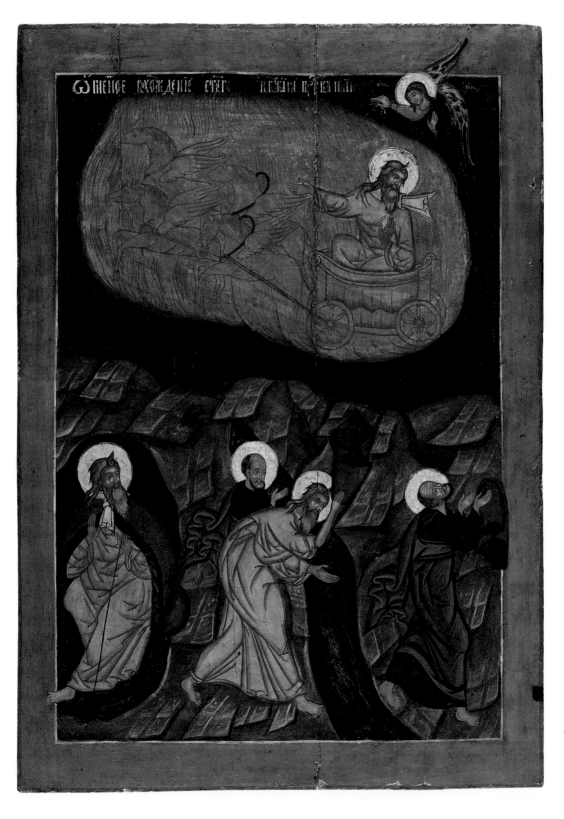

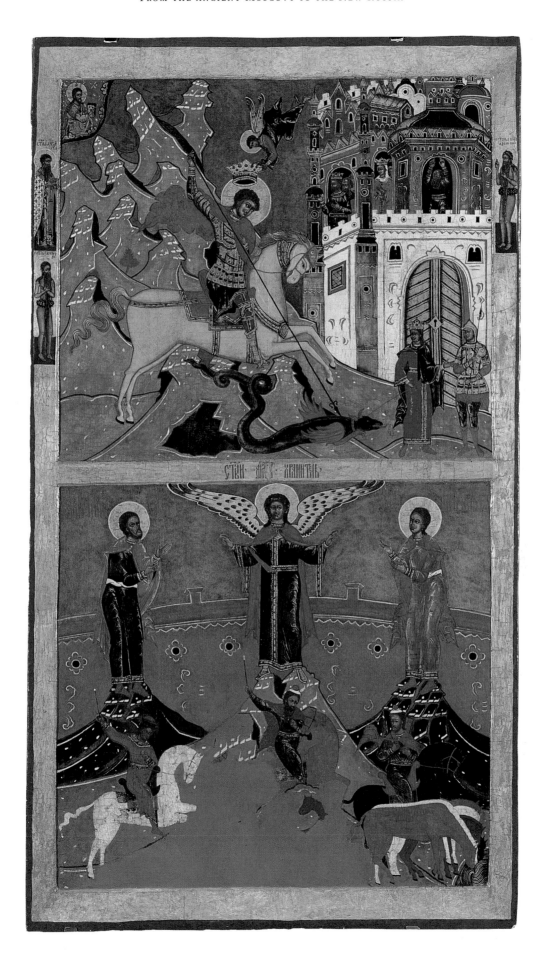

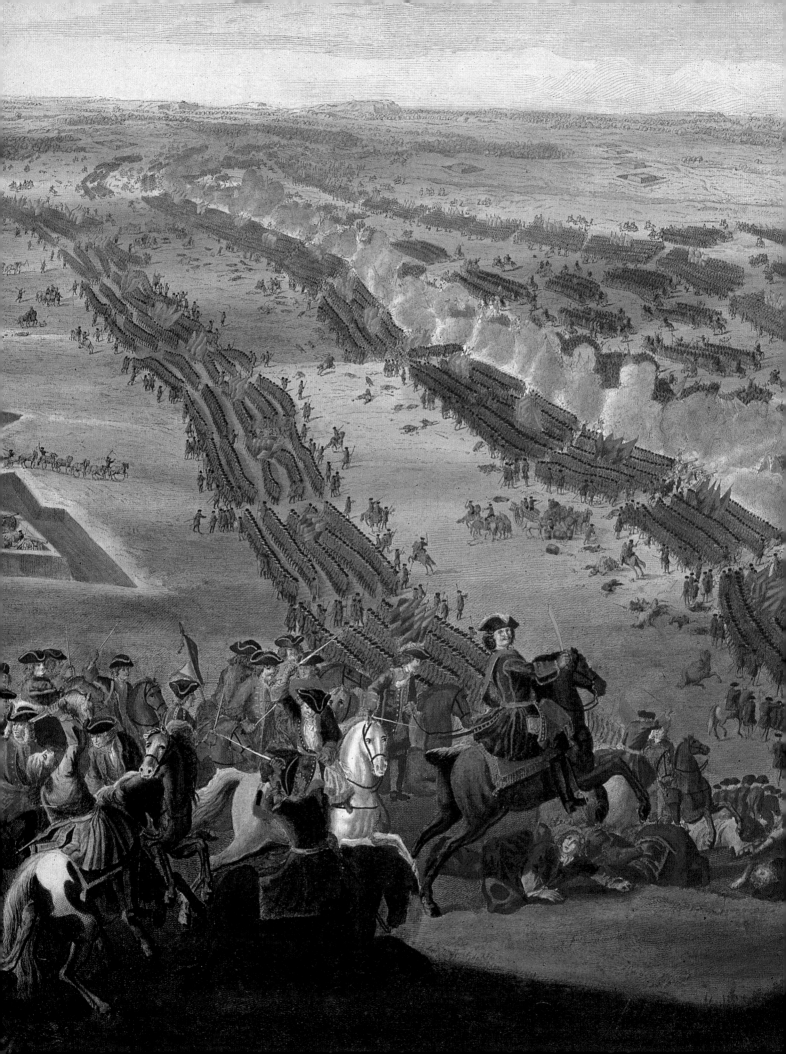

A city to be built,
a society to emerge

"When the crimson ball of the setting

January sun paints their tall Venetian

windows with liquid gold, the freezing man

crossing the bridge on foot suddenly sees

what Peter had in mind when he erected these

walls: a giant mirror for a lonely planet."

Joseph Brodsky
Guide to a Renamed City

Peter I was not destined to reign. He was born in 1672 to Alexis Romanov's second wife and was the Czar's fourth son. But the eldest son, Czarevitch Alexis, died and it was Feodor, the second son, who succeeded his father. However he too died, at the age of twenty, and Ivan, the third son was not able to reign alone because of his health. He became the co-Czar with Peter, the two of them under the regency of their older sister Sophie. It was not until Ivan's death, in 1696 that Peter became the only Czar. He was twenty-four. His love of the sea and the clear need to open up the country led him toward an access on the Mediterranean via the Black Sea, in other words, Azov. But Turkey had imposed navigational restrictions on Russia, leaving Peter no other choice than to turn toward the Baltic Sea whose shores, since the Stolbovo treaty in 1617, were controlled by Sweden. Peter was young, and so was the king of Sweden whose boldness took the place of experience. In 1700, he crushed the Russians at Narva, 150 kilometers west of the present-day St. Petersburg. The lesson was well-learned. Three years later Peter had an army. With it, he occupied a small island in the Neva delta which was frozen six months of the year. Sacks of earth in the form of a fortress gave "Hare" island the appearance of a defensive fortification aimed at intimidating the Swedes. It was May 16, 1703 by the Julian calendar and May 27 by the Gregorian calendar: these were the official dates adopted for the foundation of *Sankt Piterburch*, city which was given the name of the Czar's patron saint, but in the Dutch way, because Holland represented for Peter the model of Western countries.

The Czar set up his ship building site in front of "Hare" Island. A raid by the Swedish troops in 1705 led to the building of earth fortifications aimed at protecting the naval shipyards, known as the "Admiralty" because it was the center of maritime activity. The following year, the "Hare" Island fortress was rebuilt in masonry. Although a great deal altered during the centuries and no longer having much resemblance to Peter I's foundations, the two buildings bear witness to the early St. Petersburg's ascendancy.

Peter the founder

Founder of a new city, Peter was also and above all the founder of a new way to govern and to live. From a very early age, influenced by the encounters he had made, he gave evidence of an intellectual and scientific curiosity which he satisfied by frequenting the inhabitants of *Nemietskaia sloboda*, the foreigners' district in Moscow, Russia's capital. His childhood was in fact marked by the ostracism which had banished him to the village of Preobrajenskoie with his mother, Nathalie Narychkin, the Czar Alexis's second wife. When he was ten he was a witness to the bloody events which followed his father's succession and which caused him lifelong terror, much as thirty years before the events of the Fronde rebellion in Paris had provoked in the child Louis XIV a dread of the capital. These identical experiences explain the choice of the two rulers, once they had become adult, to abandon the city where blood had reigned. The young Peter was a boy left to his own devices who sought the company of a few good-for-nothings such as Alexander Menchikov who remained a life-long companion to the Czar. He grew up without any constraints at all, free of movement, and to act on his impulses and his desires as he wished, a freedom he evidenced on many occasions and sometimes in a most disorderly manner. But he was from a cultivated family with a father who had a fervor for Latin and for beautiful books and with uncles, his mother's brothers, who had built in Moscow and in its surroundings the most beautiful examples of what was known as the Narychkin baroque, a name coming from his maternal family. Peter who had a spirit of curiosity and was taught very young to read by his mother was also a fighter

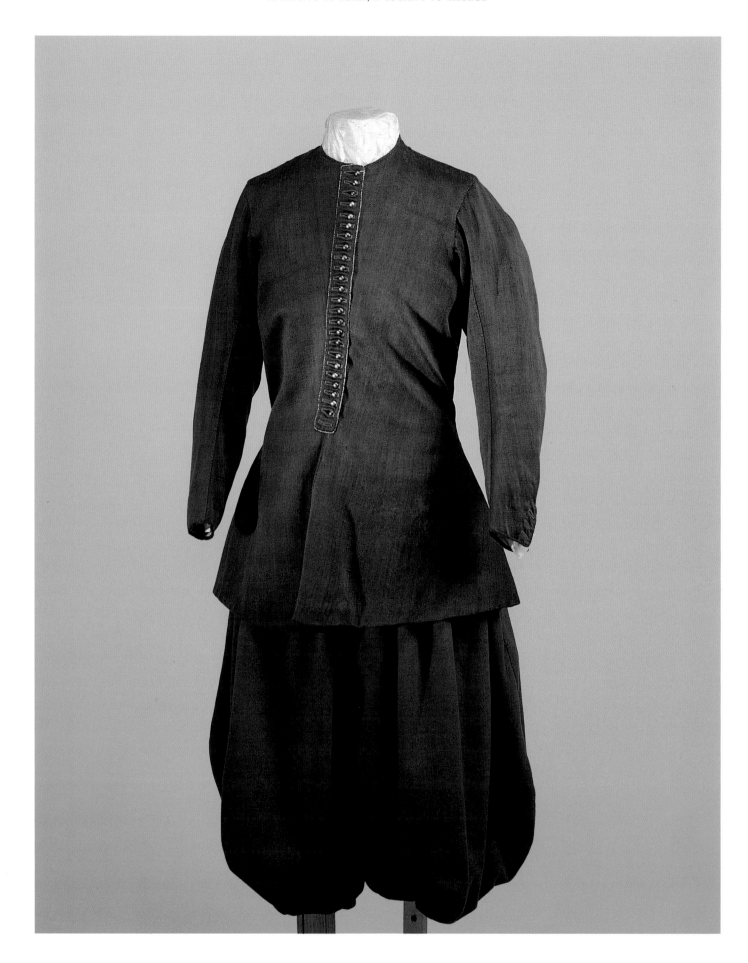

1
Peter I's seaman's outfit,
Russia, first half of 18th century

2
The Emperor's ukaze,
18th century

from his earliest age. While his sister governed, he learned. He headed a regiment of young scoundrels which he had created and which was to become a regiment of adolescents learning to fight with real weapons. In that *Nemietskaia sloboda* district from which his father had already taken the technicians which he needed, Peter learned mathematics, the art of fortification, the use of the astrolabe, the profession of turner. He discovered the famous dinghy, now in the St. Petersburg Navy Museum, which the Dutchman Christian Brandt had repaired to teach him navigation. The game became a passion. We know just where that led him since St. Petersburg sprung from it. But when he was seventeen, his mother arranged his marriage. By this, he was, according to Russian law, of age. He therefore no longer had need of a regent or of a co-Czar. He made it clear to the two concerned, his half sister and his half brother, that their services were no longer needed. Sophie did not appreciate her dismissal. Peter, threatened with capture by the all-powerful *streltsy* who supported the regent, was obliged to flee, only returning to the Kremlin once sure of the army's backing. He entrusted the care of the government to his mother and to the men of his family while he continued to discover Europe through the foreigners' district and through the first trips which he made to Holland. His mother died in 1694 and his brother Ivan two years later, and Peter I truly became Czar.

It was after he returned in 1697 from the "Great Embassy" which had taken him as far as England that Peter fully took in hand Russia's future. But at first the number of transformations that he imposed so suddenly seemed to be out of sync with reality. It was only with time that the coherence of his actions appeared: to open his country to the outside world and to make it an international power. In one word, "That Russia be!" The adoption of the Julian calendar on January 1, 1700, instead of the calendar which had fictitiously

counted time from the creation of the world, the obligation to dress in Western style, Peter himself wearing Dutch clothing to work (fig. 1), the ban on wearing a beard, which in ancient times had been a sign of power, all appeared to be superficial measures. But in reality, Peter was taking on the governmental camp which supported traditional rituals. In 1711 the Directing Senate was created, with the power to judge all the judicial, administrative and financial affairs, thus transforming the supreme authority. In the same way, replacing the *prikazes* with colleges, the ancestors of ministries, but with a collegial administration (fig. II), brought about a plurality of opinions in the decisions to be taken. In contrast, the reform of the local administration, founded on

3
Charles Simonneau
The battle of Poltava (second day),
after 1724

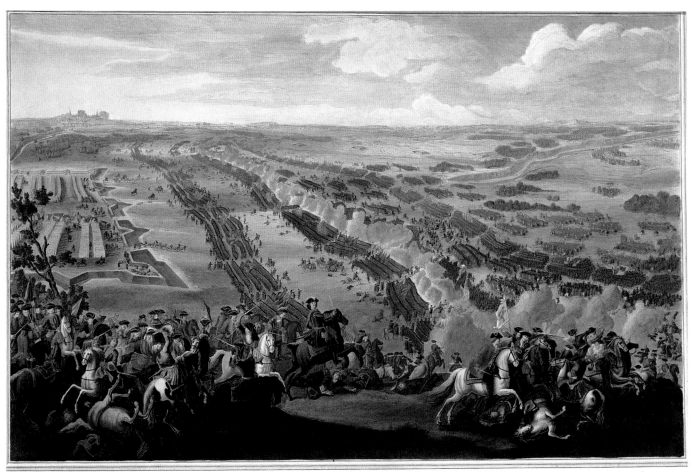

Ізображеніе конечного разрꙋшенія Швецкой армѣи. отъ росїйского войска после Гла вной Пол.
тавской баталїи. слꙋчившагося неда леко ѿпереволочны. Гдѣ оная безвсякого сꙋпротивленія рꙋжьé
свое положила сѡтоящая въ 18000. прѣнашими 9600. болше. Їюня въ 30. лѣ 1709. годꙋ.

the principle of the election and aimed at motivating the local people concerned, could not be carried out, due to a lack of comprehension and perhaps also lack of explanations. However Peter succeeded in imposing the re-apportionment of the country into "*goubernii*", the "governments", and then into administrative units.

The role of St. Petersburg in the "Reformer's" project was plain and clear. Peter was concerned very early with reorganizing Moscow's architecture and urban development, as the capital was regularly ravaged by fire. The *ukases*, decrees which were absolute orders, followed one another in imposing urban construction planning. It was compulsory to use rammed clay or hard materials in building any edifice which, in addition, had to be built along the alignment of the street and not set back from it. Beginning in 1705, the streets were paved through a method of taxation: every shipment entering Moscow had to bring with it three stones. The *ukases* were regularly handed down, but the situation was hard to control and construction of the new arsenal begun inside the Kremlin in 1701 was halted in 1706.

Peter did not like Moscow. City of blood, of revolutions, of plots, it remained in his eyes the embodiment of a ossified tradition which he absolutely had to get rid of in order to enter into what historians called "the European concert", a society in which Russia would have its word to say regarding border quarrels which concerned it, above all those in the south with Turkey as well as in the west with Poland and in the north concerning the sea. The victory of the Russian troops over the invincible Swedish king in 1709 (fig. 3) at Poltava, just at the Polish border, which had been one of Charles XII's objectives, as well as the Little Russia, the name for Ukraine, was the event which precipitated the abandoning of Moscow. For if Russia's occupation of the little islands in the Gulf of Finland had not troubled Charles XII, convinced he could take them back one day when he wanted to, that occupation became definitive and final when his army was crushed, a defeat from which he did not recover. Peter was primarily attached to St. Petersburg, a maritime port with the ambition to become a great commercial port as well as a war port, a new and open city, a military and cultural city, "his" creation, "his" city which in his eyes incarnated Russia's future. All the *ukases* which up until then had been issued regarding the construction and urban planning of Moscow began only to concern St. Petersburg. Little by little, Peter transferred the governmental bodies there. But above all, the repeated *ukases* ordered the resettlement of the population. These massive resettlements were not new to Russia at that time. They had already been carried out in 1699 in the Azov region after the taking of the fortress. But the two 1714 *ukases* (fig. 2) were decisive and the migrations were practically completed by the following year. The city was to be populated by people of quality: the nobility, the business class which made up the powerful class of merchants, and the different craft trades, from the craftsman to the manufacturer. The serfs arrived of course along with their masters.

The Czar, founder of a new society, also created a new way of living, and the foreign travelers recounted the mockery of a modern society which Peter wished to institute through the system of "assemblies." These were receptions which the nobles and notables were required to give at least once a year. An *ukase* in 1716 set down the rules for how these receptions were to be organized during which one danced, played and drank. One of the articles of the decree stated that it was not proper to drink too much just because the drink was free, being offered by the host.

Peter came back from Paris in 1717 with four Gobelins' tapestries in his luggage, woven from sketches made by Jouvenet, which had been given to him by Louis XV (figs. IV, V). He immediately created the tapestry manufacture whose name was to be translated into Russian by "gobelin." He had already created brick works since he wished the city to be constructed of hard materials, and ceramic tile manufactures based on the model of what he had seen in Holland, because he wanted to use them to cover the walls, and the stoves which heated the houses. He established in St. Petersburg the great lines which were to determine the city's aspect with its channeled rivers and the many canals destined to drain the water from the swamp (fig. III).

A port become a capital

No documents have come down to us concerning the first constructions in St. Petersburg, except for Peter's little jewel-like *isba* set in a brick casket which was periodically renewed. Part of the population was re-grouped on Gorod Island, island of the city, which stretched behind the fortress, and the other part was settled on the Admiralty island near the navy shipyards where the personnel employed by the

work-sites and the foremen and their serfs were housed. Each island resembled any of the small Russian towns: wooden *isbas*, a market, a cabaret, baths, and of course, a church. Friedrich Christian Weber wrote an account of all this in 1714, "I expected to find a regular city but I was very astonished to see only a cluster of villages one after another after another like the plantations in the West Indies."[1]

But as Sweden remained Russia's dreaded enemy until 1709, the urban and architectural planning choices remained a secondary preoccupation. It was only once having freed his country from his cumbersome neighbor, that Peter was able to devote himself to his city, his personal creation. He then called on foreign technicians whose skills were indispensable, to make the most of all these islands which formed the delta and to transform the marshy area into land that could be built upon. The Dutch were the first called upon for digging the draining canals and converting the Neva's tributaries. They were the specialists in water control and flow. However, Peter quickly understood that along with the engineers, he needed men who could draw, construct and decorate. The architects arrived beginning in 1713, followed by sculptors, painters and decorators in 1716. Italians, Germans, French succeeded one another or worked together in the same building, which explains the lack of homogeneity in the earliest St. Petersburg architecture. The *St. Petersburg Panorama*, engraved by Alexis Feodorovitch Zoubov in 1716 gives us more an idea of the Czar's dreams, than of the existing reality, but it well shows that from that time on, the most beautiful residences were built all along the Neva. The Czar's Summer Palace (fig. 6), built according to the "model house for the upper class" which was the summit of comfort imagined by the Italian-Swiss engineer Domenico Trezzini, and the accompanying garden in which the sovereign himself placed the statues that his envoy in Rome had bought for him, occupied a key loca-tion at the confluence of the Moïka and the Neva rivers. It should be said that gardens were a constant preoccupation for the builder Peter. This is one of the reasons why he hired the French architect Alexandre Leblond, a specialist in land-scaping gardens accompanying mansions. The Winter canal, dug by order of Peter I, bordered his Winter Palace which has not survived. On the other side of the river, the Menchikov palace dominated the territory which Peter had given to his favorite on Vassilievsky Island. The blueprint which was drawn up and published in Paris by Nicolas de Fer at the time of Peter I's visit to France shows the main lines of the city's appearance (fig. 4), of great interest to all of Europe and which gave rise to detailed descriptions by travelers who had had the opportunity to visit there. Engravings, which at that time played the role photography plays today, disseminated the image of the city. Another Dutchman, Ottomar Elliguer did an engraving based on watercolor drawings by the Dutch Christophore Marcelius (done in 1725 and today preserved in the St. Petersburg Academy of Science). The engraving was a black and white panorama of the Neva banks, which showed the extraordinary development of building in just ten years and also showed the importance of navigation and the ton-nage of the ships. In fact, the river was, for the Czar, the royal route, the main artery and he did not wish to see any bridges crossing it. This explains why the first bridge, a floating bridge (fig. 5) was only built in 1727 after his death. In addition, the questions of urbanism were a concern for a long time because the city grew up a little too naturally despite its founder's repeated *ukases* and the draconian measures of his successors. After two gigantic fires which ravaged the Admiralty district in 1736 and 1737, the Empress Anna Ivanovna created the "Building Commission." A real foundation plan as well as a program laying out the major streets was drawn up under the direction of an architect trained in Italy, Piotr Eropkin.

4
Nicolas de Fer
Map of St. Petersburg, 1717

5
Yakov Vassiliev
*View of the Neva toward the West
between St. Isaac's Cathedral and the
Cadet Corps buildings*, 18th century

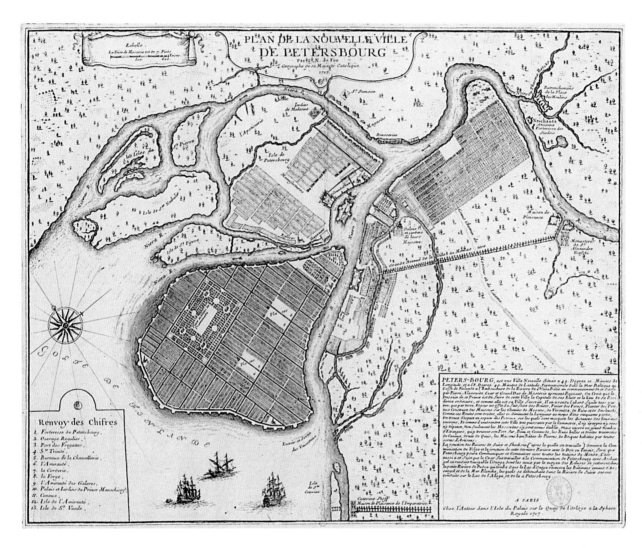

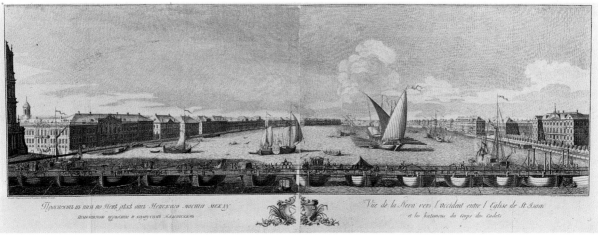

6
Andreï Efimovitch Martynov
*Peter I's Palace in the Summer
garden*, 1809–1810

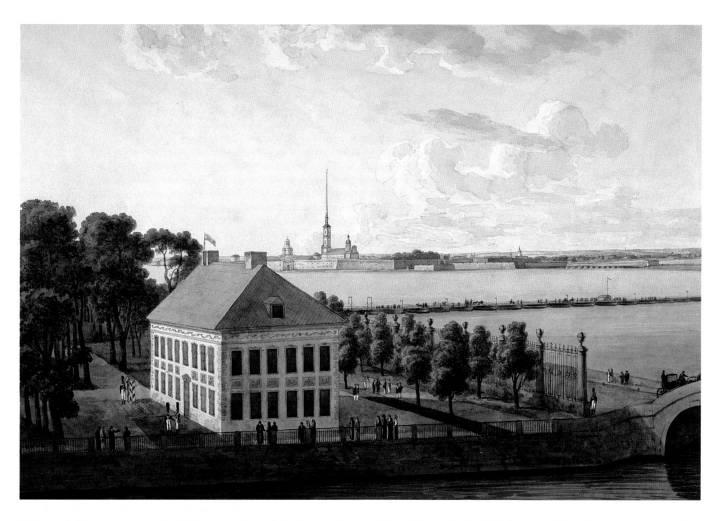

Although his premature death in 1740 slowed the Commission's work, the magnificent engravings from the middle of the century, done based on Mikhail Makhaiev's layout, provides a picture of the place which remained a reference point for years to come. It would be Catherine II's task to finish the work of her predecessors and to definitively impose the Western way of living on her subjects.

A new city, a new society

The paintings, the watercolors, and the color engravings by Benjamin Patersen, a Swedish artist who had moved to St. Petersburg in 1787 and worked there until 1815, provide a rich and colorful picture of the city one century after the first stone had been laid. Catherine II had ordered the quays of the Neva to be covered in granite, and from then on, the spectacle of the river took on a grandiose aspect. Patersen enjoyed painting a lively city, rich in color in spite of its hard climate, and indulged himself in detailing the least of the buildings as well as the city's animated population. A very charming painting shows the Tauride palace, built by Ivan Starov from 1783 to 1788 for Grigori Potemkin, Catherine II's favorite. The palace illustrates the work of an architect who had been trained in Paris, at Charles de Wailly's, and then in Rome and in Venice. The garden landscape, done by

the Englishman William Gould, was reputed for the diversity of its viewpoints. The famous Nevsky Prospect, one side of which is bordered by the *gostinny dvor*, the covered market built by the Frenchman Vallin de la Mothe, was the subject of a beautiful watercolor whose line of sight is the Admiralty spire. The views of the St. Isaac floating bridge highlight the activity linked to the life of the river, and many of the engravings of the English Quay show the liveliness of the atmosphere which dominated either side of the Neva. The Winter Palace, built by Bartolomeo Rastrelli beginning in 1754, is seen from the front in a superb color engraving, as is the Marble Palace built from 1768 to 1785 by Antonio Rinaldi for Grigori Orlov who had helped Catherine II to take power. The architects, as one can see, are far from being all Russian. As during Peter I's era, Italians and French were brought to the capital. But the best students of the Fine Arts Academy, which had been founded in 1757, were given grants to study abroad. Bajenov, Starov and Volkov studied in Paris in Charles de Wailly's studio, and Zakharov was at Chalgrin's. However the major work of urbanism and planning for the city, with its streets and its squares, only began in the early part of the 19th century under Alexander I's reign.

Patersen, portraitist of a city whose fame had reached all of Europe, enjoyed not only showing the architecture, but also showing the life which reigned in a port which was both military and commercial. For one lived, in this city! The palace provided the note, of course, and court life with its diverse and important members also played a crucial role in the development of taste, dress, choice of jewelry or hair styles. A lot of the families had traveled to Europe and many of them had stayed in Paris, capital of taste, of fashion, of literature. The Empress had an on-going correspondence with Voltaire, Diderot, d'Alembert. She proposed to the latter to come to St. Petersburg to finish his *Encyclopedia*. Court life brought in its wake receptions, and dinners laid out on table services unique in the world, ordered from the Sèvres manufacture in France, such as the Cameo service, or created in the manufacture which Dmitri Vinogradov had founded not far from St. Petersburg. It was there that the services were created dedicated to the four great imperial orders of St. Andrew, St. George, St. Alexander Nevsky and St. Vladimir which were used once a year by those who had been decorated with the titles for the festival of the order's patron saint.

Finally, the ultimate of refinement of this new society rested on the taste for collections. The example was given by the highest in the land since Catherine II had had a "hermitage" built by the Frenchman Vallin de la Mothe to exhibit her acquisitions. The noble families furnished their palaces with Italian, French or Dutch paintings, with antique or contemporary sculpture, with cameos and semiprecious stones such as malachite or lapis-lazuli which had been elaborately worked and mounted according to the current fashion.

At the same time the city was being built, a new society was emerging.

B. de Montclos

[1] Weber, F.C., *Nouveaux mémoires sur l'état présent de la Grande Russie ou Moscovie, par un Allemand résidant en cette cour, avec la description de Pétersbourg et de Kronshlot*, translated by Father Malassis into French and published in Paris by Pissot in 1725, vol. I, p. 5.

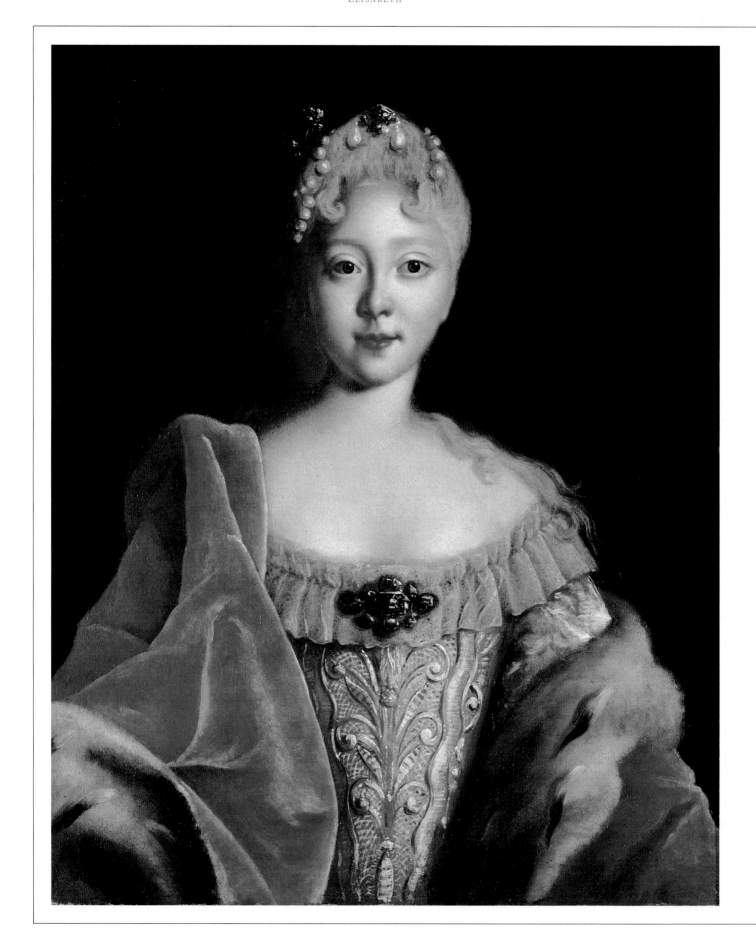

Elisabeth

Elisabeth (fig. a), Peter the Great's daughter, who ascended to the Russian throne in 1741 after the interlude of Anna Ivanovna, continued her father's work. She gave the Directing Senate back its coordinating role in the legislative and judicial fields but she allowed the nobility privileges that her father Peter I had not wished, and serfdom became more widespread. The Empress governed surrounded by advisors in every area: Russia was thus able to reinforce its military supremacy during the Seven Years' War. Elisabeth, like her father, was preoccupied with the subject of education. The Academy of Sciences which was conceived by Peter I as a teaching establishment opened its doors in 1726, a year after his death. In 1755, the first Russian university in Moscow was founded and it remains one of the main creations of Elisabeth's reign, advised to set it up by her councilors Ivan Chouvalov and Mikhail Lomonossov.

The Empress promoted not only the humanities but also the arts. In 1757 she directed that the Fine Arts department of the Academy of Sciences be detached from it in order to create a Fine Arts Academy which by 1759 was functioning. During her reign, "palaces" were built all over the city: in fact the dimensions of these constructions could not classify them as *hôtel particuliers* (private mansions) and besides, this term did not appear until the 19th century. Her Summer Palace which she ordered built in 1740 by Bartolomeo Francesco Rastrelli who was to become her personal architect was constructed from 1741 to 1742 at the convergence of the Fontanka and Moïka rivers, facing the far end of Peter the Great's Summer Garden. The ground floor was made of stone but the rest of the building was in wood.

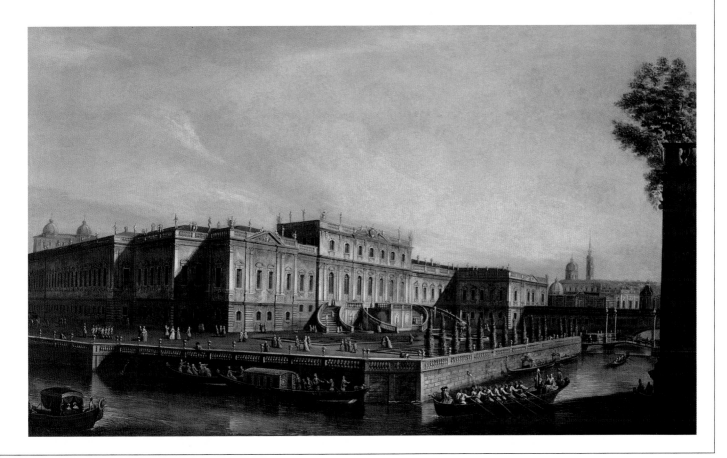

It is was huge: according to its builder, it contained "160 apartments... all decorated with mirrors and sculptures"[1] (fig. b). It was destroyed in 1796 by order of Paul I to build in its place Saint Michel's palace using the same foundations.

In 1748, the Empress gave the order to the Russian architect Zemtsov to build a palace for her favorite, Count Razoumovski. The Anitchkov palace, which is located at the angle of the Nevsky Prospect and the Fontanka river, was finished by Rastrelli. It was completely renovated for Catherine II's favorite, Grigori Potemkin, and then again by Carlo Rossi in the 1820s when the district was developed.

The Winter Palace is the royal palace, built by that same Rastrelli, for he reigned over St. Petersburg architecture, both officially and privately, until 1762. He described it himself as "the big winter castle" with its courtyards, its facades, and the "grand parade stairway with its double ramp of Italian white marble, a magnificent example of both architecture and sculptures, decorated by several statues."[2] This is the famous Ambassadors stairway, also known as the Jordan, because the reigning sovereign descended it on January 6 on his way to bless the waters of the Neva in memory of the baptism of Christ. The palace (fig. e) itself, whose construction was begun in 1754 on the site of Anna Ivanovna's palace, which Elisabeth had razed to the ground, is not of special architectural interest. However, the profusion of baroque décor, inspired by examples from central Europe, is noteworthy for its proliferation of decorative motifs and the skill of the architect in combining them. The main façade, oriented toward the city, gave onto a piece of empty land at that time and not to a constructed square. However, it was through the vaulted passageway with its three central composite bays by which one entered the palace which gave out onto the court of honor. This disharmony was pointed out by foreign visitors. The Reverend Father Georgel was shocked by this meadow where farmers gamboled about in winter sliding down icy hills, like roller coasters (sometimes known as Russian mountains), and which was the formal entrance to the royal palace.[3] The solution was only to be found twenty years later by Carlo Rossi.

Elisabeth who wanted a noble retirement in an establishment worthy of an empress ordered Rastrelli to build the famous Smolny monastery. It was she who laid the first stone in 1748. As the Empress was profoundly Russian, she requested a construction which would be contemporary, but also true to Russian tradition. Rastrelli studied the composition of Vladimiro-Souzdalian monasteries, defense monasteries all built on the same plan: a fortified surrounding wall, in the center of which was the cathedral, and in front of it, at the entrance, an isolated bell-tower which also helped contribute to the protection of the whole thanks to its height from which the surroundings could be watched. The project model, done in Rastrelli's workshop and which today is in the Fine Arts Academy collections is shown in this exhibition. Its surface size is more than 25 square meters, and the interior decoration is also in color, indicating the great importance which was given to creating a project as complete as possible. Rastrelli himself wrote, "During this time I had a model in wood made of the whole convent, and followed it for the construction."[4] This is not entirely true for the isolated bell tower, forming the main gateway, was never built. But the 120 cells, the residence of the Abbess, and the four domed churches placed at four angles of the quadrilateral were indeed built. However Elisabeth died before the monastery was finished and never

d
Master I.F. Kepping
Soup bowl,
St. Petersburg, 1750s

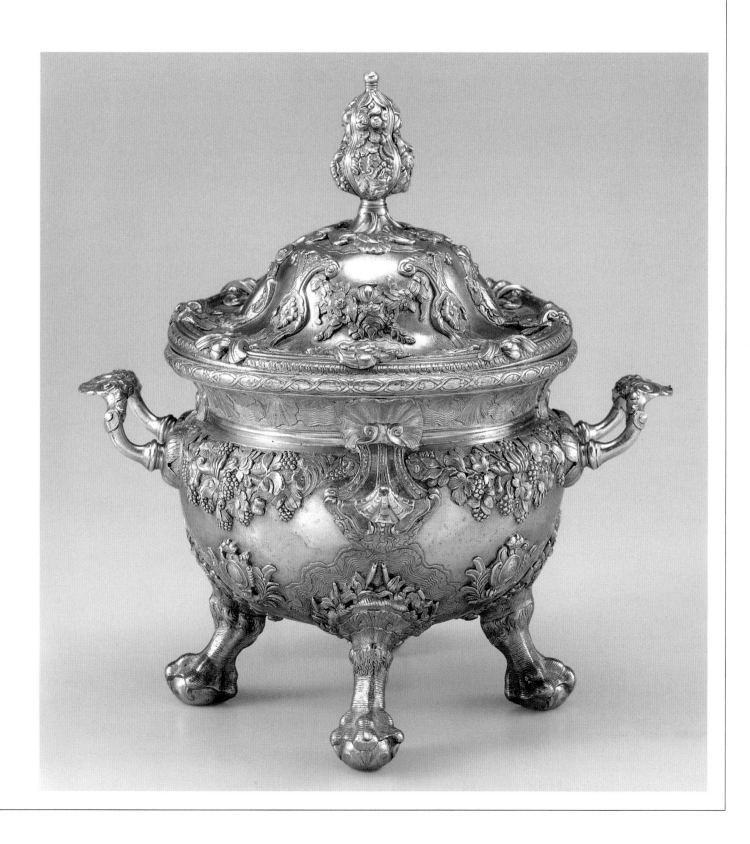

e
Johann Georg de Mayer
*View of the Palace quay from the tip
of Vassiliesky Island*, detail, 1796

lived there. The bell-tower was never built and the church was completed only in the first third of the 19th century.

In the wake of the Empress, the elite of the nobility had their palaces built by the same Rastrelli or by his disciples, always in the same spirit and style. The Vorontsov palace, built between the Fontanka river and the wide Sadovaia Avenue is as much an urban residence as a suburban villa because of the immense plot of land it occupies. The three projecting parts of the main façade, enhanced by a play of columns and twinned pilasters; the central triangular pediment; and the arched pediments without base and with vegetal adornment on the lateral projecting tympanum are a continuation of the architectural décor existing in all of central Europe, particularly in Vienna. The Vorontsov palace which was built between 1746 and 1755 foreshadows the dynamism that Rastrelli would bring to the Stroganov palace in the 1750s. The Stroganov Palace which was built at the angle of the Moïka River and the Nevsky Prospect was rapidly known

for the strength of its architecture, its interior décor and, a few years later, for the extraordinary collection of art within its walls.

Architecture, whether civil or religious, continued to be the dominant art during the reign of Elisabeth I. But the interior should be a reply to the exterior and thus there was a spectacular blooming of interior decoration which led to the growth of decorative art. The exploitation of gold and silver mines in the Ural in the second quarter of the 18th century contributed gilded statues to this deployment which up until then had been solely the domain of cultural edifices and which then became widespread in the form of light fixtures shaped as arms, consoles held up by cupids, mirrors, and especially, gold and silver work articles. In fact, the ancient shapes (fig. c) were made obsolete by a new way of life. The tall metal goblets made in the effigy of the reigning sovereign no longer reflected the tastes of the day. The *kovsch* definitively lost their role as drinking glasses and began to be made from precious metal, decorated according to

well-defined criteria, and destined to reward important officials.

In contrast, salt shakers, sugar bowls, milk jugs, teapots, soup bowls (fig. d) once rarely used, begin to spread through-out the Court and into the homes of elite families. The models came from France for Elisabeth was extremely fond of for French gold and silver work. In addition, the growing use of tobacco and the fashion of beauty spots on the face led to a proliferation of boxes: snuffboxes, candy boxes made of precious metal and richly decorated with precious stones.

Elisabeth's reign enormously marked St. Petersburg's development: city of palaces isolated from one another, made up of islands of construction whose incoherence was pointed out to Catherine II by Diderot.[5]

Yet the city is anchored in what historians call "the European entente." And in addition, thanks to Elisabeth, St. Petersburg's architecture discovered its own specific style which would become a model to be copied in the 19th century.

B. de M.

[1] *Relation générale de tous les édifices, palais et Jardins que moy Comte Rastrelli, Ober Architecte de la Cour, a fait construire pendant tout le tems que j'ai eu l'honneur d'être au service de Leurs Majestés Imp[les] de toutes les Russies, à commencer depuis l'année 1716 jusqu'à cette année 1764* in Zygmunt Batowski, *Architekt Rastrelli o swych pracach*, Lwow 1939, p. 58.

[2] *Idem*, p. 54.

[3] The reverend Father Georgel, *Voyage to Saint Petersburg in 1799-1800*, Paris, 1818.

[4] *Relation générale de tous les édifices...*, p. 49.

[5] "Wouldn't it be possible to increase St. Petersburg's population, to make it more lively, more active, more commercial place, by joining together this multitude of isolated palaces with private houses?", Denis Diderot, *Mélanges pour Catherine II*, art. VII, ed. Laffont, Bouquins, t. III, p. 239.

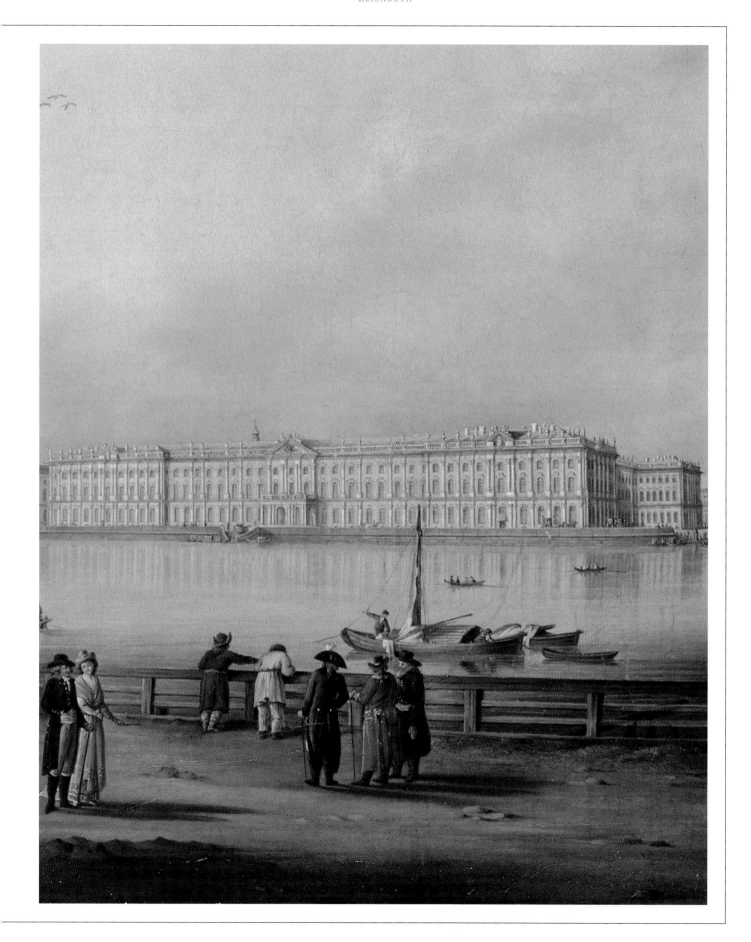

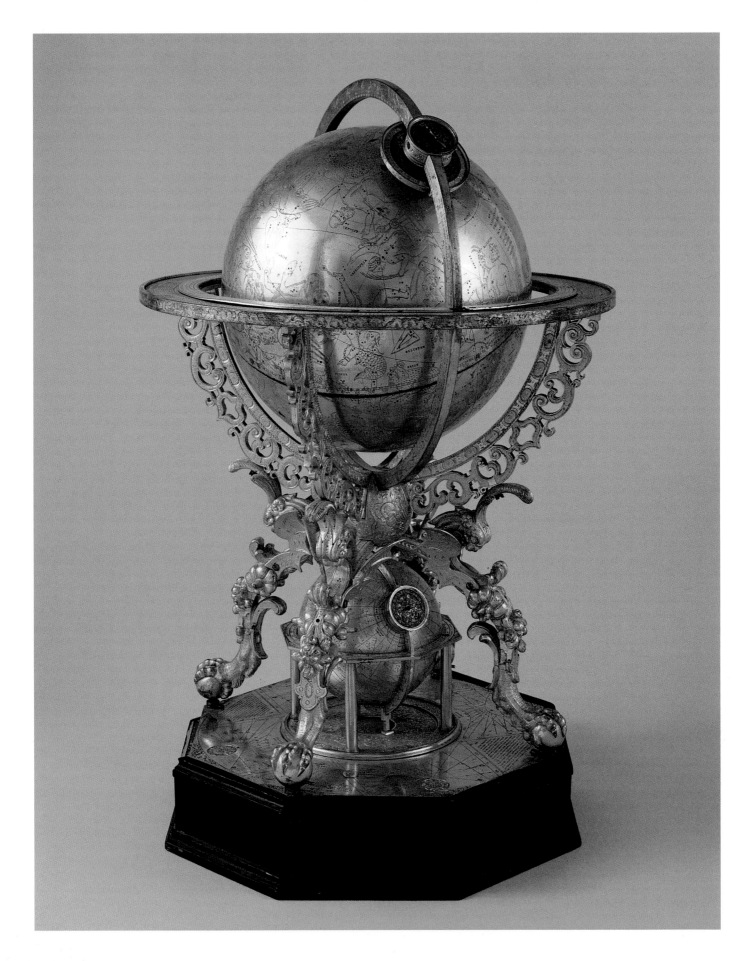

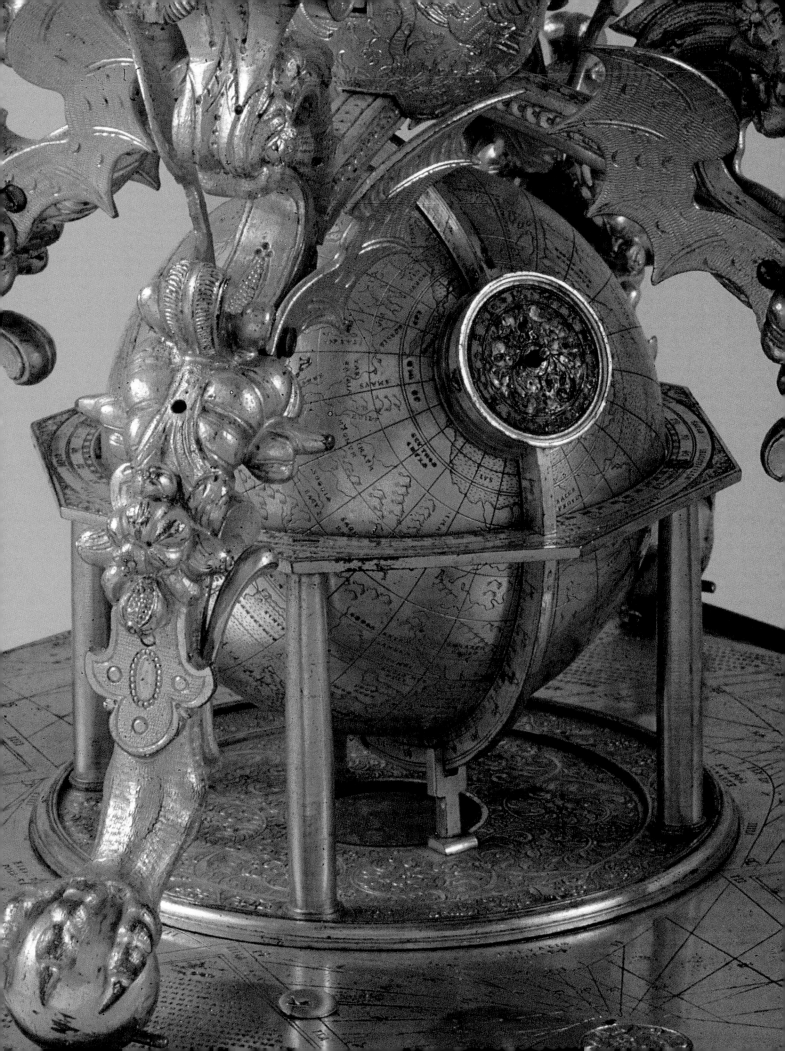

Pages 56–57
I
Masters Georg Roll
and Johann Reinhold
*Astronomical clock with celestial
and terrestrial globe,* 1584

II
Efim Terentievitch Vnoukov
*The perspective near the Twelve
Colleges building,* 1753

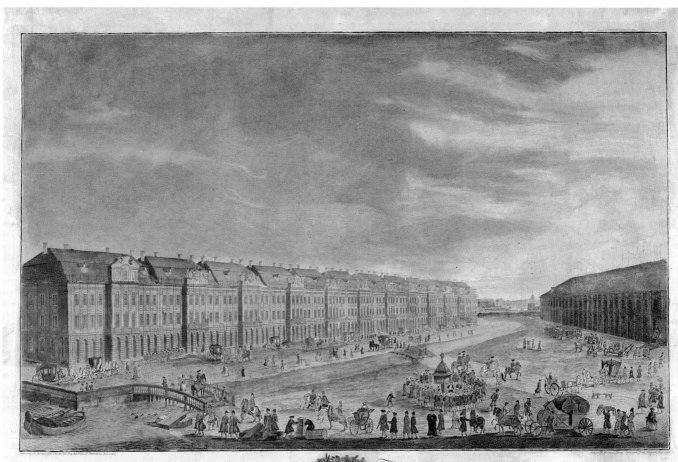

Проспектъ Государственныхъ Коллегій
съ частію Гостинаго двора съ Восточную сторону.

*Vûe des batimens des Colleges Imperiaux
& d'une partie du Magazin de marchandises vers l'orient*

III
Anonymous
Map of St. Petersburg, 1717

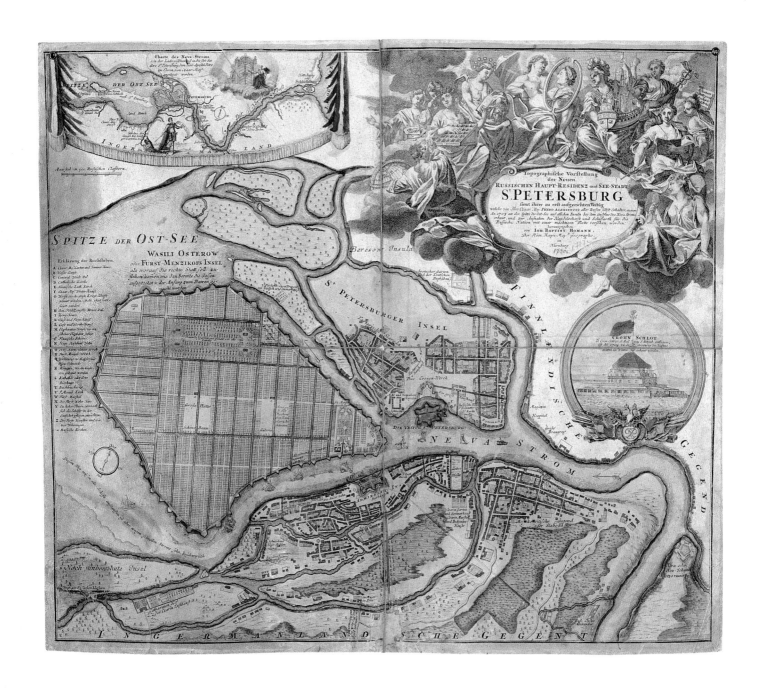

IV
Gobelins Manufacture,
Le Fevre-Sons high warp
workshop
The supper at Simon le Pharisian's,
1712–1715

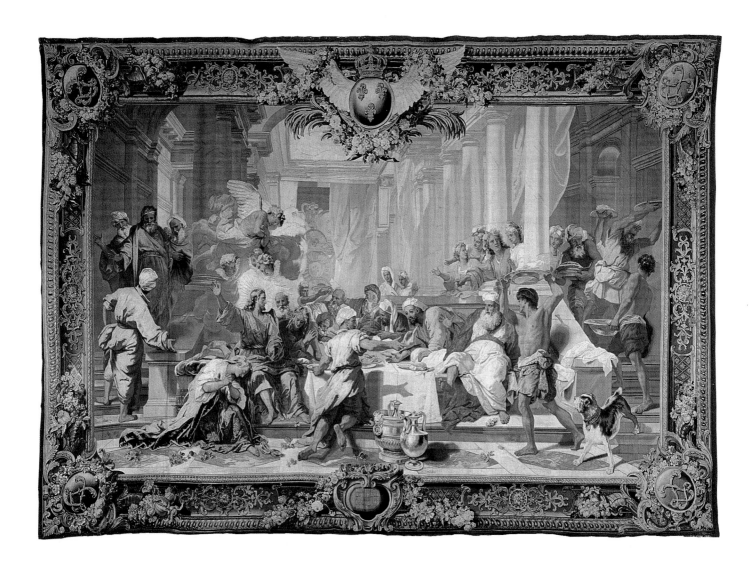

V
Gobelins Manufacture,
Le Fevre-Sons high warp
workshop
The miraculous draught of fishes,
1713–1717

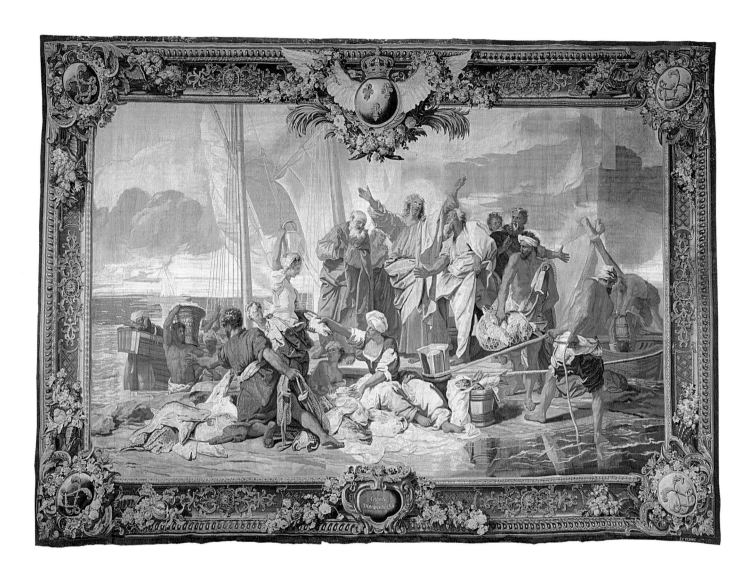

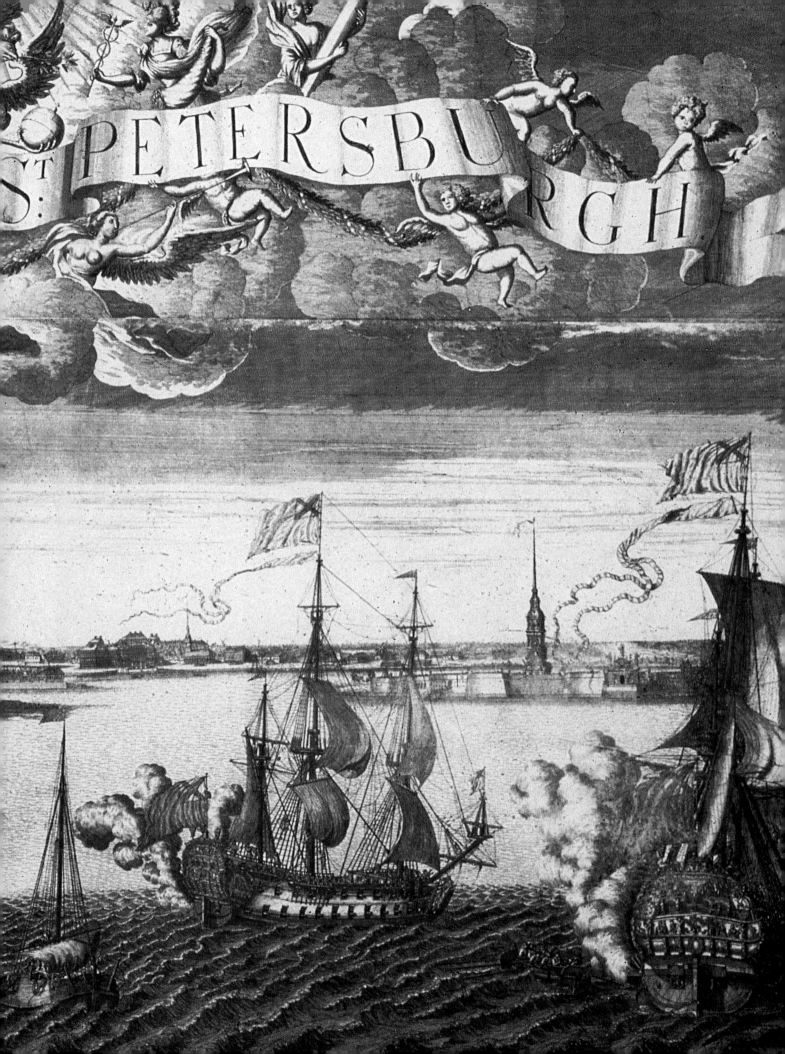

St. Petersburg seen through
engravings

"I expected to find a regular city but I was very astonished to see only a cluster of villages one after another like the plantations in the West Indies. However, one can rightly look at Petersburg today as one of the wonders of the world: as much by the magnificence of its buildings and its more than sixty thousand houses as by the speed with which this city was built."

New Memoirs on the present state of the Great Russia
or Moscovy by a German living at that Court from 1714 to 1720
(*Nouveaux Mémoires sur l'état présent de la Grande Russie
ou Moscovie par un Allemand résident en cette Cour
depuis l'année 1714 jusqu'en 1720.*) Translated by
Father Malassis into French and published in Paris
by Pissot in 1725

The engravings of the first quarter of the 18th century played a very special role in Russian art. The extraordinary ebullience of life linked to the emergence of the New Russia was to find in that art its most perfect mode of expression. The victories during the Russian-Swedish war of 1700–1721, the construction of the new capital, the high society life and the festivities in Moscow and St. Petersburg were the major sources of inspiration for the master engravers of the Petrovian period.

Contrary to the Western European countries, where the printing and engraving industries were primarily concentrated in private engraving and typography workshops, in Russia they were answerable to the State. The centers for the engraving arts at that time were the State Armory and the Moscow Printing House, followed in 1711 by the St. Petersburg typography workshop. It was at the initiative of the painter V.A. Kiprianov, the first to create his own non-religious typography workshop in Moscow, that the printing works were transferred to the State, a natural transfer given that engraving served exclusively the interests of the State.

In Peter I's view, engraving was the most useful and most easily handled art form. The possibility to multiply the prints was an incomparable advantage. The engravings could be used as a calendar of events and were accessible to all classes of the population. They could be used for political propaganda and to glorify the achievements of the Russian monarch. It was due to Peter I's efforts that the art of engraving became of such importance to his policies. The Czar himself personally oversaw the carrying out of the orders for engravings. In his letters, there is often reference to the preparation of engravings. Peter I deemed it particularly important that the artist himself participate directly in the events. The master engravers found themselves frequently at his side, even during military campaigns, and in his endless trips around the country. It was mainly because of this that the images so accurately and so vividly reproduced the main historic events of the time.

Engraving had existed in Russia long before Peter I. The first Russian engravings had mainly been running initials or vignettes for book illustrations, loose-leaf pages of a religious content, and the complex symbolic compositions of the *conclusions*. The first press had been built in Moscow in 1677–1678 by the Czar Theodore and had been used in his typography workshop.

But later, engraving became closely linked to the name of Peter I. The Czar's interest for this art form showed itself from his earliest age. At the beginning of the 1680s in the village of Preobrajensky, near Moscow, Peter had his own personal press on which proofs were made. The Czar learned about engravings through books and albums by European masters. He was especially interested in the work of the Dutch master, Adriaan Schoonebeeck (1661–1705) who had arrived in Moscow in the years 1696–1697.

It was during Peter's first trip abroad that this same Schoonebeeck introduced him to the greatest Dutch typographers and the most famous European engravers. The artist was later hired to work for the Russian state where he introduced the art of etching: this fast technique became very popular especially at the beginning of the 18th century and was used by most of the great Russian or foreign masters working in Moscow. One of the most important clauses in the contracts, signed with the foreign masters, mentions the training of Russian engravers. Thus, in 1699, students of icon workshops, such as P. Bounin and A. Zoubov, were oriented toward Schoonebeeck's workshop. In five years, there were already ten to twelve students. The art of the Dutch master and his teaching played

I
Nicolas Martin de Larmessin
The battle of Lesnaïa, 1722–1724

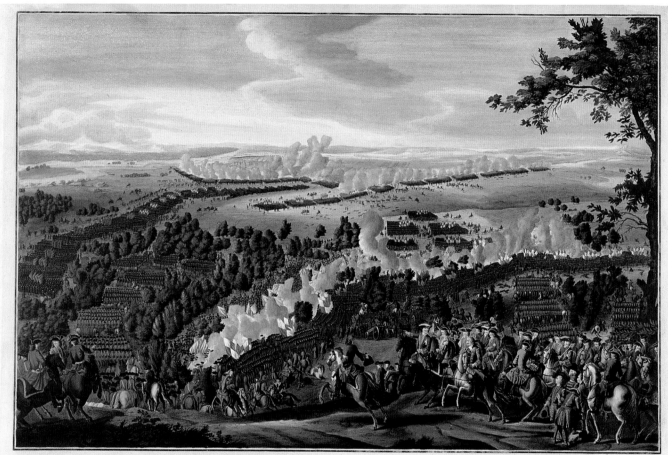

ИЗОБРАЖЕНІЕ БАТАЛІИ МЕЖДУ ЧАСТІЮ ВОЙСКЪ РОСІЙСКИХЪ КОТОРЫЯ БЫЛИ ТОГДА ВЪ ПРІСУДСТВІИ КОМАНДЫ ЕГО ЦАРСКАГО ВЕЛИЧЕСТВА ІСВѢИСКІХЪ ПОКОМАНДОЮ ГЕНЕРАЛА ГРАФА ЛЕВЕНГОУПТА ПРІДЕРЕВНѢ ЛЕСНОЙ КОТОРАЯ ОТЪ ПРОПОЙСКА ВЪ ДВУХЪ МИЛЯХЪ СЕНТЯБРЯ. ВЪ 28. ДЕНЬ. 1708.

a determining role in the evolution of engraving during Peter I's reign.

After Schoonebeeck's death, his adopted son, Pierre Picart (1668/1669–1737) who had come with him to Russia took over the management of the workshop. The name of Picart was linked to the creation in 1703 of the first engraving workshop out in the field, attached to the army. A little later, in 1709, another Dutch master, Hendrick Dewitt (1661–1716) was invited to work for Russia. Under Peter I's reign, engraving rapidly advanced and the main styles were represented right from the beginning: portraits of Pe-

ter and his military companions, battle scenes, ceremonies and fireworks.

In addition, the *panorama*, imported from Holland, became newly popular in Russia. Between 1707 and 1709, two huge panoramas of the city (70 × 245 cm) were made in Moscow's State Armory engraving workshop. One of them was a *View of Moscow from the Stone Bridge*, engraved by Picart and his Russian students, the brothers Alexis and Ivan Zoubov. The second was a *View of Moscow from Sparrow Mount*, which was done by Jan Blickland, one of the most enigmatic artists of the Petrovian period. He was

either of Dutch or Polish origin, appeared in Moscow in 1708 only to disappear without a trace in 1709. After that, no mention was ever made of him again. Later, in the middle and second half of the 18th century, panoramas of St. Petersburg became a favorite motif of artists and engravers.

Already in Moscow, in the Printing House workshops, engravings showing the military victories of the Russian armies during the Great Northern War were being made. Peter I believed that the renown of the Russian army's military victories during the Great Northern War was one of the main reasons for the increased prestige Russia had acquired abroad. Later, painters who had previously worked in the State Armory typography workshop, were given the order to make engravings of these military victories. It was in such State Armory that engraved editions, called "Journals", were printed which were devoted to the victories of the Russian armies in Lesnaïa, a village near Poltava. Peter sent sketches he had done himself of the battle plans so that they would be transmitted to the engravers. The "Journals" which were designed from plans made by Peter I himself, bore witness to the extraordinary attention which the Czar gave to the art of engraving and to the possibilities it offered. Many of the engravers and painters were to return over and over to the subject of the battles of Lesnaïa and Poltava. The subjects of the main battles of the Great Northern War were very popular even in European art. Engravings representing these battles were made, notably by the French painters Charles Simonneau and Nicolas de Larmessin (fig. 1).

Peter I's favorite subjects were the naval battles. Picart and other engravers were charged with recording these events in their works and elaborating compositions which glorified the battleship sea victories of the newly-created Russian navy. They made engravings which recorded the river victory of the Russian navy on the Neva and on the Baltic Sea, near the site where St. Petersburg was founded. One of the most important of Russia's military victories on the sea was the Battle of Grenham in 1720, in the Aland archipelago. The scale and the brilliance of the celebration in honor of the victory was equal to the event itself. Four captured Swedish frigates (fig. 2) sailed up the Neva in front of thousands of St. Petersburg citizens, to be followed by the troops parading under a triumphal arch along the quay at Trinity Square.

The painters had also received the order to pay special attention to the "triumphal" representations of the assaults of fortified cities, which were not far from St. Petersburg: Vyborg, Revel, Riga, and a number of others.

In 1710, Peter I handed down a decree on the transfer of the printing works and the engravers from Moscow to St. Petersburg where, according to the decree, they were now "to live in perpetuity." The Czar "displaced" a total of 219 people to the new city, including the artists and their families. Alexis Zoubov (1682–1751), who was one of the most talented masters of the Petrovian period, was named head of the engraving workshop on the first day of its founding. And it was in St. Petersburg that this master's talent truly developed. The work which Zoubov carried out in the Moscow Printing House was still the work of a student. But his first Petersburg engraving, a vignette for the newspaper, *St. Petersburg News*, became the emblem of typography: the Czar was so pleased with it that later, when the copper plate was completely erased, it was again engraved.

A new type of Russian art took flight with the work of A. Zoubov: representing festivities and ceremonies. One of his best works was the *Marriage of Peter I and Catherine* which was done in 1712 (fig. 3). The engraving was "imagined," in other words, it was done even before the celebra-

tion and not from life. However, A. Zoubov succeeded in conveying the lively atmosphere of the marriage, and the richness of the interior decoration. The engraving had been ordered by the St. Petersburg governor, A.D. Menchikov, one of the Czar's favorites, who had been named organizer of the festivities, marshal of the nuptial ceremony, and who wanted to give it to Peter I as a gift. The most important festivities, the diplomatic receptions, and the various ceremonies organized by Peter and attended by large crowds, did not take place at his Winter Palace (entry to which was forbidden even to his closest entourage) but in A.D. Menchikov's residence, including the marriage of Peter the Great himself, which took place not in the Russian sovereign's residence, but in the St. Petersburg governor's palace.

Almost at the same time as the *Panorama* appeared, the first maps of St. Petersburg began to appear abroad. They were made beginning in the second half of the 1710 decade, that is, at the time of Peter I's travels. The order for these maps was given to the most famous European cartographers, among whom was the Nuremberg Master I.B. Homann. The maps of the new Russian capital became very popular in Europe. A lot of map-making workshops began to produce them, proof of the genuine interest Europeans felt for Peter I and for the events which were taking place in Russia at that time.

But by the beginning of the years 1720s, Peter I's enthusiasm for engravings, and for printing in general began to wan. In 1721, all the Russian engraving and typography presses were under the control of the Synod, the supreme organ of religious power. The production of engravings on secular themes, reflecting historic events, was halted. The few etchings of the period are, as one can see, geographic maps and views of fireworks.

Little by little, the generation of the best engravers of the Petrovian period began to disappear. Hendrick Dewitt died in 1716. Pierre Picart, who had passed the torch of excellence to Zoubov, progressively lost his sight, and after 1723 was no longer able to work. Zoubov's engravings themselves became rare. His last important job was his publishing project for Catherine I's crowning, but neither the proofs, neither the drawings which he had prepared for the subject have survived.

With the death of Peter I, Zoubov's situation changed. Most of the orders began to be given to Rostovtsev, who was assisted by the Czar's resident artist, S. Korovin (around 1700–1741). Eventually, the publishing of secular books and engravings was given over to the Academy of Science. On October 16, 1727, the St. Petersburg's engraving and typography workshops were closed, and for a long time only the Academy of Science continued to print engravings.

In the years 1728–1729, Ottomar Elliger (around 1703–1735) produced his *Panorama of the Palace Quay* (figs. I–III), one of the last works which belonged to the "Petrovian engraving" period. It was based on a drawing by Christopher Marcelius dated 1725. This view, looking out on the banks of the Neva, lines with palaces and sumptuous residences, became a homage to Peter and to his era.

Thus ended the history of Petrovian engraving, an art form full of brilliance, life and of an astonishing diversity. The chronology of this phenomena practically coincided with the reign of the first emperor of Russia. Certainly, engraving did not disappear with Peter's death: a number of masters and disciples continued to work in the Academy of Science engraving workshop. But the great period of such coherence of style, during which these artists

2

Alexeï Fedorovitch Zoubov
*Ceremonial arrival in St. Petersburg
of the frigates taken from the
Swedes,* 1720

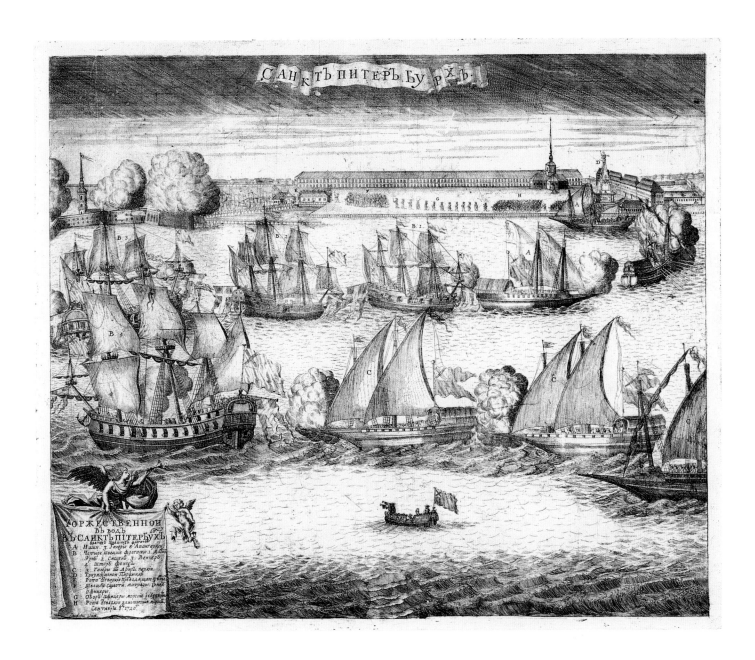

3
Alexeï Fedorovitch Zoubov
Marriage of Peter I and Catherine,
1712

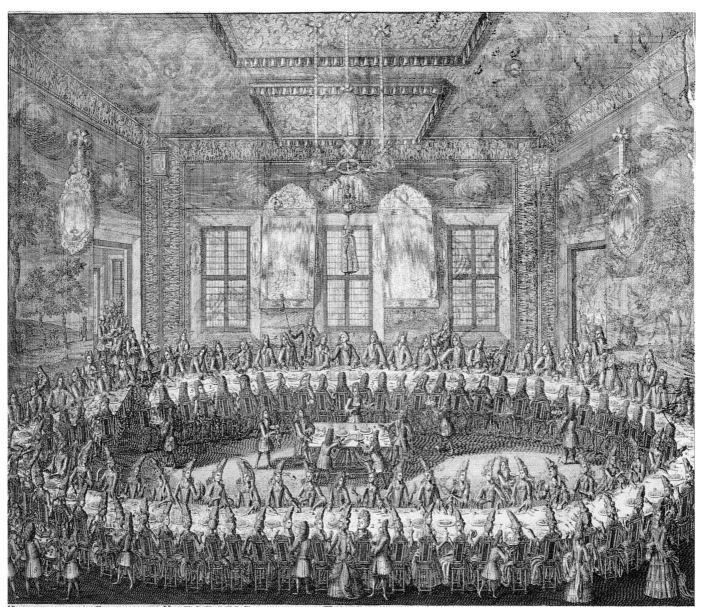

had succeeded in incarnating Peter I's era in their works, was over. The engravers of the Petrovian period had accomplished their mission. It is hard to evaluate the role they played in informing, glorifying and justifying the events of Russian history. Peter used this mode of artistic expression to disseminate his actions and to make known his successes. The Czar often gave engravings, as personal gifts, to representatives of foreign diplomatic missions. The sovereign himself received practically all the proofs as soon as they were off the press.

A system for selling the engravings had been set up in order to increase their circulation. In 1714, using 49 copper plates, 4900 prints were printed in St. Petersburg. The price of the engravings was fixed by the governor of the capital, A.D. Menchikov.

The engravings were used to decorate the interiors of homes and palaces. Known as prints or etchings, they were often to be found hanging next to paintings in Peter I's palaces, but they also could be found in the residences of Menchikov and other dignitaries of the time. Engravings were also presented to soldiers. Thus, under Peter I did the art of engraving acquire an educative and civilizing role.

D.V. Lioubin

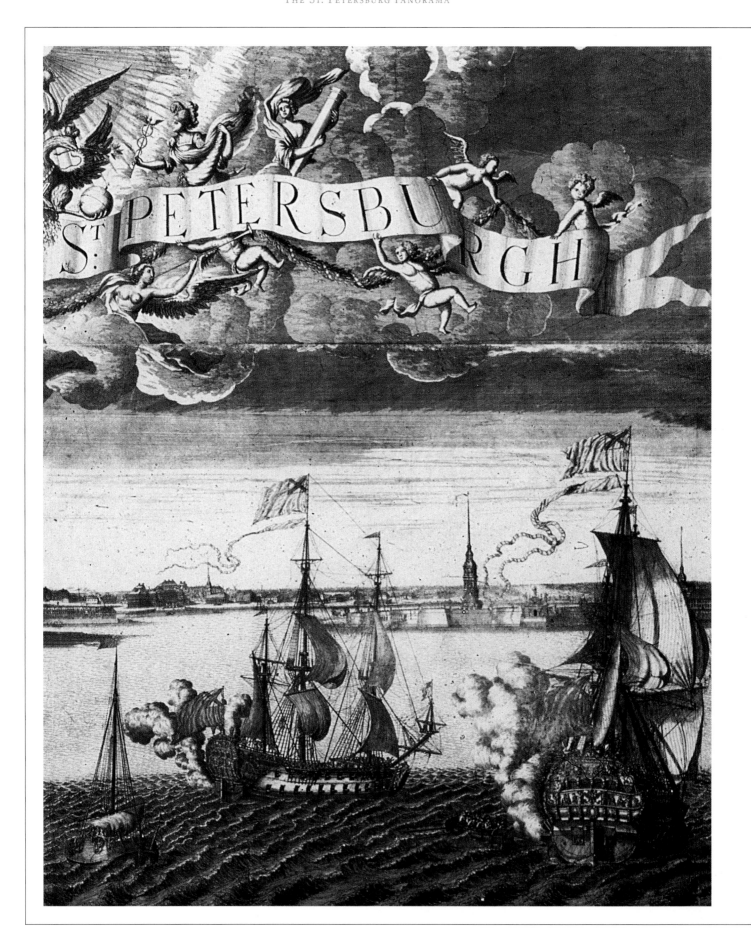

The St. Petersburg Panorama

A great many engravings were made of Peter I's adored child, St. Petersburg. In addition to representations of the city itself, many of the prints were actual instructions from the Czar about construction. He was involved in all the details of the city's development, personally overseeing the plans and projects relating to residential building. One of a series of engravings, by A. Rostovtsev (1690–post 1746) shows models of regulation buildings. Engravings were made of the projects of these "model" houses based on drawings by the architect D. Trezzini, making up a precise manual for those who wished to build houses in St. Petersburg.

The symbol of the whole Petrovian period became *The St. Petersburg Panorama*, engraved by A. Zoubov in 1716 on eight plates. The *Panorama* holds a central place in the master's work. It is the answer to the panoramic views of Moscow done by Picart and Blikland, of identical size to them (75.6 × 244.5 cm), but it has a more festive and more solemn aspect.

In his *St. Petersburg Panorama*, A. Zoubov was above all trying to portray a finished and coherent image of "Peter's paradise." He wanted to show the scale of the city building which already by then had begun to attract the special attention of Europeans, especially after Peter's first trip abroad. Zoubov "composed" a view of the city where one could see the two built-up banks of the Neva. Many palaces and houses are shown with a documentary precision. By an effect of perspective, A. Zoubov succeeds in giving the viewer, who is looking at the sumptuous facades of the capital, the impression to be walking along the quays. The painter deliberately illustrated the facades of the Princess Natalia Alexeevna and the Czarevitch Alexis Petrovitch's palace, as well as A.D. Menchikov's palace which was one of the most remarkable buildings in the city, and Jacob Bruce's and Pierre Chafirov's residences (both close companions to the Czar), along with

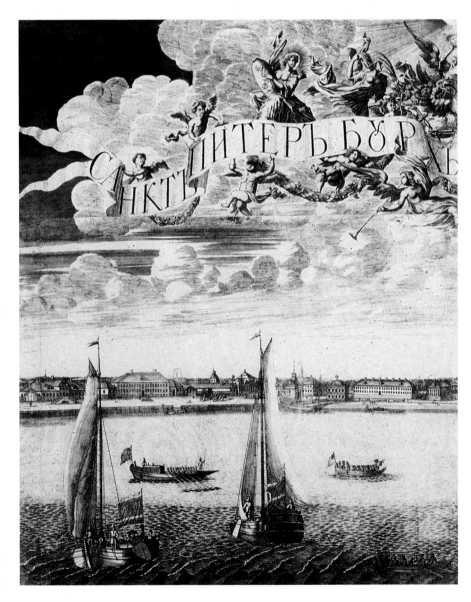

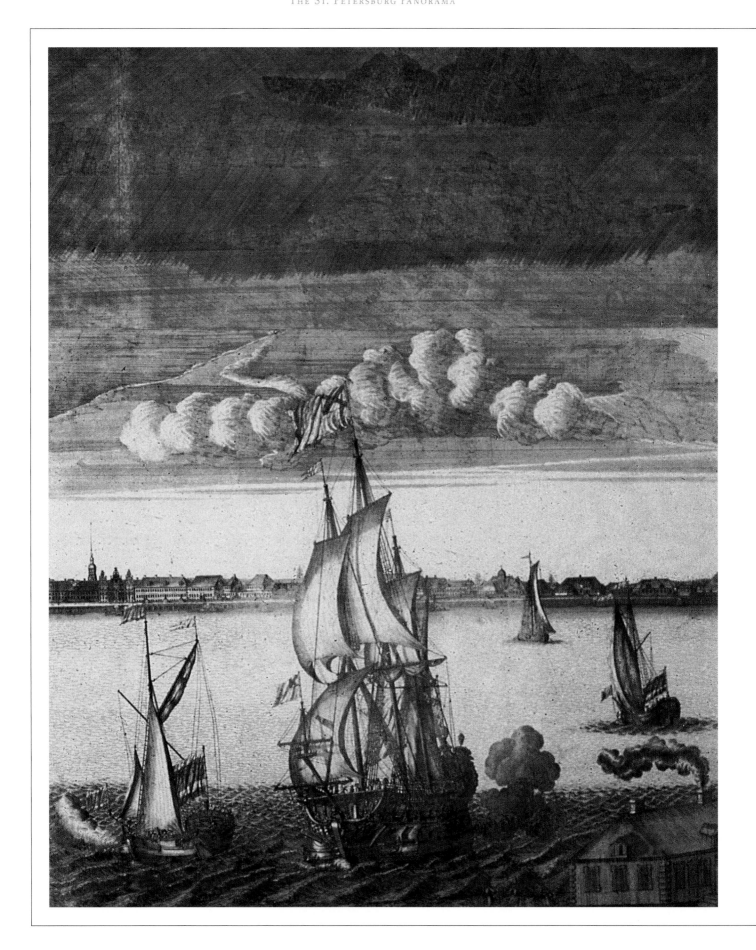

a
Alexeï Fedorovitch Zoubov
Panorama of St. Petersburg,
1716–1717

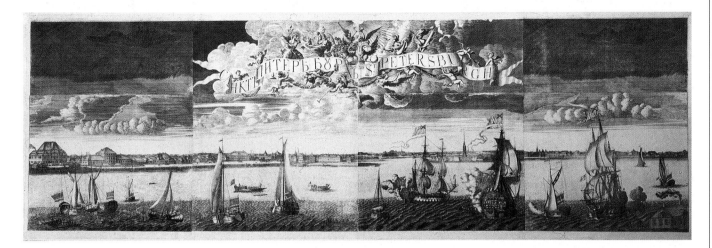

showing a number of other buildings. To achieve the most advantageous foreshortening, he also "extended" St. Peter and Paul Fortress so that one could better see the entrance of honor. The artist introduced in his engraving, along with this documentary precision, a non-negligible element of invention and fantasy. Although the spire of St. Peter and Paul Cathedral was not yet finished at that time, it is shown as finished, as are some of the other monuments which had not yet been completed. Such an approach was justified by the fact that the first and primary purpose of such engravings was to glorify Peter I's achievements and to augment St. Petersburg's prestige.

Zoubov emphasized the extraordinary animation which reigned in the city. St. Petersburg had first been built as a commercial port and, by reproducing a multitude of ships and boats on the Neva, the picture was also aimed at attracting new merchants to the city.

Peter I also resorted to all means to teach the population not to be afraid of he water.

With this end in mind, he frequently organized entertainment and festivals on the water.

The inhabitants were given boats, and at a specified moment, all of them had to come to the festival or be severely punished.

Peter took a very active part himself in these "sea games" and by the example that he set himself, taught his entourage and the common people to sail and to row. A. Zoubov shows the Czar and Catherine in one of these rowboats.

Following the Dutch tradition for engravings of this type, eleven small paintings with views of the most important buildings of the young city were annexed to the *St. Petersburg Panorama*: the Admiralty, the Gallery of Merchants, St. Alexander of the Neva Monastery, Peter I's palace itself, Menchikov's house etc.

These small-format engravings, which were done by A. Zoubov and A. Rostovtsev, were hung below the *Panorama* and completed it.

They were made by order of the Czar who received them while abroad during his second trip to Europe.

The *hieromonk*, G. Boujinsky, was in charge of presenting them to the Czar in 1717. The speech that Boujinsky made for the occasion was then itself imprinted as an appendix to the huge *Panorama* and sold with it. The text was glued under the small-format engravings.

Altogether, thirty copies of the *Panorama* were printed in the St. Petersburg typography workshop. Most of them were sent abroad to the European courts.

A good number were given to members of Peter's entourage and to foreign diplomats on mission to St. Petersburg. But only a few of these unique prints have survived.

D.V.L.

I

Ottomar Elliger
*Panorama of the Palace quay
(in three parts),* 1728–1729

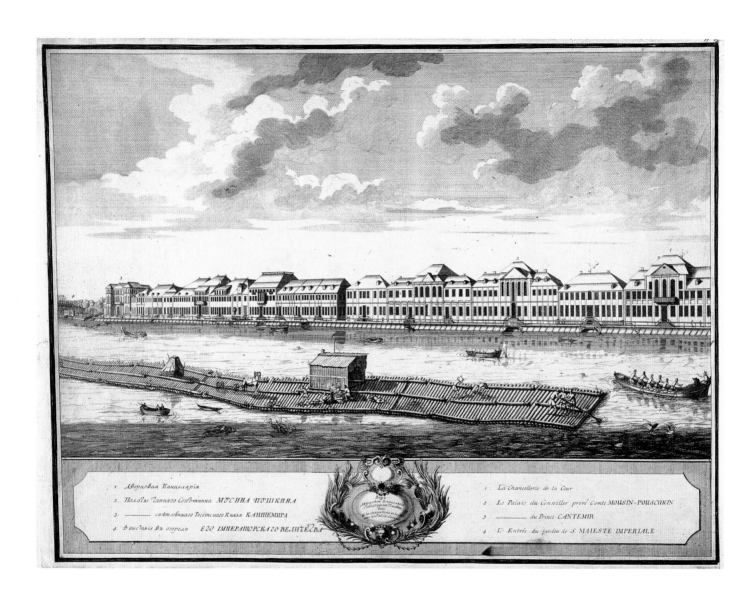

II
Ottomar Elliger
Panorama of the Palace quay
(in three parts), 1728–1729

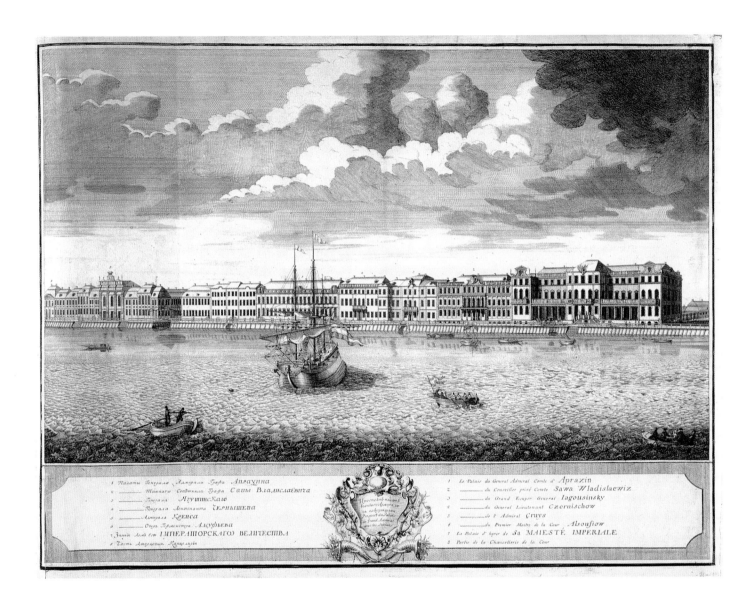

III
Ottomar Elliger
*Panorama of the Palace quay
(in three parts),* 1728–1729

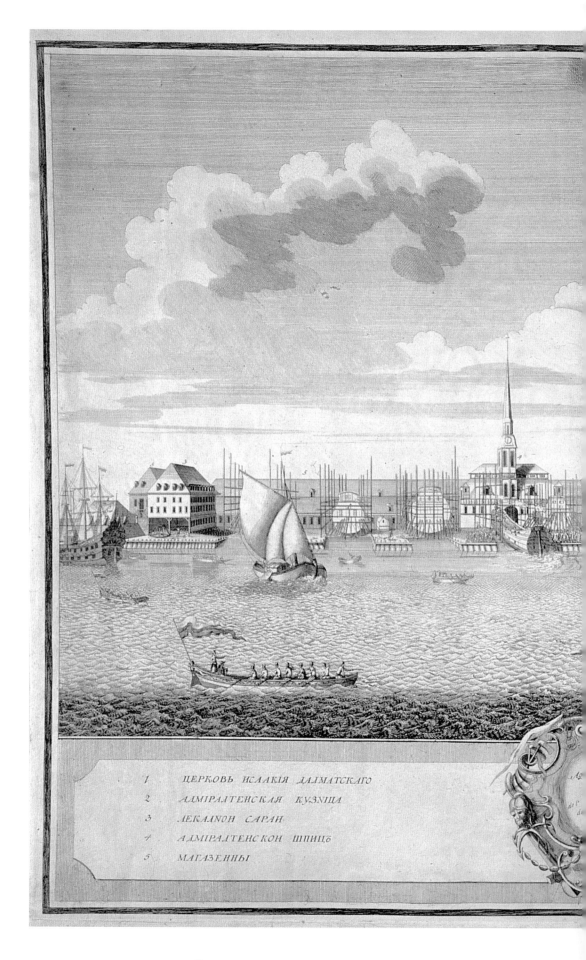

1. ЦЕРКОВЬ ИСААКІЯ ДАЛМАТСКАГО
2. АДМІРАЛТЕЙСКАЯ КУЗНІЦА
3. ЛЕКАЛНОН САРАЙ
4. АДМІРАЛТЕНСКОИ ШПИЦЬ
5. МАГАЗЕННЫ

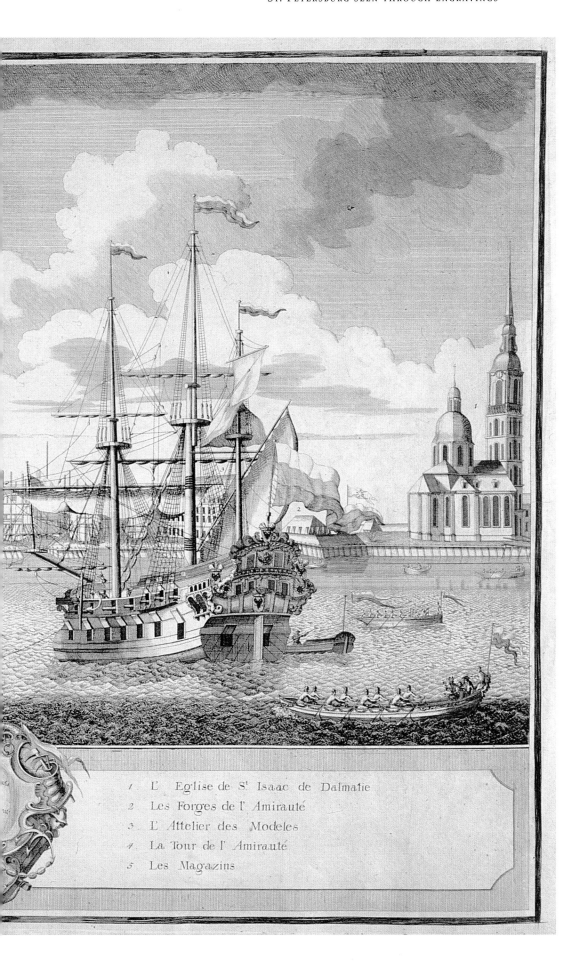

1. L' Eglise de St. Isaac de Dalmatie
2. Les Forges de l' Amirauté
3. L' Attelier des Modeles
4. La Tour de l' Amirauté
5. Les Magazins

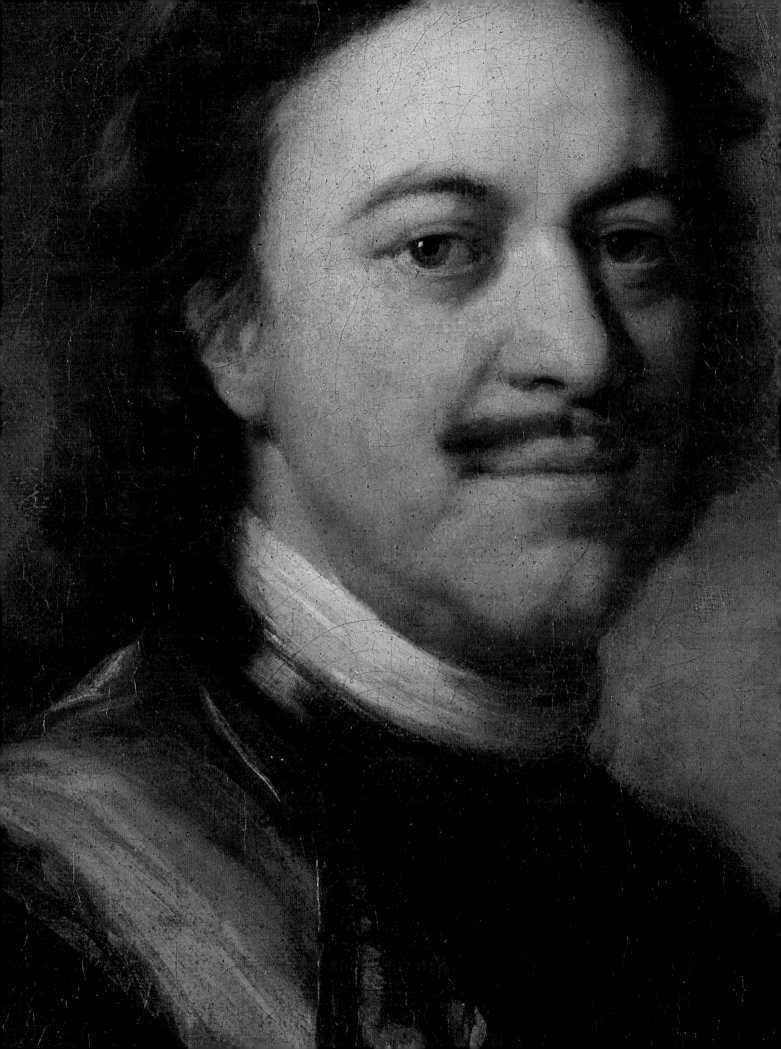

Peter the Great

"This great shadow of the Czar Peter follows you ceaselessly throughout Petersburg: it stretches across all the monuments, and walks along all the quays and through all the squares. A great monarch never leaves his people or his country."

Paul de Julvécourt
Autour du monde, Paris 1834

Peter I was born on May 30, 1672. He was the Czar Alexis's fourth child, and the first child of the Czar's second wife, Nathalie Narychkin. The name given the child at his baptism, Peter, was a rather unusual name in the royal family. Alexis's sons by his first marriage all had fragile health and the Czar was overjoyed at the birth of this robust heir. And indeed, Peter was a very lively and active child who demanded constant attention and developed very rapidly. From the age of three, he was already attending public ceremonies at his father's side. And also from a very early age, he showed a great deal of interest in wooden arms, swords, and pistols as well as in drums and flags, playing at defending a miniature fortress.

Life was peaceful for the child and his mother while Alexis was alive. But in 1676 the Czar died and his eldest son Fedor, fourteen years old, ascended the throne. The young Czar was fond of his half-brother and god-son Peter, then only four years old, but he was under the influence of his mother's family, the Miloslavskys, who hated Nathalie and all the Narychikin family.

Peter had quickly learned the alphabet and soon knew how to read psalms and the Gospels. However what most interested him was the study of history. His tutor, the sympathetic Nikita Zotov, spoke to him of the Russian heroes and of the world outside Russia, showing him pictures of cities and battles, portraits of famous men as well as maps and the Atlas. But soon, the latent hatred between the Miloslavskys and the Narychkins turned to open war and after the deportation of her brothers, Nathalie began to fear for her life and the future of her son. Things only got worse with the death of the young Czar, Fedor, who had left no heir. Peter's intellectual and physical qualities made him the choice of the boyars who placed him on the throne instead of Ivan, Fedor's younger brother who was almost blind

and slow-witted. But within a month, a false rumor was circulating that the Narychkins had had Ivan assassinated, rumor which incited a rebellion by the *streltsy* Guard. Finally, Ivan's and Peter's older sister, the ambitious Sophie, was named regent and proclaimed herself "autocrat of all Russia" while her brothers, in theory the czars, were obliged to attend the enthronement ceremonies. Dutch diplomats who wrote about the event remarked that the young Peter, who had been witness to the worst cruelties, had seemed to be impassive to all this. But the truth was, he remained marked for life by these events.

After this, Nathalie, Peter and Peter's little sister went to live in their residence of Preobrajenskoie. The young man who had been cut off from the road to power had no desire to go to Moscow, not even to fulfil the obligations of his rank. When he was fifteen, those around him tried to get him interested in the affairs of state, but he preferred his freedom and his independence. His education with Nikita Zotov, whom he always kept near him was soon over, and he was able to give himself up to his military games as much as he wished, to organize battles and maneuvers, studying strategy and the art of firing. His military comrades were young men from the best families, but kids from the street as well. Ivan Boutourlin, Mikhaïl Golytsin, Fiodor Apraxin, later Alexander Menchikov and many others joined with him in his games. It would be these companions who later would help Peter to build the new Russia.

In Peter's entourage, there were also foreigners who taught him not only the military arts, but also applied sciences and know-how. Soon this childish game of armies ceased to be simple entertainment and became progressively a real paid army, disciplined, rewarded, and with its own flags. Peter, animated by a hatred of the *streltsy* and a consciousness that the battalions of the Russian aristocracy

I
Scientific instruments,
Western Europe, first quarter
of 18th century

addition to calluses on his hands the skills of fourteen different professions. He was extremely proud of this and all his life continued to love to learn. However it was only when he was already fifteen years old, when he was studying ballistics, fortifications and the art of ship-building with the Dutchman Franz Timmerman that he began to learn arithmetic and geometry (fig. 1).

The regent Sophie paid no attention to the games her disgraced brother was playing and let him alone in his activities. However, after requesting guns, cannons and lead, he began to ask for quantities of workbenches and diverse instruments. Soon he was asking for books, a printing workshop, world globes, a game of chess, parrot cages, and many other things. Yet however vast was the scope of his interests, his greatest affinities were for the exact, and applied sciences.

Peter was not only naturally talented, but he was full of passion and full of determination to achieve his goals. An Englishman in the service of Russia, John Perry, wrote about him later: "...he is an accomplished soldier who knows what is expected of a drummer as well as of a general. He is in addition an engineer, a gunner, a blaster, a ship builder, a turner, an equipage driver, an armourer, a blacksmith and that's not all—in addition, he knows how to work with his own hands and he supervises over everything, from the smallest details to the greatest of achievements to be sure everything is done according to his plan."

In 1688, Peter requested that the musicians and a part of the soldiers of two muscovite battalions, which had remained loyal to the Narychkins, be joined to his army. With the arrival of these "grooms" as Sophie scornfully called them, he had a force capable of defending his mother and himself if necessary. These were the troops which became the first Guard battalions in the army the Czar was to create.

were outdated, gravitated toward the examples from other countries. Even the army uniforms used came from outside, from Hungary and Poland.

Beginning in 1683, this army had real cannons with cannonballs, and the purchases of arms and ammunition increased. All the while remaining Czar and general-in-chief, Peter served as a simple soldier with these troops, absolutely equal, first as a drummer, than as a gunner. All those games he had played had contributed to shape the future emperor's character by giving him the experience of having an unlimited power at his disposition, at seeing his orders instantly complied with, at answering for his acts. At the same time, he had learned to play according to the rule, obeying with good grace, and carrying out the orders of others. All that was completely in keeping with the image of his status, as a Czar without power, even more so since even when he was in charge of that army, he had to ask his mother each time he wished to leave Preobrajenskoie and undertake new military games.

In order to construct his fortresses, Peter became in turn a workman, a joiner, a stone cutter, thus acquiring in

2
Artillery aiming level,
Western Europe,
end of 17th century, beginning
of 18th century

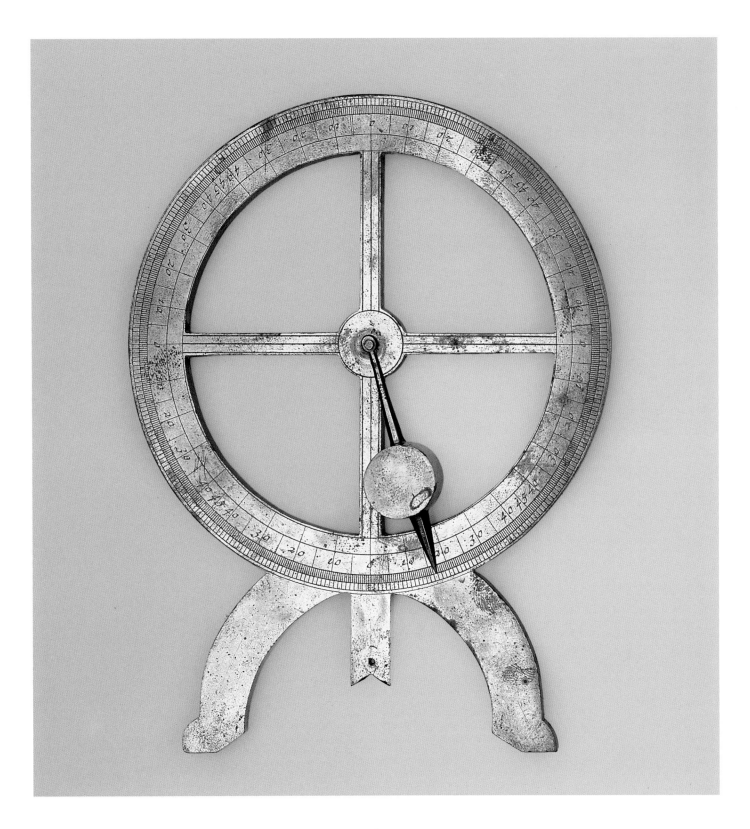

In January 1689, Nathalie married Peter to Evdokia Lopukhina. The Czar clearly had no need any longer for a regent. Having finally understood the danger surrounding her, Sophie made a last attempt to hold onto the regency but she failed and was locked up in the Novo-Dievitchi monastery.

Peter still lived far from a power to which he did not aspire. Although entirely devoted to his army and to the construction of ships on the Pereyaslavl Lake, he only went to Moscow when his mother and the Narychkins insisted on it in the name of tradition. But he was insensible to etiquette and one day caused a scandal by rushing up excitedly to the Persian ambassador in order to see the lions which the ambassador was bringing from the Shah. However there was one neighborhood in Moscow which at first astonished him, but where soon he began to be a regular visitor—*Nemetskaia sloboda*, the foreigner's district. Straight clean streets, brick houses with big windows, flower gardens and vegetable gardens, passers-by dressed in European clothing: it was a Western island right in the middle of the capital which Russians viewed with suspicion. But there, far from his mother and the Patriarch, Peter was in his element. He met merchants, doctors, craftsmen, engineers. He learned to dance, to ride, to fence, and acquired a taste for tobacco, wine and beer.

In 1689, Peter met the Scottish general Patrick Gordon who accompanied him later on the Azov campaigns. Through him, Peter met Frantz Lefort, a jolly Swiss adventurer who became one of the Czar's closest companions. He hosted at his home dinners and drinking bouts at his home which would degenerate into bacchanals and procession parodies. These "buffoon councils" soon began to criticize the Church and the Patriarch, and Moscow, shocked, began to look at the Czar with suspicion, calling

him an "anti-Christ" or a man "without God." But Peter had not forgotten his main goal.

In 1693, leaving the lake and his boat toys, he left for Arkhangelsk, the only Russian port on the White Sea. There he learned how to really navigate, and during a storm he began to be aware of the force of the sea and was filled with the desire to transform his country into a maritime power. This is what pushed him to undertake military operations against Turkey. His first attempt, in 1695, to launch an attack against the Azov fortress, was a failure. But the next year, having understood his errors and reorganized his forces, and in participating himself in the action as a simple gunner, he succeeded. Wanting to continue the war, he went in search of alliances.

This is how "The Great Embassy" came about in March 1697—a trip made by two hundred and fifty people including Peter, who was traveling incognito under the name of Piotr Mikhailov, with F. Lefort leading the group. It was the first time a Czar had ever left Russia. "To see and to learn." This was the Czar's credo. He wanted his country to emerge from its sleep, to open up to Europe. He first crossed the Swedish colonies and Riga, where he was not allowed to study the fortress, some say that this was the real reason for the Great Northern War. Then they went to Courland, Konigsberg where he studied artillery and ballistics, Germany where he only stayed briefly, and Holland which greatly attracted him because of its powerful battle fleet and the modernity of its arsenals, as well as by its prosperity. The Czar hoped to find in Holland a trustworthy ally in the fight against Turkey.

Peter went to a blacksmith's shop in the town of Saardam, which he had heard about in Moscow's foreign district, and was hired as a carpenter in the shipyards. In his spare time, he studied the local industries, spoke with

3
Scientific instruments,
Western Europe, first quarter
of 18th century

everyone and astonished everybody he met by his knowledge, his love of work and the extent of his know-how. But he was unable to remain incognito and soon crowds of the curious came to watch the Czar-carpenter, forcing him to leave for Amsterdam. There, the burgomaster Nicolas Witsen suggested he join the work-site of the Indies company where he quickly learned all the steps involved in ship building.

This work and his diplomatic correspondence was interspersed with visits to museums, theaters, the botanic garden and manufactures as well as by purchases of arms for the Russian army. Peter was interested in everything. In the anatomic amphitheaters, he enjoyed watching the cadavers being carefully prepared and studied them with Dr. Ruysch whose anatomical collections he ultimately acquired for St. Petersburg's *Kunstkamera*. Having become an expert at pulling out teeth, he also willingly attended executions, bought stuffed parrots, monkeys, and crocodiles and devoted himself not only the exact sciences (figs. 2, 3 and III–IX) but also the art of engraving with Adrian Schoonebeck, as well as studying the principles of printing which he hoped to develop in Russia.

The various governments followed all his moves with great interest. He himself met the Dutch *stathouder*, William III, king of England. He did not succeed in convincing William to bring Holland into an alliance against the Turks, but William did offer him a yacht and invited him to England.

In January 1698, Peter arrived in London on an English war vessel. Thanks to William III, he was allowed into all the work-sites, the military bases, the docks, the arsenals, the arms factories, and he made an effort to obtain information, drawings and models of ships from these places. And so he spent three months in Deptford, in a

house on the banks of the Thames which looked out over the docks, going out by the back door in order to escape the onlookers. The little noisy Russian colony haunted the cabarets or feasted at their homes, where they enjoyed from time to time the practice of shooting a cannon at the oak planks.

In London, Peter attended one of William's parliamentary sessions. The English Constitution and its system of government interested him a great deal. He learned about the rights and duties of the sovereign during peacetime and wartime, about his relations with Parliament and with the Church, and also studied how the various institutions functioned, the courts, the post office, finances, and a number of other things. He visited the Greenwich observatory, the Royal Scientific Society and Oxford University. In addition to buying arms and innumerable other objects, notably medicine and surgical instruments, Peter even bought a coffin which was sent to Moscow.

From England, the Czar went to Austria. He was in a hurry to arrive in Vienna because he had learned that the

4
Bartolomeo Carlo Rastrelli,
Andreï Constantinovich Nartov
*Bas-relief commemorating the
founding of St. Petersburg,* 1720s

5
Master C. King
Portrait of Peter I, around 1716

peace talks with Turkey were in progress. He stopped one night on the road to visit the Dresden *Kunstkammer*. But as in the early morning he had only had time to visit two of the rooms, after having visited the Arsenal, the smelting works and a few fortresses in the surroundings, he returned to the museum. Once in Vienna, he was finally able, although with difficulty, to meet with the Emperor. But, Leopold categorically refused to discuss politics or to conclude any agreements with the Czar who had come incognito. The exchange was therefore limited to mutual protestations of confidence and the usual polite exchanges. Peter was clearly impressed by the emperor's very haughty "Hapsburg" reserve as well as by the strict Court etiquette. He controlled himself, but at the end of this meeting, without paying the slightest attention to the entourage, he impulsively jumped into a boat on the pond in front of the palace and began to energetically row while turning round and round in the water.

In Vienna, besides his usual visits, he met with the Jesuits, who were pushing for a union between the Catholic and the Orthodox churches. But in spite of Peter and his ambassadors' efforts, the plans for an anti-Turk coalition came to nothing. This was a good lesson for the Czar: he understood that in politics, there are no friends and that Russia could count on no one but itself to resolve its problems.

On July 9, 1698, having learned of the uprising of the *streltsy* battalions, Peter cancelled his trip to Venice and rushed back to Moscow. But learning in Poland that the revolt had been put down, he was able to stay for awhile in the small city of Reva where he met the Great Elector of Saxony, August II, king of Poland. This meeting was decisive as it resulted in a secret agreement regarding joint actions against Sweden. Russia's foreign affairs changed ori-

entation at that moment, with its efforts now concentrated toward obtaining access to the Baltic Sea. For if Peter had, at the beginning of his long voyage, declined the Duke of Courtland's proposal to wage war against Sweden, he had since come to the conclusion that this war was necessary and inevitable. This was the major political result of his first encounter with Western Europe. In addition, even the monarch's decision itself to undertake such a long voyage to foreign lands in spite of the rules of the State and ancient Russian tradition, had been a carefully thought-out one, and well-revealed his personality and the complexity of his character.

In August 1698, Peter returned to Moscow where he immediately separated from Evdokia Lopukhina, sending

6
Snuff-box in the shape of a boat,
Russia, end of 17th century

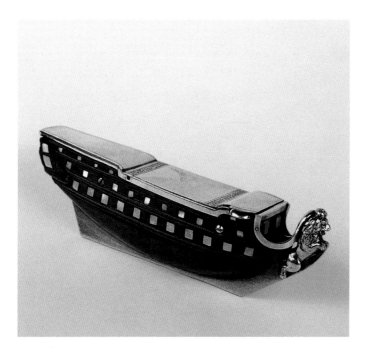

their son to be educated by his sister. He led his own investigation into the *streltsy* uprising, trying to know whom among his entourage had participated in it and trying to determine Sophie's involvement. He showed himself to be extremely cruel at this time, personally taking part in the interrogatories and torture. Mass public executions were held. The *streltsy* battalions were disbanded and rapidly replaced by a regular army organized according to the Czar's orders.

This all was the background upon which the large scale transformations were undertaken which were to result in the building of a new Russia.

The first reforms, directly inspired by what the Czar had just seen in Europe, were circumstantial and seemed to be a joke. The day after his return, on August 26, 1698, Peter decided to cut the beards of all the boyars who had come to greet and congratulate him. Shaving off one's beard was for the Patriarchate an offense even if it was true that since the Czar Alexis's reign a number of Russians wore on-

ly a moustache. And during a festival in 1699, Peter undertook to shorten the clothes and the wide sleeves of his hosts clothes himself. This was the beginning of the reforms regarding dress.

Beginning in January 7208 (since the beginning of the world), in other words, 1700, the European calendar was adopted and the New Year ceased to be celebrated September 1. Little by little, the reforms began to reach into nearly all aspects of Russian life. The sciences, teaching and art were for the Czar the tools by which he would be able to transform spirits. He was careful to see that the foreigners working in Russia trained Russian specialists in their respective fields. But trying to establish a secular culture and to forge ties between Russia and Europe was not always easy. The decisions taken, which were binding, bore the stamp of the monarch. Even entertainment was regulated.

In order to reduce the economic and political power of the Church, the Patriarch was replaced in 1721 by a Saint-Synod controlled by the Czar. The Great Northern War (1700–1721) put a heavy economic burden on the country. Peter's pet project, a powerful navy, was created and it, along with the land victory of Poltava in 1709, greatly contributed to Russia's success. On August 30, 1721, the treaty of Nystad (fig. II) was signed and on October 22, the grateful Senate solemnly proclaimed Peter Czar, Emperor of all the Russians and Father of the Country. From this day on, the muscovite state was re-baptized to become the Russian Empire.

At the very beginning of the Great Northern War, on May 16, 1721, St. Petersburg was founded. This fortress built to defend the newly conquered Baltic shore soon became the country's principal port. Ten years after its founding, St. Petersburg became the new capital (fig. 4).

Peter's personality was the object of great interest among his contemporaries and they often described him. The Italian singer Filippo Balatri, who saw him in 1698, thus described him, "The Czar Peter Alexowitz (figs. 5 and I) is tall and more thin than fat. He has thick hair, which is short and dark brown, big black eyes with long lashes, a well-formed mouth except for the inferior lip. His skin is olive-colored, and his face is round with pleasant traits. His expression is remarkable and it inspires immediate respect. His legs seemed to me to be very thin for his great height, and his head often quivers convulsively toward the right. He is about thirty-six years old, perhaps less." In fact, Peter was at this time twenty-six.

Peter, by his behavior and his style of life, was very different both from his predecessors on the Russian throne as well as from the other European monarchs. He did not like to be at the center of attention, had no taste for ceremonies and blushed easily. At the same time, he had a impressive physical force and when he walked, everyone else had to run behind him to keep up. Always in movement, he slept very little and did a thousand things at the same time. His amusements were often rather coarse, involving drinking bouts and the mocking of traditions and of his subjects. He lived modestly and invited people of all sorts to his feasts, forcing them to drink in order to loosen their tongues and sometimes keeping them with him for several days at a time.

He loved fire, adored attending fires and was crazy about fireworks, so much so that they would be set off for and all any occasion. He also loved costume balls and would most often disguise himself as a Dutch sailor or a French farmer or a drummer.

Peter I was the perfect representative of his century. Possessed of unlimited power and with a bad temper, he could be ferocious and often wielded his famous stick. Only Catherine could calm him. But these defaults were compensated for by a total dedication to the interests of a country which he was trying to wake up, trying to make up for its backwardness in all the fields of public, cultural, military and economic life.

The end of his life was darkened by personal dramas. In 1712, after years of communal life, he married a peasant, Marta Skavronskaïa who took the name of Catherine. Twelve children had been born from this union. The oldest son of his first marriage, accused of treason and sentenced, died in Peter and Paul Fortress. Catherine's son Peter Petrovitch, who Peter had hoped to make his heir, also died. Only two girls remained, Anna, the future Duchess of Holstein-Gottorp, and Elisabeth, the future Empress. In 1722, Peter adopted an unprecedented "Edict on the succession" which gave the Czar the right to choose his own successor. In 1724, Catherine was crowned Empress and received the crown, but not the scepter, symbol of power.

Peter soon learned that his wife had been unfaithful to him. On January 28, 1725, he died without leaving a will. It was only because she had just been crowned, and because of the support of the army and a circle of Peter's close companions, that Catherine could be proclaimed Empress of Russia.

V.A. Fedorov

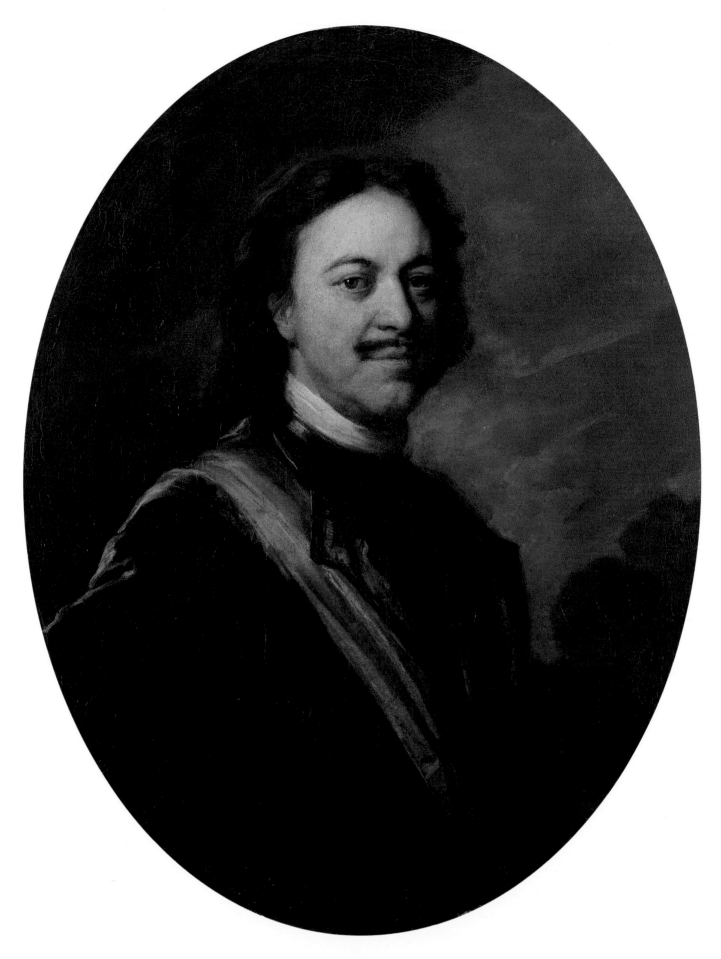

I
Andreï Matveev
Portrait of Peter I

II
Andreï Constantinovich Nartov
*Medallion with allegoric
representation of the Nystadt Peace*

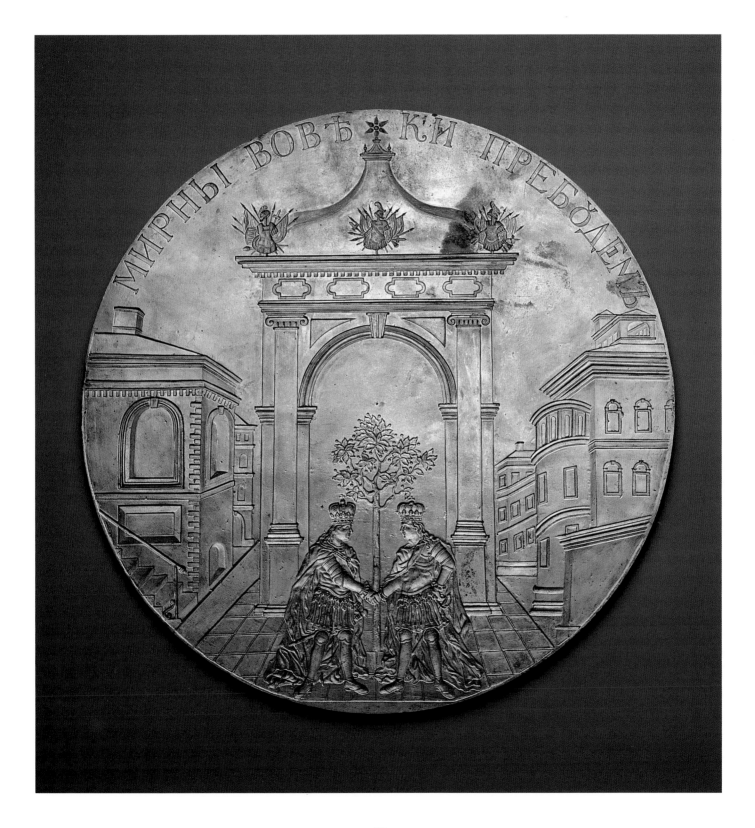

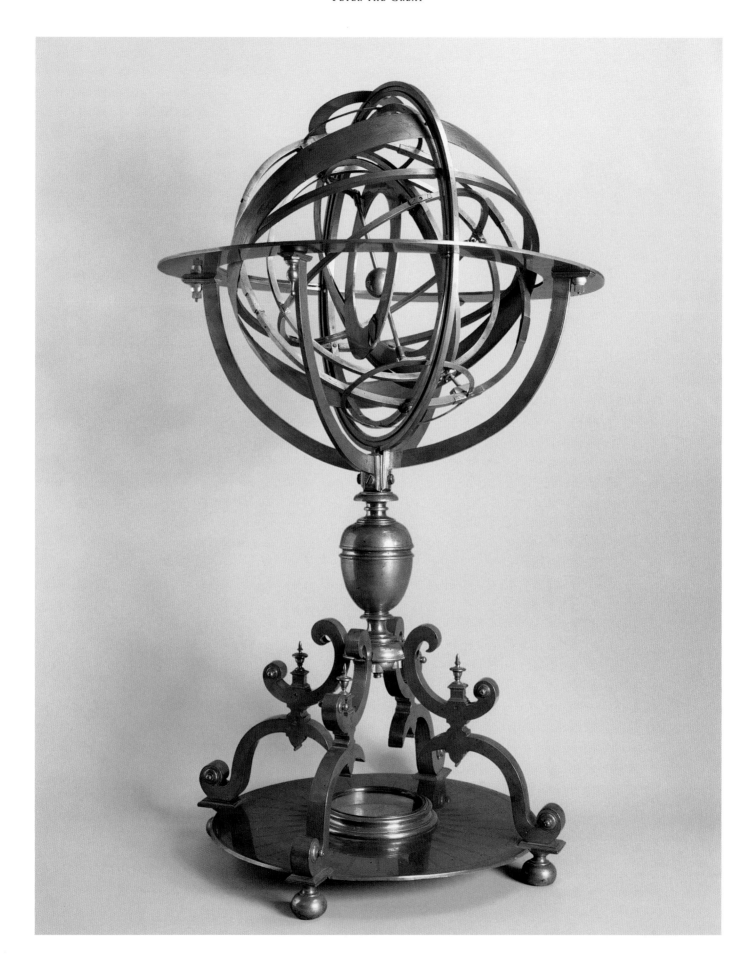

III
*Armillary sphere representing
the solar system based on
the geocentric theory,*
England (?), beginning
of 18th century

IV
Master craftsman Vesdy
Telescope binocular BISNOG,
first quarter of 18th century

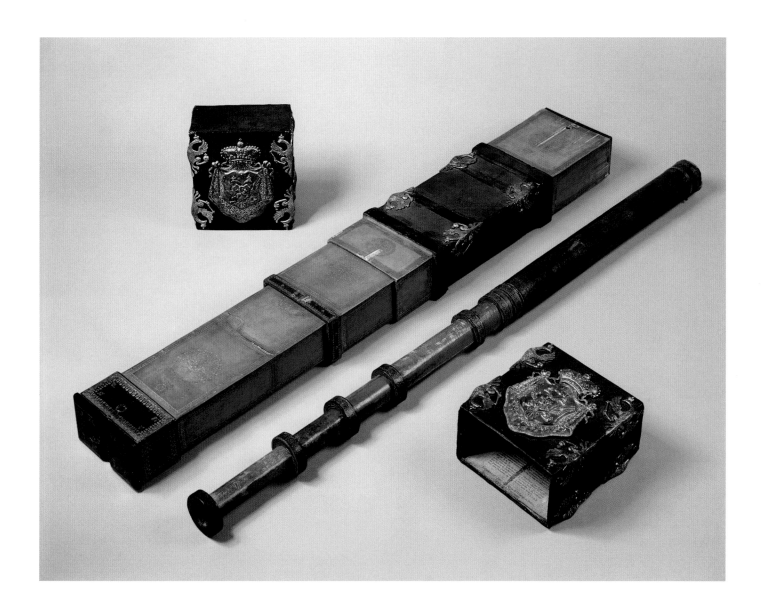

V
Artisan John Bradlee
Universal horizontal sundial,
Butterfield type, 1716–1725

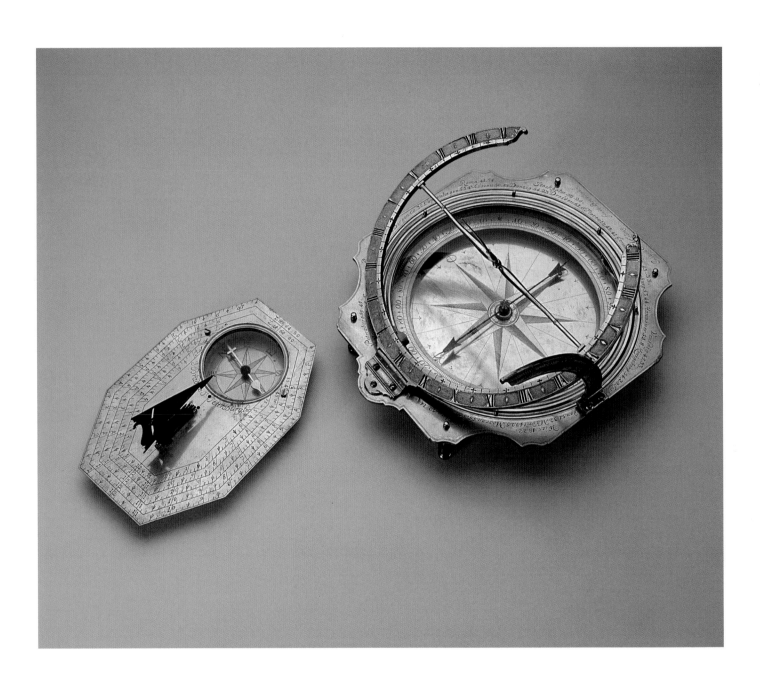

VI
Master Edmond Culpeper
Azimuthal ship's compass,
beginning of 18th century

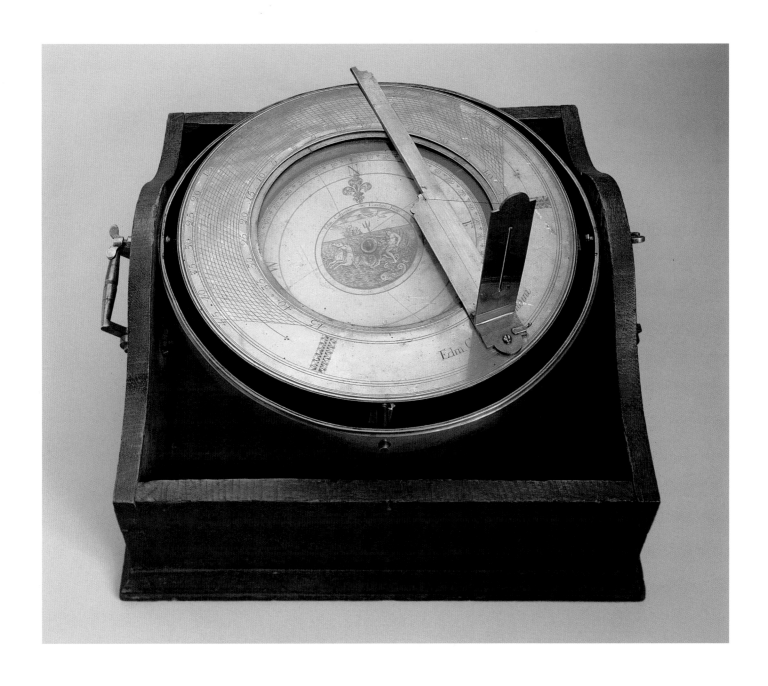

VII
Master craftsman
Edmond Culpeper
Geodesic Astrolabe, 1721

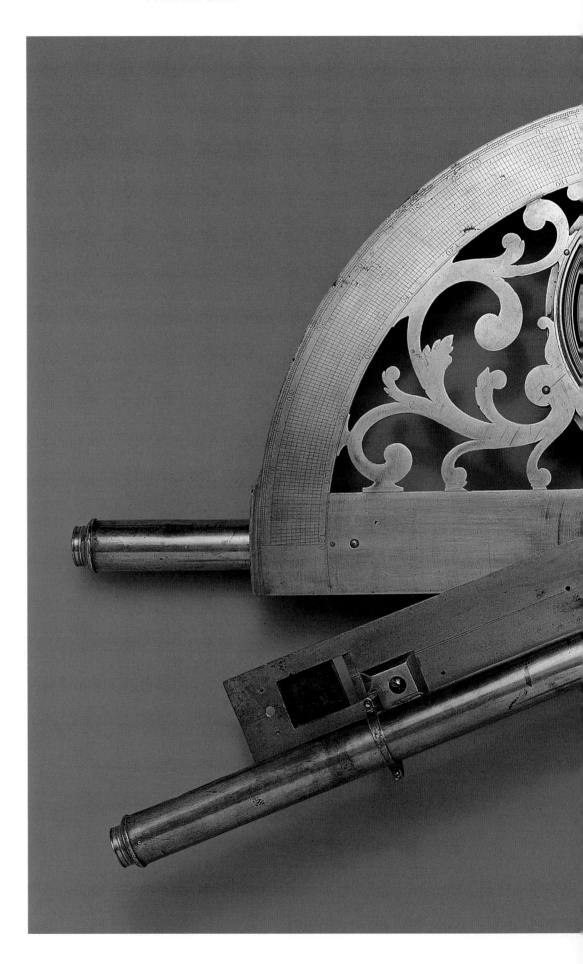

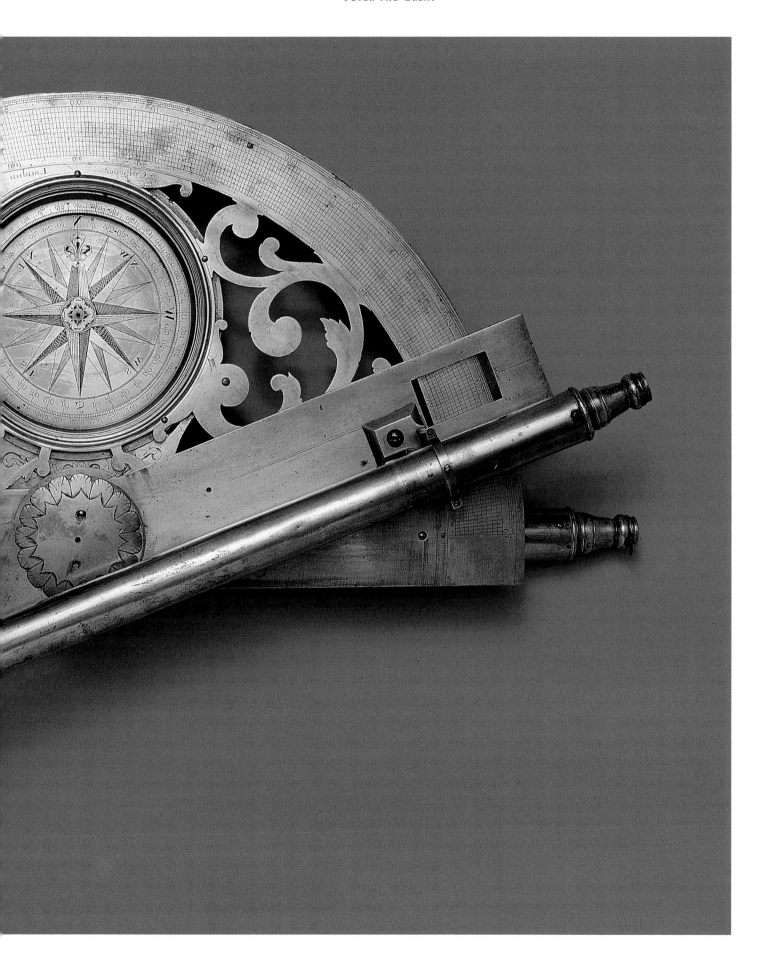

VIII
Artillery aiming level,
Western Europe, end of
17th century, beginning
of 18th century

IX
Masters Tobias Lengkhardt
and Hans Georg I Brenner
*Peter I's Military campaign
pharmacy kit,* around 1613–1615

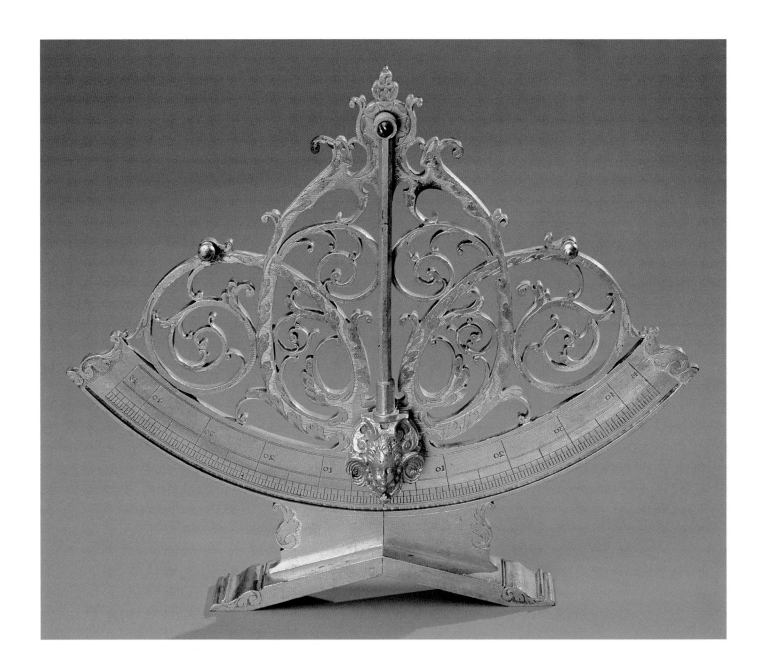

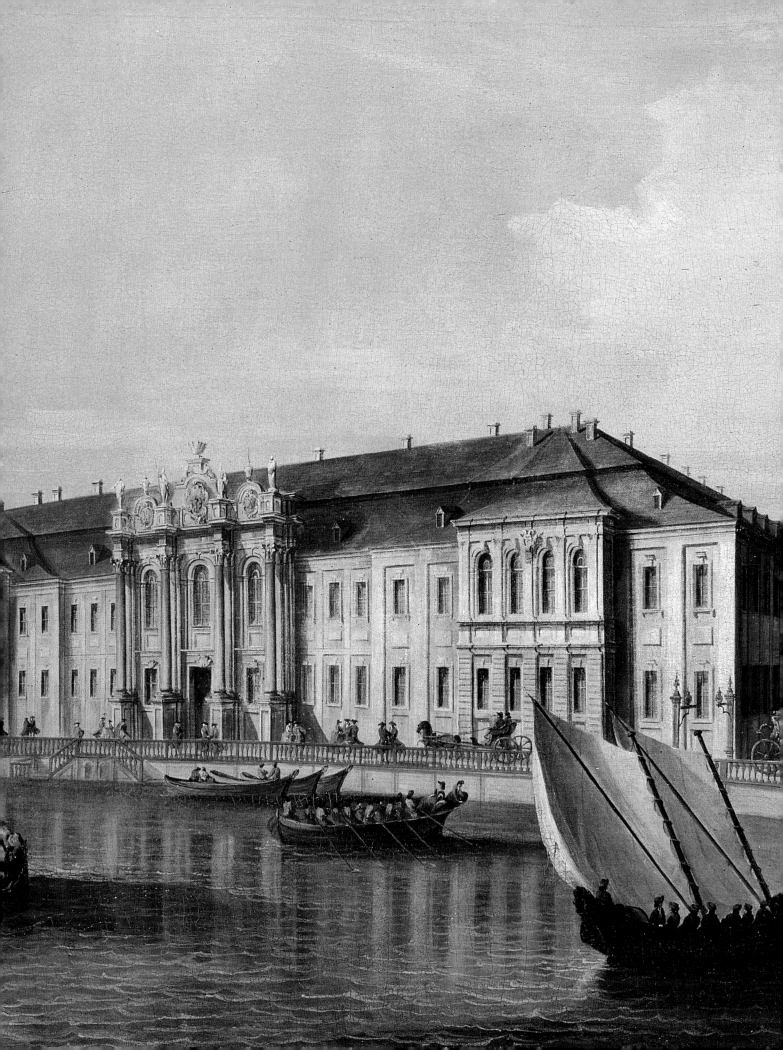

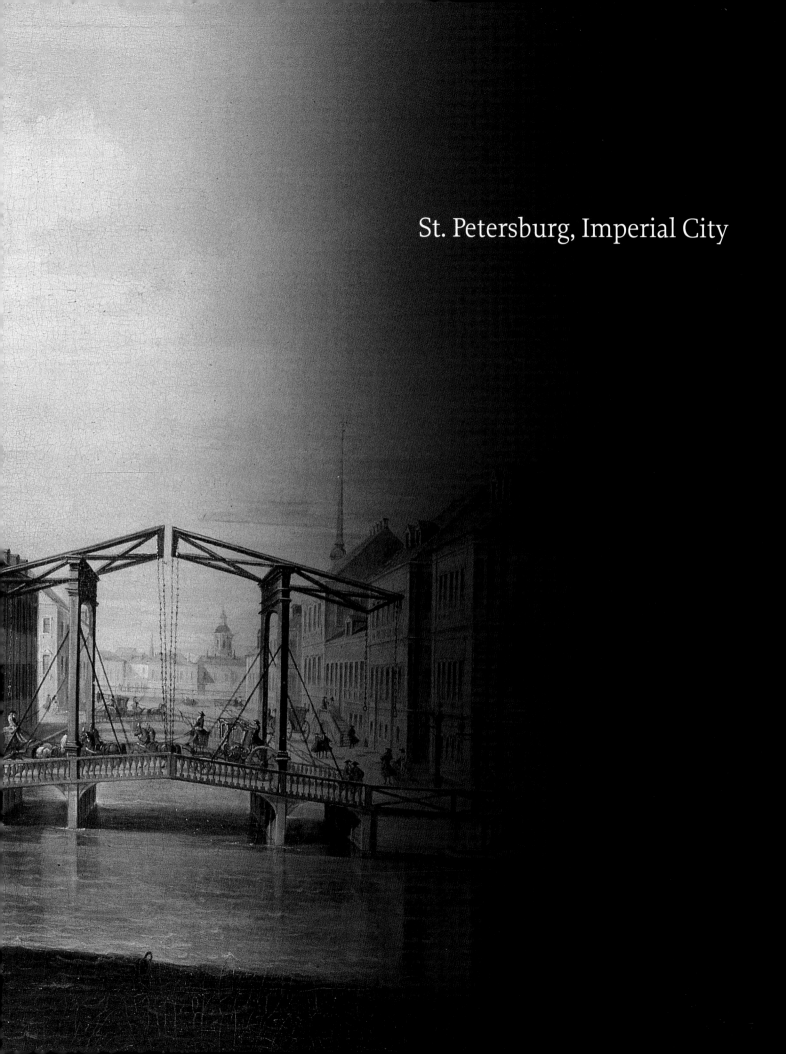

St. Petersburg, Imperial City

"I don't like men to be scattered here and there, I don't like isolated palaces, I like them linked by a great number of other family dwellings. Nothing contributes more to a civilization than a great population. The angles of the stones which touch each other take off the rough edges and the stones become polished."

Denis Diderot
Mélanges pour Catherine II,
art. XI, coll. Bouquins, p. 243

As the 18th century dawned, the history of St. Petersburg would become synonymous with that of the new Russia. Peter the Great united the destiny of this immense country to that of the port city which he had just founded on land that had so recently been captured from the Swedes. At the beginning of the Great Northern War (1700–1721), on the 16th of May 1703, the first stone of Peter and Paul Fortress was laid, fortress which was to defend the Neva estuary and the shores of the Baltic against the enemy. Around 1712, ten years after its founding, St. Petersburg had become not only a major city and an important trading port for Russia, but also the capital of the Muscovite State, state which continued to grow. Even if no official decree was ever published stipulating the transfer of the capital onto the shores of the Neva, all the government institutions, the Imperial Court, the diplomatic representatives of foreign countries were sent from old Moscow to the young St. Petersburg on the order of Peter I. In 1721, upon the proclamation of the Russian Empire and its first emperor, Peter I, St. Petersburg became the capital of the country. Moscow would remain forever in the eyes of those of that time, whether supporters or opponents of the Czar's reforms, as the state-controlled symbol of the Old Russia. And it was in Moscow that the formal enthronement ceremonies of all the Russian monarchs continued as before to take place. The new city was baptized St. Petersburg, in honor of the patron saint of the sovereign, the Disciple Peter, possessor of the keys to paradise.

St. Petersburg's brilliant destiny was above all the result of the fortuitous choice of the city site, just at the mouth of the Neva on the coast of the Baltic Sea. Before Peter I, Russia was a huge country but without any access to the sea. Deprived of a maritime trade, the economy which depended upon the export of raw materials and wheat, developed slowly. The new port resolved Russia's age-old problems of maritime trade links with the European countries. But St. Petersburg owed its glory and its reputation in the world especially to the fact that the city was the cradle of Peter the Great's reforms: they were linked to the "Europeanization" of Russia and to the radical change of the whole state-controlled socio-political structure of the country which formerly had been closed to the outside world. One of Peter I's first essential objectives was to introduce new cultural and European traditions into Russian life, and to develop the sciences. St. Petersburg became for Russia not only a "window onto Europe" but also a sort of gigantic "firing range" where Peter I gave free rein to his experimentation of every kind.

St. Petersburg grew at a fantastic rate. No city in the world has known such a rhythm of growth. Building went on day and night without respite. During the early years, and even though just nearby the city military actions were taking place on land and on sea, hundreds of thousands of builders were consolidating the banks of the Neva, building houses, and fortifications and shipyards. In spite of the danger due to the war and the proximity of the enemy, merchants were attracted to St. Petersburg, lured by the advantages of the Baltic access which opened a direct passage to Europe. This is why the number of merchant ships multiplied at a dizzying rate and the links with the foreign merchant companies were strengthened. Industry developed at a speed never before attained in Russia. A large number of businesses opened: arms factories, brickyards, sawmills and other factories aimed at meeting the needs of the port and the shipyards. At the beginning, the greatest part of St. Petersburg's population was made up of serfs and workers who had been sent by force to the marshy shores of the Neva, but little by little great numbers of craftsmen, merchants and even farmers began to flow into the capital, attracted by the city's

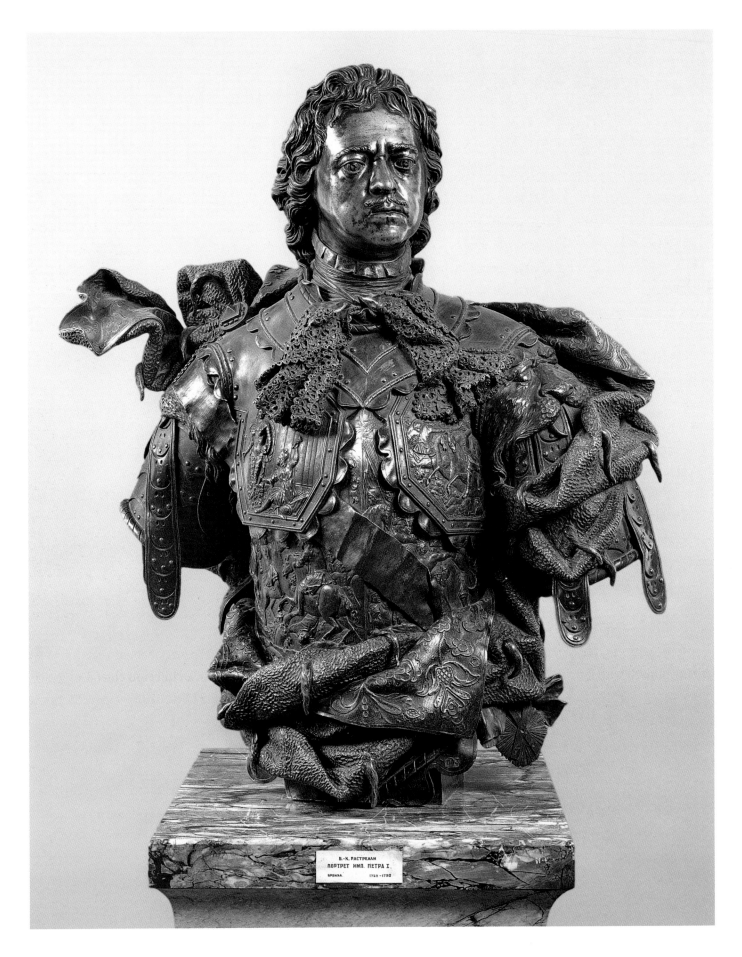

1
Bartolomeo Carlo Rastrelli
Bust of Peter I, 1723–1730

2
Jean-Marc Nattier
Portrait of Catherine I, 1717

rapid rate of growth and by the unlimited possibilities for finding work. Every autumn, the low marshy land was constantly flooded with the rising waters, making it an unhealthy place to live. And yet, the Neva marshes would soon metamorphose into a modern city. And following the Russians' triumphant victory at Poltava in 1709 when the Swedish forces were crushed and all danger of invasion ended, the city really took off.

Peter and Paul Fortress remained the center around which the city grew. Its stone bastions and its cathedral spire dominated the majestic architectural blocks which rose along the Neva quays. From the beginning, the urbanism had been subject to the spaces formed by the river. It is precisely along the river banks, near the fortress, where the city's monumental edifices were built: the imperial palaces, the residences of the nobility, the official buildings which were completed by gardens. In contrast with Moscow and all the other Russian cities, St. Petersburg was required to follow a precise construction plan, submitted to Peter I's personal control.

St. Petersburg's architectural originality at the beginning of the 18th century was in large part a reflection of the Czar's personal impressions. At a time when he was familiarizing himself with Europe, he had formed his own vision of the ideal city for the new Russia. To incarnate his project, he invited to Russia the German architect A. Schlüter, the French J.B. Le Blond, the Italians G.H. Mattarnovy, N. Michetti and, later, G. Quarenghi. Alongside of these foreigners working in St. Petersburg were the Russian masters, notably P.M. Eropkin, I.K. Korobov, M.G. Zemtsov.

From the beginning, the urban development followed strict rules. Even the construction destined for personal individual use had to follow the "model-projects" which had been especially developed for St. Petersburg. There were houses of one, two, or three levels, and each one of them corre-

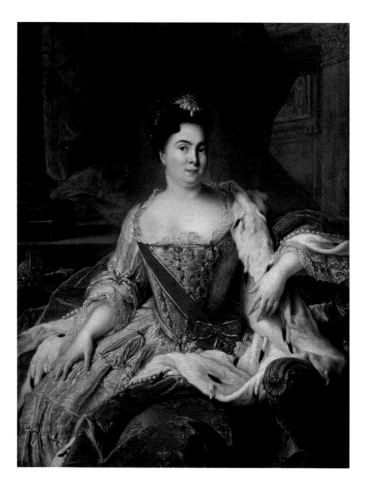

sponded to a class of society. These "model-projects" of houses had been conceived by the architect-in-chief, Domenico Trezzini, in conformance with the Czar's directives. These relatively small buildings are characteristic of the era: they are a striking illustration of what is called the "petrovian" baroque which is characterized by the rationality of the plan and the distinctiveness of the décor, formed by pilasters and sculpted symbolic compositions on the facades and on the roofs. Many of the palaces and houses had in front of the entrance a landing wharf so as to be able to easily moor small boats.

Today there is very little left of the buildings erected by Peter the Great's favorite architect, Trezzini, but fortunately aspects of them were incorporated into the building units

3
Christian-Albrecht Vortman
*Perspective from the Kunstkammer
library*, 1741

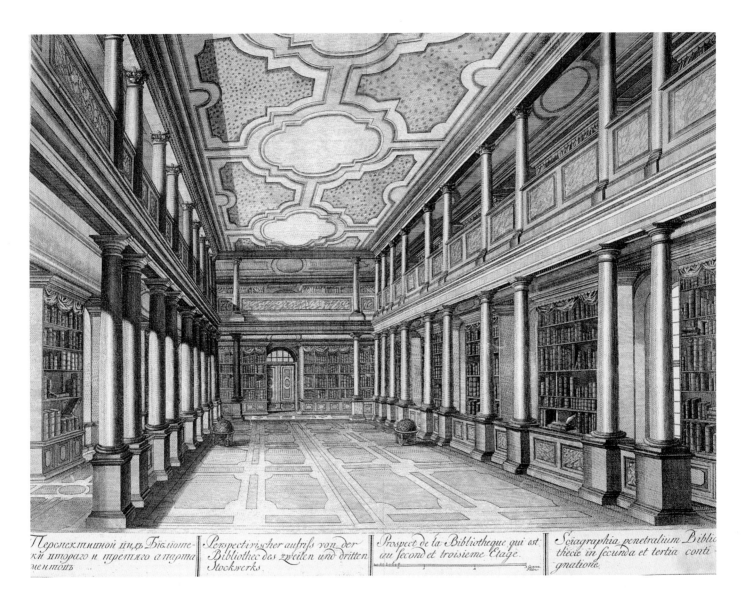

Перспективной видъ Библиоте-
ки втораго и третяго апарта-
ментовъ

*Perspectivischer aufriß von der
Bibliothec des zweiten und dritten
Stockwerks.*

*Prospect de la Bibliotheque qui est
au second et troisieme Etage.*

*Sciagraphia penetralium Biblio-
thecæ in secunda et tertia conti-
gnatione.*

created by the masters of the following eras who all the while developing new architectural styles also attempted to carefully conserve the heritage of the "petrovian" era.

The imperial residences are an example of the first stone constructions in St. Petersburg: the Summer Palace which gives onto the Summer Garden and which has conserved its original aspect, and the Winter Palace which was rebuilt and enlarged in the second half of the 18th century. The two palaces were built by D. Trezzini on the left banks of the Neva, in front of Peter and Paul Fortress. The Summer Garden is still today one of the most important historic sites in St. Petersburg. Those of the time marveled at the abundance of its water fountains and sculptures, at the presence of small pavilions and ponds. In summer, it was used for the famous "assemblies" instituted by Peter I.

Almost at the same time as Peter's Summer Palace was being built, the splendid residence of the prince A.D. Menchikov (work of the architects M. Fontana, I.-G. Schädel

and D. Trezzini) was constructed on Vassiliesky Island, as well as the Twelve Colleges building (by D. Trezzini) where the seats of the leading administrative bodies of the country were to be located: the Senate, the Synod, and the Ministries (or *Colleges*). Just nearby, the first Russian museum, the Kunstkamera, was constructed. Vassiliesky Island, according to Peter's project, formed one of the city's most important districts. At the beginning of the 18th century, the Admiralty was used as a shipyard and citadel—it was there that almost all of the military and merchant ships of that era were built.

Near the end of Peter I's reign, the quays and the banks of many of the canals were bordered by lines of houses, administrative and industrial buildings, gardens and parks which decorated the Czar's palaces and the residences of the nobility. The new Russian capital had become a teeming city with numerous administrative, industrial, commercial and military activities. It was the theater of official life, as well as of parades.

Unlike the other European cities, St. Petersburg had no bridges across the Neva. The first floating bridge, near the Winter Palace, was only installed in 1727, after Peter's death. Until then, one could only go from one bank of the river to the other by boat. These small light boats enabled one to get to any part of the city. The Czar loved the sea and wanted to ensure that his subjects were familiar with it and comfortable in that element. The Neva and the canals were crowded with innumerable boats of all sizes, in the middle of which stood the masts of the great war vessels and merchant ships. Each official institution had its flotilla. The boatmen attached to the service of the different State establishments wore a livery of a distinct color which was chosen by Peter himself.

Peter had conceived the future city as a capital of an empire, but also as the crucible of a new civilization. Through his reforms and the ties with the West, he was seeking above all to break the resistance of the Church, to liberate culture, art and private life from its grip, and to subjugate it to the State. The affirmation of the principle of secularism in Russian life was to triumph in St. Petersburg, where the Czar wished to incarnate the ideal of a new and enlightened Russia. His personal tastes and his contacts with the greatest scholars and artists of Western Europe led establishment of a vast program of education in the country and to the flourishing of the sciences and of a national art which was to radiate out from the capital.

Peter himself had not received much of an education. He was self-educated. Everything interested him: the exact sciences, applied sciences, mechanics, medicine. One of the essential events for the development of the sciences in the country was the Czar's creation of the Academy of Science. It included notably an anatomy amphitheater, an astronomy observatory and a big richly endowed library which was the wonder of foreign travelers and scholars visiting St. Petersburg.

The *Kunstkamera* (fig. 3) was the first public Russian museum to be placed under the direct authority of the Academy. The nucleus of the collection came from Peter I's private collections which before had been divided between the Summer Palace and the Winter Palace. The Kunstkamera was organized on the model of European museums of natural science, of universal character, bringing together archeological antiquities, ethnographic material, scientific instruments and machines, anatomic preparations, exotic stuffed animals. The purpose of the museum was to educate the Russian people and to initiate them into the sciences. In inaugurating a museum accessible to all, Peter declared, "I want people to see and to educate themselves." He published an *ukase* regarding the collections of rare works and antique objects destined

for the Kunstkamera. This was the very first law in history concerning the conservation of the patrimony.

St. Petersburg was also the place favored for the development of secular Russian art. The presence of famous European artists invited by the Czar largely contributed to this dazzling flourishing of a new art. The rapid evolution of the Russian Applied Art School was encouraged by the contribution of works acquired by order of Peter I: they were used to decorate his palaces and the houses of the nobility. Under his reign, Russia discovered the examples of antique and European sculptures which held places of honor in the residences, the Court museums and in beautifying the city. Sculpture adorned the facades of the most important buildings (fig. 4), gardens and parks regardless of the old Russian religious tradition. In St. Petersburg, the sculptures were especially concentrated in the huge Summer Garden and in the Emperor's favorite residence, Peterhof. Their paths were dotted with Greek and Roman antique statues and works of the Italian masters of the 17th and 18th centuries. One of the best sculptors of his era, C. B. Rastrelli, was still at that time working in St. Petersburg. He was the author of splendid sculpted portraits of Peter (fig. 1) and of Russian dignitaries in bronze, marble, and wax.

Peter I was proclaimed emperor and Russia the Empire in 1721. By then, St. Petersburg had been in existence eighteen years. The city had become not only a great fortified port city, with a European appearance, but especially the real capital of the new empire. Almost all of the cultural and artistic life was focused there. It was the center of elegance, the bastion of the avant-garde of industry and of the artistic life of the New Russia which had so quickly known how to appropriate European culture.

But its edification and the transfer of the State apparatus to the banks of the Neva was not effected without a relentless fight against the supporters of tradition. It was perfectly understood both by the opposition parties inside Russia and the foreign diplomats posted to the Russian Court that the city was built and existed only by the sole will and sole efforts of Peter I. The emperor pursued his reforms with an almost fanatical determination which were personified in St. Petersburg, symbol of a transformed Russia. He even declared that it would be preferable to lose half of the country rather than to part with the city. The emperor as well as his entourage linked the viability of his policies directly to the future development of the capital. Near the end of his reign, St. Petersburg, then already more than 20 years old, was almost entirely finished. The main arteries of the city had been carved out, private homes in great numbers had been raised all along the banks of the Neva and the canals. At the same time, these relatively small buildings, of one or two stories with modest facades, added their own note to the city. It was truly an immense city which had grown to adulthood. Its rhythm of growth was the astonishment of contemporaries and of foreign travelers. St. Petersburg teemed with the life of an industrial city and a commercial port. Its defensive role remained active, even if the Great Northern War against Sweden had ended in 1721 and no battle fire had been heard since then at the Peter and Paul Fortress.

After Peter I's death and the brief reign of his wife, the Empress Catherine I (fig. 2) (1725–1727), a real menace hung over the city. Peter II (1727–1730) abandoned St. Petersburg for Moscow. The new capital began progressively to empty. Wild animals from the surrounding forests began to wander through the city streets. The work of construction was no longer being supervised. Soon, houses that had been built began to sink into the marshy ground. Big fires frequently

4
Anonymous
View of Peter I's Winter Palace

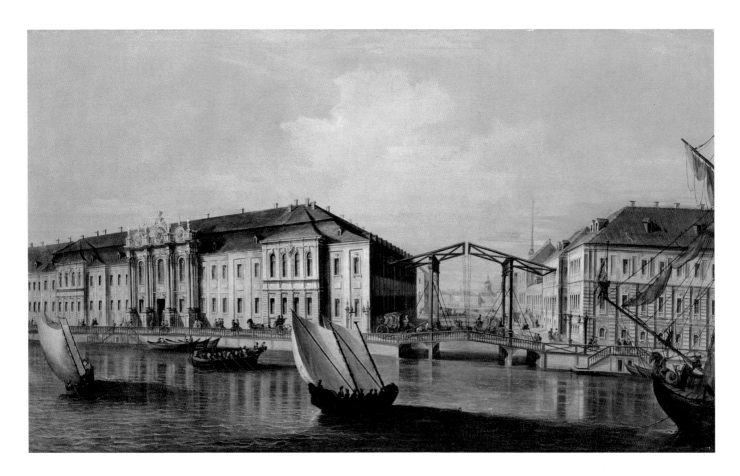

broke out. The lack of jobs and the decline of trade made the city an unappealing prospect. Nevertheless, in 1729 an *ukase* was promulgated which forbid tradesmen and workers from leaving the already quite deserted city under pain of penal servitude. It was only the premature death of Peter II and the crowning of the Empress Anna Ivanovna (1730–1740) which saved the situation.

The Empress Anna Ivanovna continued Peter I's policies and reinstated the capital in St. Petersburg. To put some order back into the construction policies of the city, she promulgated an ukase in 1737 which set up a "Commission for St. Petersburg Urban Development." Its main mission was to develop a general plan for the capital. The job was given to the architect P. Eropkin. He developed the trident schema

designed by Peter I according to which the three main streets of the city converged toward the Admiralty. The most important of these was the Nevsky Prospect. All the building in St. Petersburg until the end of the 18th century continued to follow P. Eropkin's plan.

Construction work in the city began to flourish once again. A new Winter Palace was built for the Empress and new churches were edified. But at the same time, Anna Ivanovna did not have free rein in bringing about serious innovations in the principles of urban development which had been elaborated by her predecessors. The Empress loved luxury: she was passionate about the hunt, knew how to handle a rifle and thrilled to the exhilarating atmosphere of balls and festivals.

5
Thomas Malton
*View of the Vassiliesky Island near
the Academy of Science*, 1789

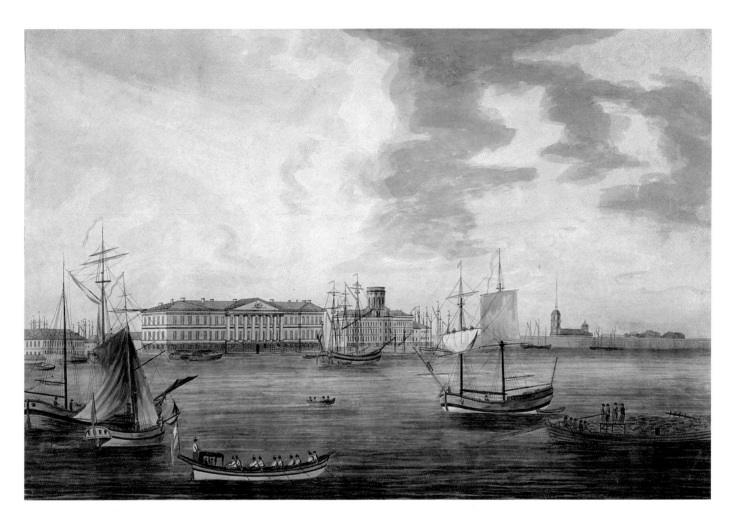

A new and brilliant page in the city's history opened the day Peter's daughter, the Empress Elisabeth Petrovna (1741–1762), mounted the throne. From the beginning of her reign, there was a radical change in St. Petersburg's appearance. Under Peter I, the architecture had featured relatively modest and sober forms characteristic of a trade and business city. But Elisabeth indulged in sumptuous palaces, private mansions, and groups of buildings in the new pompous Russian baroque style whose indisputable master was the Empress's favorite architect, F.B. Rastrelli.

Just as the work of D. Trezzini had been the symbol of the petrovian St. Petersburg of the former era, so now it was Rastrelli's work which was to define in its turn the physiognomy of the Elizabethan capital, reflecting the new sovereign's character. He built around 20 royal palaces and pleasure residences for her in the capital and its surroundings. During Elisabeth's reign, St. Petersburg once again assumed the aspect of a real capital.

The crowning glory of Rastrelli's work is indisputably the Winter Palace (1754–1762), built on the site of the old Winter Palace which had been Anna Ivanovna's. Elisabeth's palace became the convergence point of the whole empire. According to Rastrelli's own words, the palace was built "for

the sole glory of all Russia." And although Elisabeth died before it was completed, the Winter Palace became the symbol of her reign. Even Catherine II, who was attracted by totally different architectural forms, only slightly changed the interiors and did not touch the splendid and solemn facades.

During her reign, immense architectural works were begun which would be brought to completion by future generations. Along the banks of the Neva rose an architectural unity, the Smolny monastery, built by Rastrelli, with the abbey in the center of it. On the main street of the city, at the Nevsky Prospect, Rastrelli built the mansion of one of the richest men of the times, Count A.S. Stroganov. It was among the architect's most successful works. Not far was the Anitchkov palace, a gift of Elisabeth for her favorite, A.G. Razoumovsky. M.G. Zemtsov's more modest facades were later reworked by Rastrelli. Thanks to him the building which originally was of rather sober construction was transformed into one of city's most sophisticated and elegant residences.

In another district of the city, the architect S.I. Tchevakinsky built one of the most important churches, the Cathedral of St. Nicolas or Nicolas of the Sailors' Church. He also built the Cheremetiev Palace on the Fontanka which at that time in the middle of the 18ᵗʰ century was the boundary of the city.

The "Elisabethan" St. Petersburg, as that of Peter I's, was full of striking contrasts. For almost all of the 18ᵗʰ century, contemporaries did not fail to remark that alongside the palaces and majestic groups of buildings subsisted rows of small buildings, ready to tumble down, which could have been replaced by magnificent stone buildings. But in the middle of the century there were no longer the strict rules regarding urban development that had governed the petrovian era. Even if building continued to respect the principle

of regularity along the main streets, the districts far from the center were totally chaotic. Nevertheless, as in the past, no construction could be undertaken without the authorization of the high authorities.

St. Petersburg under Elisabeth was a city of brilliant splendid never-ending festivities. Any occasion was good to hold a masquerade, a popular kermis, ice sliding (Russian mountains), fireworks. The Empress's and her courtiers' ceremonial displacements to Moscow or to the summer residences were transformed into genuine theatrical performances. The grandiloquent cortege of gilded calashes of ceremonial magnificence, attached to horses who were richly harnessed and decorated with plumes, all going through the city at a stately pace, created an astonishing atmosphere in the streets.

Music held an important place in the Court and in St. Petersburg life. If in the era of Peter I it was the music of trumpets and drums which sounded' under Elisabeth, horns were the preferred instruments. The harp and the guitar also became popular. As for the theater, this was the Empress's and the nobility's favorite entertainment. Balls and theater performances were put on in the courtiers' residences. Elisabeth's favorite, A.G. Razoumovski, was in his time an *a cappella* singer at the Court. Theaters in the home were all the rage at that time. The dignitaries gave shows at their homes with their own serfs as the actors. Among the best of these "theater serfs" were those from the Ioussoupov and Chermetiev families. They had theater auditoriums in their Petersburg palaces and the Empress, accompanied by the Court, often attended performances there.

At her accession, Elisabeth Petrovna had proclaimed that the objective of her reign was to bring back the measures which had been instituted by her father, and she continued Peter I's educative program. She gave her support

6
Anonymous
Portrait of Mikhaïl Vassilievitch
Lomonossov, 2nd half of 18th century

to the Academy of Science (fig. 5), and gave her patronage to the greatest Russian scholar of the 18th century, M. Lomonossov (fig. 6). In 1755 she founded by decree the University of Moscow, and in 1757, the Fine Arts Academy. Innumerable scientific expeditions criss-crossed the country and geographic maps of Russia were drawn up. In the middle of the century, the *Atlas of Russia* was written. Only one other country of Europe, France, had anything equal to it at that time.

After Elisabeth Petrovna's death and the reign of Peter III which only lasted six months, a coup d'état on the 28th of June 1762 placed the Empress Catherine II on the throne (1762–1796). The thirty-four years of the Great Catherine's reign have been rightly called Russia's "golden age." She finished the building of St. Petersburg which had been begun by Peter. Under her reign, Russia became a true European power, a developed country and an "enlightened" State whose capital, mostly due to her efforts, was considered one of the most brilliant of Europe, thus making Peter's dream come true.

A host of foreign travelers, of philosophers, of political statesmen were curious and interested to discover the life of the Russian capital. Catherine did not like Moscow and considered that her true home was St. Petersburg. She rarely left the city and never went abroad. From the moment of her crowning, her entire life was intimately and entirely linked to the city on the Neva.

Catherine II loved architecture, understood it, and had an acute sense of the beautiful. She collected drawings, maps, albums and books on the subject. She compared her passion to an illness and often said, "the more one builds, the more one desires to build." The dimensions of the buildings, as well as the sums allotted to their construction, were considerable.

St. Petersburg urbanism in the second half of the 18th century answered to the new tendencies of the era and, for the most part, were dictated by the personal choices of the "enlightened" Empress.

A whole group of prestigious masters fashioned the shape of the city. A.F. Kokorinov, J.-B. Vallin de La Mothe, J.M. Velten, A. Rinaldi, I.E. Starov, D. Quarenghi and many others worked in the new style to create palaces and admirable public buildings. It was these architects who carried out Catherine's many orders most of which were for her favorites. She built for them splendid palaces in the capital each one of which is significant in the history of architecture. She built a palace for G.G. Orlov right near the Winter Palace so that she could see it from her private apartments. This palace, built from a blueprint by A. Rinaldi, is one of the most elegant buildings in the city: thirty-two sorts of natural stones extracted in Russia, including marble, were used for their decoration. This is why it is called the Marble Palace. There was also another remarkable project by Rinaldi for St. Isaac Church which has not come down to us.

But the most perfect of all the palaces built by Catherine for her favorites was without any doubt the Tauride Palace which she gave to Prince G.A. Potemkin. This building, constructed after a plan by the greatest master of Russian classicism, I.E. Starov, was a model for many of the nobility's residences as well as for public buildings. The Tauride Palace was built near the Neva and at the time, there was a small canal which led to the building so as to give access to the private wharves. The palace park enjoyed a special reputation: it had been designed by the Dutch master of landscape arts, William Gould for whom the "house of the gardener" had been especially constructed (fig. 7).

While continuing Peter I's reforms, Catherine II brought a totally new impetus to the sciences and the arts.

7
Benjamin Patersen
View of the Tauride Palace,
around 1800

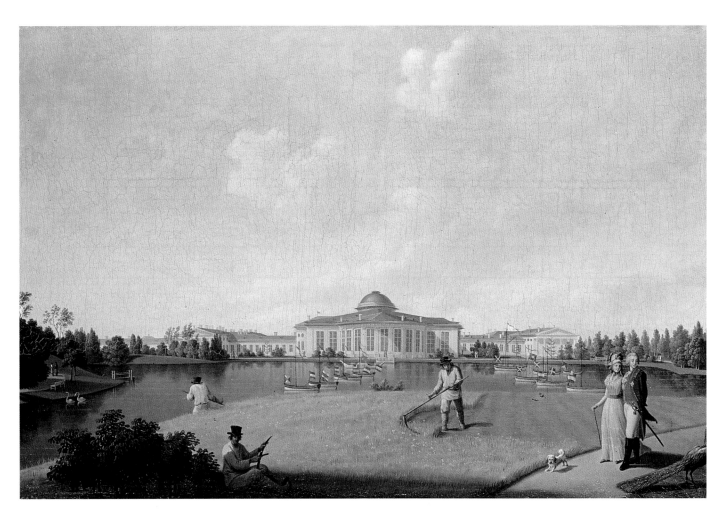

Her private collections of paintings, sculpture, drawings, and her huge library required additional arrangements. Even the vast Winter Palace could no longer accommodate this quantity of treasures which grew at a dizzying pace. To house them were built successively the Small Hermitage (based on J.-B. Vallin de La Mothe's blueprint) which was just next to the Winter Palace, and then the Old Hermitage (by Velten), and finally, based on D. Quarenghi's blueprint, *The Raphael's loges* on the ground floor in which was housed a unique and richly-endowed library. And many other museums and libraries at the end of the 18th century followed these first Hermitage buildings.

Catherine II played the role of patroness to the Russian artists. In 1764 she scrapped the Fine Arts Academy. On her order, a new Academy building was begun on Vassiliesky Island, with workshops and classrooms installed there. She personally attended the inauguration ceremony for the Academy which became, thanks to her patronage, one of the most important art teaching establishments in Russia. The professors included both Russian artists as well as foreign masters, painters, engravers, sculptors, architects. Among the graduates of the Academy were remarkable painters such as A.P. Lossenko and F.S. Rokotov, F.F. Chtchedrin and V.L. Borovikovsky; sculptors such as F.I. Choubin, M.I. Ko-

8
Johann Wilhelm Gottfried Barth
Dacha of the Counts Laval
Apterkarsky Island in St. Petersburg,
around 1816

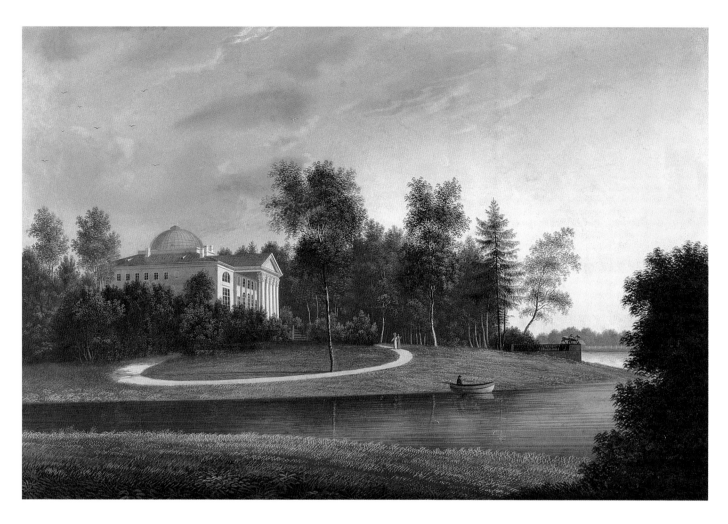

zlovsky, and many others. The most talented students were sent abroad for advanced study, often to Italy.

The new Academy of Science building was built by G. Quarenghi just next to Peter's *Kunstkamera*. It held a predominate place in the city. During Catherine's reign, not only theoretical but also practical education was taught there. At the Empress's initiative, the Russian scholars would travel immense distances in order to describe Russia's boundaries and to drawn up exact maps of the Empire. In addition, Catherine made sure that the ships destined for scientific exploration were equipped with good libraries.

Catherine's tastes reflected the diversity of her interests. Her favorite in the field of architecture was G. Quarenghi. It was Quarenghi who best expressed the spirit of Antiquity in St. Petersburg, inspired by his idol Palladio whose works incarnated that ancient spirit. Quarenghi lived in St. Petersburg from 1779 until his death and it was thanks to him that Palladio was given a second country, Russia, where the full scope of his genius could be honored and displayed. Quarenghi's work is characterized by its terse, austere monumental style. His many buildings gave to the city its aspect of "severe grace" which it continues to have today.

9
Ludwig Gabriel Lory I
and Mathias-Gabriel Lory II
*View of the Stroganov dacha
from Kamenny Island,*
beginning of the 1800s

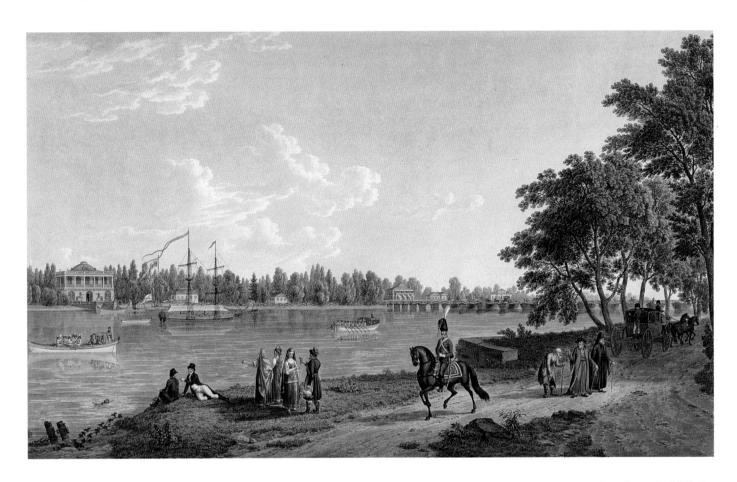

In addition to the Academy of Sciences, many other buildings were admirably achieved based on Quarenghi's blueprints: the Bank of State Assignats, the Smolny Institute, Saltykov's house on the Neva quay and many private mansions belonging to the St. Petersburg nobility. One of his most successful works is the Hermitage theater. The 300-seat auditorium is in the form of an antique amphitheater. The first performance was given even before the building was finished. Among the plays performed were pieces written by Catherine II. The Hermitage Theater continued the tradition of the *Court Opera* which had been housed the twenty years previously in the Winter Palace.

At Carrousel Square, the architect A. Rinaldi built the great theater which could seat 3000 people—it was at that time the biggest public theater in Russia. Theatrical life in St. Petersburg was characterized by the great variety of repertory and by the excellent acting. The most famous opera and theater companies performed all year round on the stages of the Court Theater, the Grand Theater and in the private theaters of the nobility.

During the second half of the 18th century, the banks of the great rivers and the small canals were bordered with magnificent granite parapets and ramps of honor. Catherine II called on the best architects so as to preserve the harmony of the city. The granite decoration along the Neva's Quay of Honor in front of the Winter Palace was created by J.M. Velten, as were the original footbridges and the sloping passageways giving access to the river. He was also the creator

of the famous Summer Garden grille which gave out onto the Neva. The originality of St. Petersburg is due to the "islands." Along the sandbanks formed by the rising of the Neva emerge the *dachas*. These country houses where the Petersburg nobility would come to vacation in summer were very popular in the second half of the 18th century and in the 19th century. The best architects were called upon to build these *dachas* on the islands, the same who had built the most beautiful examples of architecture in the capital. Among the impressive *dachas* were the house of the Counts Laval (fig. 8) on Aptekarsky island (architect Thomas de Thomon) and the Stroganov *dacha* (fig. 9) on Kamenny island (built by A.N. Voronikhin.)

Near the end of Catherine II's reign, St. Petersburg (figs. I–VIII) had the visage of a brilliant city with solemn tones, a city which was now the capital of a powerful and enlightened European state, exactly as its founder, Peter the Great, had imagined it. Catherine continued Peter's work, not in order to carry out the will of the first emperor of Russia whose aspirations she had nonetheless completely understood, but in order to achieve her own goals. These two sovereigns, the one who had inaugurated that brilliant century of Russian history, and the other who had completed it both had, the one and the other, personalities which at the same time were exceptional and yet comparable. Catherine felt herself to be the heir to the work undertaken by Peter, as can be evidenced particularly in the construction of St. Petersburg. She would say, in paraphrasing the words of Sueton about the Emperor Augustus, "I found a city in wood and left a city in stone."

In a hundred years, there where at the beginning of the 18th century one could scarcely see a few tiny Finnish hamlets, one of the most brilliant European capitals, St. Petersburg, had been constructed. Contemporaries marveled at the splendor of its buildings, at the lively traffic of equipages, at the nobility of customs and lifestyle. An unusual sort of spirit characterized its inhabitants. St. Petersburg which had become the center of the immense Russian empire was the glorious embodiment of the power and pride of the State. The reign of each of its sovereigns is reflected in the visage of the city, and the history of St. Petersburg personifies the whole history of the new Russia.

D.V. Lioubin

I
Benjamin Patersen
View of the St. Petersburg
surroundings near the porcelain
factory, 1798

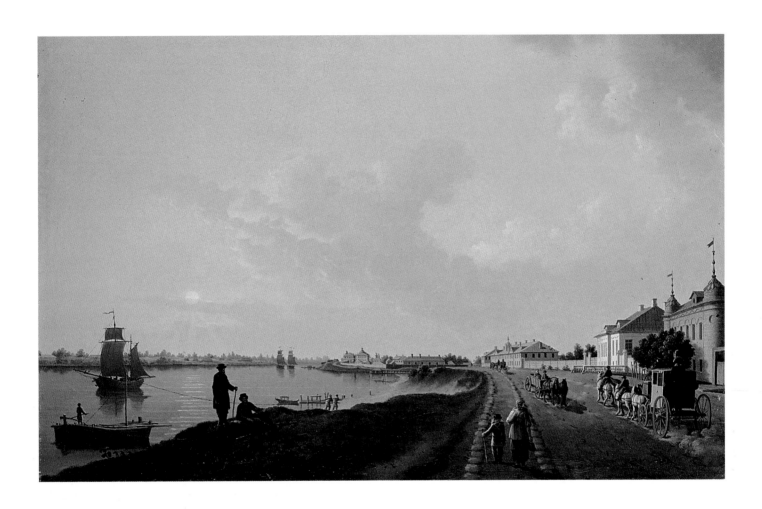

II
Ludwig Gabriel Lory I
and Mathias Gabriel Lory II
View on the Marble Palace from
Peter and Paul Fortress,
beginning of the 1800s

Pages 122–123
III
Benjamin Patersen
View of Sennaia Square, "haymarket
square", around 1800

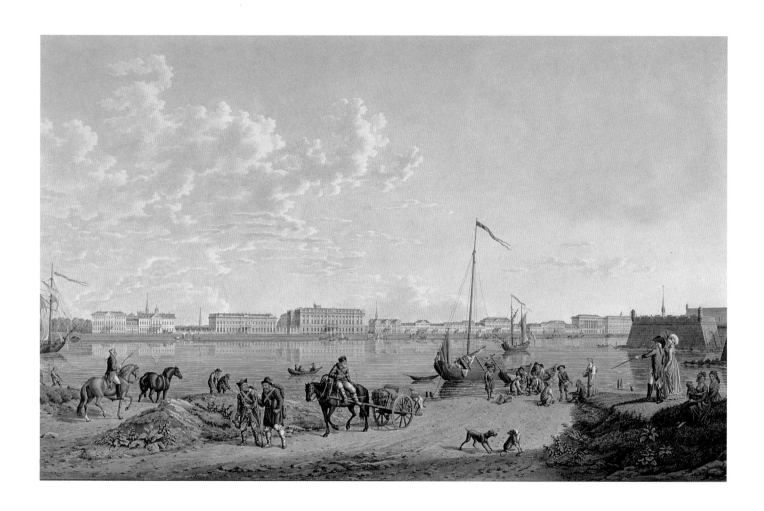

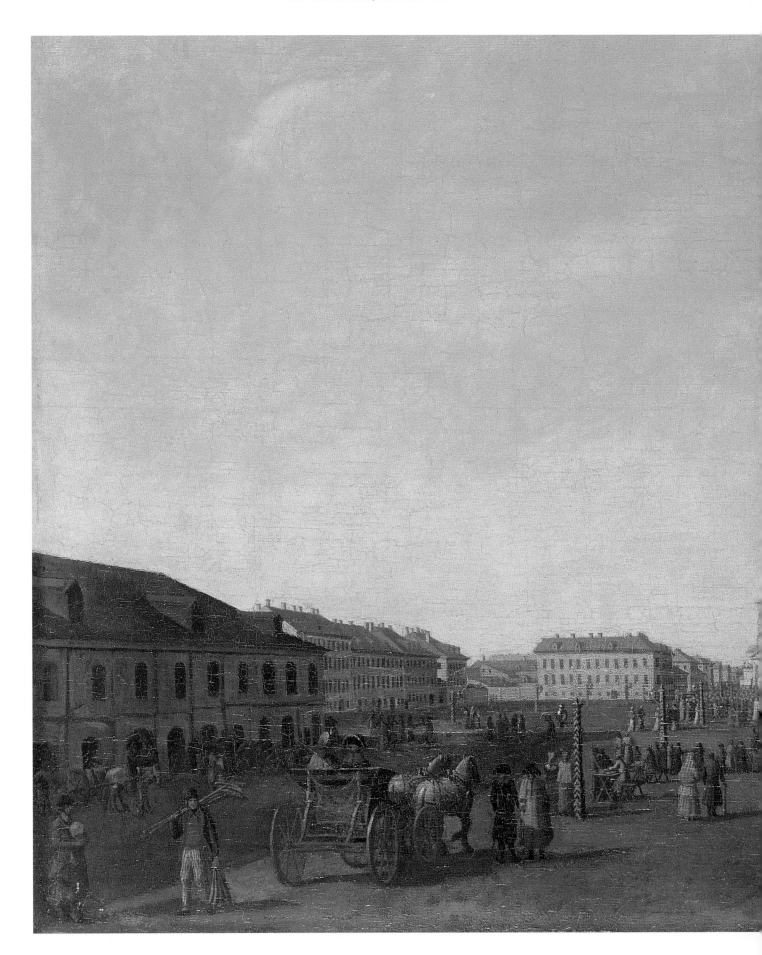

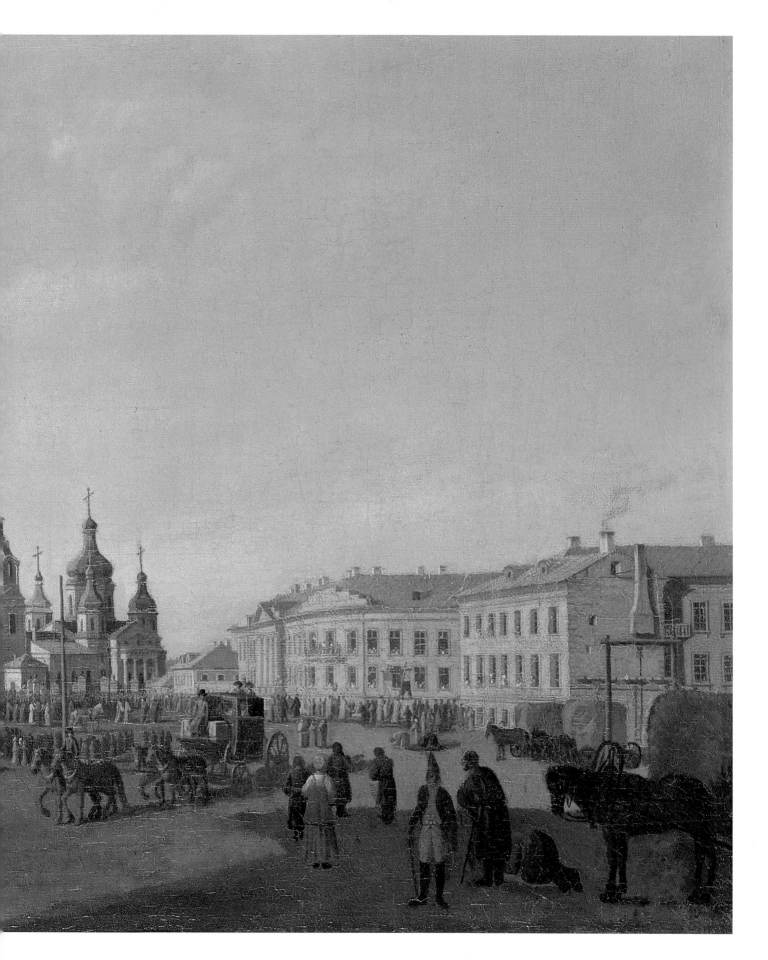

IV
Benjamin Patersen
*The Neva gate of Peter
and Paul Fortress*, around 1800

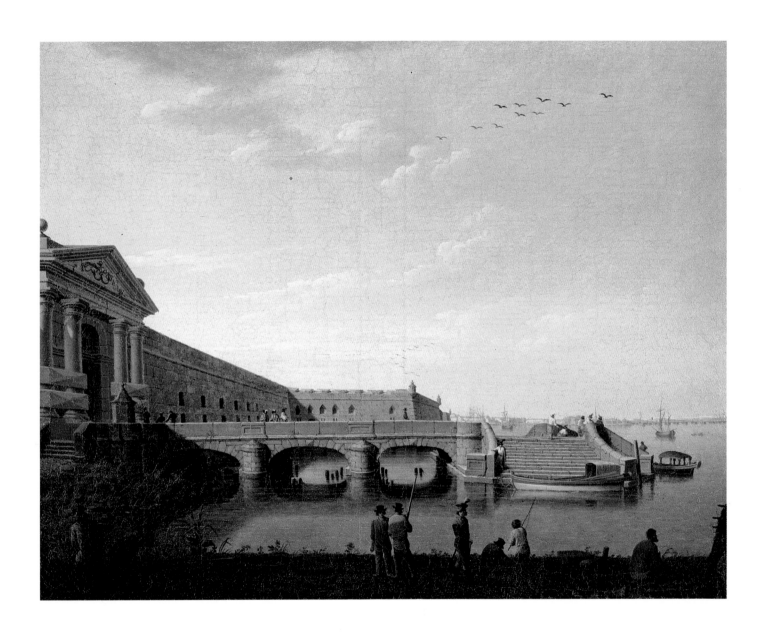

V
Benjamin Patersen
Vassiliesky Island Quay near
the Fine Arts Academy,
around 1799

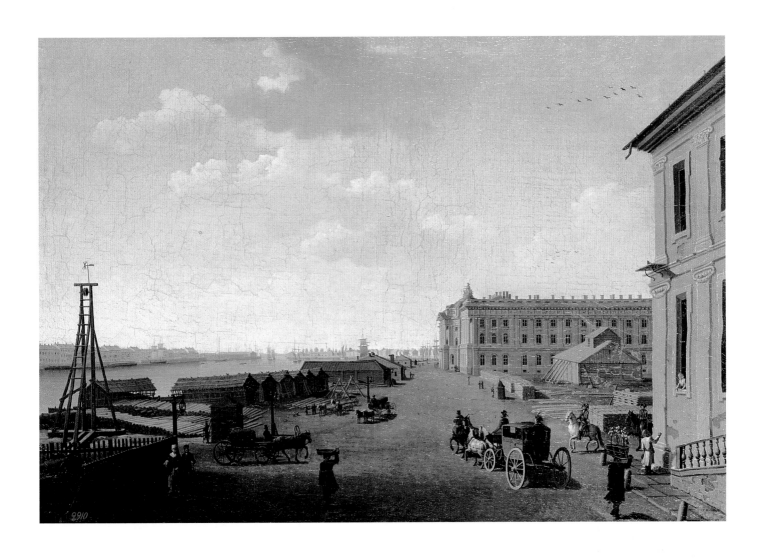

VI
Benjamin Patersen
Panorama of the English Quay,
first part, 1799

VII
Benjamin Patersen
Panorama of the English Quay,
second part, 1799

VIII
Benjamin Patersen
Panorama of the English Quay,
third part, 1799

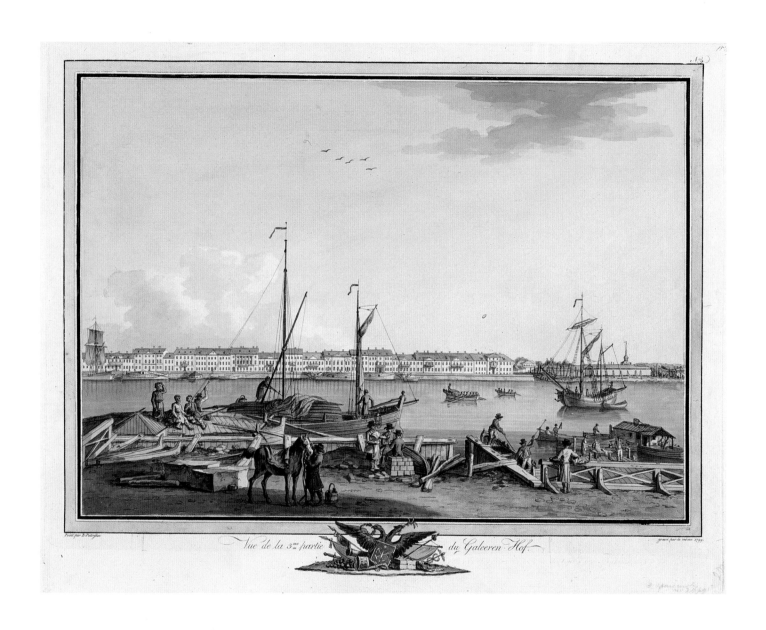

Vue de la 3me partie du Galeeren-Hof.

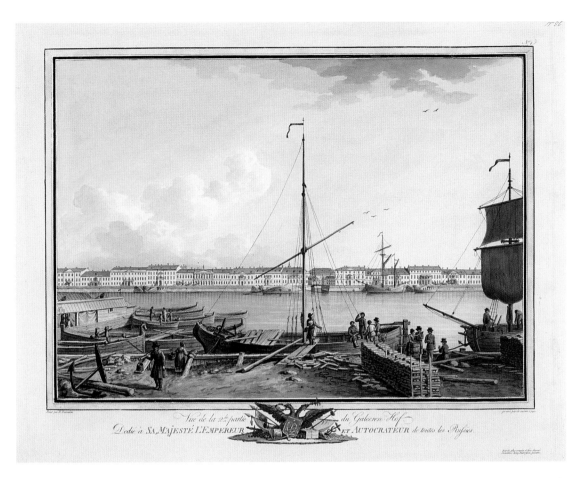

Vue de la 2.de partie du Galeeren-Hof
Dedié à Sa. Majesté l'Empereur et Autocrateur de toutes les Russies.

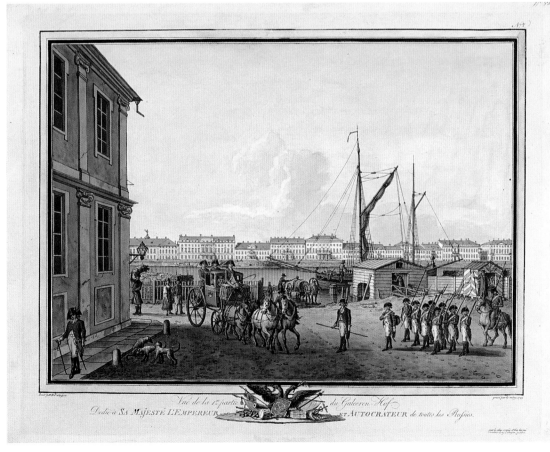

Vue de la 1.re partie du Galeeren-Hof
Dedié à Sa. Majesté l'Empereur et Autocrateur de toutes les Russies.

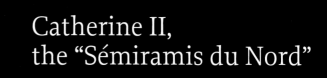

Catherine II,
the "Sémiramis du Nord"

"The snuff-box with Voltaire's tomb made me sad, and so I could not keep it. I could not look at it without sorrow. That might seem strange to you but it's true: I could not accept that he was dead because I loved knowing he was in this life. He loved me a lot and I also felt a great deal of gratitude to him."

A letter by Catherine II to Grimm, March 19, 1781, in Louis Réau, *Correspondance artistique de Grimm avec Catherine II*, Archives de l'Art français, Paris 1931–1932

On November 6, 1796, Catherine II died in her Winter Palace after having governed an immense country for thirty-four years, longer than any other emperor of Russia.

A long time before that, she had written, not without humor, her own epitaph. "Here lies Catherine II, born at Stettin on April 21 (May 2), 1729. She arrived in Russia to marry Peter III. At the age of fourteen, she had the triple objectives to please her husband, Elisabeth, and the people. She bent all her efforts into succeeding. During eighteen years of boredom and solitude, she had in spite of herself, the time to read a great deal. Once having ascended to the throne of Russia, she showed herself benevolent and tried to give her subjects happiness, liberty and prosperity. She forgave easily and did not feel hatred for anyone. Clement, affable, naturally joyful, filled with sentiments for the public good and having a generous heart, she was surrounded by friends. She worked without displeasure, loved the arts, and appreciated company."[1]

Ironic though this clearly is, the epitaph is perfectly objective and does not contradict the truth. The Empress of Russia had already received from her dear Voltaire the title of "Great" (fig. 1). The Prussian King Frederick II had echoed him: "In France, four ministers do not work as hard as this one woman who must be counted among the number of "great men."[2] If one can trust the recollections of P.A. Viazemski: "A English minister to Catherine's court pronounced these words during the funeral: 'Russia is being buried.'"[3]

"Only in Russia could I be what I am. In the other countries, there is no longer any authentic nature. Everything is as false as it is affected"[4] she said, reflecting over her own destiny. Undoubtedly in any other country, the talents and ambitions of this woman would have found their outlet. However circumstances were such that it fell to her to become the head of this enormous and difficult country. That she happened to find herself there appears today to have been a very good thing, both for her and for the future of Russia.

The future empress was born in the small Prussian town of Stettin (today Szczecin in Poland). Her father, the prince Christian-Auguste d'Anhalt-Zerbst, was a major-general in the Prussian army. The family of his wife, Johanna Elisabeth, daughter of the princess Baden-Durlach and of the prince Bishop of Lubeck, was in the strange ways of destiny, closely linked to the imperial house of Russia. Karl-Auguste, her older brother, was married to Elisabeth, daughter of Peter I; Karl-Friedrich von Helstein-Gottorp, her cousin, was the spouse of Anne, Elisabeth's sister, and father of the future emperor of Russia, Peter III. And so it came to be that the young Catherine, also named Sophie Augusta Frederika (or simply Fike) was to marry her third cousin, Peter Fedorovitch, who had been declared heir to the throne in 1742.

On February 3, 1744, "Fike" and her mother arrived in St. Petersburg. The princess Sophie did everything she could to please Elisabeth as well as her fiancé, and quickly won the sympathies of the Empress. But in order to become grand duchess of Russia, Sophie had above all to master a language which was completely unknown to her, assimilate a great deal of scientific knowledge, and convert to orthodoxy. The young princess applied herself assiduously to the accelerated study of the Russian language as well as to the religion of her new country. Her perseverance and her application bore their fruits. On July 28, 1744, day of her baptism according to the orthodox rites, Fike repeated the words of the Slavonic Credo with scarcely an accent. She was then proclaimed grand duchess and giv-

en the name Ekaterina Alexeievna, fiancée of the heir to the throne, Peter Fedorovitch.

Although anxious to be a good wife to the future emperor, Catherine had no illusions about him. Peter who was ugly, badly-formed and infantile, had absolutely no interest in her as a woman. The heir to the throne cared first and foremost for all the prestigious trappings of a military career: uniforms, guns, equipment. He tried to share these interests with his fiancée and involve her in his games with toy soldiers to which he devoted the largest part of his time.

The marriage was celebrated in magnificent style on August 21, 1745 but nothing much changed in Catherine's personal life. Her husband continued to play with his little soldiers, tried to teach her how to handle arms, tortured her in playing the violin which she couldn't bear, and gave himself up to drunkenness. Over the years, the Grand Duchess suffered more and more from her unhappy marriage, and the Empress Elizabeth became more and more irritated over the situation. Peter was openly unfaithful to his wife, and solitude pushed Catherine to seek the attention of men elsewhere. Serge Saltykov, an officer of the Guard, was apparently the first of a series of young and beautiful men who were loved by Catherine and who surrounded her during the duration of her long life.

In 1754, the Grand Duchess gave birth to a son, named Paul. The Empress finally had the heir she had so long desired. She brought him to live in her apartments and brought him up according to her principles. Saltykov was sent on diplomatic mission to Hamburg.

Catherine, ignored by her husband, deprived of her lover and her son, began to read assiduously and to teach herself by herself. Little by little, the love stories on her table came to be replaced by the works of the French writers of the Age of Enlightenment, mentors from Europe—Montesquieu, Diderot, Rousseau and especially Voltaire—transforming her vision of the world and inciting her to a profound study of history, philosophy, economy and law. Among her favorite works were those by Plato and Tacitus, Pierre Bayle's *Encyclopedic Dictionary*, C. Baroni's *History of the church*, the *Mémoirs* of the Abbé de Brantôme, the work of the English jurist O. Blackstone, Madame de Sévigné's *Letters* etc. But for many years, her favorite works of all remained those of Voltaire whom she called her master.

Only the death of Elisabeth could resolve the many problems confronting Catherine and her husband. Peter dreamed of the throne and Catherine understood perfectly well that he did not have the abilities to govern Russia and that it would be she who would hold the reins of power. Her new favorite, the officer of the Guard Grigori Orlov (fig. I), was ready to back her, with the aid of his four brothers, all influential in the Petersburg regiments. At the time of the Empress Elisabeth's death, the division of the forces was the following: on the one side, Peter, who had paid obeisance to the King of Prussia and had proclaimed his desire to repudiate his wife; on the other, Catherine, pregnant by Grigori Orlov, who wished to govern Russia alone and who could count on the support of the Guard.

Elizabeth Petrovna died in December 1761. Peter III, the new emperor, aged 35, ascended to the throne. Four months later, in April 1762, Catherine gave birth to a son who became the count Alexis Bobrinski. That same month, Peter signed a peace treaty between Russia and Prussia, by the terms of which Russia was to give up all its territories.

All Peter's actions as emperor were above all motivated by an infantile desire to change everything in a state that he hated, to have new experiences which up until then had been forbidden him. "In the morning, to be the first

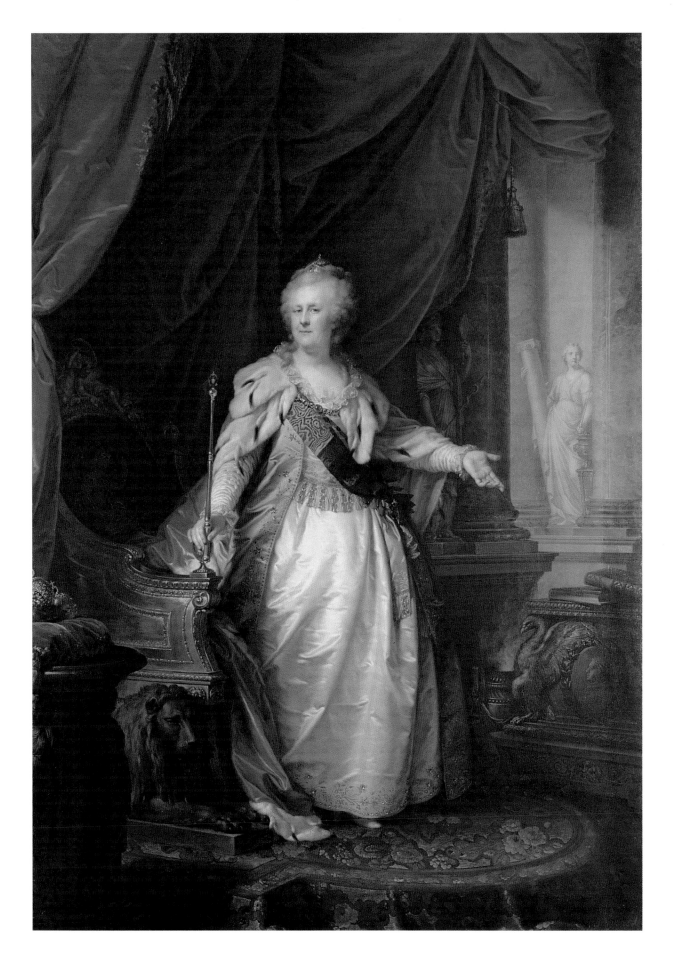

2
Anonymous
*Catherine II, surrounded by the Court
on the Winter Palace balcony greeting
the Guard and the people on the day
of her "coup d'État",*
end of 18th century to first third
of 19th century

corporal in the parade, then to lunch copiously, drink an excellent Burgundy, pass the evening with his buffoons and a few women, and to carry out the orders of the Prussian king, this is what makes Peter III happy,"[5] wrote Catherine Dachkova, a close friend of Catherine II.

After just 18[6] days of his reign, Peter had succeeded in turning everyone against him: the courtiers, the army, the clergy, the nobility. Catherine II, who was constantly being humiliated and mocked by her husband, had also lost patience.

The opportunity for a "coup d'État" occurred on June 28, 1762. Peter was at his country residence of Oranienbaum. Having been assured of the support of the regiments of the Guard who had unhesitatingly sworn fidelity to her, Catherine II seized the power in the capital rapidly (fig. 2) and without bloodshed. And then, at the head of a detachment of 14,000 men, she rode to Oranienbaum. Peter and his few partisans, finding themselves encircled, gave up without resistance. On June 29, Peter signed the act of abdication and was soon after taken to the country resi-

3
Anonymous
*Portrait of Catherine II, holding
the Nakaz (or Instruction),*
1770s

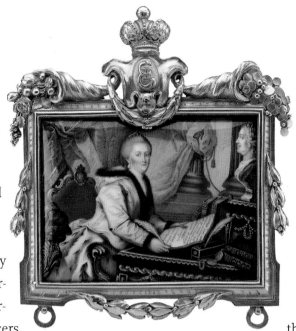

dence of Ropcha. There he was kept under surveillance by a group of officers and soldiers under the command of Alexis Orlov.

The deposed emperor died a few days later, officially of a crisis of haemorrhoidal colic. According to another version given by Alexis Orlov in a letter to Catherine, he was killed accidentally during a fight with some drunk officers. The death of Peter III, and the part played or not by his wife remains an enigma, as do a lot of other secrets from that troubled time.

The thirty-four years of Catherine's reign have often been called Russia's "golden age." The Empress had the indispensable qualities of a good head of state: a subtle understanding of human beings and a knowledge of psychology in her dealings with them, patience and a unique wisdom of life. The talents of this woman along with her extraordinary capacity for work, her desire to be involved in all the affairs of the empire, her solid knowledge of politics, science and philosophy were appreciated at their true worth by her subjects but also by foreign heads of state, diplomats and philosophers. Frederick II wrote with obvious admiration, "Russia had need of such an empress in order to complete the construction of its immense edifice... She encompasses everything in the sphere of her activity, no aspect of government escapes her, she is even interested in the police. She is a living reproach to a number of monarchs sitting lethargically on their thrones who understand absolutely nothing of the importance of the projects that she is involved in carrying out."

Starting from the basis of the "Rules of government" which she herself had drawn up, Catherine began first by reforming. One of her audacious moves was to create a legislative Commission. Catherine who was very influenced by the thinking of the Enlightenment understood that the prosperity of the state and the well-being of its citizens depended upon the equity of the law. In 1767, for the first meeting of the Commission, the Empress drew up for the legislators the *Nakaz* (fig. 3) or Instruction on which she had worked for more than two years. She was inspired in the writing of it by the principles of the Enlightenment and, in particular, by the works of Montesquieu and Beccaria.

But the Empress's efforts to change the established order came up against the opposition of the nobility. The work of the Commission was disappointing: the representatives of the different ethnic groups and the different classes of the society were unable to come to an agreement on most of the questions or to draw up a new Code of Laws for the Russian empire. By the end of 1768, disillusioned, Catherine took the pretext of the war against Turkey to dissolve the Commission.

Hard times were up ahead for Russia. A terrible epidemic of plague which had ravaged Moscow had provoked great unrest, and no sooner was that over than a violent revolt broke out in the Don steppes, fomented by the Cossack Memlian Pougatchev, an escaped prisoner. He claimed to be the Emperor Peter III and succeeded in gathering around him thousands of followers who were unhappy with the present regime. It was the bloodiest uprising of

4
Alexeï Kiprianovitch Melnikov
*Inauguration of the monument
of Peter I*, middle of 19th century

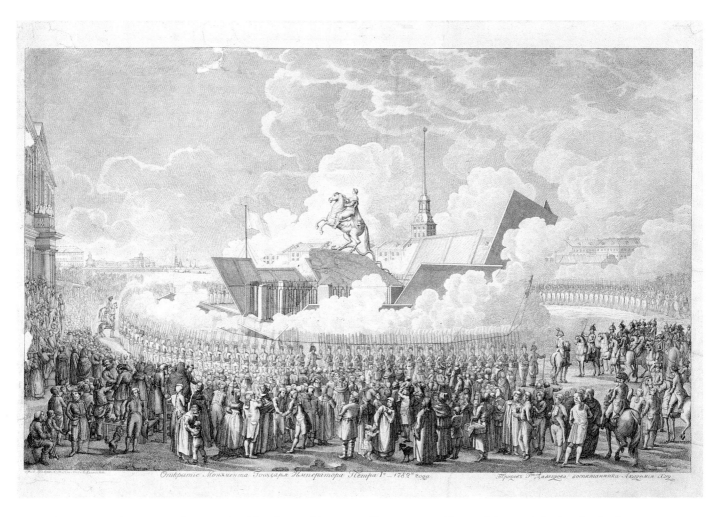

the 18th century. There were thousands of deaths, and houses, factories and churches were destroyed and burned. There are a number of accounts from that time concerning the massive execution of officers, of property owners but also of simple soldiers, civil servants, priests, innocent women and children. Pougatchev's army was finally defeated in 1774 by government troops. The rebels were executed cruelly and mercilessly in all the small towns where the revolt had occurred. In January 1775, the one who had called himself emperor was quartered in Moscow.

In 1775 Catherine, who had been alarmed by the extent of Pougatchev's revolt, tried to find a way to stifle all discontent of her subjects right in the bud. A new structure of local government was developed in Russia. On November 7, 1775, "The Organization of government of the provinces of the Russian Empire" was published, the basis of the reorganization. Instead of 25 provinces, the Russian Empire now was to have forty-one, each of them populated with three to four hundred thousand inhabitants. Each province was in turn subdivided into districts, already numbering 493 by the end of Catherine's reign. This new system of local government remained in place until the reforms of the 1860s, with the territorial administrative division continuing right up to 1917.

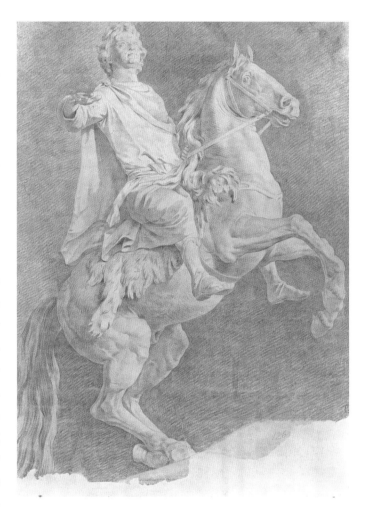

5
Antoine Lossenko
*Statue of Peter I by Falconet
in St. Petersburg*, 1770

Other important documents bear witness to the Empress's legislative activity. In the "Charter of the Nobility," Catherine recognized all the rights of the nobility, encouraged them to meet in assemblies and to contribute to the reorganization of the government. The charter confirmed their privileges and gave them the freedom of serving or not serving the state. The "Charter of Cities" encouraged all the inhabitants of the cities to take an active part in the economic and political development of the country.

Catherine's policies in foreign affairs also showed the admiration she felt for the ideas of the Enlightenment. On the one hand, in agreement with their ideals, she expressed her desire for peace. On the other hand, convinced that Russia as the heir to the Byzantine Empire was invested with a special mission, Catherine believed in the right to intervene in the affairs of other states. The first war between Russia and Turkey, declared by Turkey in 1768 and which lasted six years, was first of all defensive. However, seeing the victories of her armies, the Empress decided to provide Russia with an outlet onto the Black Sea which would give it the possibility to penetrate into the Mediterranean market. The Turkish navy was sunk in the Tchesme Bay in July 1770 by an squadron commanded by Alexis Orlov. That same year, under the command of the Count P.A. Roumantsiev the army was victorious in a number of important land battles. These brilliant victories by the Russian army enabled Russia to reach the Black Sea and the Sea of Azov.

Catherine's second important foreign affairs objective was to deprive Poland of its independence. She was successful in putting a puppet king onto the throne of Poland and, aided by a Russophile party, governed the country. Stanislas Auguste Poniatowski, diplomat and a former lover of Catherine, was crowned king of Poland in 1764 and given the name of Stanislas II. In 1772, European foreign affairs interests led to the partition of Poland between Russia, Prussia and Austria, with the lion's share going to Russia.

Poniatowski was not the only one of the Empress's favorites to actively support her in her political maneuvers. Some of the men who were close to her have gone down in history not only because they were her lovers but also because they were talented generals, clever politicians, expert managers. This was particularly the case with Grigori Potemkin (fig. III), a general whose power at the center of the state did not cease to grow. In June 1774, Catherine se-

6
Stepan Semenovitch Chtchoukin
Portrait of the Emperor Paul I,
1797–1798

had ports and fortresses built. During the Russian-Turkish war of 1787–1791, Potemkin, future commander in chief of the land forces in the south of Russia and of the Black Sea flotilla, showed himself to be a talented strategist who knew how to direct eminent generals.

None of Catherine's favorites who succeeded Potemkin after their rupture possessed the exceptional caliber of the illustrous prince. They were all young officers in the Guards who pleased the Empress primarily by their seductive appearances. Platon Zoubov, 22 years old, the last of Catherine's lovers, received all possible favors, and he tried, as Potemkin, to wield an influence over the affairs of state. But he didn't have the abilities necessary and in spite of unlimited power, never succeeded in having a political career.

Thanks to her impressive capacity for work and the support of her devoted military companions, Catherine was able to carry to fruition many of her projects. She gave considerable impetus to the development of science and culture. She was interested in the work of St. Petersburg and Moscow Universities and encouraged the formation of Russian scientists. Professors and students at the University of Moscow translated the works of Rousseau and other Enlightenment philosophers into Russian. This had a profound impact on the education of more than one generation. On Catherine II's initiative, the St. Petersburg Academy of Sciences organized large scale scientific expeditions from 1768 to 1774. Catherine was also interested in questions as diverse as agriculture, forest resources, water, zoology, botany, mineralogy, the customs of different ethnic groups... In addition, during Catherine's reign, there were expeditions to discover and claim the islands located between Russia and Northwest America which were the starting point of relations between the two countries.

cretly married him. She showered him with honors and medals, gave him control of the government of the border province of the new Russia and named him president of the War Council. She consulted with this secret spouse on all major issues. Even in the 1780s when their attachment began to loosen, Potemkin's position at court and in the country remained unshakable and his power unlimited.

In 1783, Potemkin succeeded in bringing the Crimea (formerly known as Tauride or Tauria) under Russian control and was given the title of illustrious prince of Tauride. He populated the deserted steppes, founded new important cities, Sebastopol, Ekaterinoslav, Nikolaev, Kherson, and

In 1783, the Russian Academy was founded. It was given the mission of studying the problems of the Russian language. Its membership was made up of such eminent men of letters and scholars of the time as: G.R. Derjavine, D.I. Fonzivine, I.B. Kniajnine etc. Catherine Dachkova was its president until 1796. From 1789 to 1794, the Academy wrote and published the first *Dictionary raisonné of the Russian language*. The Empress was also concerned about developing literature and printing. She herself wrote several satiric plays, stories, treatises and articles, and attentively followed the publication of new literature.

Catherine did everything she could to follow the same direction as Peter the Great regarding politics and culture. One spectacular example of this: in 1782 at the Senate square, the equestrian statue of Peter I (fig. 4) was being solemnly inaugurated. The French sculptor E.M. Falconet (fig. 5), who had been recommended by Diderot, had worked for nearly ten years on one of the most beautiful monuments in St. Petersburg. The pedestal, made of a single block of stone weighing more than two and a half tons, has a brief inscription which is highly symbolic: To Peter I. Catherine II."

Under Catherine's reign, St. Petersburg took on the appearance of a city-museum. St. Petersburg's most famous masterpieces of architecture are due as much to foreign architects, such as J.B. Vallin de la Mothe, G. Quarenghi, T. Cameron, A. Rinald, as to the Russian artists, A.A.F. Kokorinov, I.M. Velten, I.E. Starov etc. The Winter Palace was completed by the buildings of the Old Hermitage, the Small Hermitage, and the Hermitage Theater.

Catherine's sudden death in 1796 was not only a blow for her entourage. Europe, for whom Russia had been intrinsically linked for so long to the image of its Empress, was in a great state of uncertainty: in what direction would that country, now become a world power, go without its enlightened empress? Catherine's son, Paul Petrovitch, ascended the throne. He had not liked his mother as everyone knew and he gave evidence of that even during her funeral.

"At the moment of Catherine's death and Paul Petrovitch's (fig. 6) ascension to the throne, St. Petersburg was one of the most beautiful cities in Europe (...), wrote a contemporary. "The brutal change which took place in just a few days to the exterior of this capital was simply unbelievable (...) St. Petersburg no longer looked like a contemporary city but took on the boring appearance of a small 18th century German city."[7] It was the beginning of Paul I's reign, a brief but dark and humiliating period for Russia.

A. Soloviev

[1] *Imperial Russian History Society collection,* Saint-Petersburg, 1823, vol. 23, p. 77 *(Sbornik imperatorskogo russkogo istoriceskogo obscestva).*

[2] *Russian Archives,* 1906, book 2, p. 116 *(Rousski Arkhiv).*

[3] *Russian Memories,* 1800–1825. Moscow, 1989, p. 526 *(Rousskié Memouari).*

[4] Quoted from Klioutchevski, V.O., *Aphorisms, portraits and historic studies (Aphorismes, portraits et études historiques.) Cahiers,* Moscow, 1993, p. 266.

[5] Dachkova, C.R., *Notes,* Leningrad, 1985, p. 39 *(Zapiski).*

[6] *Russian Archives,* 1906, book 2, p. 113 *(Rousski Arkhiv).*

[7] Sabloukov, N.A., *Notes. The assassination of the Czar, March 11, 1801 (Notes. L'Assassinat du tsar, le 11 mars 1801),* Saint Petersburg, 1908, p. 27 *(Zapiski...).*

Catherine II and the Philosophers

There is still debate today regarding the sincerity of Catherine II's relations with the philosophers of the Age of Enlightenment. Catherine was very attached to letter writing and corresponded with Voltaire, Diderot and d'Alembert for it was through this correspondence that not only her power as sovereign was recognized but also her own intellectual research. She admired the *Encyclopedia*, so criticized in France, and proposed to the mathematician d'Alembert to come finish the work in Russia and to take on the position of tutor to her son Paul. But d'Alembert, aware of the rumors concerning the assassination of Peter III, was not eager for the visit and politely refused. She had the works of Jean-Jacques Rousseau (fig. d) translated as soon as they were published, with the exception of *Emile* and the *Social Contract*, but carried on no correspondence with him in spite of the invitation Grigori Orlov had sent him in 1765. However Catherine wanted the help of the philosophers to make concrete in writing the reforms necessary to better organize the government of her huge country. The famous "Instruction" which she wrote for the legislative commission which she created in 1766 is directly inspired by

Montesquieu *The Spirit of the Laws* and *Dei delitti e delle Pene* by Cesare Beccaria. The reforms were ultimately not carried out but Catherine continued her frequent correspondence with the philosophers, particularly with Voltaire and Diderot.

The laudatory compliments which Voltaire (fig. a) addressed to the sovereign have never been explained, for he was aware of all that was said about Catherine II, and particularly, regarding the death of her husband. He knew also that the letters were being read by everyone, especially when written by an author whose views were controversial and he took certain precautions, naturally. But how can such flattery on his part be explained? Some have said that he was so proud to

be the Empress's correspondent that his vanity blinded him. And in fact, this correspondence was of use both to Catherine and to Voltaire for it increased Catherine's notoriety as well as that of the philosophers. The latter were being attacked in France by the representatives of the church as well as by the Court whereas the Russian Empress offered them protection, thus showing her understanding, her interest in reflection and her openness of spirit. It could have simply been an exchange of mutual favors to which the admirer of the "Semiramis of the North" adhered. In any case, Catherine ordered a model and blueprints of the house of the patriarch of Ferney (fig. b) order which was carried out under the personal surveillance of Voltaire, with

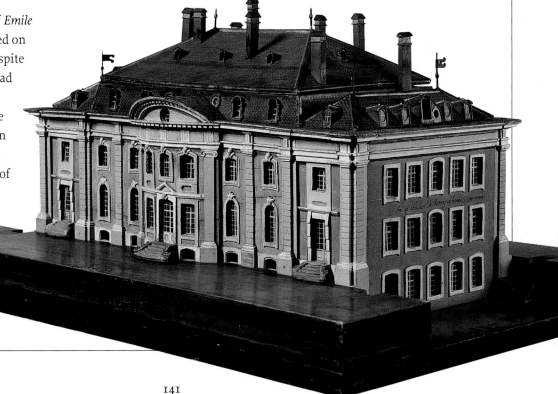

Page 140
a
Jean Antoine Houdon's studio
Bust of Voltaire, 1778–1779

Page 141
b
Master Pierre Morand
Model of the "Ferney Chateau,"
Voltaire's house, 1777

c
Marie-Anne Collot
Bust of Denis Diderot,
1772

d
Jean Antoine Houdon's studio
Bust of Jean-Jacques Rousseau,
1778–1779

the aim of building a monument in the garden of her country residence Tsarskoye Selo, which would be the exact reproduction, a project which however was never achieved.

The correspondence with Diderot (fig. c) was of a different nature. It was through the intermediary of Frédéric-Melchior, Baron of Grimm and director of the *Correspondance littéraire*, a magazine reserved for the elite of the European aristocracy and the crowned heads of state, that Catherine II learned of Diderot's wild scheme: to sell his library, object of all his passionate efforts, in order to provide a dowry for his daughter. She bought the library, named Diderot the curator of this precious collection and left him the life tenancy of it. Diderot was overwhelmingly grateful and did not hesitate to despoil France of its patrimony in order to satisfy the artistic desires of the Empress. He even went to St. Petersburg from October 1773 to March 1774 where he saw his benefactor two to three times a week. Unfortunately the advice that he gave had no relevance to Russia's social and governmental situation. The Count of Ségur, French ambassador to Russia from 1784 to 1789, recorded the words that Catherine II is said to have spoken to Diderot: "You, you work only on paper, which accepts everything: it is all smooth, flexible, and doesn't throw up any obstacles either to your imagination or to your pen; whereas I, poor Empress, I work with human

skin, which is far more irritable and touchy."[1] They separated, each of them somewhat disappointed by the other, for Diderot had understood that they did not view the "benevolent despotism" in the same way. He was however the only one of these so admired philosophers to have accepted the invitation of the "Semiramis of the North."

B. de M.

[1] Ségur, L.Ph., *Mémoires, Souvenirs et Anecdotes*, Paris, 1824, vol. 3, p. 41.

I
Andreï Ivanovich Tcherny
Portrait of the count G.G. Orlov,
end of the 1760s–beginning
of the 1770s

II
Andreï Ivanovich Tcherny
Portrait of the Empress Catherine II,
1765

Page 146
III
Johann Baptiste Lampi, the Elder
Portrait of G.A. Potemkin,
Prince de Tauride, around 1790

Page 147
IV
Anonymous
Portrait of the Empress Catherine II,
end of 18th century

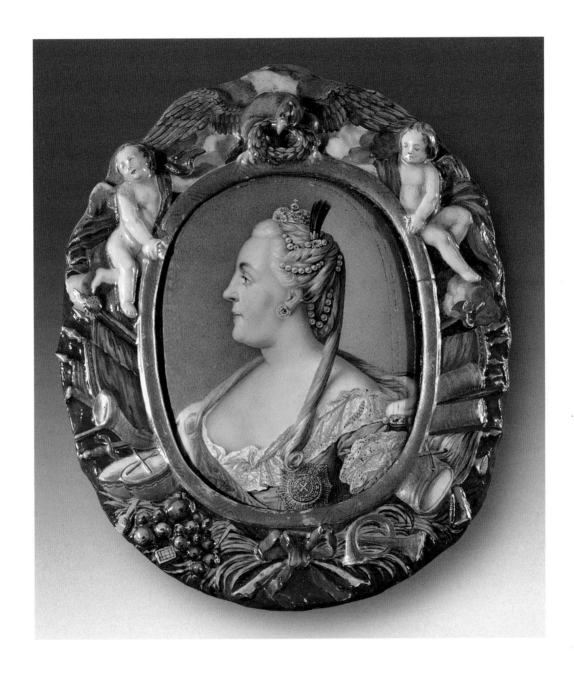

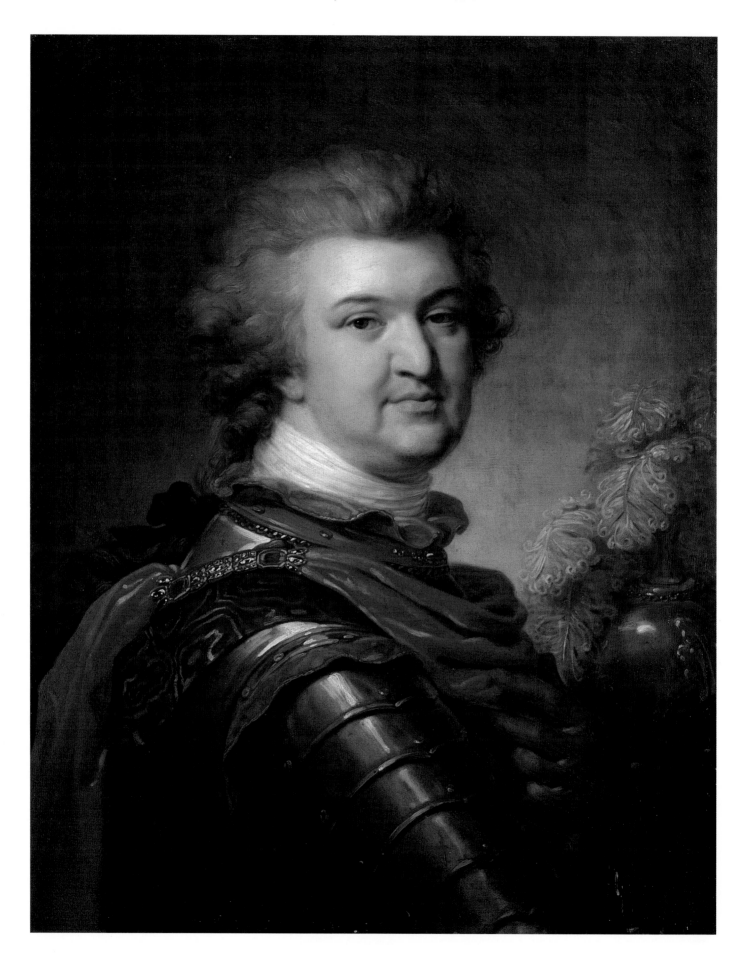

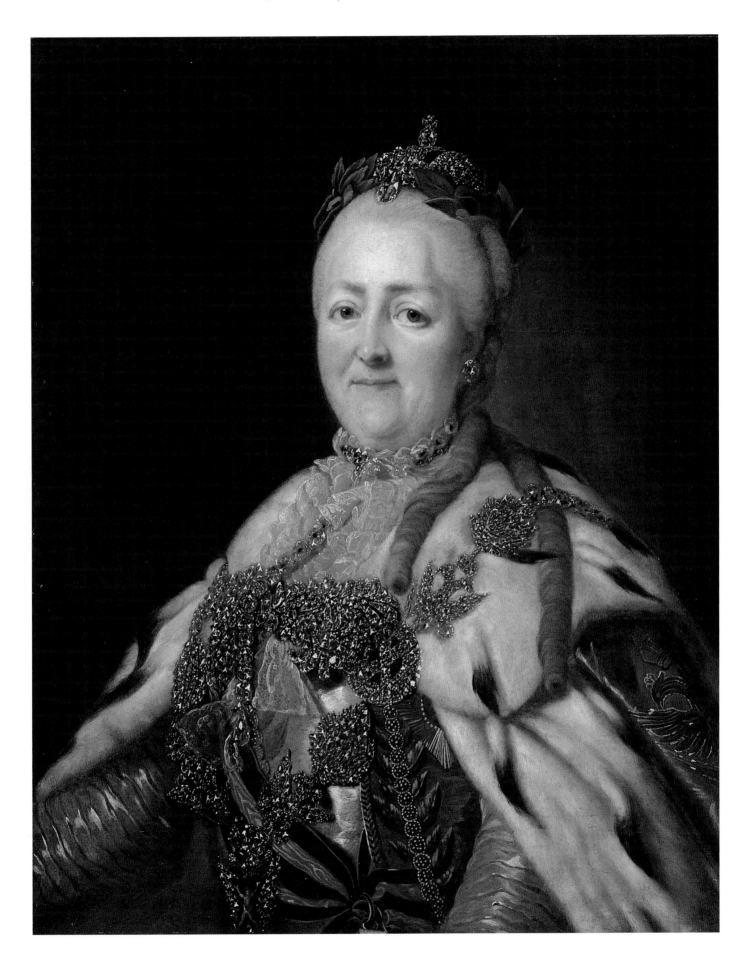

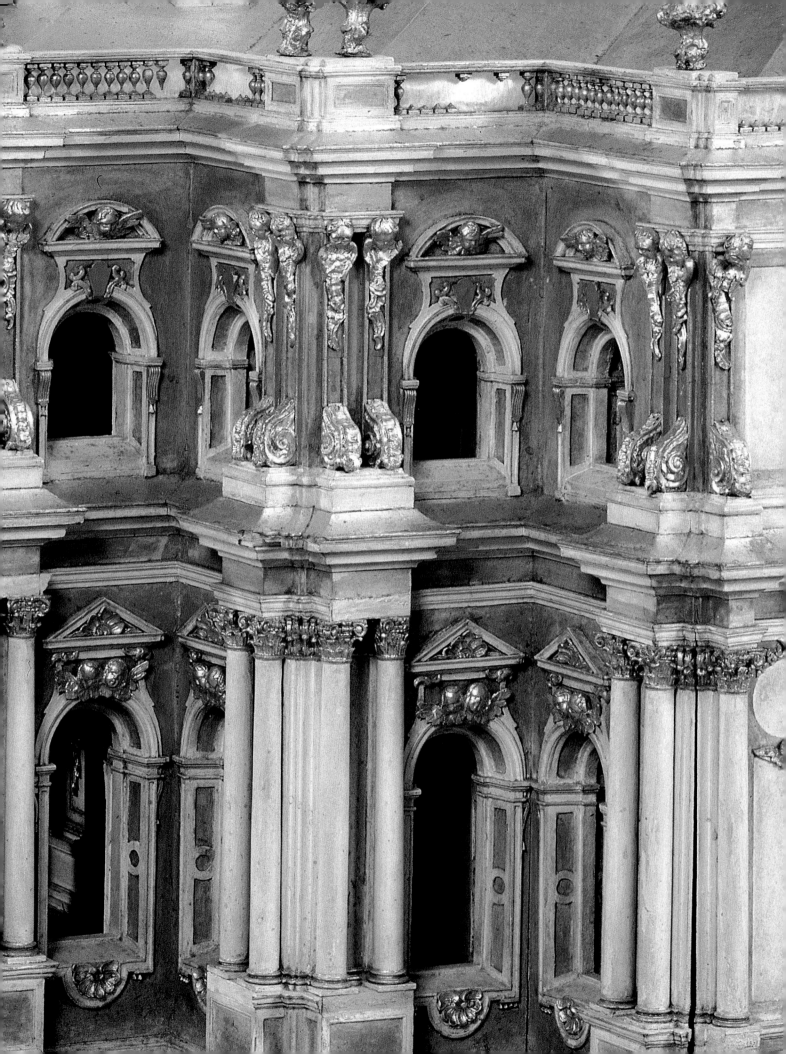

The Architectural Models from the Russian Fine Arts Academy

"We met to discuss the subject of the models which we would use to carry out the architectural works. The Company, after a great deal of reflection regarding the difficulty or even the impossibility of putting into the drawings everything that would be necessary for the execution of a great work, decided that in order achieve the most perfect of architectural works, it would be indispensable to have models, as well as drawings."

Official report of the Royal Academy of Architecture, vol. III
Official report, Monday, January 27, 1710

The Academy of Fine Arts Museum was created in 1758 with the remarkable collection of European paintings and drawings put together by Ivan Shuvalov, founder of the museum and its first curator. It soon became the first collection in Russia, opening its doors from the 18th century on to all classes of society. During the Age of Enlightenment and the reign of Catherine II, the Imperial Fine Arts Academy, an institution to train artists, was attentively encouraged by the Crown. The young Empress, accompanied by her suite as well as by the most important dignitaries of the State, and by generals and foreign ambassadors, would often attend examinations and visit the exhibitions. It was considered a great privilege to be elected to the rank of noted art lovers and members of honor of the Academy, and the personalities who had been judged worthy of such honors donated paintings, drawings and engravings to the Academy, enriching its collection. Famous foreign artists, inventors, princes and kings who had received this academic honor did not fail after their election to send their portraits to be hung in the Council Room. The sovereign herself who accorded a special status to this unique institution of higher artistic training more than once donated works to the museum from the Hermitage and from the Oranienbaum palace.

By the end of the 18th century, the museum had one of the most important art collections in the country, but its first vocation was to shape the taste of future painters, engravers, sculptors and architects, using examples of the masterpieces by their great predecessors. The Academy gradually began to assemble a collection of the works of its professors and its best students, these in addition to the paintings by Annibale Carracci, Guerchin, Guido Reni, Luca Giordano, Andrea Celesti, those of the "minor Dutch masters" of the 17th century, and the drawings by J.-B. Greuze and J.C. Natoire, as well as A.R. Mengs. These works remained in the classrooms, to be used as models to copy for the next generations of young artists. In addition, the foreign professors, painters such as Le Lorrain, J.L. Lagrenée, J.-L. Mosnier, S. Torelli, the sculptor N.F. Gillet, the architects J.-B. Vallin de La Mothe, J. Thomas de Thomon, O. Montferrand, had brought with them indispensable drawings and engravings for their courses which also ultimately entered into the Academy collections.

The works were hung not only in the museum rooms but also in the amphitheaters where the classes were held, and in the residents' dormitories (between 1764 and 1840, when the Academy possessed its own school, the artists lived on the third floor of the main building), or even in the hallways, as was the case, for example, of the works by the German painter, I.F. Grooth, who taught a class on "animals and birds." In fact, in 1765, Catherine II ordered that 54 paintings by this artist which had been in "Mon Bijou" pavilion in Tsarskoye Selo be given to the Academy "for the edification of the students."

And so, from the very first years of its existence, the Academy (fig. 1) gathered within its walls a collection which was a reflection of all of the steps of the Russian art school's development. The core was made up of the best work—studies, sketches, copies, projects to obtain the title of artist, academician and professor—of all the painters, sculptors and architects who were ultimately instrumental in the development of the national art and were its brightest stars: A.P. Lossenko, G.I. Ugriumov, F.A. Brouni, K.P. and A.P. Brioullov, I.E. Repin, F.I. Shubin, F.F. Shchedrin, M.I. Kozlovsky, I.P. Martos, V.I. Bajenov, I.E. Starov and many others. The exhibitions put on by the Academy to present its activities served to make known to the public not only the work of the students but also the works of their pro-

1
Thomas Malton
*View of Vassiliesky Island quay near
the Fine Arts Academy,* 1789

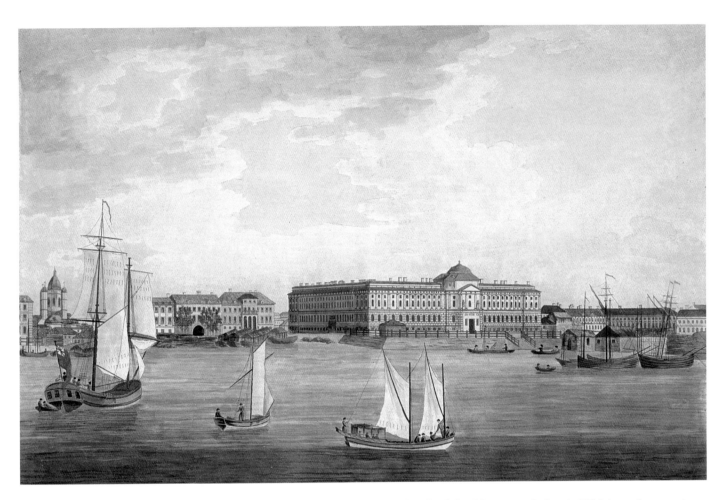

fessors and that of the artists who were competing for awards. These exhibitions which drew a large public also attracted a great deal of interest: they were seen by writers and poets, such as K.N. Batiuchkov, A.S. Pushkin, N.V. Gogol, F.M. Dostoevsky.

The Academy of Fine Arts was under the special protection of the Imperial House, to such an extent that beginning with its founder Elisabeth, all the representatives of the dynasty made a point of enriching the precious collections by the addition of paintings, sculptures, engravings, books, tapestries and architectural models. Thus was it that Paul I ordered all the models from the Hermitage to be sent to the Academy, in particular thirty experimental

models which had been made by A. Kiki, based on antique edifices, as well as a whole series of paintings coming from St. Michael's Castle and the suburban residences. Nicolas I decreed that the nomination of the Academy presidents be made exclusively from among members of the imperial family, and at his behest, the museum's collection was significantly enriched with several precious private collections bought by public funds and which were, on his order, deposited in the Academy gallery, as were copies made in Italy by Russian resident artists from originals by Renaissance painters.

Beginning in the middle of the 19th century, the range of exhibition subjects shown by the Academy was con-

siderably extended. Alongside traditional annual shows illustrating the Academy's activities, in 1851 a huge "Artistic Exhibition of exceptional works belonging to private individuals" was organized by the Academy's president Maximilien de Lichtenberg. For the first time, the most important private collections in the capital were shown. Ten years later, the Great Duchess Maria Nikolaevna, who had succeeded her husband as president, presented an exhibition of exceptional art works from the imperial palaces. Both of these exhibitions were charity functions. Masterpieces from the Academy collection enhanced the presentation of the show, "Historic Exhibition of architecture and the arts." In this exhibition a number of models were shown, among them that of the Smolny Monastery, St. Isaac's Cathedral based on a project by Rinaldi, and St. Michael's Castle, based on a project by V. Brenna.

Beginning in the second half of the 19th century, the Fine Arts Academy began to take an active part in the major universal and international exhibitions, showing not only the work of contemporary artists, mosaicists, who were often the recipients of awards and medals, but also works belonging to the museum collections. The participation of the study and research museum of the Russian Academy of Fine Arts in the exhibition "Imperial St. Petersburg" organized by the Grimaldi Forum is in a direct line of its remarkable traditions and will enable art lovers in Monaco to better understand Russia's history and culture through the masterpieces belonging to the collection of one of its oldest museums.

V.I. Bogdan

The collection of architectural models from the Academy of Fine Arts was created at the same time as the founding of the Academy. Wooden models of buildings constructed in St. Petersburg in the 18th century make up the essential of the collection. The exhibition presents three of the most famous examples.

Novodevichy Monastery of the Resurrection (Smolny) (fig. 2)

The name Smolny comes from the "Tar Court" which was built on the Neva banks facing Okhta, when the Capital of the North was first being constructed. It was a part of several buildings which were annexes to the Admiralty shipyards. There the tar needed for the St. Petersburg flotilla was stored. Not far from there, Peter I had the country residence of Smolny built in 1720 as a summer residence for his daughter, the Grand Duchess Elisabeth Petrovna. It was there that Elisabeth, after having become Empress, decided to build a monastery where she would end her days in serenity and peace. A hundred and twenty young women of good families were to live there with the future Mother Superior. She ordered that monastery to be built which would be of unprecedented beauty and magnificence and would stand as a monument to the prosperity of the monarchy. Francesco Bartolomeo Rastrelli, architect-in-chief of the Imperial Court, was given the commission to build the monastery. Rastrelli was born in France, son of a Spanish mother and an Italian father, the famous sculptor B.C. Rastrelli. The elder Rastrelli had left Paris for St. Petersburg in 1716 at the request of Peter I, and his son had accompanied him. The younger Rastrelli was involved in organizing Elisabeth's coronation ceremonies and that of the fireworks displayed for the celebration to honor her name-day and her birthday. In just ten years of work, he transformed the face of the city.

F.B. Rastrelli was one of the most remarkable architects in Russia, an eminent representative of High Baroque, more precisely known as Elizabethan Baroque.

2
Benjamin Patersen
*View on Smolny monastery from
Okhta*, around 1800

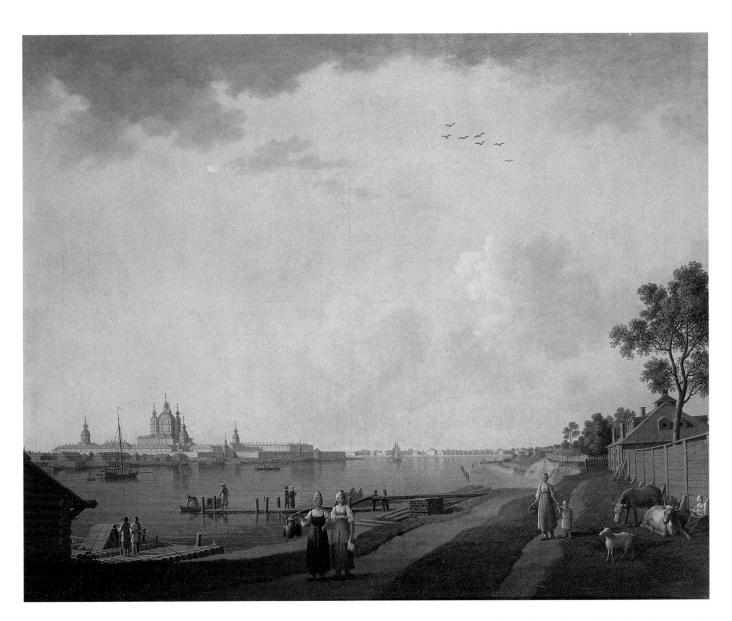

In 1748, the Novodevichy Monastery of the Resurrection of Christ was solemnly inaugurated. During Elisabeth Petrovna's lifetime, only the cells and the collegiate church of the monastery were built from the architect's project, and those without any interior fixtures.

Rastrelli had designed the Smolny monastery in the tradition of monastic buildings of ancient Russia with a five-domed church predominating and a several-storied steeple (which was only built in the model), forming a main gate on the west side of the monastery lands. The two major Russian cities, Moscow and St. Petersburg, were already rivals in the 18th century for the appellation of capital city. Elisabeth ordered the architect to build a steeple inspired by Ivan Veliki's Kremlin steeple in Moscow, but which would be two times higher and would be the symbol of St. Petersburg's greatness and superiority. At a height of 140

meters, it would have been one and a half times bigger than the collegiate church and would have exceeded by eighteen meters Peter and Paul Cathedral. But this grandiose steeple was never built. Only the granite foundations were laid. Construction was halted because of the war against Prussia and Elisabeth's death, and remained interrupted for seventy years. It was only in the years 1832–1835 that the classical architect V.P. Stasov finished the construction of the monastery. However he refused to build the richly decorated central Baroque dome, and gave a much more severe look to the interior decoration, contrary to Rastrelli's project.

St. Michael's Castle

Three models of other facades of St. Michael's Castle have also been conserved at the Academy of Fine Arts Museum: the model of half of the main façade (the southern façade), the model of half of the northern façade (toward the Summer Garden) and that of half of the façade and of the oval room.

St. Michael's Castle, one of the most beautiful but also one of the most enigmatic of the palaces in the Capital of the North, was built to be Paul I's residence. The architecture of the castle is the realization of Paul I's philosophical conceptions and mystical presentiments. The artistic impressions that the Great Duke Paul Petrovitch brought back with him from his travels to Europe in 1781-1782 were to find both direct and indirect expression in the buildings which made up St. Michael's Castle. The Chantilly castle in France, its garden and its park as well as the Caprarola castle near Rome had left a deep impression on the future emperor. Henri-François-Gabriel Viollier (1750–1829), Swiss miniature painter, decorator and architect was a member of the Czarevich's suite and it was to him that the Czar entrusted the realization of his architectural project. The Swiss master worked for two years on the plans of the future "St. Michael's Castle." In his auto-biography, Viollier writes that the first sketches were drawn by the hand of the future emperor himself in 1784.

We know today the names of only two of the architects who worked on this project: Vincenzo Brenna and V.A. Bajenov. But documents are missing to indicate just what role they had in the project—we do not know at which step of the work these architects were called on for the project nor the degree of their independence or creativity regarding it. Vincenzo Brenna who was named in 1797 to direct the construction of St. Michael's Castle, established the final architectural plans for Paul I's residence. He carried out with great talent an incredibly complicated task: to bring together the various artistic and stylistic compositional ideas used in the different plans by his predecessors.

The building which was square according to the plan, had a vast octagonal courtyard. Each façade has its own originality. The central façade—the southeast façade—had ionic columns and two inserted obelisks (fig. 3). The northern façade, facing toward the Summer Garden, was enhanced by a huge terrace-balcony which was supported by a colonnade of pale pink marble. The two stairways of the west façade, decorated with vases, led to the entrance of the church (fig. 4). The east façade which gave onto the Fontanka, had a semi-circular overhang including a dome and a turret. The frieze had an inscription in bronze lettering: May the divine spirit be upon your house until the end of its days." And just as the inscription, which had been written in Old Slavic, had exactly forty-seven letters, so the owner of the castle, Paul I, lived just to the age of forty-seven. In November of 1798, he received

3
Giacomo Quarenghi
St. Michael's Castle. View from the
southeastern side, 1801

4
Anonymous, based on the project
by V. Brenna
Model of half of the west façade and
of the church of St. Michael's Castle,
end of 1790

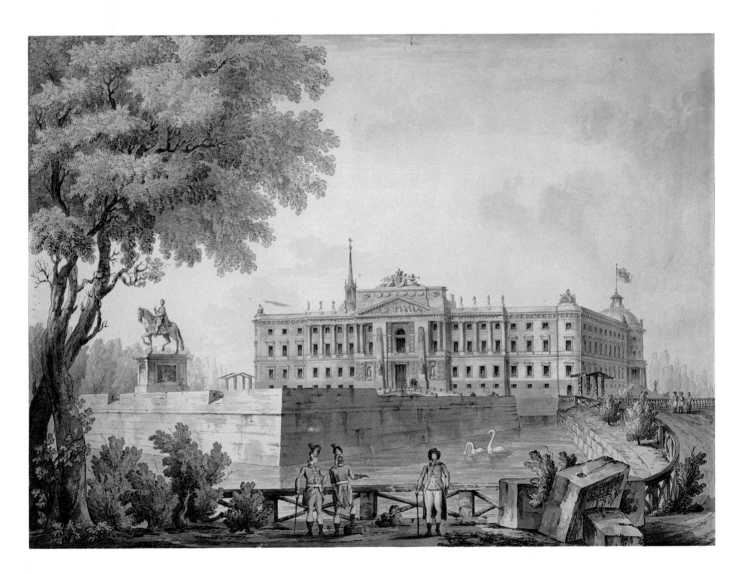

the title of Grand Master of the Order of St. John of Jerusalem (Malta). The imperial residence now by definition incarnated an example of a knight's castle. In the middle of the official reception apartments, one could see a Malta throne room. The Marble Gallery was transformed into a Knights of Malta gallery and the characteristic potent cross became an element in the exterior and interior arrangement of the building. It is supposed that the original plan of St. Michael's Castle, which has a square with an octagonal interior courtyard, was based on a sacred for-

mula. The octagon as a symbol of the "eighth day" of the creation, that is, the day of the resurrection of Christ, is reminiscent of celestial Jerusalem which according to "the revelation of John the Theologian" had the shape of a square. It is likely that in calling the doors of the castle the "Doors of the Resurrection", and calling the room situated above, the "Room of the Resurrection", and in choosing a courtyard in the shape of an octagonal, Paul I was embodying in the castle his faith in a future immortality, that of his own but also that of the Russian empire's and that of the

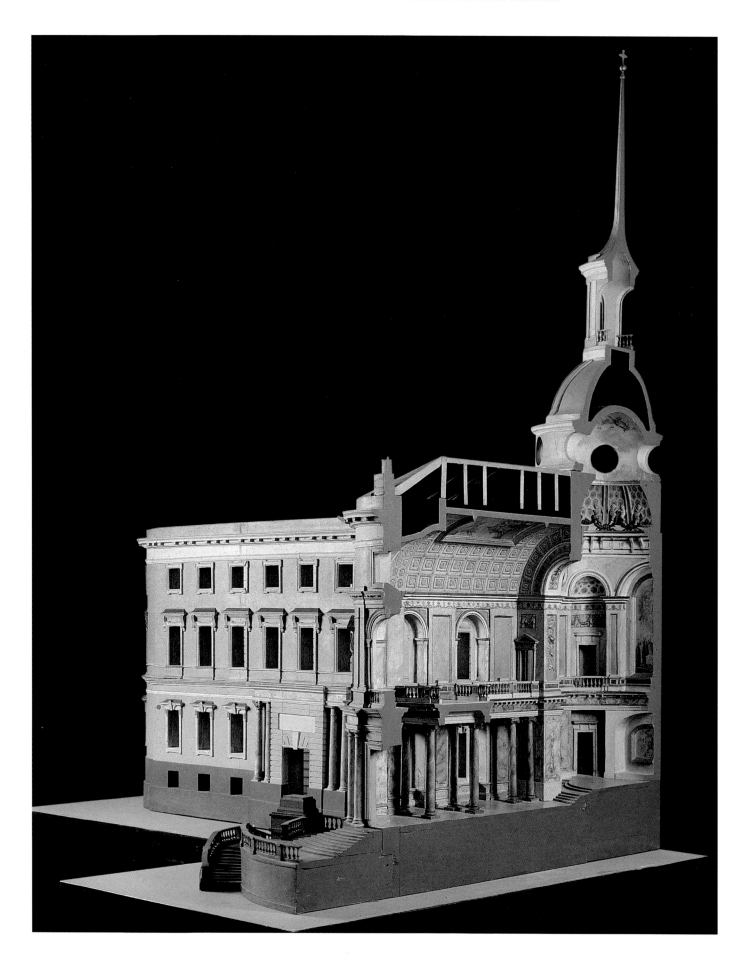

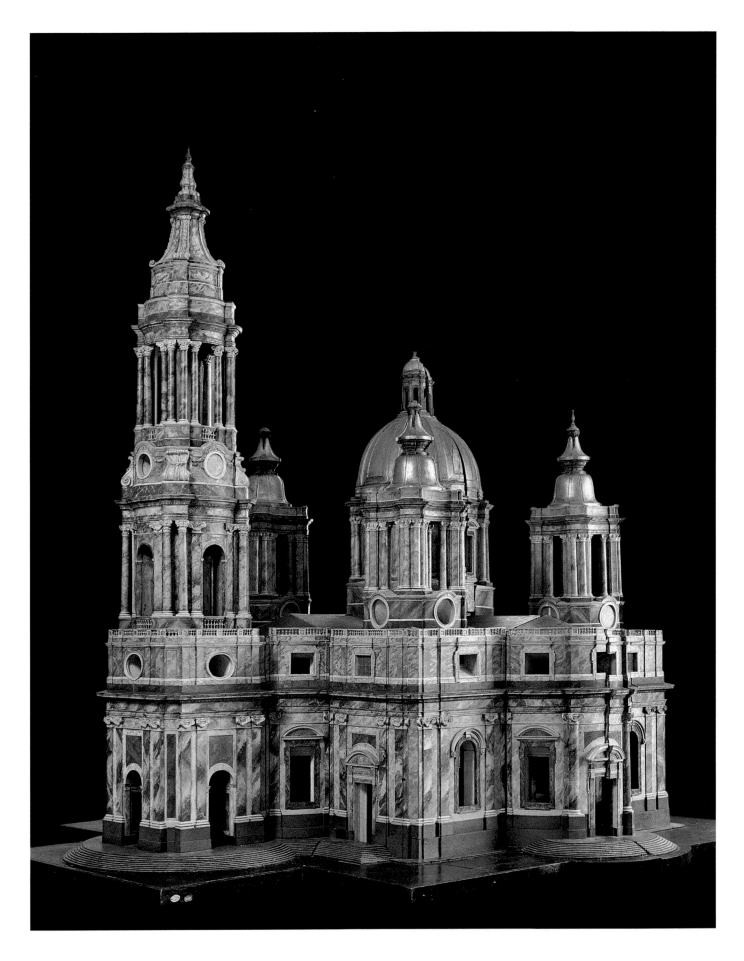

5
Group of artists directed by A. Vist
based on a project by A. Rinaldi
Model of St. Isaac "The Dalmatian's"
Cathedral, 1766–1769

whole Christian world. St. Michael's Castle remains a completely unique building in the history of Russian architecture where decorative elements of the most diverse styles exist side by side: Renaissance, Baroque, Classicism. Neither completely classical, neither completely empire nor romantic, it has nonetheless characteristic traits of all of these styles and can be seen within the context of Classical architecture.

St. Isaac "the Dalmatian's" Cathedral

Peter I was born on Isaac the Dalmatian's festival day. Isaac was a little-known Byzantine monk in Russia who at one time had been made a saint. In 1717, Peter ordered a wooden church to be built in St. Petersburg in honor of his patron saint. It was located not far from the Admiralty and was built on a single level with only a small steeple devoid of any architectural decoration. Its simplicity was characteristic of the first Petersburg constructions of the Petrovian period. Although it was a modest construction, it was one of the important St. Petersburg churches. Peter I and Catherine married in this small church. In 1717, Peter laid the first stone himself for the new Isaac the Dalmatian's church to be built in the center of St. Petersburg on the banks of the Neva. The architect G.I. Mattarnovy was named head of the project. In 1735, the church was seriously damaged by lightening. In 1762, Catherine II came to the throne. She approved the idea of creating a church dedicated to Isaac which would be linked to the name of Peter I. The job of constructing the third church of Isaac was given to the architect A. Rinaldi (fig. 5), who had arrived from Italy to Russia in the year 1750. It was decided to build the church on a new location, far from the Neva. To cover it, Olonetz marble was to be used whose vivid colors, dazzling and rich according to eye-witness contem-

porary accounts, were characteristic of the Great Catherine's "golden century." But construction was delayed and by 1796, at the death of the Empress, only half of the church had been built.

At his ascension, Paul I commissioned the architect V. Brenna to finish the construction but he ordered that the marble which had been destined for St. Isaac's church be used instead for the construction of St. Michael's Castle. In the place of marble, the church was to be built in brick. In order to follow the wishes of the Czar, the architect was forced to modify Rinaldi's project: he had to diminish the dimensions of the upper part of the building and the main dome, and to abandon the idea of smaller domes. The result was a massive and ridiculous-looking church from an artistic point of view: extremely ugly brick walls rising from a luxurious marble base. In spite of the negative and ironic opinions by contemporaries, St. Isaac's Cathedral, in reality the third St. Isaac's church, was inaugurated in 1802.

E. Savinova

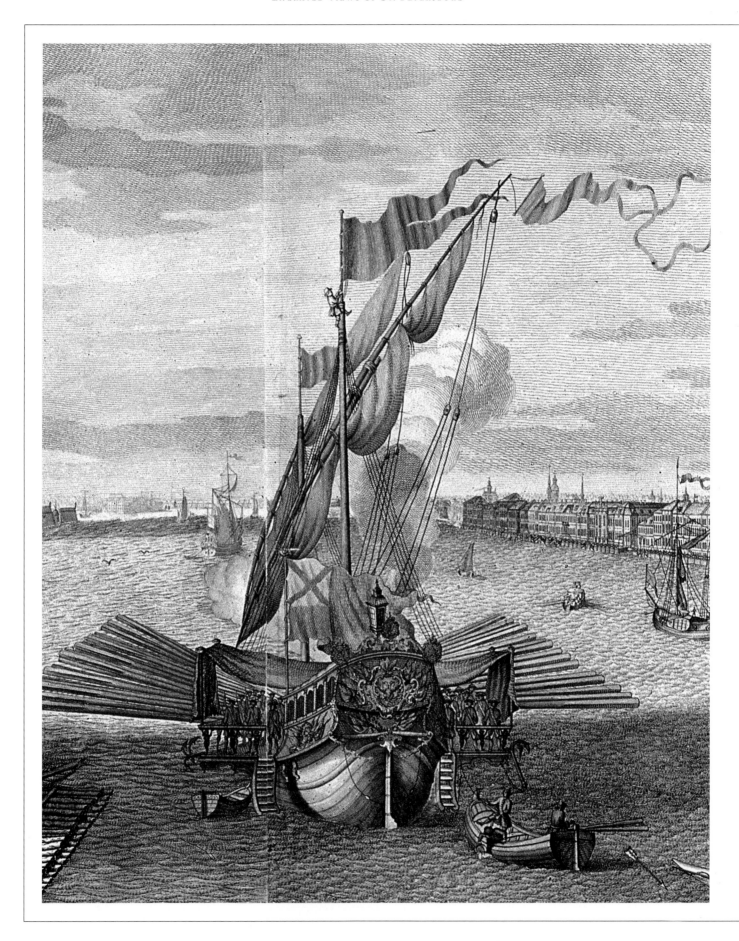

Engraved views of St. Petersburg based on Mikhaïl Ivanovitch Makhaïev's drawings

St. Petersburg, the new Russian capital founded at the very beginning of the 18th century at the mouth of the Neva, is only known to us as it was in the first decades of its existence by a very few images. Among these images is one series which is certainly the most exceptional by its consistency and the quality of its execution. It is a series of engravings for the large Jubilee album called "Plan of the capital St. Petersburg with the representation of its most famous avenues, published by the St. Petersburg Imperial Academy of Science and Art which was created for the city's 50th anniversary in 1753. The album includes a large map of the city as well as twelve plates including four double ones, which show the isolated monuments and the panoramas.

All the urban cityscapes which are included were drawn from life by the admirable master drawer and engraver, Mikhaïl Ivanovitch Makhaïev (1718–1770) using a precision instrument known as the "camera obscura." The use of these precision instruments to carry out the work enables us not only to see an artistic production of remarkable expressive quality in these engravings but also provides us with a precise account of the major architectural and urban achievements in St. Petersburg during the brilliant period of the 18th century. Makhaïev was not content simply to choose the most eloquent point of view to make his drawings but also participated in the engraving of the plates. He himself drew the main contours of the image onto the copper plate which was afterwards done with burin by the masters of the Academy of Science engraving workshops whose names appear on the plates as engravers.

The album immediately became very well-known and was very popular. The first bound copies of the engravings came out in May 1753 and were put up for sale at the Academy of Science.

At the same time, copies of the albums were sent to Paris, London, Vienna, Berlin, Stockholm, Warsaw, Copenhagen and other major European cities, to the royal libraries and as gifts for the ambassadors. Engraved and painted copies, based on the landscapes in this series, proliferated, done not only by Russian artists but also by French and English ones. It is known that Makhaïev's views of St. Petersburg were at the origin of L. de Lespinasse's engravings for the work by N. Leclercq on the history of Russia, published in the years 1780. Evidence of the immense popularity of these productions also comes from the fact that utilitarian objects of applied Russian art of the period, such as furniture or snuff-boxes in porcelain were frequently decorated with views of St. Petersburg inspired by the engravings based on Mikhaïl Ivanovitch Makhaïev's drawings.

A.A.

a
Grigori Anikievich Katchalov
View of the banks of the Neva in going down the river between Her Majesty's Winter Palace and the Academy of Science buildings, 1716/1729–1770

b
Efime Grigorievitch Vinogradov
View seen from the banks of the Neva in going up the river toward the Admiralty and the Academy of Science, 1716/1729–1770

Page 160
Detail

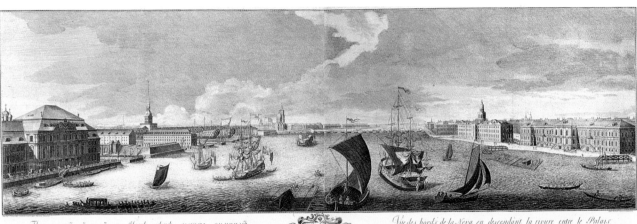

Проспектъ внизъ по Невѣ рѣкѣ между зимнимъ Ея Императорскаго Величества домомъ и Академіею Наукъ.

Vue des bords de la Neva en descendant la riviere entre le Palais d'hiver de Sa Majesté Imperiale & les batimens de l'Academie des Sciences.

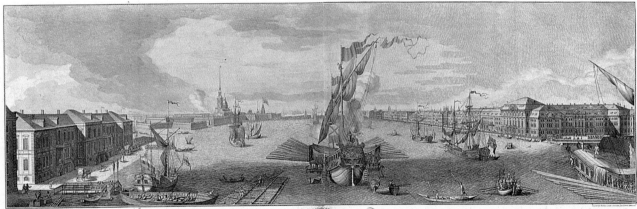

Проспектъ вверхъ по Невѣ рѣкѣ отъ Адмиралтейства и Академіи Наукъ на востокъ.

Vue des bords de la Neva en remontant la riviere entre l'Amiraute et les batimens de l'Academie des Sciences.

c

Yakov Vassiliev
*View of the Neva toward the West
between St. Isaac's Cathedral
and the Cadet Corps buildings,*
18th century

d

Ivan Eliakov
*View of the Neva toward the East
between the Galleys Shipyards and
the 13th line of Vasiliesky Island,*
1716/29–1770

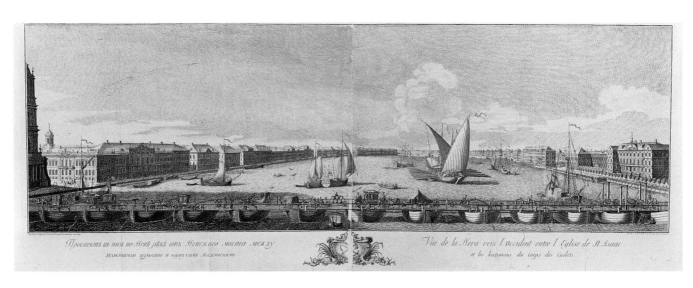

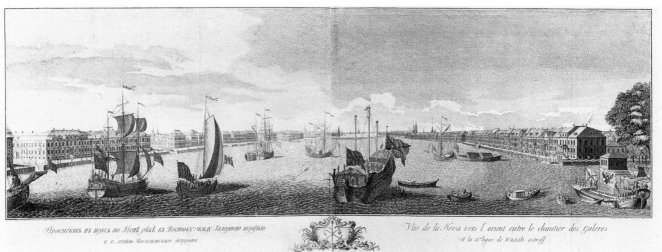

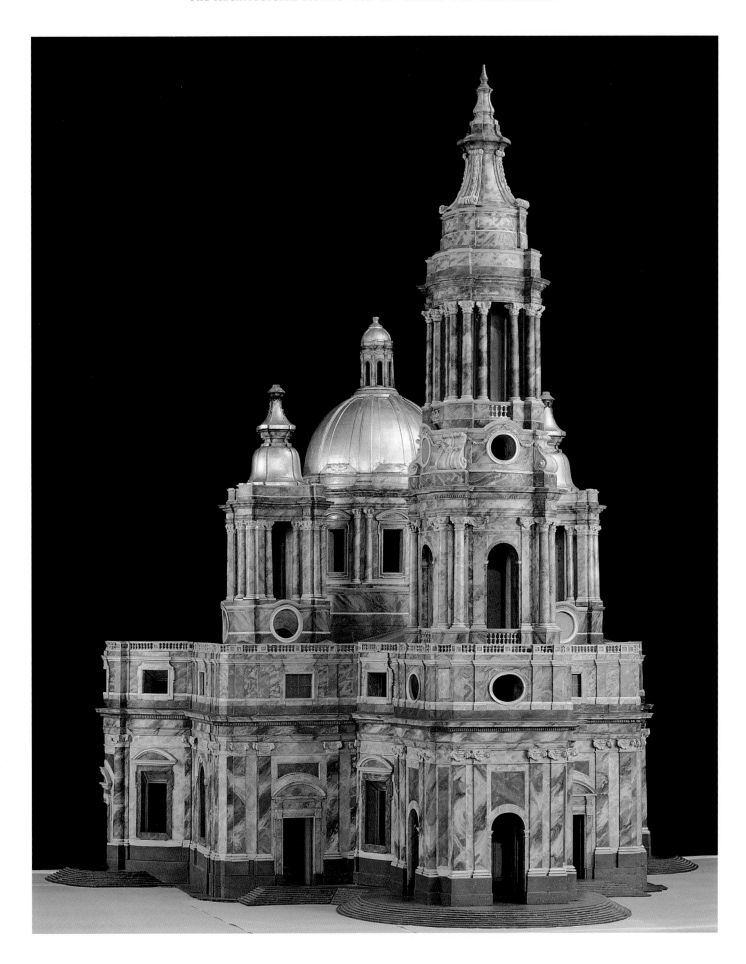

I
Group of artists directed
by A. Vist based on a project
by A. Rinaldi
Model of St. Isaac "The Dalmatian's"
Cathedral, 1766–1769

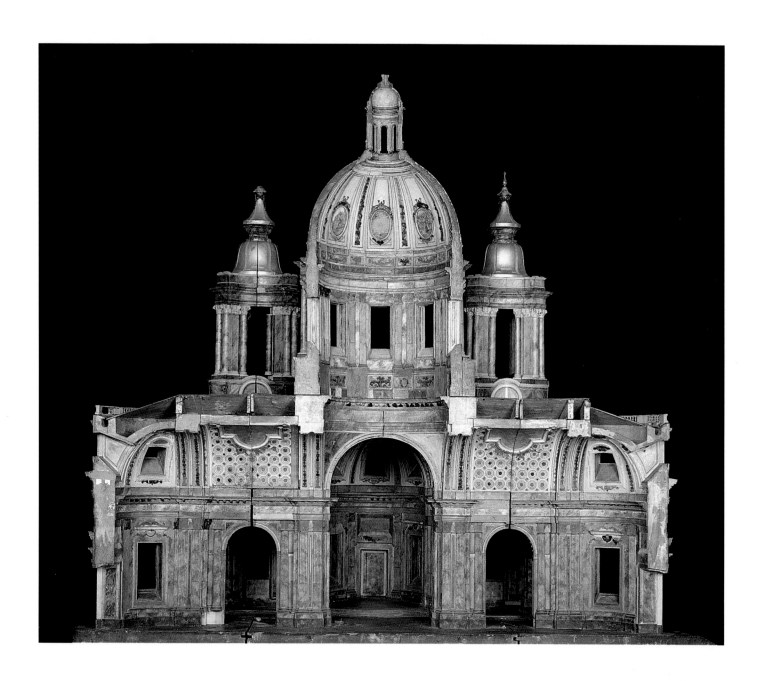

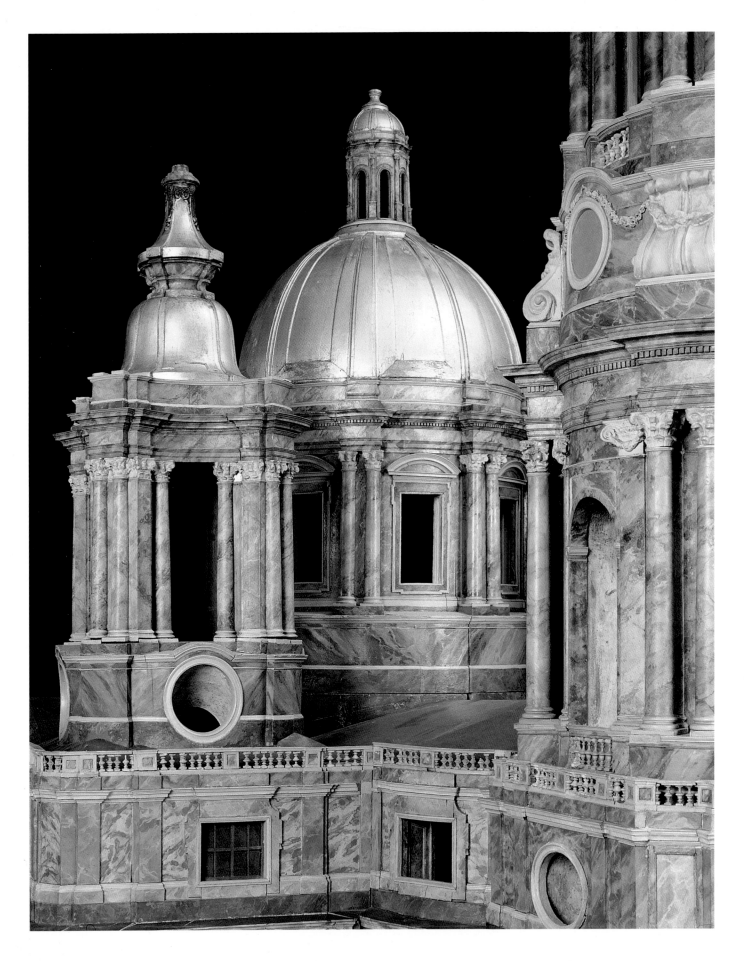

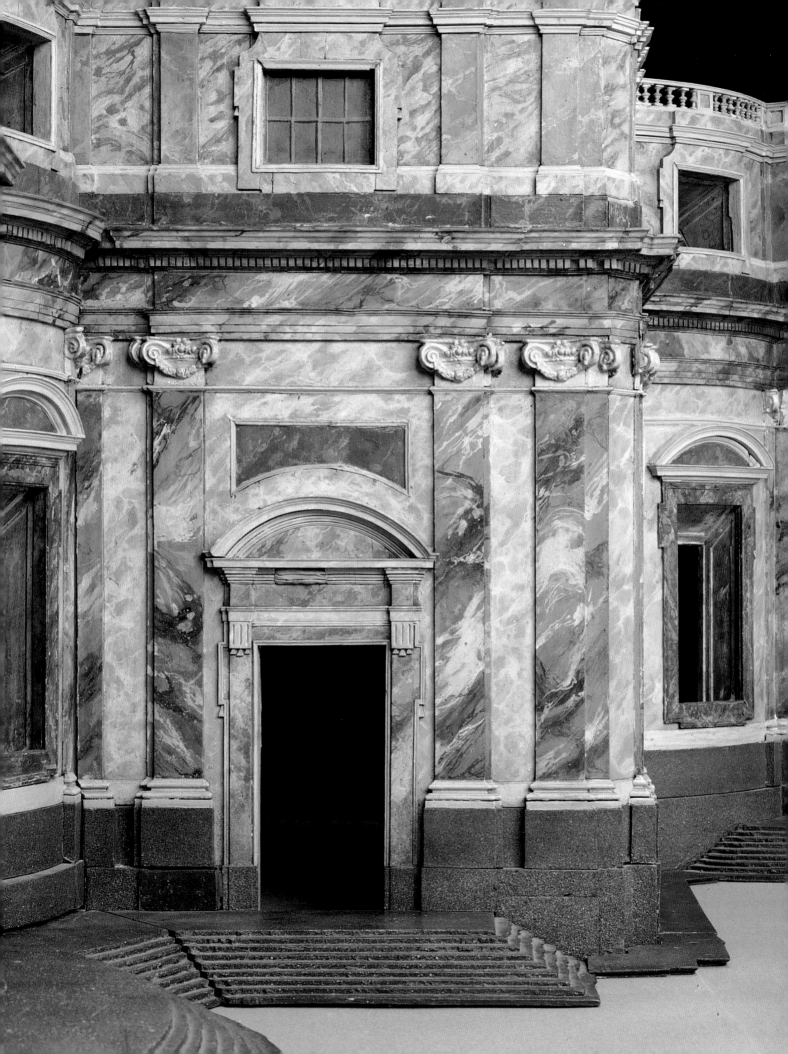

II
Group of artists under
the direction of Y. Lorents
*Model of the Smolny Monastery
based on a project by F.B. Rastrelli,*
1750–1756

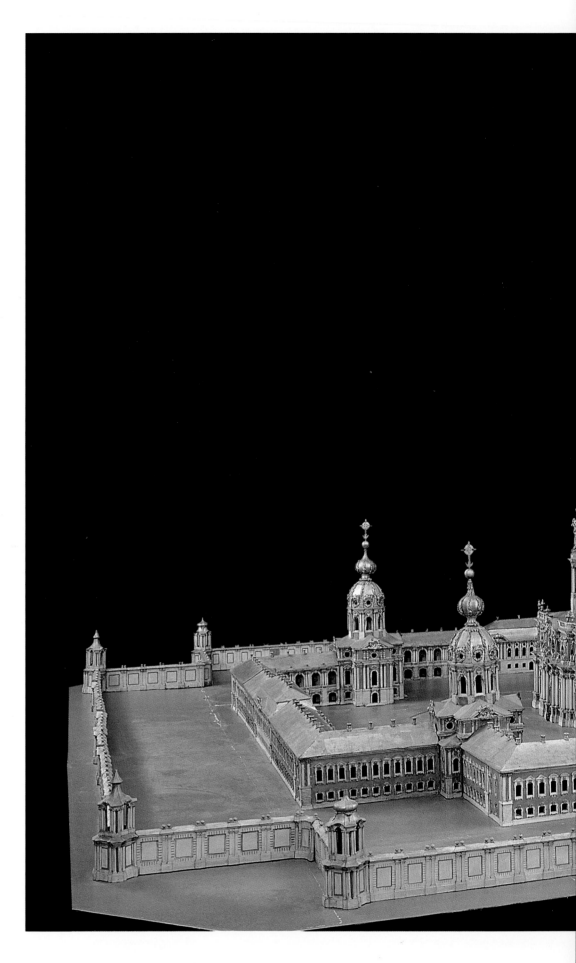

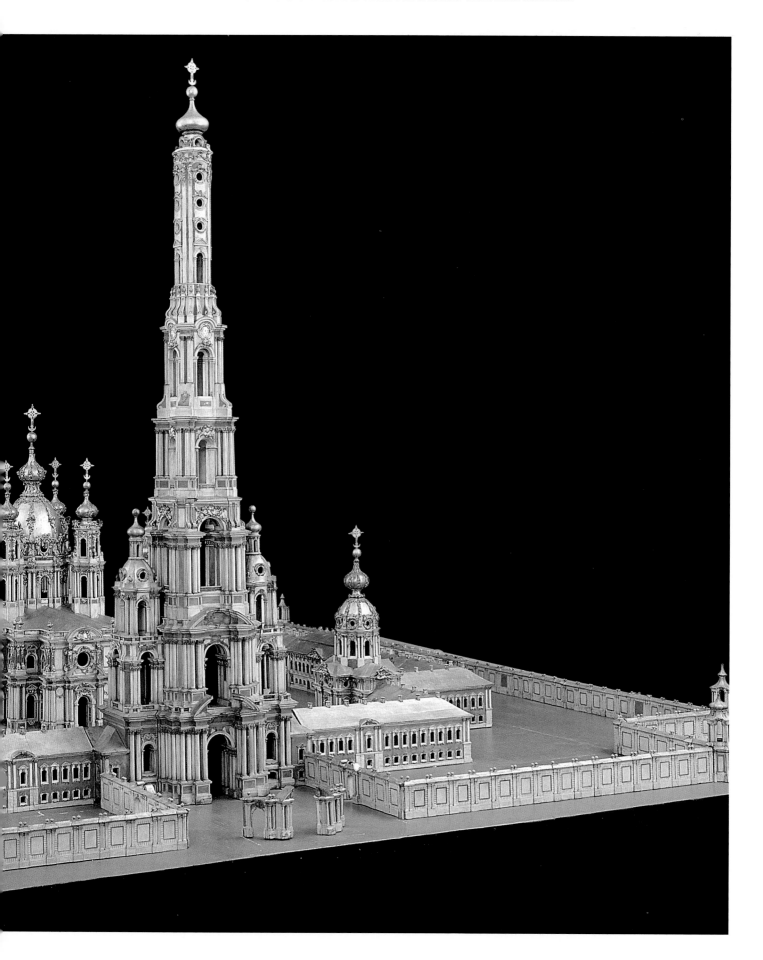

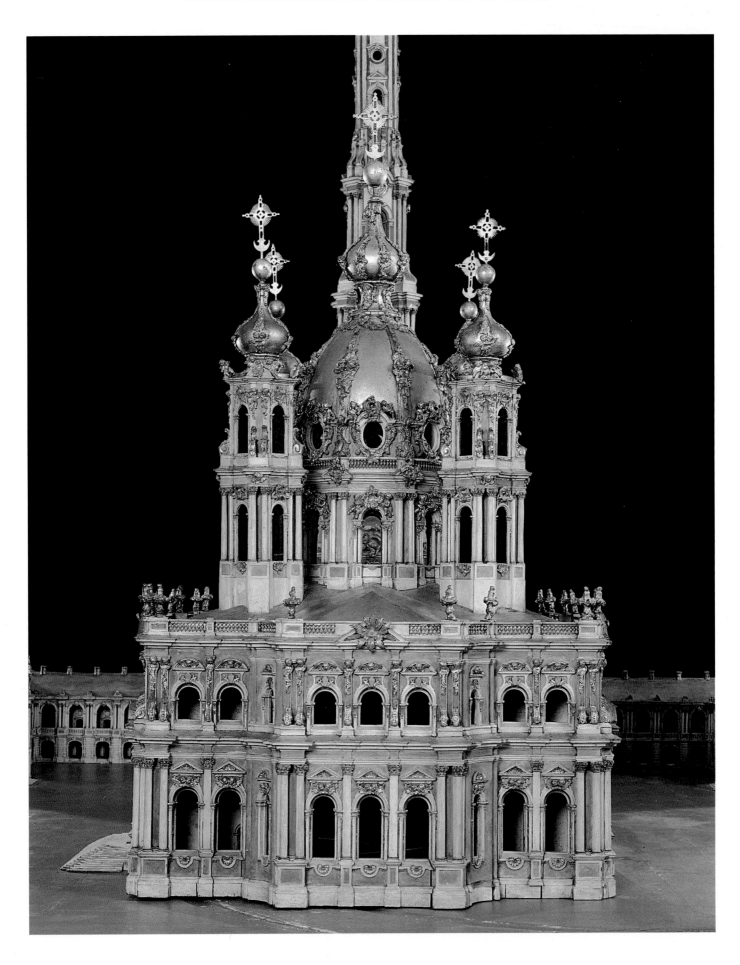

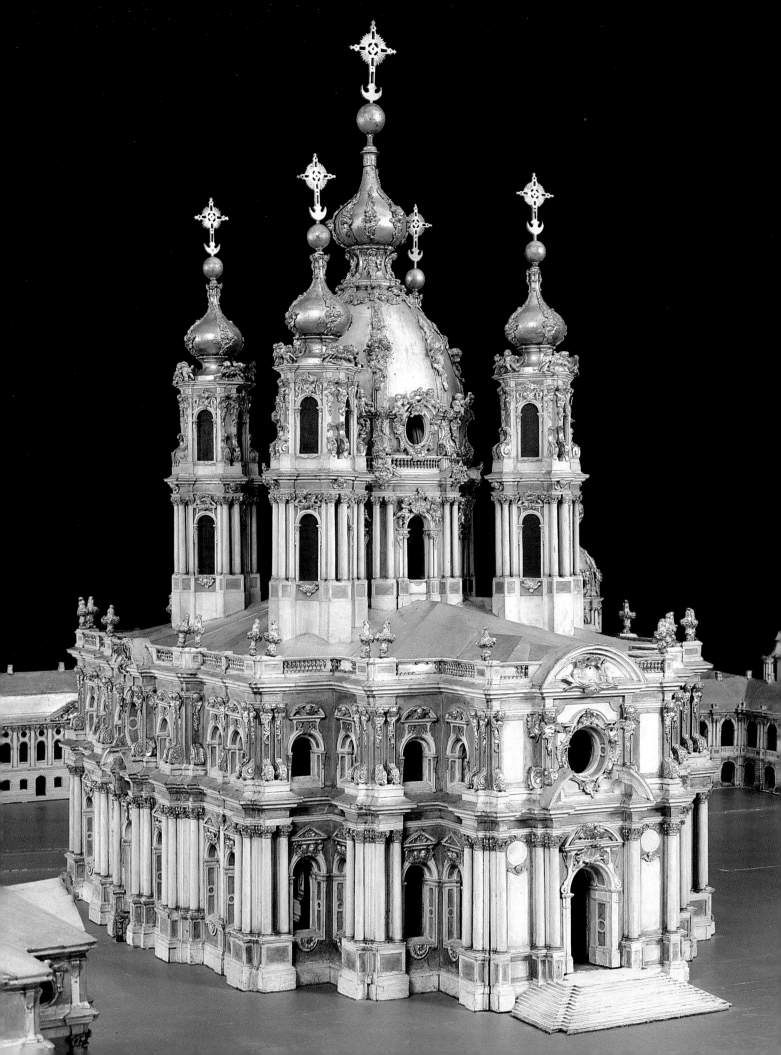

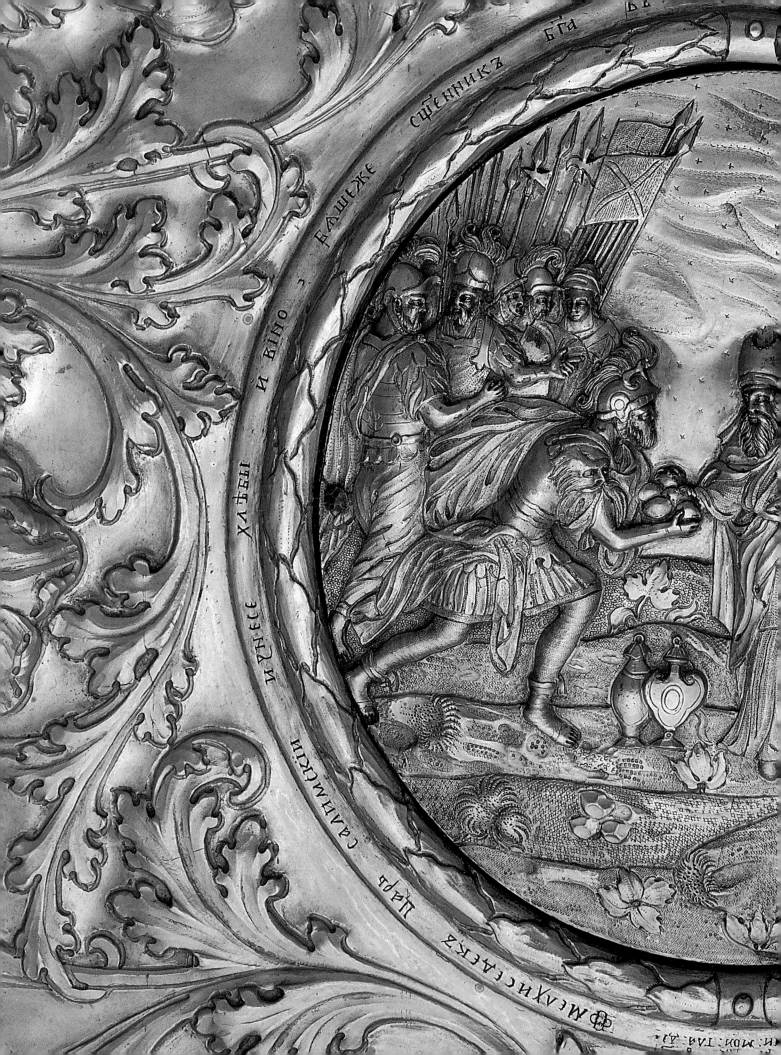

Russian gold- and silver-work
in the 18ᵗʰ century

"The women's jewelry and diamonds glittered with a magical brilliance in the midst of all those treasures from Asia hung on the walls of the sanctuary, where the royal magnificence seemed to challenge the majesty of God that it was honoring, without forgetting itself. All of that is beautiful."

Marquis de Custine
La Russie en 1839, Lettre onzième, Paris 1843

With the founding of St. Petersburg and the transfer of the Russian state capital to the banks of the Neva, the new city became the seat of the gold- and silver-smithing activity. Some of the master craftsmen from the State Armory, a major center of muscovite Russia's gold and silver work, were transferred from Moscow to St. Petersburg. An imperial edict regrouped the workers, as had been done elsewhere, into two workshops, one Russian, the other foreign. The Emperor himself ordered very little, preferring to use the public funds for the Great Northern War and for building a "paradise", but his entourage didn't hesitate to spend great sums for the purchase of table services in gold and silver or for costly jewelry and finery.

The magnificent and noisy festivities of that era were radically different from the carefully regulated solemnity which accompanied the Czar's public appearances, and the ceremonies of Ancient Russia which Peter the Great detested so greatly.

For a long time, Russia did not have its own resources of precious metals. This is why the Emperor Peter I issued an edict on August 24, 1700 setting up a Mines Establishment whose mission was to organize the work of "searching for mines of gold, silver and other metals." It was due to the activity of this department that the first factory for transforming silver minerals was opened in Trans-Baïkalia near Nertchinsk in 1704. It became so successful that beginning with Peter the Grand's reign, those who worked this metal in Russia, used only Russian silver.

Gold, however, continued for a long time to be imported, whether as ingots or as money coming from the Western European countries and Turkey. It was only in 1745 that the first local Russian gold field was discovered in the Urals, not far from Ekaterinenburg. The importa-

tion of this precious metal was thus almost completely ceased.

The new ways and manners which the Czar had imposed on Russia led to a considerable diversification in the choice of objects which at first were shipped from abroad, but which rapidly began to be part of Russian artists' current production.

Thus it was that during Peter's era, the use of tobacco became widespread, although it had been absolutely forbidden in muscovite Russia. It was smoked, taken as snuff, chewed. Smoking tobacco was considered as an excellent means of fighting headaches, and women as well as men willingly used it. In order to conserve it, the craftsmen who worked the gold and silver created special little boxes, snuffboxes. Those produced in the Petrovian era have a simple shape and are rather modestly decorated. At the beginning of the 18th century precious stones were being used only for jewelry—brooches, necklaces, earrings, buttons. As a signal mark of royal favor, some had breast medallions and rings with the portrait of the emperor on them, in a diamond setting. The ancient Russian tradition of decorating table articles, drinking cups, the *kovsch* (a ladle-like drinking cup) or goblets had become a thing of the past.

Peter I introduced new drinks into the domestic customs of the Russians, imported from across the seas: tea, coffee, chocolate. Very expensive sugar loaf was substituted for the traditional honey. New pieces for table settings appeared on the tables of notable citizens or those of high rank which were borrowed from European customs such as teapots, coffee pots, sugar bowls. The craftsmen in Russia who worked silver, quickly learned how to make by themselves these types of dishes and decorations which were new to them, skillfully interspersing the luxurious compositions of exotic flowers and fruits which charac-

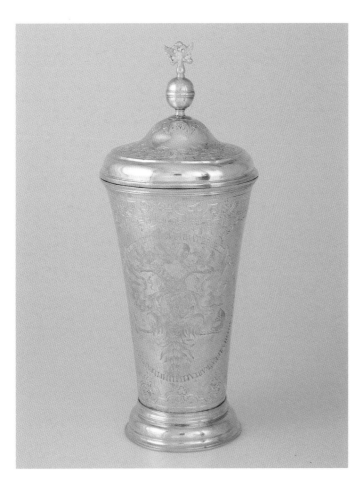

1
Master Ivan Mikhaïlov
Goblet with lid,
Moscow, 1734

(fig. III) which was created in the 1720s by an anonymous St. Petersburg craftsman and which was offered to the emperor Peter I. Its rim is covered with superb carved foliated patterns and gilded with fantastic flowers which seem to surge from the small oval base shown in the lower part of the object. This plate was probably offered to Peter I by the Senate to commemorate the attribution of his title of emperor in 1721. On the flat part there is a Biblical scene, "The encounter of Abraham and Melchisedech." The subject was an important symbolic one for Russia by its allusion to the construction of St. Petersburg, the new capital, for the city was to be the spiritual, cultural, commercial and military center, as had been Jerusalem in Biblical times. According to the Bible story, Abraham had met Melchisedech in the desert not far from where Jerusalem would ultimately be founded. The association of a form of ancient dish with a very innovative decoration for the times, the natural color of silver brought out by the brilliance of the gilding, all this created a remarkable decorative effect.

Among the most prestigious silver tableware, the various wine cups have been held in special reverence since the first quarter of the 18ᵗʰ century. While summoning up traditional European forms, the Russian master silversmiths elaborated remarkable and very original creations. They made the cups in the shape of exotic fruits, pineapple, bunches of grapes, while the lids would be decorated with sheaves of wheat (fig. I), figures in the round, and with stems resembling tree trunks on the side of which would be the figure of a wood-cutter. In the Middle Ages, the gold- and silversmiths in Western Europe created vases in shapes of various animals.

terized European decorations of the era with traditional Russian decorations known as "grassy", in other words, in foliated patterns. It was the same for the liturgical objects where new methods of ornamentation began to be used: complicated foliated patterns and fantastic flowers in which one could recognize the contours of tulips, carnations, peonies which were so beloved of the European Baroque craftsmen.

And yet, during all of the 18ᵗʰ century, the Moscow and St. Petersburg silversmiths held on to the memory of the traditional forms of Russian dishes (fig. 1): trays, the *kovsch*, bratinas (fig. II), drinking vases, hanaps. One of the most representative of the specimens of silver art of the era is the plate

At the beginning and in the middle of the 18ᵗʰ century, the Russian silversmiths followed the example, cre-

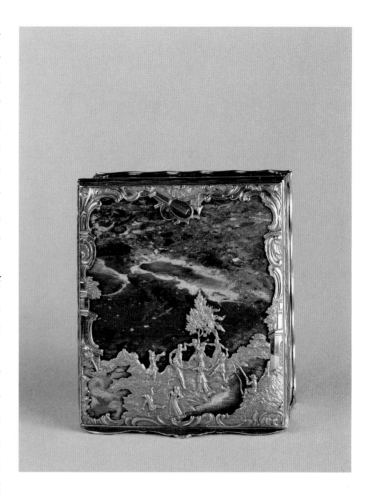

2
Beauty-mark box with embossing decoration,
St. Petersburg, middle
of 18th century

ating silver drinking vessels with animal shapes. But contrary to the practice in Europe, they did not make fantastic heraldic creations, but perfectly realistic images of small amusing animals: roosters singing, owls with their huge round astonished eyes, bears holding in their paws a small cask of honey. Outside of St. Petersburg, which had become for the whole Russian empire the absolute reference in the field of gold- and silver-work, craftsmen were actively working in other traditional centers, Moscow, Veliki, Oustioug, Yaroslavl, Novgorod. Their work was for a long time dependent on Russian traditional forms and decorations.

During Peter's era, the ancient Russian tradition of only putting bread and salt onto the table during official receptions was still being followed. The dishes and wine were served the guests by servants.

But as European customs spread, the Russian nobility borrowed Western types of table services with a lot of dishes and precious table decorations. Gradually it became the fashion to decorate ceremonial tables for official receptions, to have table centers, coolers for the wine, superb dishes and sauce boats as well as recipients of all sorts. Beginning at the end of the 1720s, first in Western Europe and then in Russia, table services and toilette articles in silver and gold began to appear, all of which were created in the same style of forms and ornamental motifs.

In the 1730s the shapes and the decoration of gold and silver objects became more complex. The Empress Anna Ivanovna brought to St. Petersburg many European gold- and silversmiths, mostly Germans. Their influence on the Russian art of gold- and silver-work was immense. Among the characteristic elements of the decoration of precious objects could now be found complex carved ornaments forming cartouches. These heavy protruding decorations with their polished background formed a kind of frame for the image. The creations of the period were often enhanced by diamonds which underlined the details of the carved relief. The use of precious colored stones was a great deal rarer.

The Empress Anna Ivanovna was very strict about Court etiquette and the rules of how it should function. It was under her reign that the Winter Palace's collection of silver was acquired. She had all the pieces in the collection verified and stamped and ordered new items. It was the foreign silversmiths who received the most lucrative orders. The first table services and toilet sets made at the order of the Imperial Court appeared in the archives of the Court intendance beginning in the years 1730. At first, the orders were placed abroad, at Augsburg, Paris, London, Amsterdam.

3
Alexander Nevski's Tomb,
1747–1752
The State Hermitage Museum,
St. Petersburg

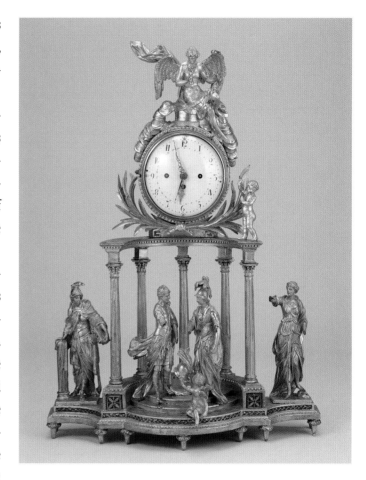

4
Mantle-piece clock,
Russia, 18th century

The work of the Russian master-craftsmen at that time was solely to complete the services received by isolated pieces, plates, place settings, salt holders, made after already existing models.

At the time of the Empress Elisabeth Petrovna, Peter the Great's daughter, St. Petersburg's official receptions and balls had made a big impression on Europeans, dazzled by their luxury and their scale: the abundance of exotic food, the myriad of sparkling lamps, the profusion of precious stones worn by the members of the Court and the brilliance of the solid silver on the huge tables.

In the middle of the 18th century, colored stones began to be regularly used. These precious or semi-precious colored stones were more and more frequently used to decorate the snuff-boxes, beauty boxes, hair pins, bouquets. Many of these objects were entirely created out of large stones. Often, the natural aspect of the colored surface and the application of a delicate decoration in carved gold were combined so that this surface became the natural background canvas for genre scenes or decorative motifs. The two beauty-mark boxes belonging to Elisabeth's collection which are shown in the exhibition were certainly gifts which were bestowed for the Easter ceremonies. The beauty-mark box in red jasper (fig. 2) is decorated with a scene showing the "Semik" festival which takes place before that of the Trinity. Noisy groups of marchers parade through birch woods toward a stretch of water. The Petersburg artist whose name has not come down to us has represented the round of young girls and the beribboned birch woods with marvelous virtuosity. He has used the natural colors of the stone to skillfully and beautifully express the evening sky and the peaceful waters of the small lake.

In 1746–1753 on the order of the Empress, a unique monument in the history of Russian art was created: a tomb in silver (fig. 3) for the celestial protector of St. Petersburg, the prince Saint Alexander Nevsky. The tomb which weighed almost 89 pounds (about 1500 kilograms) had been made with the first shipment of silver produced by the Kolyvan factories in Siberia. Elisabeth II had ordered that it be placed in the Alexander Nevsky Lavra in memory of her father. The emperor Peter I had founded this monastery for men in 1710 at the very place where, according to oral tradition, the prince Alexander Nevsky had conquered the Swedes in 1240. The tomb was made with a sarcophagus provided with a lid, a big five-level pyramid, a double pedestal with trophies and two candelabras. Three reliefs told the story of the feats accomplished by the

prince's warriors: the Battle on the Ice on Lake Chudsky against the Teutonic knights in 1242, the Russian troops entering Pskov after this battle, the battle of the Neva against the Swedish in 1240. On the sides were subjects linked to his death: the arrival of the prince, coming from the Golden Hoard encampment to the Bogoroditsky monastery, and the scene of his death. On the back panel of the sarcophagus there was an epitaph written by M.V. Lomonossov. Behind the sarcophagus rose a five-level ornamental pyramid decorated with images in relief of Alexander Nevsky and figures of angels in the round. The combination of smooth carefully polished surfaces with the parts in the round and the reliefs created an astonishing decorative effect.

The reign of the Empress Catherine II truly merits its appellation as the "golden century" of Russian gold- and silver-work. The tastes of the sponsors had undergone a radical change. The Rocaille style fantasies of Elisabeth's era were replaced by the more sober and austere forms of Classicism. The decoration, hearkening back to antique models, was more laconic: laurel crowns, pearl bands, ovoli (or "thumbs").

Gradually, the smooth surfaces framed by precious stones and enamels took on an important place in the decoration of the finely-worked pieces. Big diamonds, very popular at the beginning and middle of the century and which were accompanied by smaller stones, gradually began to be outdated. Colored stones were used with moderation, but pearls became very popular in the 1790s. The precious stones were especially used to underline the form of objects or to mark the center of them. It is probably due to Catherine's edict in the last quarter of the 18th century that the Court began to exercise restraint in the use of precious stones. This edict was intended to simplify Court toilette, "with the aim of bringing about more simplicity and moderation in order to safeguard one's own belongings for better and more useful purposes and to flee extravagant luxury."

In the second half of the 18th century, there were important changes which also affected the work of the master silversmiths. The abundant massiveness of the Baroque silver of Elisabeth's time progressively gave way to serene and austere forms which harmoniously married simplicity and elegance. Ornamental vases, water carafes, table silver took on forms which clearly were inspired by geometry and which often resembled rectangles, circles, ovals, spheres, cylinders. Important changes were also taking place in decoration. The elegant foliated patterns characteristic of the Baroque and the Rococo disappeared, to be replaced by a symmetric ornamentation which highlighted garlands, bows, pearl belts (fig. VI). For the large pieces, preference was given to smooth surfaces, polished to the shine of a mirror. A place of choice was given in the décor to the images of classical Antiquity: motifs borrowed from architecture (fig. 4), figures of gods and antique heroes draped in stylized clothing.

It was naturally the artists in the capital city who were the first to react to this change in fashion. In the second half of the 18th century, St. Petersburg became the center of the art of silver in Russia. The Petrovian tradition of the specialized workshops continued to exist. Among the master craftsmen in the foreign silversmith workshops were Germans, French, Italians, English, Swedes, Finns, Poles. St. Petersburg which had thus become the crucible for aesthetic points of view and technical modalities relevant to the diverse artistic schools of Western Europe, began to develop a silver-work style that was all its own. The greatest influence in creating this Petersburg style was that

5
Anonymous
Chalice with medallions in enamel,
St. Petersburg, 1795–1799

6
Chalice,
Moscow, 1796

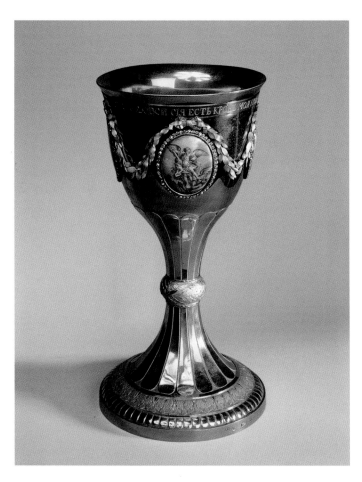

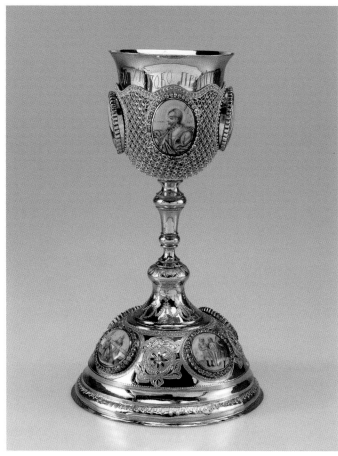

of the French masters. Outside of table silver, quantities of albums of engravings with illustrations of objects were shipped from France to the Russian capital. The St. Petersburg craftsmen often used them as models to develop their own pieces, carving and embossing, polishing and applying details in relief.

In the St. Petersburg churches and cathedrals, the sacred vases (figs. 5, 6), the icons and the Bibles (fig. V), the oil lamps, all of them generally in gold and in gilded silver, were often enhanced by precious stones and pearls. As with the churches, a quantity of objects in precious metal were ordered for the mansions which the aristocracy and the rich merchants built for themselves, in particular one-

of-a-kind table services weighing several pounds, toilette kits and solid gold or silver candelabras. Yet it was still the Imperial Court which ordered the greatest number of pieces made in gold and in silver. Master-craftsmen in France, England and Germany worked in response to its demand for great luxury services. The St. Petersburg artists also frequently received orders from what was known as the Court Office, where expenses for the needs of the palace were controlled and allocated. During Catherine's reign, the palace silver reserves were enriched by an enormous quantity of silver dishes. The Court Office ordered and paid for the making of more than forty silver services.

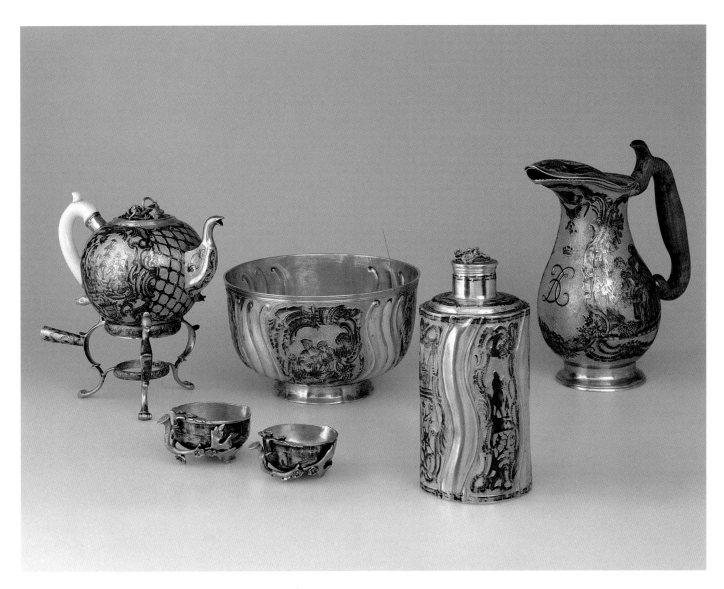

Contrary to those in the capital, the gold- and silversmiths in Moscow and in the provinces were brilliantly skilled in the rare and very complex technique of engraving on nielloed silver. Niello decoration is one of the oldest Russian traditions which goes back to the furthest Antiquity. Artists focused their attention on the subject represented whether it was an antique motif or a subject linked to Russia's recent military victories. On the cups, the salt shakers, the vases, the goblets, the trays, allegoric subjects or scenes of antique ruins would be next to gracious Rococo foliated patterns or picturesque garlands of leaves and flowers. The niello engraving and the ornament were freely applied to the objects, the elegant somber contours surged out from the large gilded background spaces, often covered with a motif of chips or fine hatchings.

One of the masterpieces of niello work art is a tray of great originality which has a map of the Black Sea on it (fig. IV). It was done by an anonymous muscovite artist in

1774 and was offered in July 1775 to the Great Duke Paul Petrovitch and the Great Duchess Natalia Alexeevna in honor of the victory in the Russian-Turkish War of 1768–1774. The whole surface is covered by an admirable nielloed engraving with a detailed map of the lands annexed to Russia during the war. The natural color of the silver indicates the possessions of the Russian crown, particularly the Crimea peninsula. The gilded silver indicates the Turkish territories. And so as to perpetuate the tradition of the old Russian way of working silver, the edge has a large dedicatory nielloed inscription which is an important element in the decoration of the tray.

The muscovite niello tradition influenced the work produced in many of the artistic centers in Northern Russia and in Siberia. Around 1770, the art of niello work had a brief flourishing in Tobolsk. The Tobolsk governor, D.I. Tchitcherin (fig. 7), was instrumental in developing silver work there. He himself ordered a large table service from the local craftsmen. Hunting scenes with landscapes, people, animals figured on the teapots, sugar bowls and goblets, all as always expressive of local color.

The enormous quantity of gold- and silversmith work and of gold and silver utensils collected for a century in the imperial residences showed Europeans the great wealth and splendor of the Imperial Court, enhancing the prestige of the Russian Empire and giving proof of its economic power.

L. Zavadskaïa

The Kovsch

It was during Peter I's reign that the traditional Russian *kovsch* ceased being used as a drinking cup. However the craftsmen continued nevertheless to accept orders for them, as they had become the most common form of royal rewards. The tradition of offering the *kovsch* had existed in Russia since ancient times. During all of the 18th century, nobles were awarded for their military achievements by membership in the orders which had appeared in Russia during the Petrovian era. But other government officials—atamans of the Cossack troops, customs officials—received the *kovsch* with dedications (figs. a, VII–X) which recounted in detail which achievements were being rewarded by the precious gift.

The inscription was usually placed on the upper rim, in decorated cartouches. The upper part of the *kovsch* was ornamented by a stylised crown with the emperor's monogram or his portrait. The lower part, the sloping edge, was most often completed by an image in the round of a two-headed eagle.

L.Z.

a
Kovsch,
Moscow, middle of 18th century

I
Beer tankard with lid, 1789

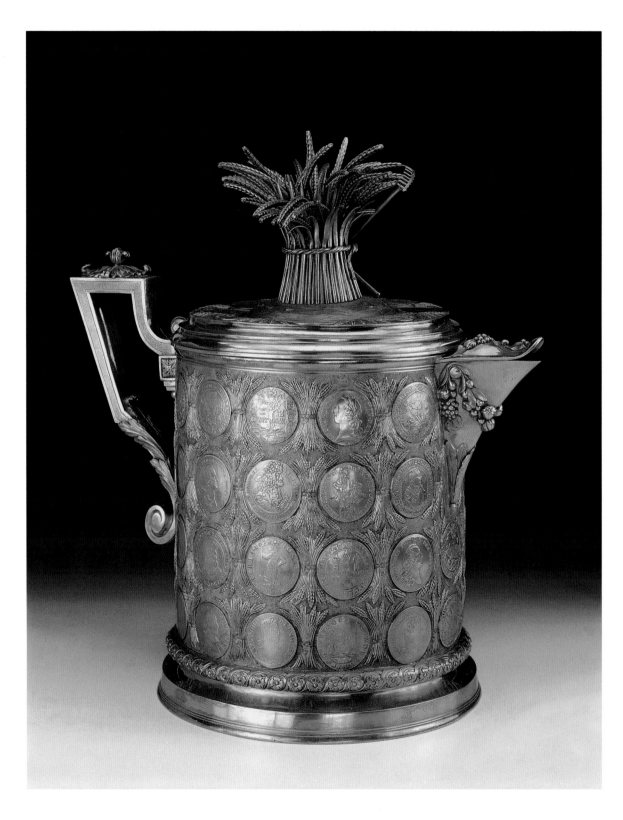

II
Bratina (friendship cup),
Moscow, 1660s

III
Tray,
St. Petersburg, 1720s

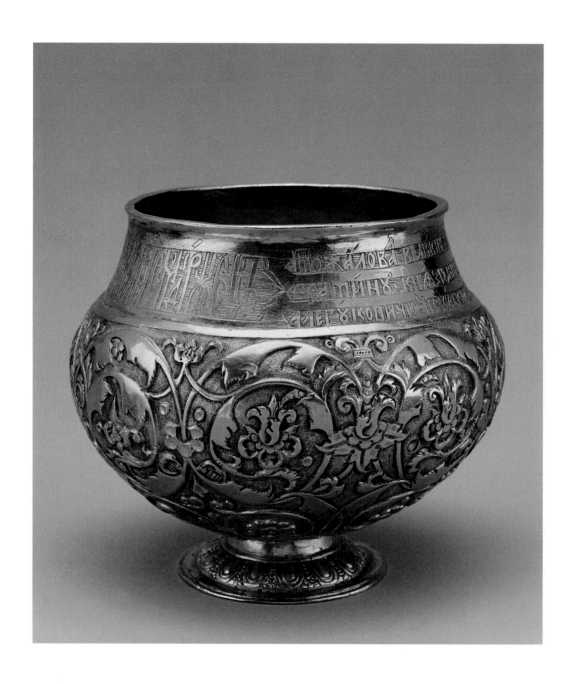

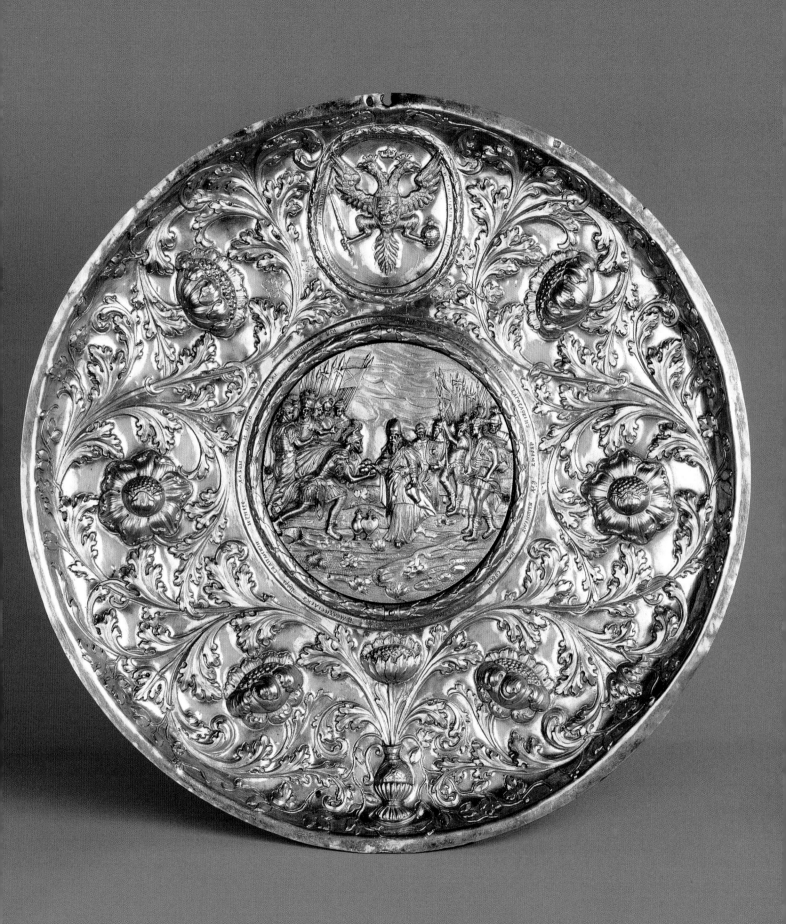

IV
Stamps of master's guarantee
Ivan Savelev
Tray,
Moscow, 1774

V
*Evangelistary with medallions
in enamel and niello,*
Moscow, 1789

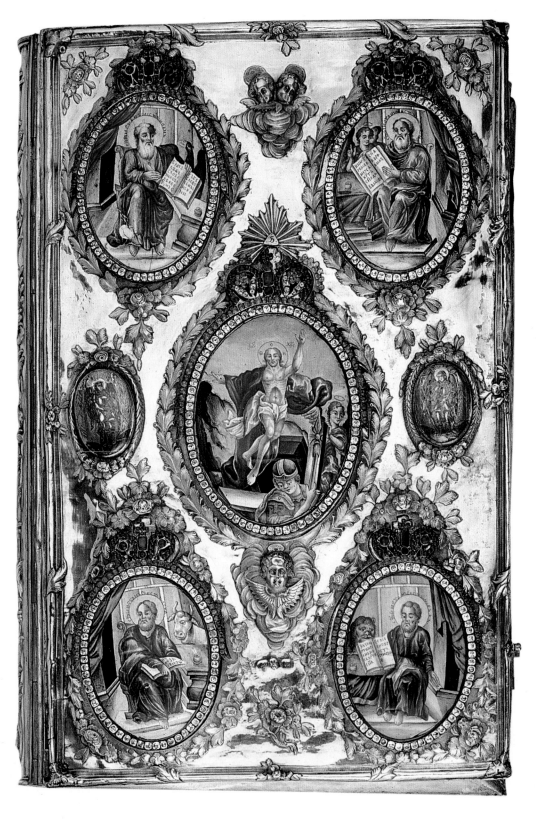

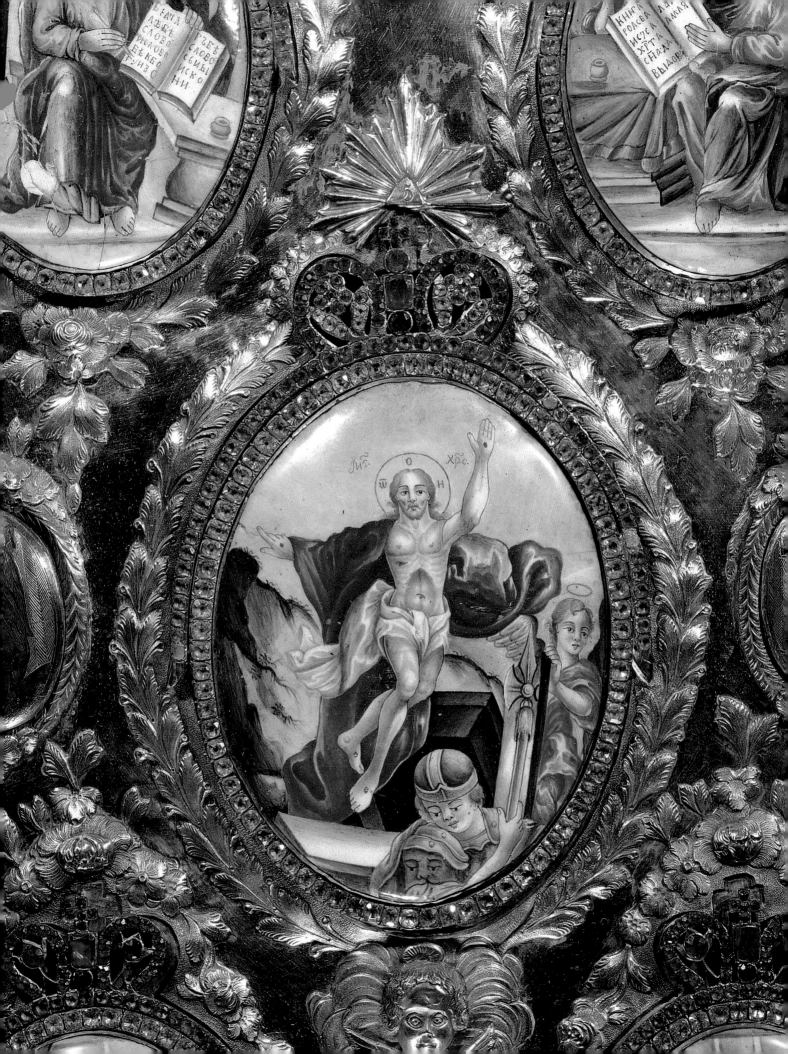

VI
Masters A. Guerasimov
and A. Polozov
Oval plate,
Moscow, 1762

VII
Kovsch,
Moscow, 1718

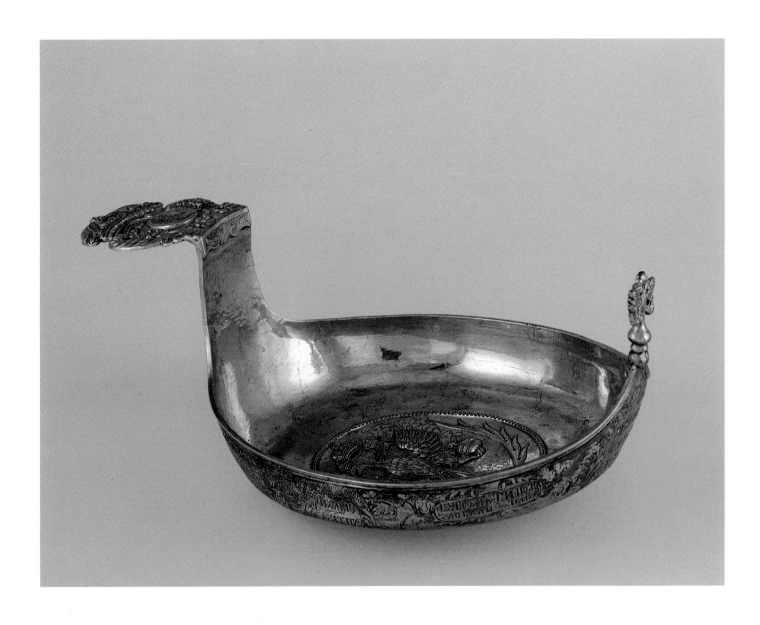

VIII
Master Ia. Maslennikov
Kovsch,
Moscow, 1761

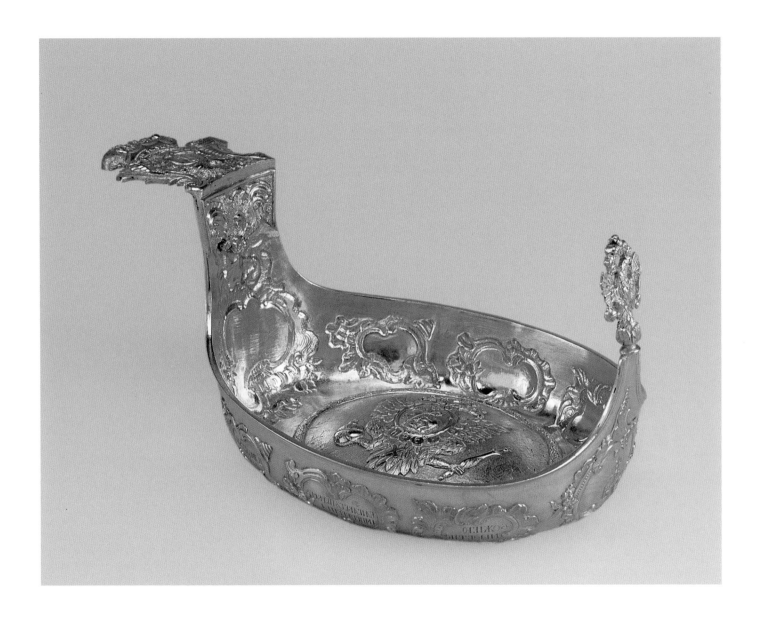

IX
Kovsch,
middle of 18th century

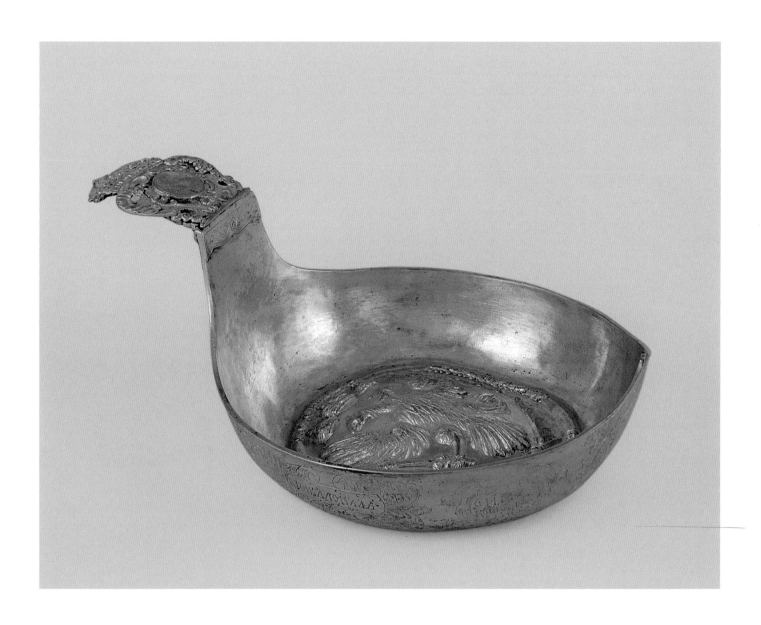

X
Kovsch,
MOSCOW, 1720S

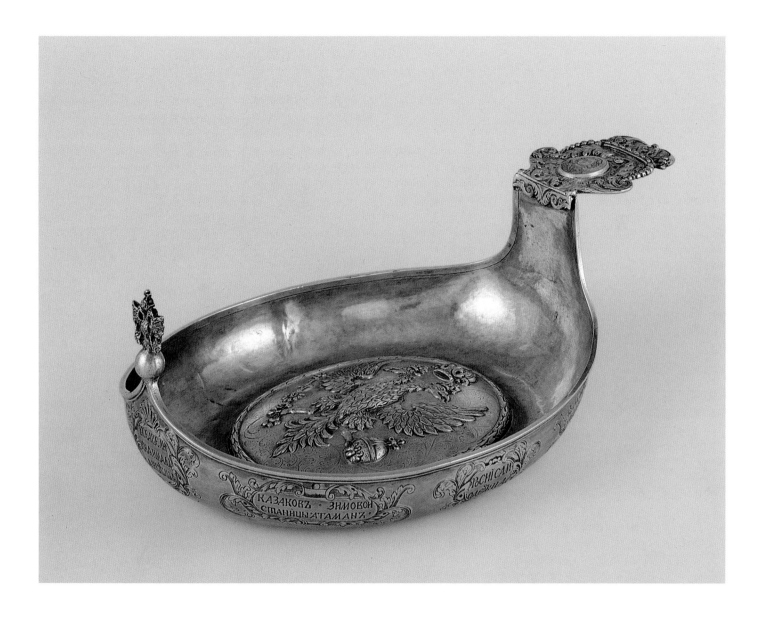

Catherine II and the European Decorative Arts

"As for M. David Roentgen's letter, as it's
a fantasy on your part, I am putting it aside
until I will be better informed about it.
The armoires with a hundred drawers
are for the fathoms of our engraved stones
which you are going to augment with those
belonging to the Duke of Orleans. (...)
As for M. David Roentgen and his two
hundred drawers, they have safely arrived
and are most appropriate for storing all
the gluttony."

Louis Réau
Catherine II to Grimm, June 30, 1787,
*Correspondance artistique de Catherine II avec
Frédéric-Melchior, baron de Grimm,*
Paris 1922, p. 175–176

In the 18th century, the image of Russia would be considerably modified: from that of an unknown country "peopled by barbarians" which was how Russia had been seen for so long through contemporary accounts, would be substituted, due in large part to Voltaire and Diderot, that of a European power progressing by seven league boots down the road of progress. Foreigners gave profuse accounts in their travel journals of the magnificence which reigned at the court of the Russian Semiramis. "The wealth and splendor of the Russian court surpasses all the pomp and ceremony which one could describe: vestiges of Asiatic sumptuousness united with European refinement..."[1] Such were William Coxe's comments in 1778. This Asiatic magnificent was underlined by all the foreign travelers. France's ambassador to Russia, the Count of Ségur noted that the Russian society "has nothing to envy those of the most brilliant European courts."[2]

In the second half of the 18th century, Russia quickly rose to the rank of a major European power, not only in the fields of politics and science but also of culture. Innumerable objects of Western make were imported into the Russian capital which integrated them into the furnishing of the imperial palaces and the residences belonging to the nobility.

While the painting collection acquisition adhered to a coherent policy, the Empress's orders and purchases of porcelain, furniture, tapestries, silver and jewelry were especially for her personal pleasure with the goal of providing her luxurious surroundings. The most famous arts craftsmen were called upon to decorate the residences with all that was most fashionable and expensive. Was all this a reflection of the Empress's own taste, her intuition? Was it due to her German origins or was she rather surrounded by well-chosen advisors who enabled her to acquire all

that was of particular interest? Whatever the answer, the fact is that the interior decoration of the Russian palaces rivaled with those of the best courts in Europe.

Catherine II knew perfectly well which artists to approach. Informed by her Parisian correspondent, Baron Grimm, of the cabinet maker David Roentgen's reputation, she managed to attract him to Russia to furnish her apartments. This was a happy choice. The famous German master had several shipments of furniture sent to Russia. Nearly all the European monarchs had recourse to his services. Roentgen's furniture had long held an important place in the Paris, Berlin and Stockholm royal palaces. His workshop, in Neuwied on the Rhine, produced remarkable furniture, decorated by marquetry and equipped with all sorts of odd mechanics. The furniture shipments for the Imperial Highness of Russia began in 1784, and for several years thereafter a uninterrupted flow of furniture was delivered. This furniture, destined to embellish the palaces being built in St. Petersburg, was extremely varied: tables of all sorts, desks, consoles, boxes and caskets, clocks. The master had done them all in the style which was de rigueur at that time in Europe, the neo-classicism which had come to replace the rococo. In other words, the proportions of the furniture which Roentgen intended for Russia were rigorous and rectilinear. The decorative effect came from the contrast between the veneer in mahogany wood as was standard, of delicate texture, and the motifs of gilded bronze, applied with virtuosity. It is deemed that Roentgen developed a particular style for Russia specifically termed "architectural." And although this master's work is most eclectic, his furniture which has been conserved in Russia marks a unique chapter in the artist's work.

In order to make sure that the Russian Empress would understand that she was dealing with "the best cab-

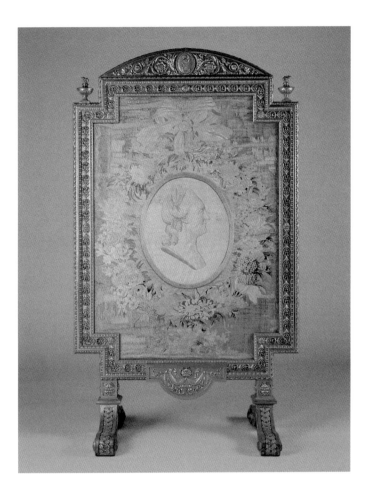

inet maker and mechanic" of the century, as Baron Grimm had described him, Roentgen sent a large-sized desk to Russia. It was crowned with the figure of Apollo and was in fact called "Apollo's desk." The cabinet maker had used all of his skill and knowledge to create this work. In collaboration with Peter Kinzing, a mechanic working in his same workshop in Neuwied, the master had equipped this astonishing piece of furniture with a whole multitude of mechanisms allowing to use cleverly hidden levers and buttons to open the consoles, the doors and the drawers. These manipulations were accompanied by music which had been recorded onto rolls fixed onto the back panel of the desk. Such a marvelous creation could not help attracting the attention of the Empress. To judge by her correspondence, Catherine II, whose relations with the master of Neuwied had been rather frosty at first, soon came to appreciate his brilliant virtuosity. She ordered furniture from him for the Winter Palace and her summer residences. Roentgen was also to furnish the Pella palace which had been built for her on the banks of the Neva River (a grandiose project by the architect Starov which was only partially completed), and to provide not only the furniture itself but also the different parts of the richly ornamented paneling of the interior décor, including the doors. Models of these doors which were created by the artists have been conserved. They are decorated with a marvelously engraved bronze motif made up of lambrequins, roses and volutes. They arrived in Russia along with the rest of the furniture for the Pella Palace in 1787 during the third shipment of furniture sent by Roentgen. The same kinds of doors would be fixed later onto the armoire with its forty-eight shelves, which was built to house Catherine's collection of sculpted stones. The door leaves are decorated with arabesques in bronze which were done by F. Rémond and J. Martin. The bottom part of the armoire was finished by the Russian masters Christian Meier and Henrich Hamms. Catherine II's order to Roentgen of five more such armoires for her favorite collection of cameos indicates the interest the Court took in his work. Today only twenty-two pieces from Roentgen's furniture deliveries to the Russian Court remain in the Hermitage collection. But the Russian collections are still those which most illustrate the work of this German master during the period 1780–1790.

If the Empress had need of the furniture, the porcelain, and the silver for the decoration of her residences, none of it came to form a specific collection of objects, in contrast with the special place held by the collection of

2
David Roentgen's studio
Armoire-cabinet for engraved stones,
1786–1787

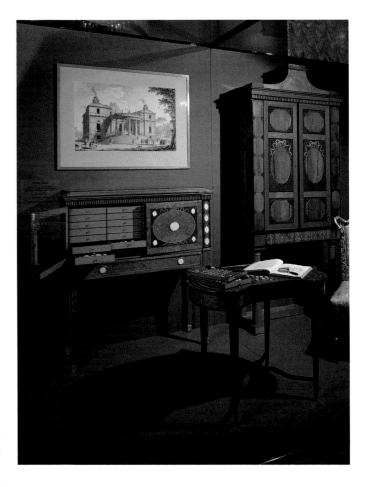

sculpted stones. Catherine II devoted herself to creating the latter collection methodically and with ardor, with even more enthusiasm than she gave to the gallery of paintings, despite the fact that the paintings were more vital to the political status of the country. Cameos were a genuine passion of the Empress's. So much so that her infatuation for them was most appropriately termed a "sickness of cameos." Stones dating from Antiquity and recent gems were part of the collection. Near the end of Catherine's reign, she had a total of 10,000 cameos and another 3400 casts. But the Empress was not the only one to collect cameos. She had passed her "illness" to her friends and her favorites. She wrote on the subject of her cameo collection, "God alone knows the pleasure one feels in touching them each day: they are a source of inexhaustible knowledge."[3]

The marvelous mechanics also seduced the Russian Empress. We are indebted to her reign for the appearance in Russia of the astonishing work by the Englishman James Cox: the Peacock clock which became a very original symbol of the Hermitage. This clock, which had been a part of the late Duchess Kingston's patrimony, had been bought in 1788 by Catherine's favorite, Prince Grigori Potemkin. It was the master Ivan Koulibin who had assembled the clock in Russia and set it working.

Catherine II had very often been the model for porcelain representations. The figure of such an extraordinary woman, incarnated into a bisque sculpture created in the Berlin porcelain manufacture, was a part of the set offered by the Prussian king Frederick II. Catherine II was represented in sculpted porcelain, such as the equestrian portrait in Meissen, made from a model by J. Kändler. When one thinks of the rarity and the cost of these materials in the 18th century, one can understand the extraordinary aesthetic and historic value of these services and porcelain sculptures which are conserved in the Hermitage.

More generally, Catherine II had become a theme of inspiration for the Western masters who incarnated her into the most varied art techniques. Thus, her portrait was reproduced in a tapestry made from a painting by Rokotov in the Gobelins workshop. She was pictured in an oval in a three-quarters pose, wearing the ribbon of the Order of Saint Andrew.[4] After that, this portrait was taken up by a tapestry manufacture in Russia. The master of Lyons, Philippe de la Salle, made a profile portrait of her in woven silk. The princess Dachkova, Catherine II's lady-in-waiting, had been able to see it at Voltaire's home in Ferney.

From that point on, the reputation of the Lyon silk trade incited Catherine to place orders with the Pernon brothers who became her suppliers. They delivered hundreds of meters of hangings to decorate the Empress's palace walls, in particularly the Peacock and Pheasants hanging which decorated the apartments of Tsarskoye Selo, the Empress's favorite residence. A series of tapestries glorifying the Russian Empress's military victories during the war against the Turks was ordered from la Salle. On one side of a gilded screen (fig. 1) in the Hermitage on which the Empress's monogram appears is her portrait woven in silk, on the other, is Catherine II represented as Minerva crowning her favorite, the count Orlov, victor over the Turks at Tchesme. On the lower part of the screen one can read these lines by Voltaire:

> *Receive from this Amazon*
> *The noble prize of your combats*
> *It is Venus who bestows it upon you*
> *Under the figure of Pallas. V...*

The Empress placed an order for the famous Orlov set, destined for her favorite, with the French gold-and silversmith masters, J.-N. Roettiers and L.-J. Lenhendrick. The enamel worker and jeweler B.-A. de Mailly created, at Catherine's request, a writing set for the Tchesme palace which included miniatures representing episodes from the Russian-Turkish war. In Italy, Luigi Valadier created a table décor made up of a multitude of subjects made with semi-precious stones in the form of antique temples, triumphal arches, Egyptian figures, and a variety of columns.

Regarding relations between the French and Russian courts, one cannot neglect to mention the trip to Paris undertaken by Catherine's son, the grand duke Paul Petrovitch and the grand duchess Maria Fedorovna, using the pseudonyms of the Count and Countess of the North. This trip, of importance in itself for the development of contacts between the two countries, had another interest: the couple brought back from France a quantity of objects from the applied arts.

French, German, Italian works were present in the Russian Empress's apartments. These were not second-rate articles but masterpieces by European artists, Catherine's contemporaries.

England, whose relations with Russia were up and down during the Czarina's reign, was nonetheless not forgotten either. It was from England that a production of casts from James Tassie's famous sculpted stone collection was ordered. Tassie had just recently and most happily completed his own collection of those cameos so beloved of the Empress. It represented more than 16,000 inventoried articles which had been created especially for her. Catherine II could not ignore this unique English collection which included intaglios and antique and European cameos. The Englishman Rudolf-Eric Raspe prepared the catalogue of the Tassie collection for Catherine II and it was he who informed her that the collection was housed in special armoires made from drawings by the architect James Wyatt who worked in the style of Adam. Thirteen armoires (fig. 2) from this set have survived, partially remade. R.E. Raspe is lavish with his praise in the catalogue of the Tassie collection: "executed with virtuosity...." They deserved, according to him, to be placed in the forefront "of the splendid décor of Her Imperial Majesty's sumptuous Court."[5] The big armoire-cabinets, on a leg base in the form of the Greek letter π (redone by the Russian master C. Meier) are the same type. They were made in the tradition of neo-classical English furniture with a veneer on satin-finished wood

3
*Beauty-mark box with embossing
decoration,*
St. Petersburg, middle
of 18th century

forming oval figures, polygons, suspended garlands, and including compositions in marquetry on the lateral door leaves. In this same series, there are smaller armoires on incurved feet. And there are also armoires with two rows of trays for holding the cameos. The armoire-cabinets are attributed to the English master Roach, very little known in his own country. The presence on one of them of an ivory plaque with his name on it attests to its origin. These works so pleased Catherine II that she ordered a similar armoire-cabinet for her favorite, Lanskoy who following her example, also collected sculpted stones. And if truth be told, on that particular piece, the work on the lateral marquetry panels is of such masterful virtuosity that it even exceeds the decoration on the armoires which were destined for the Empress herself.

As we can see, the Empress bought articles from her era for her personal use. But jewelry art held a special place and was her pride. It was not a real collection in the full sense of the term for there were very few pieces from the past included, it was rather made up of the works by contemporary masters from Catherine's century. These jewels can be looked at both as luxury objects and as accessories used to add the finishing touches to her dressing. To house and conserve them she had a special place fitted out which was called "the room of diamonds" where "the myriad of jewelry sets and other precious stones" were arranged in armoires.

"The Empress took from there what she pleased to present as gifts."[6] Naturally, watches, snuff boxes, rings, and bracelets were the articles most frequently offered as gifts or rewards. The snuff-boxes were the most common object, given that taking tobacco had become very fashionable. The Empress also liked tobacco: "she took it always with her left hand so as to keep her right hand free to be kissed

by her faithful subjects."[7] The snuff-boxes or the beauty mark boxes were in gold, silver, in semi-precious and precious stones, and often they were adorned with a miniature portrait accompanied by a monogram, or by theme scenes. The motif was frequently linked to the destination of these little treasures. A lapis-lazuli beauty mark box (fig. 3) in the Hermitage collection with a relief in engraved gold, has been decorated with children who are rolling eggs, a tradition which took place for the Easter festivities. The clear influence of the English masters can be seen in the decoration of these small boxes.

The snuff-boxes which were presented as gifts or reward often had the portrait of the Empress in the center. This is the case of the round snuff-box (fig. 6) created by Jean-

4
Master Alexandre Lang
Snuff-box with allegoric composition,
St. Petersburg, 1776

5
Jean Pierre Ador
Snuff-box with a portrait
of Paul Petrovich,
St. Petersburg, 1774

François-Xavier Bouddé who reproduced the portrait of Catherine II on tapestry (based on an original by Rokotov, already mentioned above): the Empress, in a coat and with a small crown, is wearing the chain and the insignia of the Order of St. Andrew. The portrait, done in enamel, is encircled with diamonds. The author of this snuff-box arrived in St. Petersburg in 1769 where he became the master of the foreign corporation of St. Petersburg jewelers. Another master, A. Lang, adorned the center of a snuff-box lid with an allegorical portrait of the Empress (fig. 4) as the goddess who remains near the sacrificial altar. In addition to diamonds, he used garnets in the decoration which gave to the object an even more elegant aspect. Two famous snuff-boxes have reproductions in their center of Catherine's son and grandson, Paul Petrovitch (fig. 5) and Alexander Pavlovitch (fig. 7). The two portraits are set onto the lid: the portrait of the future emperor Paul I shows him in parade attire, wearing the order of St. Andrew, while Alexander's, done in porcelain, was revealed to be an imprint based on an agate cameo which had been done by his mother, the Empress Maria Fedorovna.

Catherine II offered jewelry to other countries as official gifts and was offered the same in return. She had the best jewelers working for her and she could not have done without the European artists. Poizie, Adam, Scharff, Bouddé are only a few of the names of the foreign jewelers who worked at the Russian Court.

The ceremonial equipages also illustrated the splendor of the Empire. It is known through documents of the time that 19,000 horses took part in Catherine II's crowning, all of them richly harnessed and attached to luxuriously decorated calashes. The Hermitage collection has conserved more than ten or so calashes and equipages of all sorts which belonged to the Imperial Court and to the Russian nobility. Owning a ceremonial calash was a proof of being a high-ranking dignitary. These carriages were built in Russia—there were workshops both in Moscow and in St. Petersburg. However, they were most often ordered from abroad. The best master carriage makers were concentrated in Paris. The adornment of the carriages with sculpted wood, bronze plate, inlays of mother of pearl and painted decors is characteristic of the years 1760 when French Rococo was being combined with an emerging classicism. A variety of specialists were called upon to build

6
Master Jean-François-Xavier
Bouddé
*Snuff-box with the portrait
of Catherine II,*
St. Petersburg, around 1780

7
Master Pierre Etienne Teremen
*Snuff-box with the portrait of the
Grand Duke Alexander Pavlovich,*
St. Petersburg, 1799

the carriages: coach builders, wood sculptors, cabinet makers, blacksmiths, cart-wrights, tapestry makers and many other top ranking artists. It took months, sometimes years, to build a carriage. Three French calashes are conserved at the Hermitage, of the same sort as the "*vis-à-vis*" for two passengers. One of them belonged to Ivan Ivanovitch Betsky (1704–1795), an eminent personality in the Russian cultural world during Catherine's reign. It is estimated that the calash exhibited (fig. IV) was made before 1761 since it was soon after that date that Betksy, invited by Catherine to the Court, arrived from Paris to St. Petersburg.

The Count of Ségur, describing Catherine's court, wrote that in St. Petersburg, "the fashionable jewelry sets, the sumptuous banquets, the majestic triumphs were just like those which entertained the high society of Paris and of London."[8]

Such an observation once again helped to place Russia among the great European powers: and one can easily be convinced of that power in contemplating even just a tiny part of the treasures which decorated the Russian palaces in the 18th century.

T.V. Rappe

[1] Pyljaev, M.I., *Old St. Petersburg* (Staryj Peterburg), Spb, 1990, p. 193–194.

[2] Ségur, L.-Ph., *Memories of my stay in St. Petersburg under the reign of Catherine II* (*Mémoires sur mon séjour à Saint-Pétersbourg, sous le règne de Catherine II*), cf. Collection: "Russia of the 18th century as seen by its foreign visitors" (Rossija XVIII veka, glazami inostrancev), L., 1989, p. 329.

[3] SRIO, *Russian History Society collection* (*Sbornik russkogo istoriceskogo obscestva*), vol. 23, p. 329.

[4] Saint Andrew, also known by the name of "St. Andrew the First called among the Disciples." He was the Disciple Peter's brother: cf. Book of John, 1,40 (n.d.t.).

[5] Holloway, J., *James Tassie*, Edinburgh, 1992, p. 14.

[6] Georgi, J., *Description of the Russian Imperial Capital of St. Petersburg* (*Opisanie rossijskogo imperatorskogo stolicnogo goroda Sankt-Peterburga*), Spb, 1794, vol. 1, p. 77.

[7] Pylaev, M.I., *op. cit.*, p.183–184.

[8] Ségur, L.-Ph., *op. cit.*, p. 327.

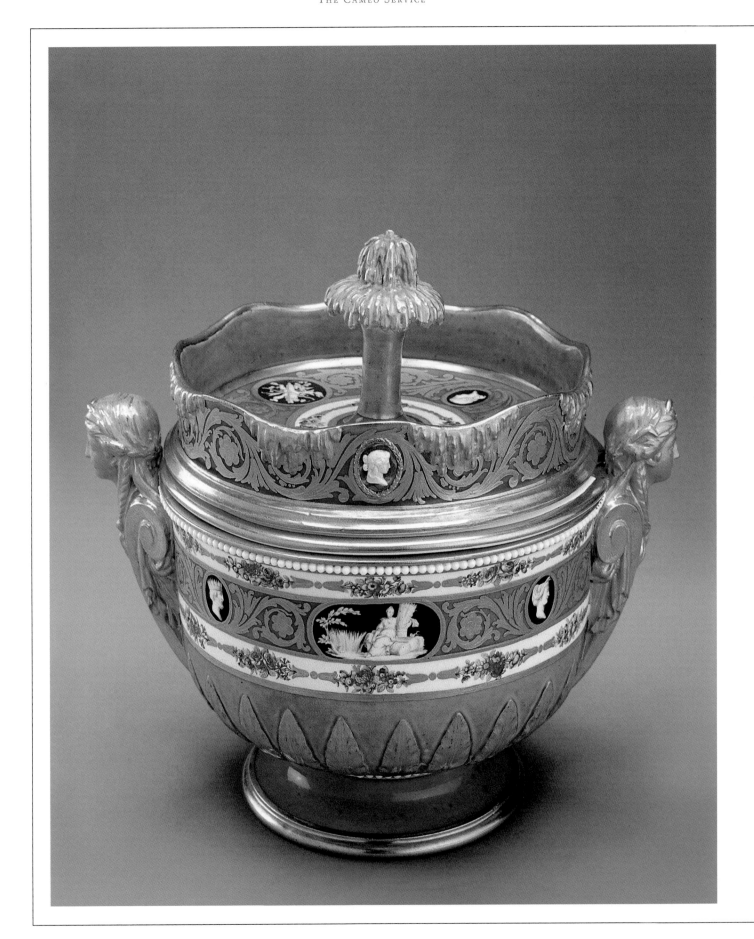

The Cameo Service

The gifts offered by the Russian Semiramis to her many admirers reflected her taste. And how exquisite it was! An example: the Cameo service of such rare beauty which Catherine II ordered from the Sèvres Manufacture in 1777 for Prince Grigori Potemkin. The set was finished in 1779 and sent to the Russian capital on a Dutch ship. The whole service included more than 800 pieces (more than 600 are still intact) and was conceived to serve sixty people. Thanks to this Russian order, the Sèvres Manufacture created one of its most beautiful neo-classical services. Dozens of artists worked on the creation. The order which had been transmitted by Prince Bariatinsky, requested that fabrication of the service should be inspired by "antique models" and reflect Catherine II's passion for the cameos of Antiquity. Following this suggestion, cameos especially made from porcelain were incorporated into the decoration of the set. The service was for hors-d'œuvres, desserts, tea and coffee. In addition to the plates, there were several trays for bottles and glasses, coolers for the wine, sauce boats, creamers and sugar bowls, various liqueur "cabinets." There were also fruit bowls whose decoration was formed by the Empress's monogram E in a floral motif topped by a crown. There were also cameo imitations, copies of antique originals, as well as representations of mythological scenes or scenes from ancient history, and more than 2000 subjects in medallions (figs. a–c, I–III). Finally, the set included a table piece in bisque which was to be placed in the center, as was the custom in the 18th century. It was made up of forty vases, twelve of which were placed on a base. They surrounded the sculpture which represented the Russian Empress as Minerva, accompanied by allegoric figures. This décor, inspired by a model of Simon-Louis Boizot's was called *The Russian Parnassus.* One can imagine the splendid effect produced when around this sculpture and the vases were placed the plates and the innumerable pieces of the service whose austere refinement married turquoise, white and gold, the whole sprinkled with *terra cotta* cameos which had been especially made for the occasion: the whole creating an impression of extreme majesty which recalled the Empress's taste. The cost of the set, estimated at 331,362 pounds, seemed excessive to Catherine II and there was an interminable correspondence afterwards with the sum paid only with great difficulty and many delays.

There was a very precise protocol in the second half of the 18th century as to how the service was to be laid. A culinary dictionary had been published during the last year of Catherine's reign which included a meticulous description of how the plates should be placed on the tables: it was what was known as "the table *à la française.*" Depending on the use, all the dishes of a same service were placed at the same time. There were a great variety of tables: rectangular, oval, in form of a horseshoe. They were arranged in a variety of ways, like geometric figures. There were strict rules regarding the setting of the table. A well-defined space had to be left between the plates, with a greater space left between the dishes for the women. Glass dishes were not placed on the tables, but remained on the sideboards placed along the walls. The glasses, the wine in the bottles, were placed on their respective trays, and the waiters would present them to the guests throughout the meal. A décor adorned the center of the table which most often had been made to go with the service. It was almost always accompanied with a floral element.

T.V.R.

Page 210
a
Pieces from the "Cameo Service",
Sèvres, 1778–1779

b
Pieces from the "Cameo Service",
Sèvres, 1778–1779

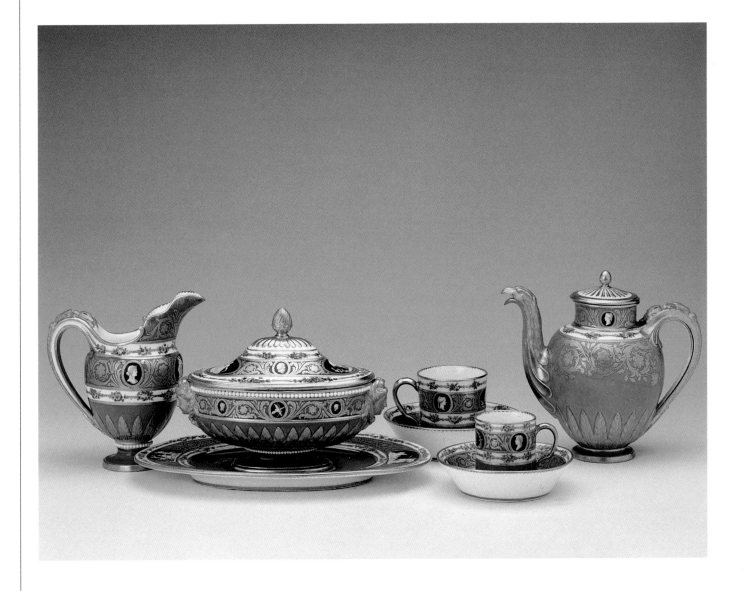

c
Pieces from the "Cameo Service",
Sèvres, 1778–1779

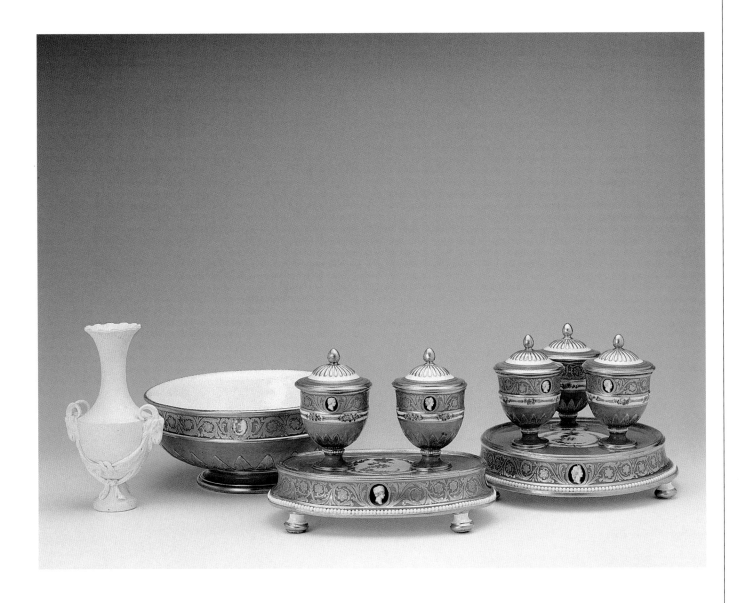

I
Pieces from the "Cameo Service",
Sèvres, 1778–1779

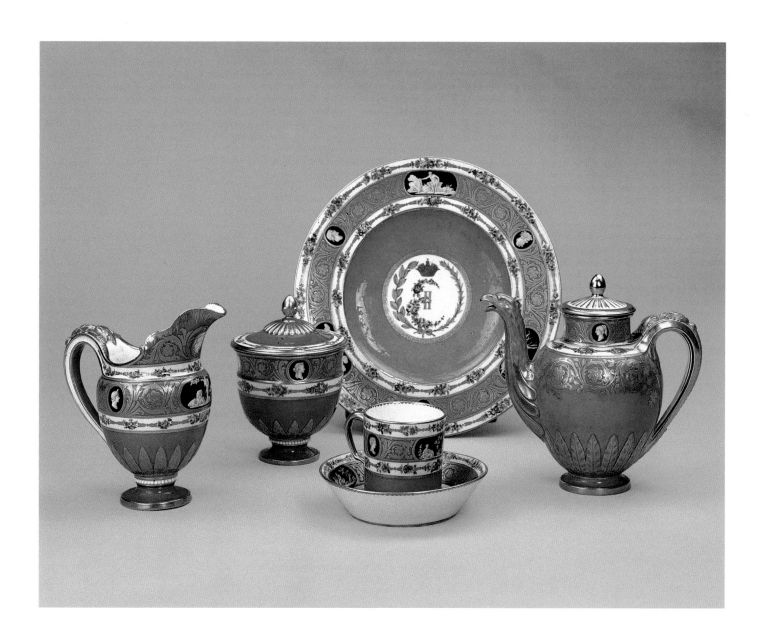

II
Pieces from the "Cameo Service",
Sèvres, 1778–1779

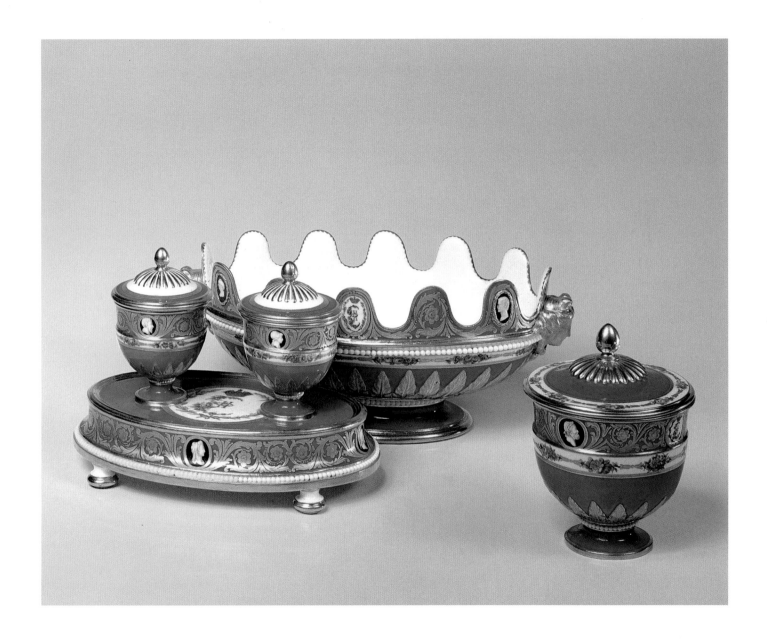

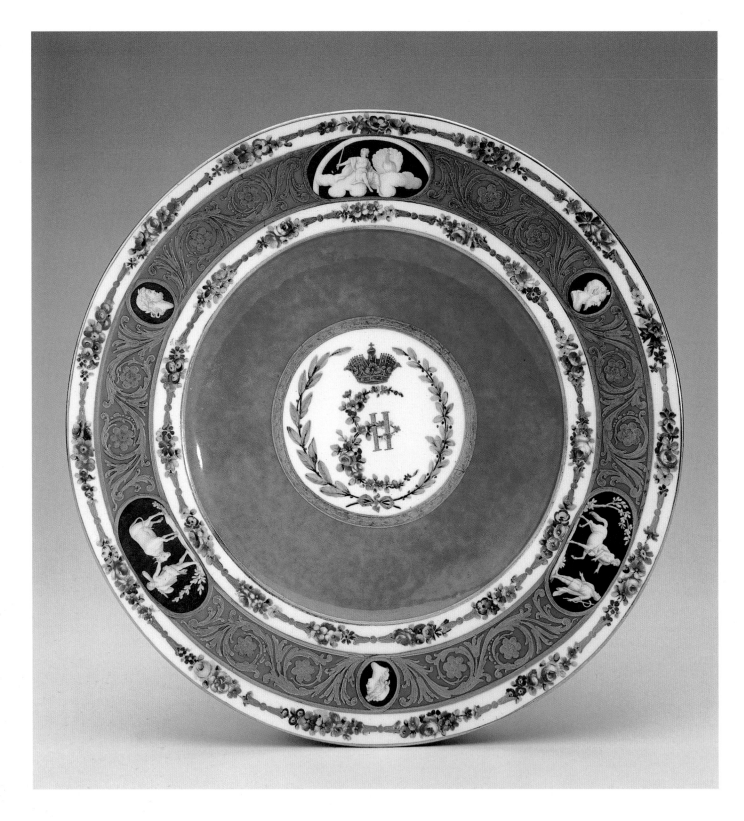

IV
Two-seated "vis-à-vis" carriage,
Paris, around 1761

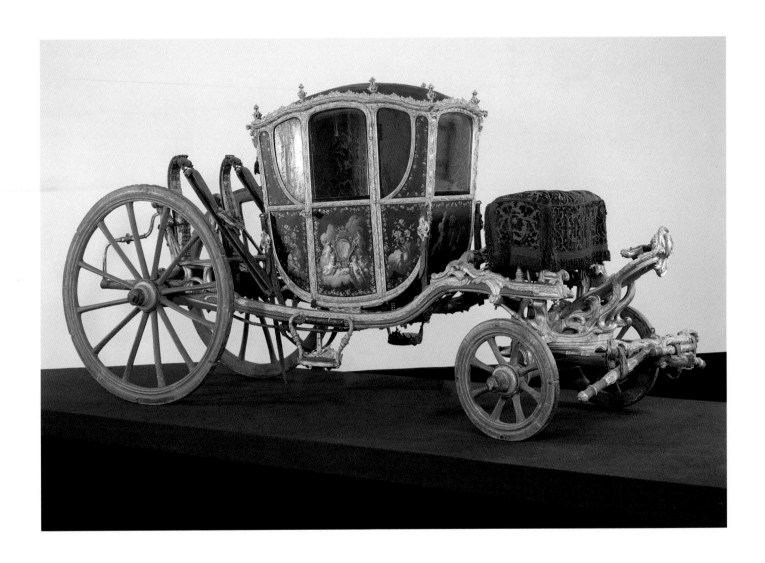

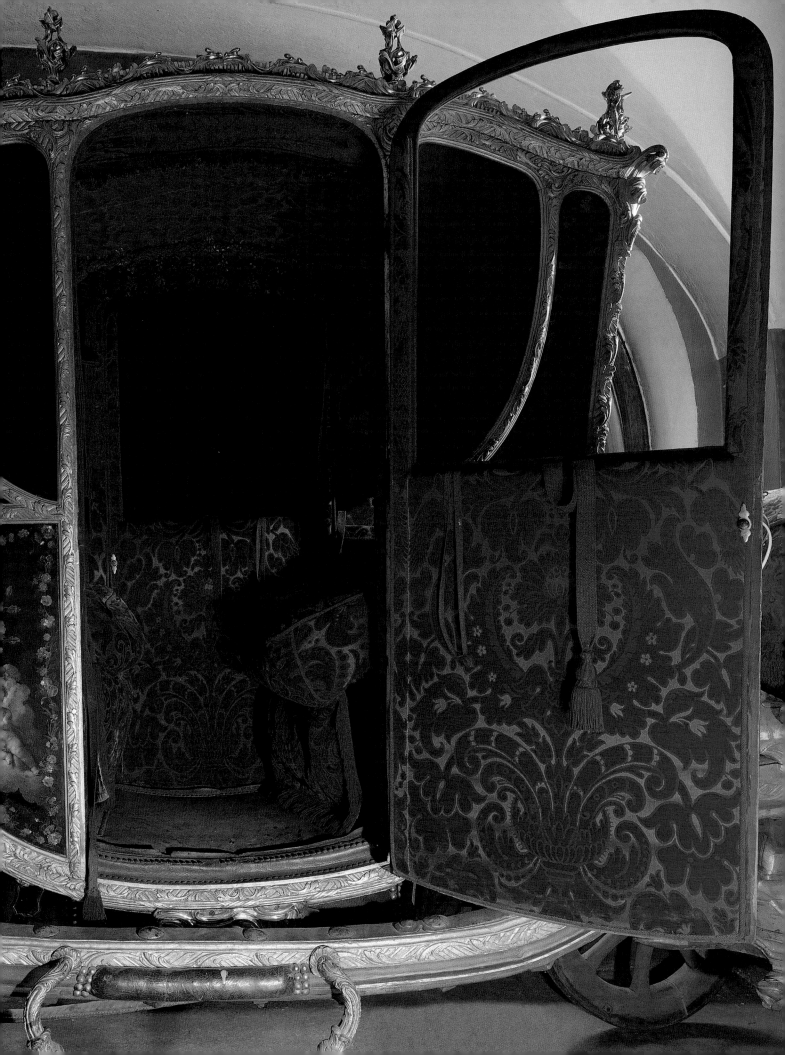

Tula, the city of master craftsmen

"Thursday, November 9, 1775.

We had dinner at Count Potemkin's.

He showed us pieces in steel from Tula of

great beauty notably for the blue of the steel,

the gilding and the delicacy of the

ornaments."

Marie-Daniel Bourrée, chevalier de Corberon
Un diplomate français à la cour de Catherine II, 1775–1780,
Paris, 1901, 2 vol., vol. I , p. 106

The old Russian city of Tula stretches out along the Upa river banks, 200 kilometers south of Moscow. Tula, a major center for the metalworking industry in Russia, has been known since ancient times. Its excellent location at the crossroads of trade routes and on the defensive border of Moscow State, plus the existence of major iron ore deposits, its abundance of forests and the presence of highly qualified artisans led to Tula's rapid transformation as one of the major arsenals in the country.

The first thirty blacksmith families arrived here from Moscow to live in a district especially created and reserved for them by an Edict of the Czar in 1595. Already in the 16th century, the reputation of the Tula artisans who made weapons—arquebus and muskets—by state order had gone far beyond the city limits. The "arquebusiers craftsmen"— as the gunsmiths were then called, constituted an urban caste which enjoyed specific rights and privileges. Thus, all the craftsmen in the blacksmith district were exempted from the draft, were allowed to sell arms to individual parties, and also to have in their homes unlimited quantities of drinks, barley ale, beer and mead without paying any tax.

The master craftsmen of Tula, as those of the State Armory in Moscow, made weapons not only for the Czar's troops, but for export as well. We have an example of this in the cast iron canons for the ships of the Dutch navy, which at that time was the most powerful in Europe.

As time passed, the pieces made by the craftsmen became increasingly perfected, followed by models of firearms and luxury knives, all of a remarkable artistic quality.

The beginning of the 18h century saw major changes in Tula's history. The reorganization of the army and the navy—without which Peter I would have been unable to secure an access to the coast of the Azov Sea and to that of the Baltic—meant that the old system of making weapons and providing them to the troops, still a mostly traditional system, had to be replaced. In 1712, the Czar, who was perfectly aware of the existence in the city of a specialized district dependent on the crown as well as of highly qualified gunsmiths, ordered the establishment in Tula of the first factory in Russia to make firearms and knives. The State Armory in Moscow ceased to be used as the Russian arsenal and thereafter became a repository for the State treasures.

After Russia's victory over Sweden in the Great Northern War (1700–1721) which transformed it into a maritime power, the production of ordinary offensive weapons was considerably reduced. At the same time, a demand was growing for luxury arms, ordered in great number by the Russian aristocracy or as gifts for ambassadors and foreign hosts. The Tula craftsmen thus were able to devote much more attention to the creation of single models of honorary arms and finely crafted hunting arms. The spirit of emulation in the fabrication of exceptional metallic pieces and the inventiveness in decorating them were major factors which contributed to raising the level of craftsman mastery and creative initiatives. The best work was awarded financial bonuses. There were also edicts presenting the Tula gunsmiths with silver and gold medals and, in very exceptional cases, gold medals set off by diamonds.

To have the right to the title of master craftsman of the Tula workshop, the gunsmith had to present probationary work showing his artistic abilities to work the metals: iron, bronze, copper, silver and gold. The apprenticeship of this art was from seven to fifteen years. Particular attention was paid to teaching apprentices the knacks of the trade and transmitting to them the techniques of work-

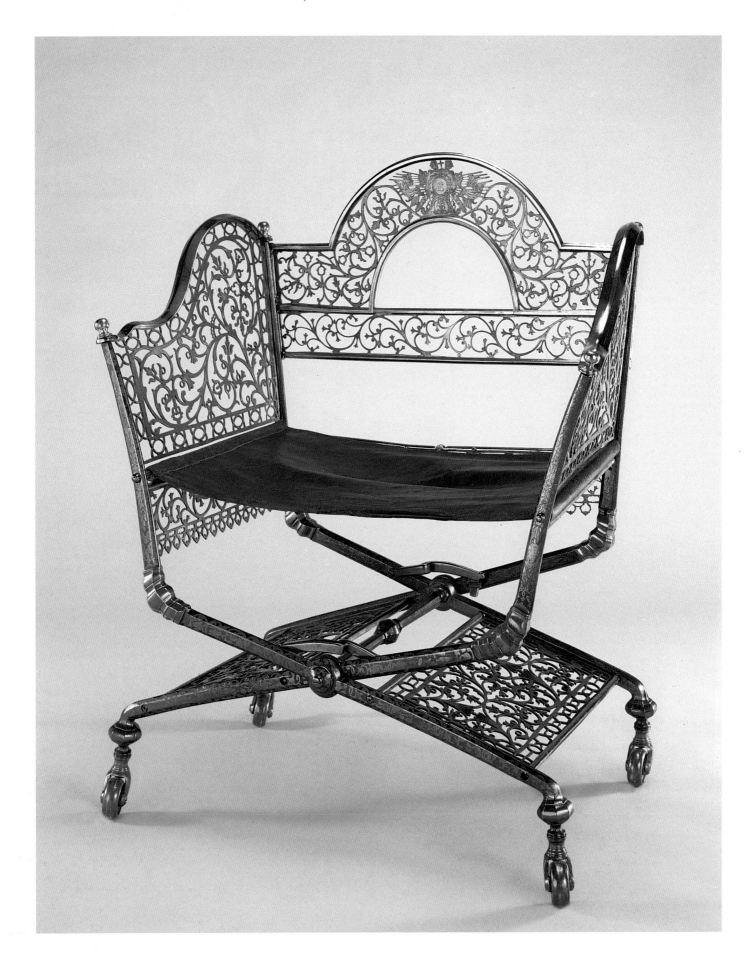

1
Folding armchair,
Tula, 1744

2
Chansky factory
Table,
Tula, 1744

ing metal. In addition, the workshop management decided to broaden the scope of the young gunsmiths' field of knowledge and know-how. According to a number of archival documents, "...by the present Edict of 1736, September 1, it is commanded that up to 20 people be chosen from the workshops to be taught arithmetic, geometry, drawing and mechanics..." In order to perfect their art, the most capable blacksmiths were sent on mission to foreign countries. Well known is the story of the gunsmiths from Tula, Alexeï Sournine and Andreï Leontiev, who went to England, a country at that time very advanced in the field of metal work. And yet, even there, the exceptional talents of the two Russian craftsmen were a cause of great amazement. After a difficult sojourn and many varied adventures in that foreign land, only Alexeï returned to Russia where he was appreciated at his true worth. An edict in 1794 from the Empress Catherine named him "inspector" of the whole of the Tula activities for weapons production. More than a century later, the famous Russian writer Nicolas Leskov wrote his *Story of the Lefty of Tula and the Steel Flea*. This marvelous legend tells how a self-educated and most extraordinary gunsmith was able to shoe in steel the feet of an English flea—a minuscule marvel from beyond the seas that could only be seen by using a microscope. Since then, the name "left-handed" has become synonymous with the talent and the virtuosity of the Tula gold- and silversmiths.

The weapons production in Tula was at the origin of the development of a great many local industries. The Tula samovars, for example, famous the world over, were first made by the "arquebusier" blacksmiths. And the first to have established the samovar factories were the gunsmiths Lisitsyne and Batachov. It was the same for cart building, for workshops producing military equipment articles. Even the making of gingerbread involved having re-

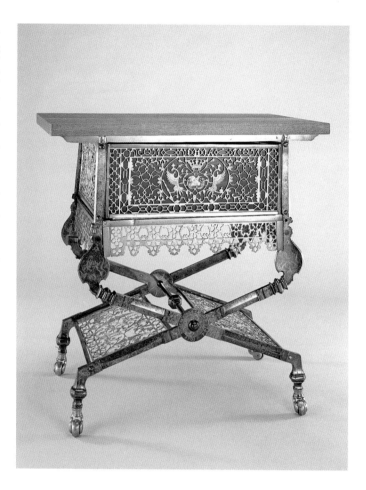

course to the arms manufacturers: as they were very skilled in woodworking, they created engraved plates of great originality to stamp the brands on the gingerbread.

By the beginning of the 18th century, Tula's expert craftsmen were not content just to carry out official weapons orders, but also executed "personalized" orders, in other words, objects of daily life. Tula furnished a large choice of metal objects of great variety to the Russian market. Lamps, sewing boxes, writing instruments, furniture, umbrellas and mirrors, buckles, seals, snuffboxes, buttons. These objects, made from a material, steel, which was not a "goldsmith's material" were impressive by their refinement and the extraordinary delicacy of their work which

3
Usine Chansky,
Steel furniture,
1780s

made them luxury articles. Thus an autonomous branch of Russian art craftsmanship grew up, born of an exceptional virtuosity in the treatment of metal.

In the Hermitage collections, the oldest objects which were made in Tula are the pieces of furniture. These are productions from Maxime Mosolov's private factory. A former gunsmith craftsman, Mosolov founded four metal works factories, the most famous of which was the Chanski factory. In the years 1740–1750, there was a scarcity of furniture in the palaces of the Russian aristocracy and a large demand for folding furniture, particularly in steel, whose shape was inspired by models of Western Renaissance furniture.

The table and the armchair (figs. 1, 2) presented in the exhibition are particularly interesting because of their lightness and the refinement of their wrought brass. One can see on the intertwining legs and curved armrests a motif on a burnished background of dark blue which is known as "grassy" (stylized vegetal decoration) and the image of a lion and a unicorn in heraldic display. These motifs are closely linked to the 17th century Russian tradition. The decoration of the object also includes two-headed eagles as well as a monogram under the imperial crown which states that the armchair and table had belonged to Peter the Great's daughter, the empress Elisabeth Petrovna (1741–1761). And a particularly invaluable detail: at the intersection of the table legs appears the stamp, "Chanski Factory 1744."

It is generally agreed that it was during the second quarter of the 17th century that the art of the gunsmiths reached its full bloom. The works which the Tula master craftsmen of the time conceived and completed stand out by their sumptuous character and by their exceptional richness. This was due to the many and varied techniques employed for the creation of a one and only object. The "goldsmiths" of Tula were masters at the art of polishing, knowing how to use that technique to get the effect of a reflecting mirror. The burnishing enabled the craftsmen to give extremely varied nuances to the metal, depending upon the degree of heating time, from night blue (fig. 4) to pale blue and pink, thus opening the way for a large variety of colors. All sorts of motifs were used to decorate the objects, done using the incision process. For this type of inlay, a thread or fine leaves of other metals—gold, silver, copper—were impressed into the depth of the steel surface. Another method of inlay consisted of placing an amalgam of mercury on the steel surface, onto which a drawing had been previously engraved. When it was heated, the mercury would evaporate and the non-ferrous metals would fix themselves solidly to the steel surface.

Among the different finishing techniques, the "granulation in diamonds" (fig. 3) held the place of honor. The Tula gunsmiths used this technique to ornament the most valuable pieces, particularly the furniture, in steel. The "diamonds" of steel had variable forms: globular, oval, oblong. Ranging in dimension from good-sized to minuscule grains, they were scattered over the surface of the object by hundreds and sometimes by thousands, giving the illusion of the sparkling of precious stones.

Although the Tula craftsmen's production had been very widespread and willingly purchased both by the aristocracy as well as by the members of the imperial family, the stamped objects remain rare. One of them is a box which is in the Hermitage collection and which is signed by its author, Rodion Leontiev. The box is in the form of a sarcophagi (fig. 5) with four small columns and vases at each angle. The decoration of engraved steel in sinuous lines, and in flower and leaf garland inlays with cornucopia

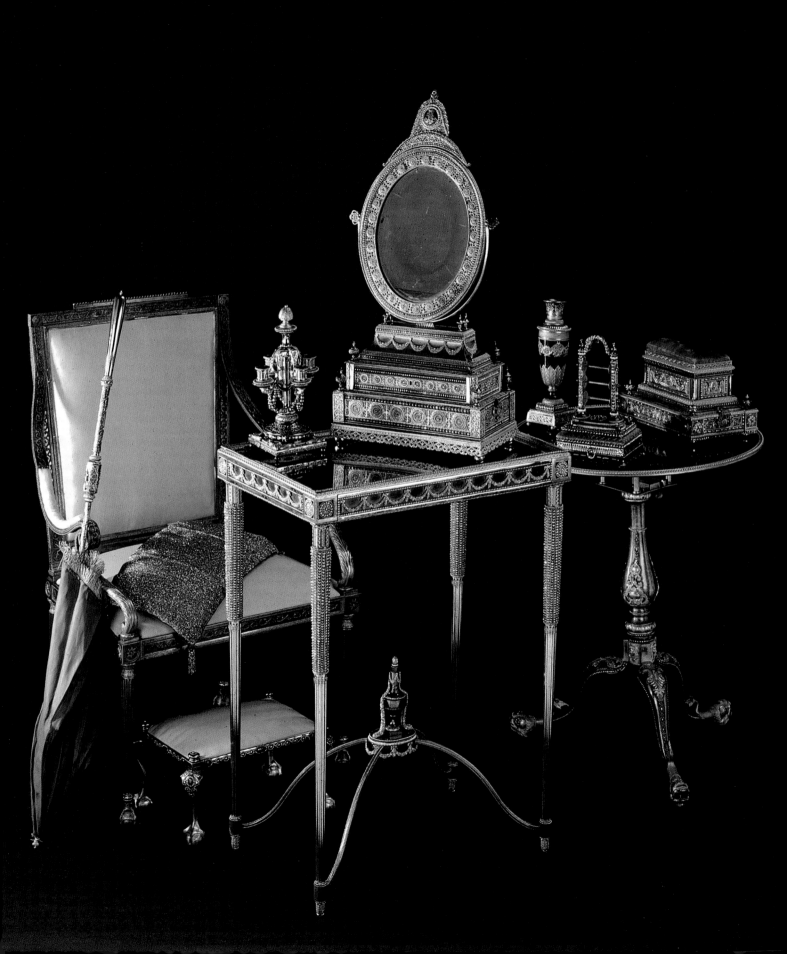

4
Perfume and incense burner,
Tula, end of 18ᵗʰ century

5
Master craftsman Rodion Leontiev
Chest,
Tula, end of 18ᵗʰ century

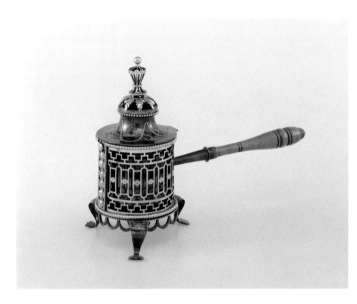

decorated with the image of a reconstruction project of the Tula arms factory. All the pieces or almost all of them are in the form of turrets of diverse shapes capped by several different types of cupolas which themselves are topped by spires. They are adorned by a floral decoration of silver and applied copper with, at the base, a drawing of great delicacy which can only be seen in enlarging it. But it is in the figures of the horses that the artist has been the most inventive. He replaced the lower part of their bodies by fish tails covered with scales. The blue-tinted horses have manes and gold stars and their tails are covered by a sort of "diamond" net. As for the white horses, they have manes and tails in silver. These horses recall the seahorses of ancient art.

A superb example of the Tula gunsmiths' skills is a sewing box (fig. 6) of great sobriety of line and decoration which has on it the Empress Catherine's monogram, "EA" (Ekaterina Alexeevna) (fig. V) under the royal crown. The smooth and polished sides of the box are decorated with rose garlands in a high relief design. The profusion and delicacy of the gold nuances is extraordinary, from the lemon yellow to the orange red. The oval medallions are encircled by garlands of leaves.

Another of the absolutely unique pieces of this exhibition is the umbrella with steel handle whose ribs are covered with green silk with a gilded fringe. According to the monogram which is also on this piece, it too was made expressly for Catherine II. A part of the handle rod is decorated with steel strips and multi-faceted miniscule pearls encircled by ribbons inlaid with a floral ornament. In the middle of the rod, there is what appears to be a little gilded bronze box with inlays covered in glass on which one can clearly distinguish the monogram "EA" under a crown, a bouquet of forget-me-not, small baskets filled with flowers and a heart topped by a flame.

stands out on the burnished night blue. A profusion of small multi-faceted steel balls of varying dimensions which refract the light of the lamps and candelabras into twinkling sparkles makes this box a marvel of enchantment.

Pieces of a chess game (fig. II) were created especially for the Empress Catherine II. There were 80 pieces originally but unfortunately, only 44 have come down to us. They were kept in a large presentation case whose cover was

6
Spool,
Tula, end of 18th century

Catherine II who showed a real interest for this original artistic craft was twice a visitor to the Tula armament factory. In 1775, the Court record described one of those memorable visits: "The master craftsmen from the first class had gathered in the room with various of their works demonstrating their know-how. As Her Majesty wished then to sit down at the lunch table, the designated master craftsmen were introduced to her by their commander in chief, Lieutenant-General Joukov, and they brought to Her Imperial Majesty bread and salt as well as various pieces of their craft, and Her Very Gracious Majesty rewarded them herself." The Empress's second visit to Tula was in 1787. She had the kindness to accept from the gunsmiths the gift of "armchairs, tables, candelabras, as well as a complete writing boxed set made especially for her," and also ordered several other objects.

Among the furniture, the tables of diverse configurations were very popular, such as the table-screen (fig. 7) with a round top coming from the Hermitage collections. This table has a mechanism which enables the top to be fixed either horizontally or vertically (it could then be used as a chimney screen). Its imposing foot-balustrade is richly ornamented with a relief design in the form of rose stems, leaves and laurel garlands. Three dolphins of blended and worked bronze complete the decoration. One remarkable detail: an eight-branched silver star along with the engraved Tula coat-of-arms and the date "Year 1785" has been applied onto the center of the gilded copper table-top.

A dressing table from 1801 (fig. VI) is a superb example of the classicism of forms and of decoration which then characterized the whole of Europe. Its structure is distinct and precise. The whole is of great delicacy: the slender silhouette and the fine shapes as well as the decoration which is of an irreproachable delicacy and which would

have been impossible to create other than in steel and bronze. The polished rectangular table top is fixed into a low bronze balustrade like a frame. Below is an elegant burnished vase.

The most outstanding productions by the Tula gunsmiths attracted the attention not only of Russian dignitaries, but of foreigners as well. The French ambassador to Russia, the Count of Segur, who had accompanied Catherine during the trip she made across Russia to the Crimea, wrote, "On the road to Moscow, we saw nothing more beautiful than the city of Tula which can be considered as one of Catherine's works, so much has she done to beautify it.

7
Table-screen,
Tula, 1785

Tula has long been known for its weapons production which supplies the whole Russian army. Here objects of steel are also made, and thanks to the Empress's impetus, this branch of the production has been brought to such a high degree of perfection that it quite easily rivals the English factories. Her Majesty gave us gifts of works from the Tula factories, all made with the greatest of artistry."

It was the War College which managed the affairs of the National Arms Manufacture as well as those of the private factories. Its president, Prince Grigori Alexandrovitch Potemkin (1739–1791), one of the outstanding statesmen and a favorite of the Empress, followed the production and success of the Tula gunsmiths very closely. The prince possessed his own collection of masterpieces in steel and would willingly show them to his prestigious guests.

Catherine II herself often purchased Tula pieces to give as gifts, as lottery prizes, as diplomatic presents. The purchases were most often made during the Saint-Sophia Fair, near Tsarskoye Selo, the Empress's favorite summer residence. There every year in May, on the day of Saints-Constantine-and-Helene, goods were brought from just about everywhere, luxury products for the most part. The *St. Petersburg News* gave advance information to the inhabitants of the arrival of the Tula craftsmen with their merchandise. As notes from the Court record indicate, many of these objects in steel were considered relatively expensive.

The art of the Tula gunsmiths was highly regarded by their contemporaries. The dark blue color of the burnished steel along with its surface as finely polished as a mirror, the diversity of gilded ornamentation, the play of light on the facets of the "diamonds", these were the elements of the inimitable style which was that of the "goldsmiths" of Tula. Genuine artists, they were unceasingly in quest of new forms, new subjects, new associations of material and other techniques of fabrication.

It is certainly not by chance that from the end of the 18th century, many of the objects shown in the exhibition were in the collections of the Cabinet of Curiosities, and then in those of the Winter Palace and the Hermitage's Gallery of precious objects.

Today, we can see the works of these famous artists of metal in the national museums and private collections in Germany, England, France and America. But the greatest collection in the world of the works of the Tula gunsmiths, some three hundred pieces, remains that of the Hermitage Museum.

M.N. Kosareva

I
Ink-well in the shape of a globe,
Tula, beginning of 19th century

Pages 234–235
II
Eleven pieces of a chess game,
Tula, 1780s

III
*Candelabra with four candles
and vase,*
Tula, last quarter of 18th century

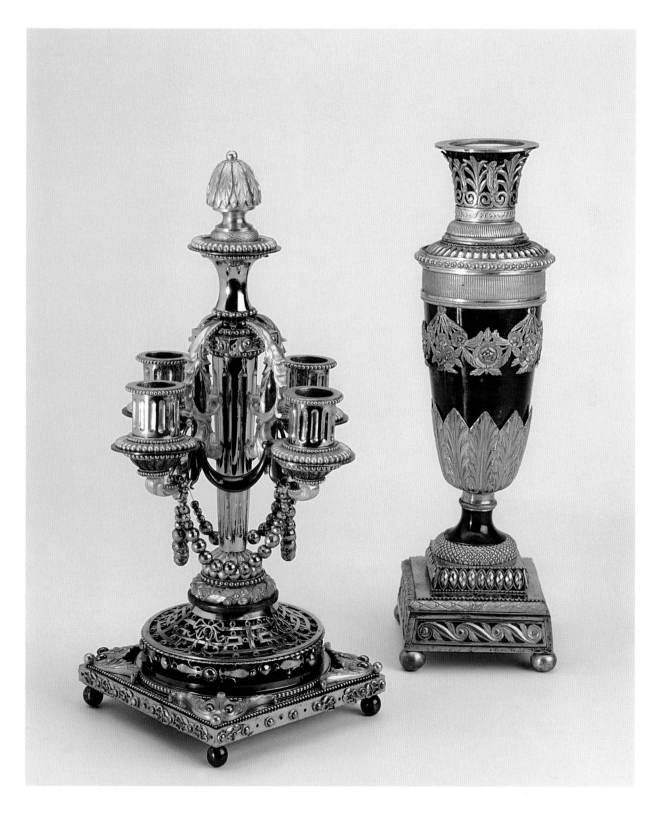

IV
Writing set with ink well, sand recipient and candle holder on an oval base,
Tula, end of 18th century

V
Chest,
Tula, end of 18th century

VI
Dressing table,
Tula, around 1801

Foot-stool,
Tula, end of 18th century

Armchair,
Tula, 1790s

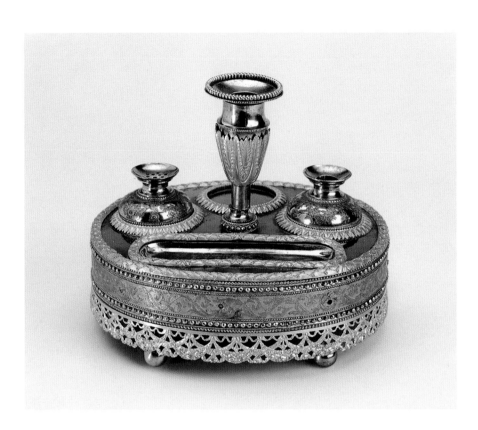

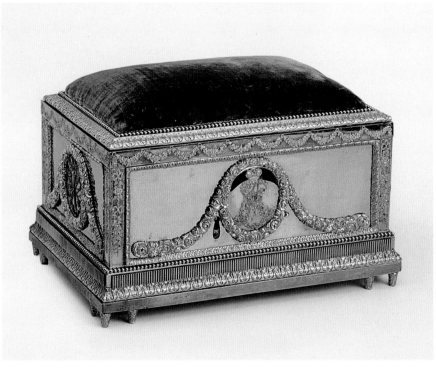

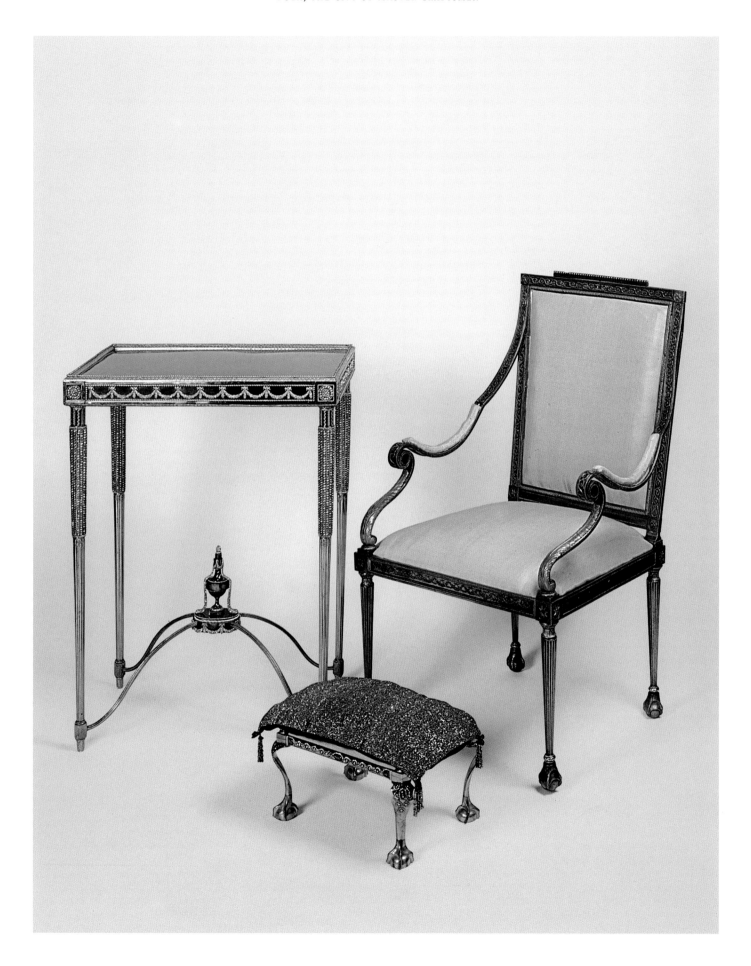

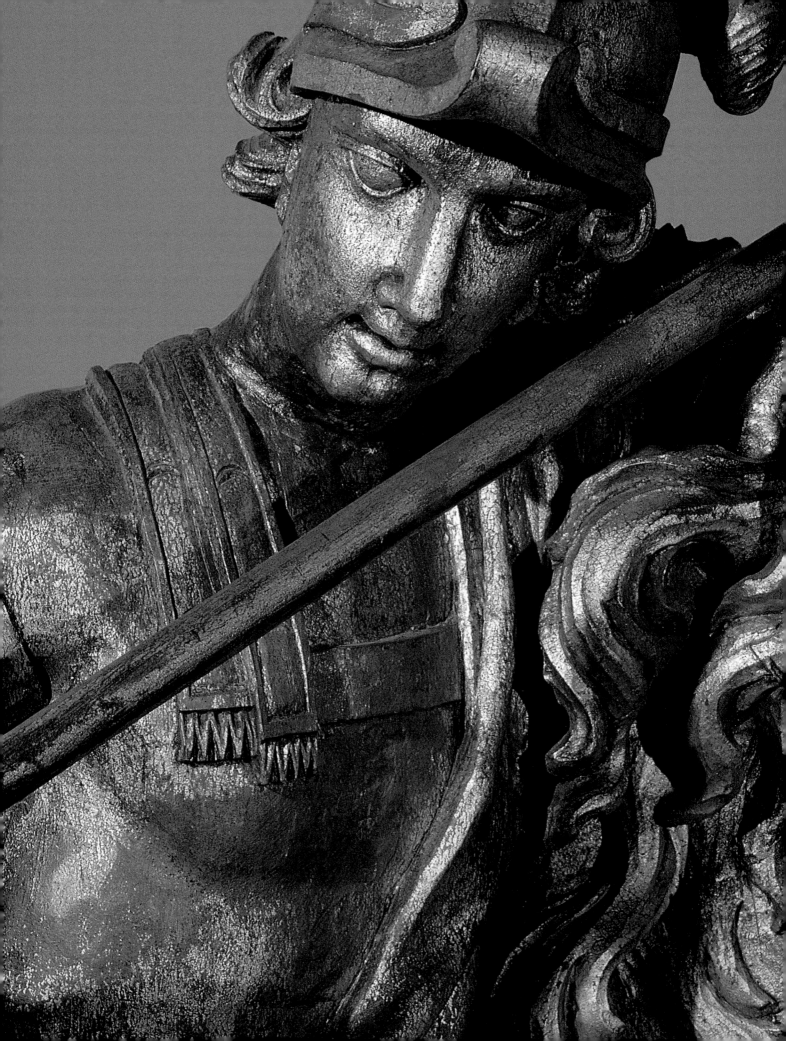

Decorative Arts during
the era of Catherine II

"As for the furniture, it is similar to ours but bigger, more spacious, as is necessary for the size of the rooms. But what is so very Russian is this cabinet, made of a delicate and precious wood, and cut out like the leaves of a fan, which is in a corner of the salon and which is adorned with climbing plants."

Théophile Gautier
Voyage en Russie, Paris, 1866

Catherine II's era (fig. 1) was characterized by fundamental transformations in all the areas of political, social and cultural life. Art and art professions were to know an unprecedented flowering. In the first half of the 18th century, many new branches of national artistic production developed. Due to Peter I's inexhaustible efforts, and those of his successors, Russia set up its own manufactures, on the European example. In the second half of the century, these were reaching results comparable to the European ones. Catherine II, the ambitious sovereign who wished her reign to be a great and brilliant one, sought by every means to encourage the development of the sciences and art professions. She attracted artists to Russia who were skilled in every field, and the most talented masters. By placing regular orders with the Russian businesses, she encouraged them to refine their techniques and to find solutions to ever more complex problems of artistic creation.

The ideals of "enlightened despotism" which were firmly established during Catherine's reign were imbued with the harmonious and majestic forms of Classicism. The exuberance of the fantastic Baroque forms gave way to a severity of proportions. The representations based on antique models exalted and emphasized the enlightened monarchy's successes. Decorative motifs harked back to the inexhaustible sources of Antiquity: garlands, crowns, rows of pearls, lines broken by meanders, profile portraits on medallions, stylized acanthus leaves, incense-burners and vases decorating the buildings and every-day objects.

It was due to the work and talent of a whole army of architects, decorators, and foreign and Russian craftsmen that St. Petersburg, Moscow and many other major Russian cities were developed and embellished. They were given that original and magnificent appearance which seduced the imag-

inations of so many travelers of the time, even if, according to certain eye-witnesses, the sumptuous facades and dazzling luxury of the ceremonial rooms often hid the disorder of daily life and the lack of the necessary.

Building the imperial residences, the courtiers' homes, the palaces hosting the royal guests, went on far more rapidly than did that of the production of furniture. In her description of court life during Elisabeth's reign, Catherine II often writes in her *Mémoirs* about how poorly the rooms were furnished, and this despite the fact that she was living in the grand style of a great duchess.

The empress, who had been brought up in Stettin, in much more modest surroundings, began on her own initiative and with her own means to acquire the indispensable furnishings for her rooms at the Winter Palace and the Summer Palace. After her accession to the throne, she used all the means available to make her residences comfortable.

The most famous architects, painters, decorators and cabinet makers came from all over Europe to the Semiramis of the North's dazzling court. C. Cameron, G. Quarenghi, J. Velten, A. Rinaldi, I. Starov, A. Kokorinov, J.-B. Vallin de La Mothe and many others as well took part in the embellishment of the Russian capital.

The furniture suppliers for the Russian court were the famous cabinet makers D. Roentgen and J.-H. Riesener. The houses of the wealthy were also furnished with German, Dutch, English and French furniture, as well as with specially made pieces based on models by the Russian masters. The second half of the 18th century saw the training of Russian master cabinet-makers, who used the popular secular traditions of wood sculpture in their works. The Okhta district, founded by Peter I in 1721 in St. Petersburg, provided the master-cabinet makers qualified to work with

mahogany and here worked joiners and carpenters who had come from all over Russia. The Okhta masters built ships and also built up the city. They also made precious and elegant furniture for the St. Petersburg palaces and imperial residences. The Noskov family, talented masters from Okhta, created the superb marquetry furniture in Tsarskoye Selo. Working alongside the famous architects were less well-known masters who worked on the furnishing and decoration of the capital's palaces. They perfected their techniques by familiarizing themselves with the most recent achievements of European cabinet making.

Around the end of the 18th century, it was not only the imperial residences and the palaces of the rich dignitaries of the capital which possessed an extensive variety of luxurious and comfortable furnishings and decorations. But, as the traveler I.G. Georgi wrote, the well-off residences of St. Petersburg "also are trying to have huge well decorated homes."[1]

The art of furniture developed in the nobility's luxurious manor homes (*oussadba*) in many of the regions of Russia. Peter III's promulgation of the law on the exemptions of the nobility (February 18, 1762) provided the impetus for a whole new form of culture. The nobles, exempt from the *obligation of any service, including military service*, began to concern themselves with their seigniorial residences. The art professions began to spread in the workshops adjacent to these country residences. Marvelous architectural units were created thanks to the dexterity of the serfs. The rooms were then furnished with elegant pieces and decorated with precious objects.

The manor homes of the rich Russian dignitaries became genuine workshops for the arts and the arts professions. An example is that of the Bezborodko, Kourakin, Cheremetiev and Ioussoupov families in whose homes

flourished the plastic and decorative arts, theater and music. The master serfs often attained the same level of perfection as the most famous of European masters. The works, brilliantly decorated pieces in mosaic made up of various essences of wood which were done by Matveï Veretennikov, A.V. Saltykov's master serf were at first mistakenly attributed to the famous French cabinet maker Riesener.

During Catherine's time, furniture began to be decorated with painted and gilded sculptures, veneering done with mahogany and other precious essences of wood and bronze ornaments. They were covered with decorated motifs and compositions in marquetry. The desks, the dressers, the consoles, the tables and the armoires of all sorts, the sofas and the armchairs had more severe designs and motifs imitating antique models. The surprise-desks, equipped with small secret drawers and technically smart "hiding places" were very popular in the daily life of the Russians. Small elegant "bean tables" whose name came from the form of their table top were also common. The Empress began her day seated at this kind of a table. The table tops were decorated with motifs in marquetry showing designs of bouquets, landscapes and varied ornaments. The game tables were identically decorated: often the Empress would finish her day seated at one of these tables, where she would enjoy resting in the middle of a circle of her friends playing cards or other games.

The skills of the masters who made the coaches and the sculpted sleds (fig. I) covered in frescoes and gilding were of an unparalleled virtuosity. Riding in one's equipage was strictly regulated according to rank and status of the person and the carriages were especially splendid. The ceremonial carriages and the sleds, rich in relief sculptures and sophisticated decoration were marvelously majestic. The carriages destined for the important occa-

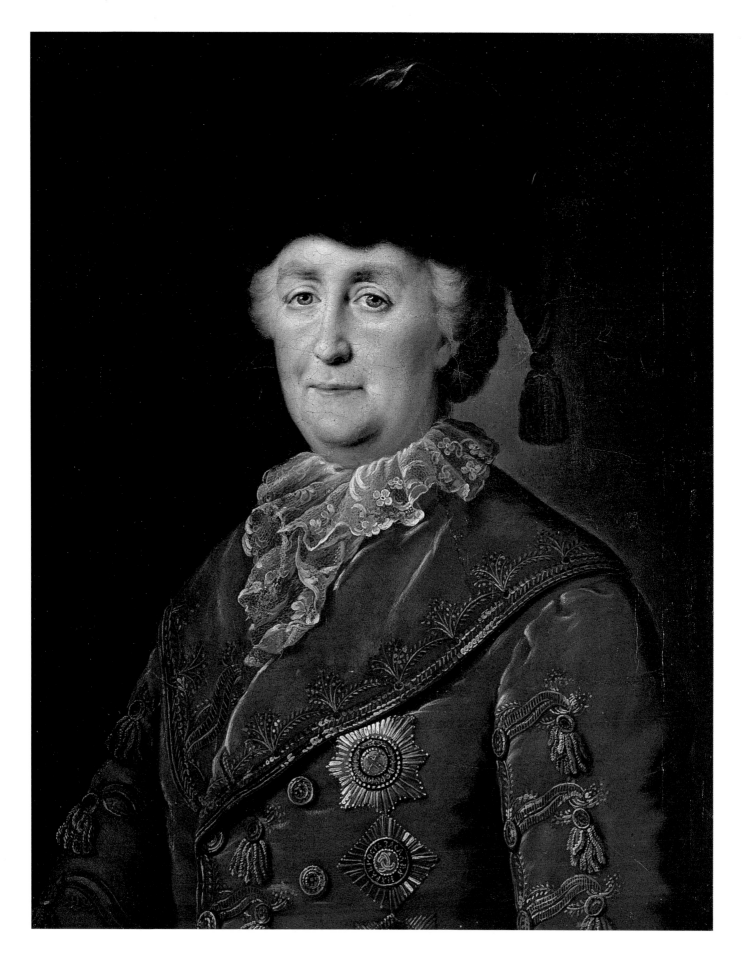

2
Catherine II's uniform dress based on the Horse Regiment Imperial Guard,
St. Petersburg, 1773

3
Catherine II's uniform dress based on the Imperial Guard dress of the Preobrajensky Regiment,
St. Petersburg, 1763

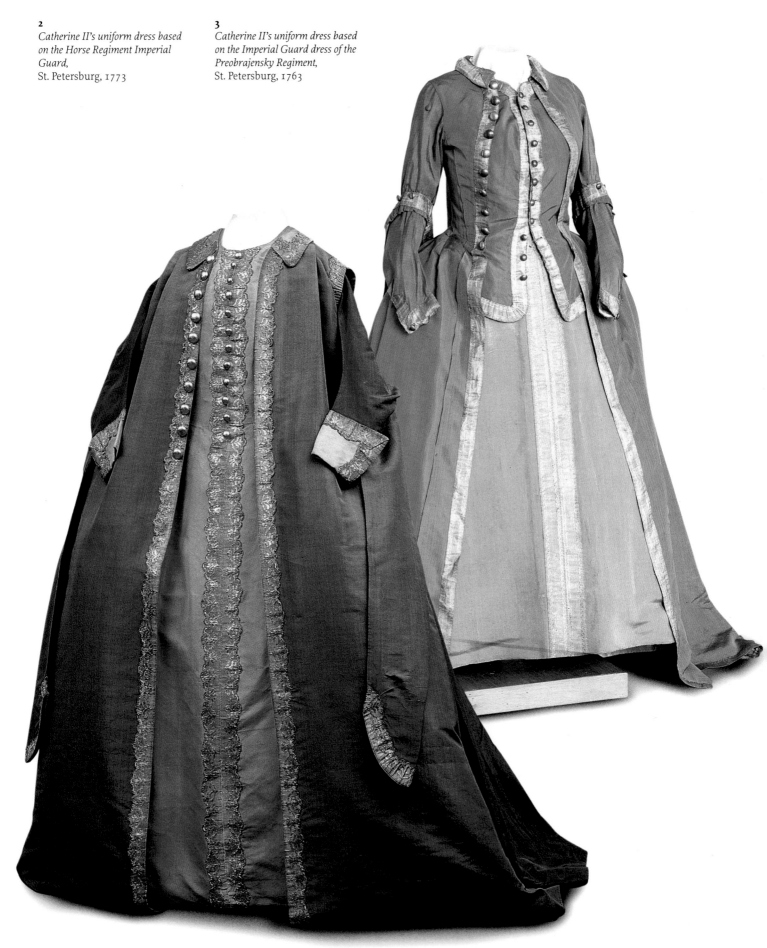

portant in Europe and its masters created virtuoso works of the greatest complexity. The splendid services for private individuals were created: the Iakhtinsky service, the Arabesque service, the Cabinet service, the Ioussoupov service. Each one of them had a particular theme represented in the painted decorations or in the sculpted compositions which accompanied these ceremonial services.

J.-D. Rachette who had worked at the imperial workshop as master modeler since 1779 considerably enlarged the scope of sculptures from the imperial manufacture by creating models which reproduced in porcelain many well-known works: the bust of Catherine II by F.I. Choubin, the group *Amour and Psyché* by A. Canova, *The Vestals* by C.M. Clodion and many others. These figures were often reproduced in biscuit and were used as table decors for the ceremonial services.[3]

The first series of sculpted figurines, *The people of Russia*, which inaugurated this favorite theme in porcelain was also created in Rachette's workshop. The work of the traveler I.G. Georgi *Description of the peoples of Russia...* served as the base of the work which Rachette carried out with his students from 1780 to 1804. The series was completed by the figurines of merchants and craftsmen, based on engravings by M.I. Kozlovsky and J.-B. Le Prince. The finished work included sixty figures.

The first private factories appeared at the end of the 18th century. Catherine also honored them with prestigious orders for the Court. In 1766, F.J. Gardner, an English merchant and forestry agent, founded a porcelain factory near Moscow in the village of Verbilki. Ten years later he began work on large dessert services (figs. 4, a, b and II–V) for the court receptions of the knights belonging to the four main imperial Orders. He succeeded brilliantly in carrying out

this order and gained an immense fame from it which assured the glory of his manufacture.

In the middle of the 18th century, glass was also very popular. Around 1760, twenty-five glass manufactures already existed in Russia. The most important of these was the St. Petersburg Imperial Manufacture. Before 1792, it belonged to Prince Potemkin. But it was Lomonossov who largely contributed to the expansion of glass-making. In 1754, he founded a glass factory in Oust-Rouditsa where he resumed the production of mosaics and conducted innumerable experiments to obtain new ways of making colored glass. Using smalt which had been perfected by Lomonossov, portraits and battle scenes began to be made in mosaic, on decorative panels and on table tops.

In the second half of the 18th century, the Russian master glassmakers continued Lomonossov's tradition in producing remarkable objects in vividly colored glass of such purity that they rivaled semi-precious stones. The glassmakers had at their disposal a palette of varied nuances. The vases, the palace dishes, the torches, the lamps, the candelabras, the furniture and the details of the decorative architecture were all made with colored glass. The greatest artists of the period participated in creating these objects in glass: G.I. Kozlov, D. Quarenghi, C. Cameron, I.E. Starov, and later, A.N. Voronikhin, V.I. Stassov, J. de Thomon, K.I. Rossi.

I.P. Koulibin, a talented inventor and mechanic, used a drawing by G.I. Kozlov to develop a marvelous construction called "the mountain of mirrors" with cascades of moving crystals. This curiosity was installed in the Winter Garden of the Tauride Palace[4] for the celebration of the conquering of Izmail. This was the farewell party for the master and organizer of these entertainments, Prince Potemkin. That day, the rooms and gardens were arranged with a luxury and inventiveness that astounded all the

4
F.I. Gardner Factory,
project designer G.I. Kozlov
*Pieces from the service
of St. George's Order,*
Moscow, 1778

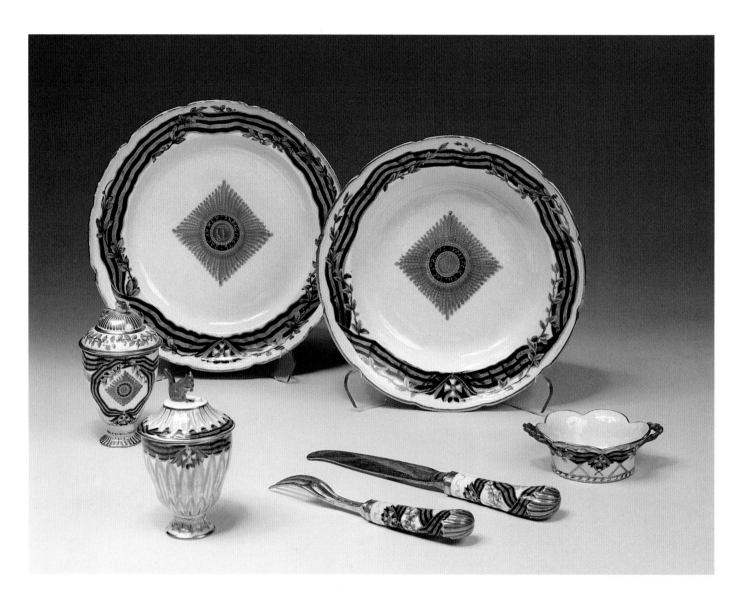

pletes the preceding period with verve, linked as it is to the work of the master D.I. Vinogradov and to the Baroque style, as well as inaugurating the Classical period. The project was elaborated by the famous painter-decorator G.I. Kozlov. It was customary in the 18th century for high dignitaries to spend a certain amount of time dressing in the morning while taking their breakfast, often in the presence of guests. This is why toiletry objects were a part of the services. The name of the owner of the service was designated by his monogram painted in gold "GGO" and the themes chosen evoked his life. The author who painted the decoration was the well-known miniaturist André Tcherny. The finely-painted views of military camp and war trophies were a reminder that Orlov had served in the artillery. The diversity and subtlety of the decorative process makes this service a masterpiece of the Russian porcelain of the era.

During the last decades of the 18th century, the imperial porcelain workshop became one of the most im-

los and in polychrome enamel as well as elegant pieces decorated with openwork in filigree.

The oldest center of enamel work and the production of objects in nielloed silver was Veliki Oustioug, where the famous Popov Brothers Factory was located during the years 1761 to 1776. They furnished an immense variety of dishes and utensils decorated with enamel and niellos.

In the second half of the 18th century, the obsession for natural stones and other fine stones was at its zenith. The most important mineral resources in Russia were at the origin of the extraordinary growth of the art of sculpted stones. Deposits of great varieties of jasper, of porphyry, of lapis-lazuli, of malachite, of agate, of cornelian, of amethyst and other semi-precious stones were found in the Urals, in the Altai and in Siberia during the 16th, 17th, and 18th centuries. The most important centers for lapidary art were the Peterhof gem-cutting workshops (founded in 1723), in Ekaterinburg in the Urals (in 1774) and Kolyvan in the Altai (in 1786). The art of sculpted stones in the second half of the 18th century was characterized by its remarkable technical skill. The most famous collectors in this field were the Empress herself, the prince G.A. Potemkin, the count A.S. Stroganov, the counts Cheremetiev and many other Russian dignitaries. In the applied arts and the architectural decorations, obelisks were very popular. They were introduced in honor of the Russian armies' victories—they crowned the cornices and decorated the chimney mantles.

In the second half of the 18th century, the art of tapestry reached its summit. In the 17th and 18th centuries, the tapestries were imported from France. Peter I who had discovered the works of the Gobelins Royal Manufacture had taken steps to develop the production of tapestries in Rus-

sia. In St. Petersburg, the National Tapestry manufacture began its activity under the management of the architect J.-B. Leblond in 1718 with the French master Philippe Béhagle as its director. In the St. Petersburg manufacture, works were ordered which were destined for the imperial residences and the private mansions of the aristocracy. In 1755, the Empress Elisabeth Petrovna ordered by decree that a tapestry be woven for the Winter Palace, then under construction, which was to represent the scene of her enthronement. Under Catherine, a period of great blossoming began for the manufacture: the entire production was reorganized, the number of masters was increased to 150. At the same time, dozens of students were trained and so the tapestries began to be Russian-made. These Russian artists worked with a vast number of themes and styles. The walls of the Petersburg palaces began to be covered with hangings and tapestries representing battles and historic scenes, allegorical and mythological compositions, portraits of emperors and dignitaries, still life, animals, birds.

Porcelain and glassworks were also among the main branches of the national artistic industry in the second half of the 18th century. The imperial manufactures of porcelain and glass which had been founded in the first half of the century flourished under Catherine II's reign. The imperial factories provided for the needs of the Court. Ceremonial services *au monogramme* of the person for whom they were destined, decorative vases and sculptures to decorate the private apartments of the palaces as well as a multitude of objects for daily life were made in these workshops for the Czars' residences. At the Empress's request, unique pieces were created to serve as diplomatic gifts or to be given to her close companions or her favorites.

The Orlov service, which Catherine gave to Prince Grigori Orlov, is a work of the transitional period. It com-

sions, such as the one for Catherine II's crowning, were unique objects of art.

The luxury of the courtiers' dress struck the young Catherine when she first arrived in Russia, enhancing as it did the splendor and the brilliance of the Court. The tone had been set by the Empress herself whose legendary taste in luxurious jewelry and finery and whose elegance had no equal among her entourage.

High society rapidly adopted all the ingenious details of the universally reigning French fashion. At the balls, the women, covered with diamonds, and with their high powdered hair styles and elegant finery, rivaled with each other in elegance. Under Catherine, the splendor of the Court receptions more than rivaled the magnificence of the Elizabethan Baroque fetes. They were the astonishment of foreign travelers and guests who were honored with an audience to the Court.

Elisabeth, and later Catherine, published frequent *ukases* to try to limit the aristocracy's clothing expenses. At the same time, "protectionist" decrees required materials to be bought from the Russian manufactures. Catherine, who criticized Elisabeth's extravagance, purposely was restrained in her own purchases for her personal needs although this restraint did not carry over into the considerable sums spent for the upkeep of her palaces and her gifts to her entourage and her favorites.

In daily life, Catherine wore a "Moldavian" dress, of loose-fitting cut and with large sleeves in lilac fabric or raw silk over which she wore a white shirt whose sleeves were gathered at the wrists. On ordinary days, she wore no precious jewelry or decoration. During celebrations or solemn occasions when she appeared in public, she wore the "Russian" dress in brocade or velvet with ribbons and medals of St. Andrew's, St. Vladimir's and St. George's orders. A small crown was placed at the top of her hair, exposing her forehead. During the Guard regiments' patron festivals, the Empress would appear in the uniforms (figs. 2, 3) whose color corresponded to those of each regiment, including stripes and buttons.

Catherine introduced the wearing of the "Russian" dress to the Court, and she enjoyed taking elements from the national dress for her personal wardrobe: the *kokochnik*[2], covered with an embroidered silk kerchief, of loose-fitting cut, with Russian motifs, and with large armholes and sleeves. In the years 1780 to 1790, fashionable dress took on a more and more classical style. The sumptuous dresses were replaced by lightweight, light-colored tunics which gave the women an air of antique statues.

Catherine was passionate about collecting fine rare stones, the most perfect jewelry specimens, and to store them, she had the "room of diamonds" built in 1764 in her Winter Palace private apartments. She gave expensive gifts most liberally to her favorites—delicate snuff-boxes, rings and extremely valuable jewelry sets. A whole group of famous European jewelers worked in St. Petersburg: G.P. Ador, I.G. Scharff, J.F.X. Bouddé, L.D. Duval, G. Koenig.

Master jewelers of extreme virtuosity such as J.F. Köpping, J.N. Lundt, J.H. Blom who made dishes and other precious objects to decorate the homes of dignitaries living in the capital. As for the muscovite masters, A.V. Polozov, I.I. Verechtchaguin, J.S. Maslenníkov, P.A. Afanassiev, A.P. Kouzov, they followed the tradition of the Russian jewelry makers. Particularly skilled artists lived in Veliki, Oustioug, Kalouga, Vologda, Tobolsk, Yaroslavl, Pskov, Kiev and in a lot of other ancient centers where these art professions were practiced. They were particularly dexterous at creating objects decorated with ornaments and motifs in niel-

guests. A myriad of fires emanated from the black crystal lamps, and thousands of lights and colored-glass lamps had transformed the palace into a enchanting vision. Incense burners had been placed in the garden among the fragrant-smelling plants and the exotic flowers. A water fountain of lavender had been installed, a temple made of Paros marble had been built to honor the Empress, and there were pyramids made of mirrors, all their crystals shining and sparkling. The precious dishware added even more to the sumptuousness of the atmosphere in which receptions and feasts succeeded one another without end and where the Russian dignitaries gave themselves up to "the pleasures of the table." The vice-chancellor, Count I.A. Osterman, gave four official banquets every year in honor of the Empress: the day of her birthday, the day of her enthronement, the day of her coronation, and her namesake day.

The masterpieces of decorative arts presented in this exhibition are a perfect illustration of the production of the great centers where they were first created. They reflect the brilliance and the magnificent of the Great Catherine's era and bear witness to the variety and the specificity of this "golden age" of Russian artistic creation.

T.V. Koudriavtseva

[1] Georgi, I.G., *Opisanie Rossijskogo imperatorskogo stolicnogo goroda Sankt-Peterburga*, Spb, 1794, p. 602-603.

[2] Head-dress which varied according to the regions: a sort of a band in the form of a diadem or sometimes conical.

[3] Popova, I.P., *Farforovye kompozicii J.D. Rasetta k paradnym servizam konca XVII v.*, Presnovskie ctenija, E.L., 1989.

[4] Kučumov, A.M., *Russkoe dekorativnoe prikladnoe iskusstvo v sobranii Pavlovskogo dvortsa-muzeja*, L., 1981, p. 178.

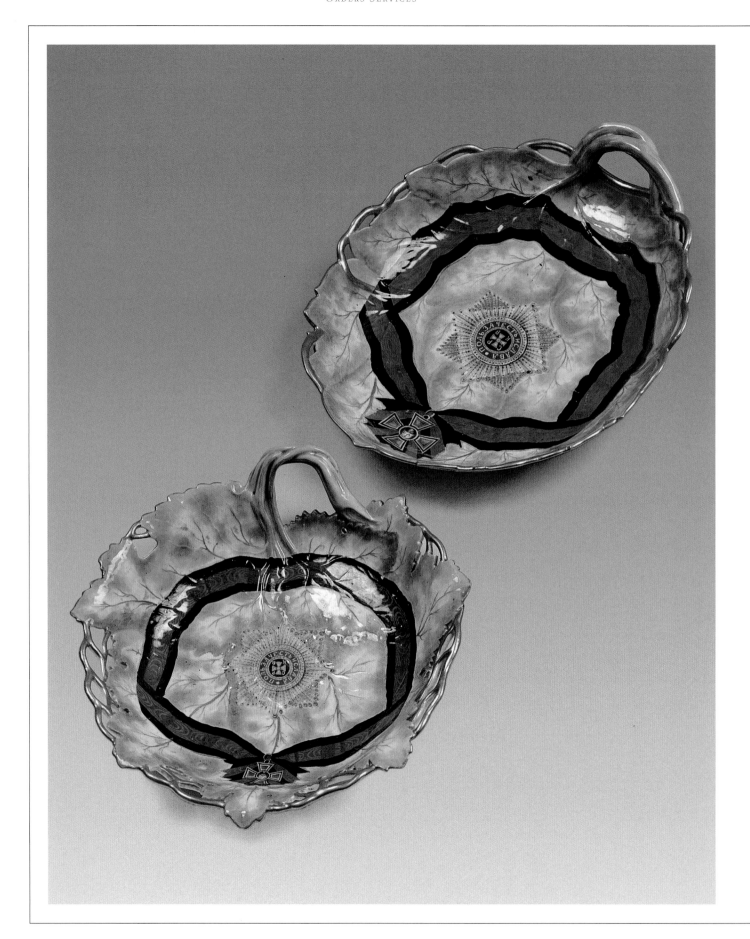

Orders Services

It was the sumptuous service by the Berlin manufacture, offered by Frederick II (1772) to Catherine the Great which inspired the Imperial Orders services. The painter and decorator G.I. Kozlov created the pieces for this project. He had often worked for Prince Potemkin who recommended him for important occasions.

The artist used the particular shapes and details from the decorations of Prussian services while at the same time giving them the smoother, picturesque, plastic qualities so characteristic of Russian porcelain. The decorative elements of color with the emblems of the Orders dominated the final project: stars, crosses, coiled ribbons in the garlands and leaves. The service of St. George's Order which included 80 place settings, that of St. Alexander Nevsky which had sixty and that of St. Andrew which had 50 were ordered in 1777.

Catherine had always remembered the role the officers had played in her accession to the throne and during her entire reign, and sometimes in spite of her personal fatigue, never missed attending the ceremonies for the regiments and the knights.

In 1780, all the services which had been ordered arrived at the Court.

Between 1783 and 1785, the most impressive among them, the St. Vladimir service which had been created for 140 people was finished at the Gardner manufacture.

All the services of the Imperial Orders, once they arrived, were kept in the Winter Palace warehouses, in the Court Marshal's Supply Corps, and were used once a year upon the occasion of the ceremony in honour of the knights of the corresponding order.

Gradually during the whole of the 19th century, the Imperial porcelain manufacture completed the services.

T.V.K.

a
F.I. Gardner Factory,
project designer G.I. Kozlov
*Pieces from the service
of St. Vladimir's Order,*
Moscow 1783–1785

b
F.I. Gardner Factory,
project designer G.I. Kozlov
*Pieces from the service
of St. George's Order,*
Moscow, 1778

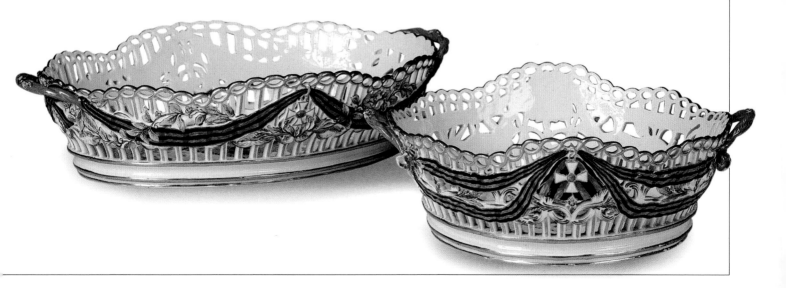

I
Carnival sleigh,
Russia, 1760s

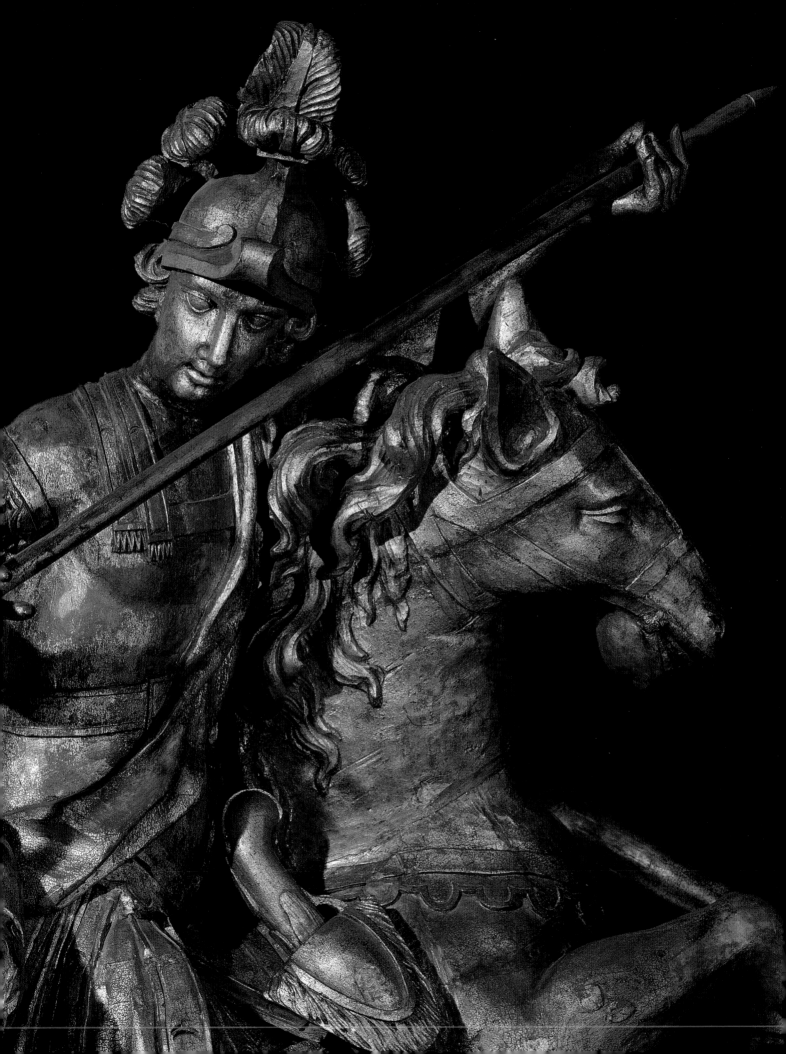

II
F.I. Gardner Manufacture,
project designer G.I. Kozlov
*Six pieces of the service of the Order
of St. Andrew the First Called,*
Moscow, 1779–1780

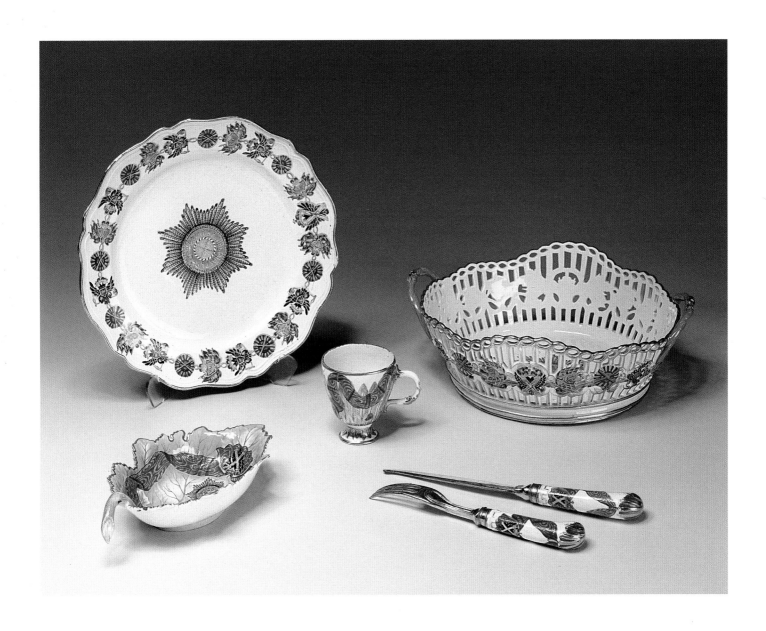

III
F.I. Gardner Manufacture,
project designer G.I. Kozlov
*Seven pieces of the service of
the St. Alexander Nevsky's Order,*
Moscow, 1779–1780

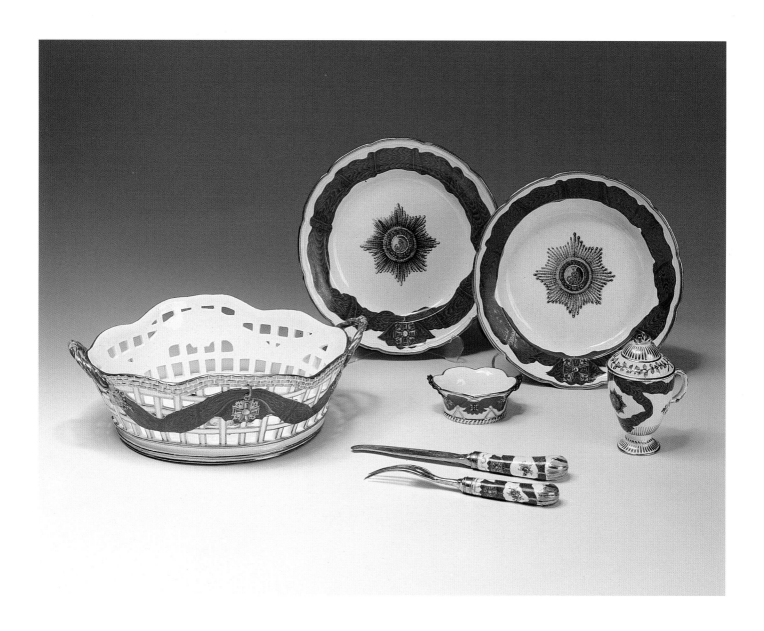

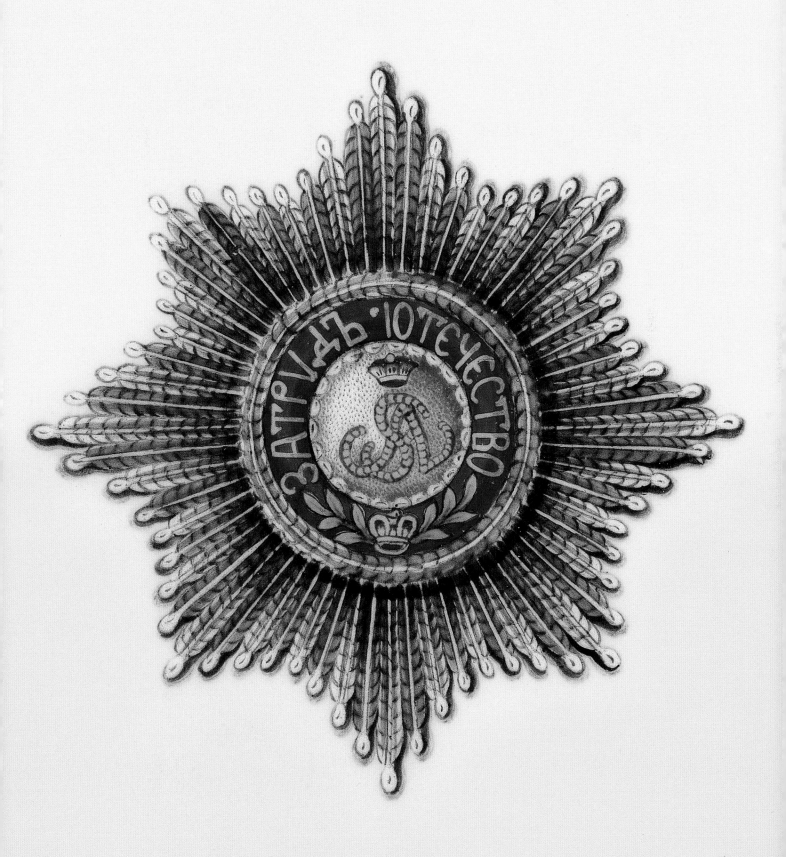

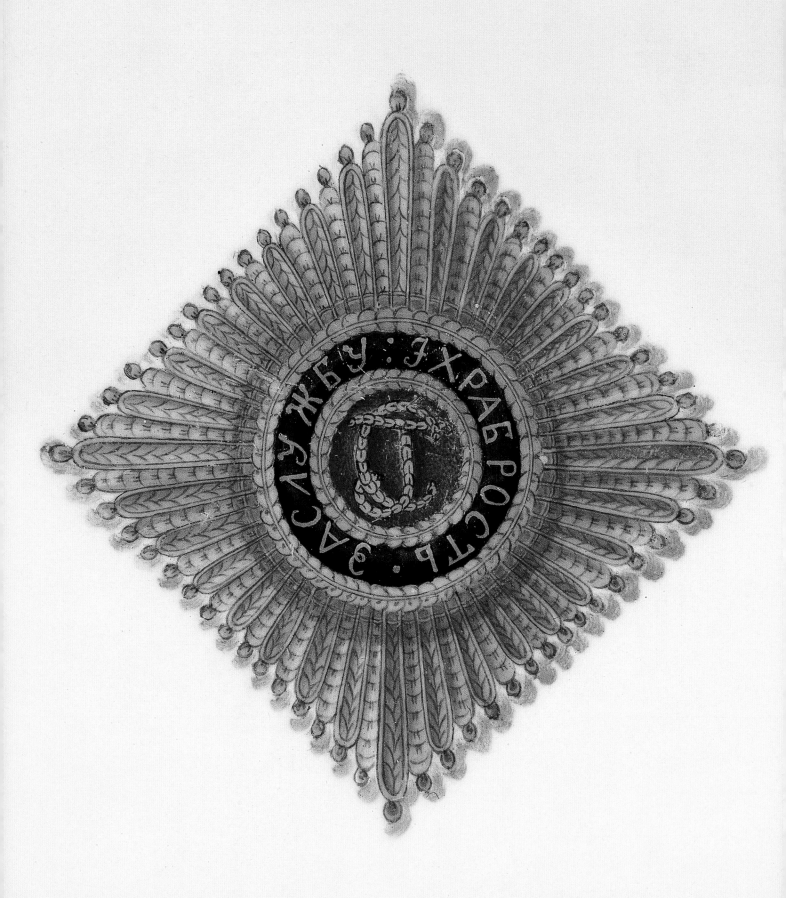

IV
F.I. Gardner Manufacture,
project designer G.I. Kozlov
*Two pieces from the service
of St. George's Order,*
Moscow, 1778

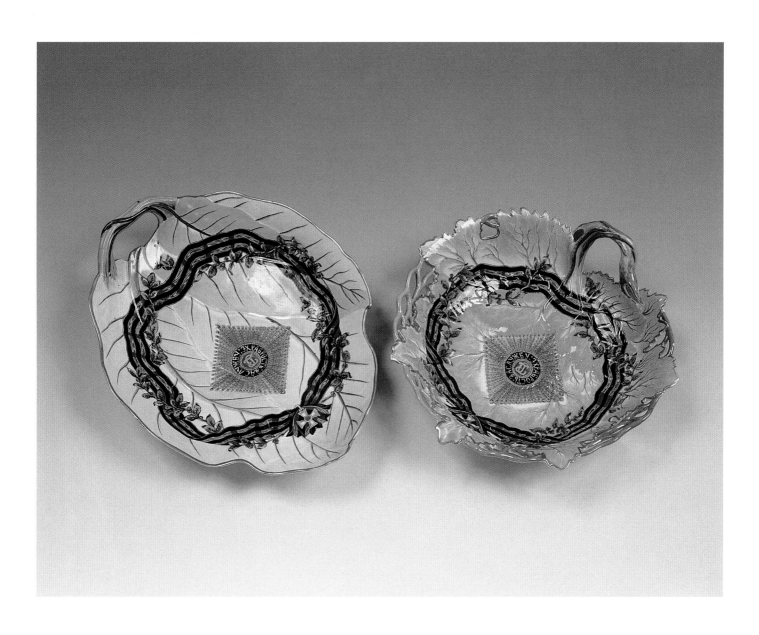

V
F.I. Gardner Manufacture,
project designer G.I. Kozlov
*Five pieces from the service
of St. Vladimir's Order,*
Moscow, 1783–1785

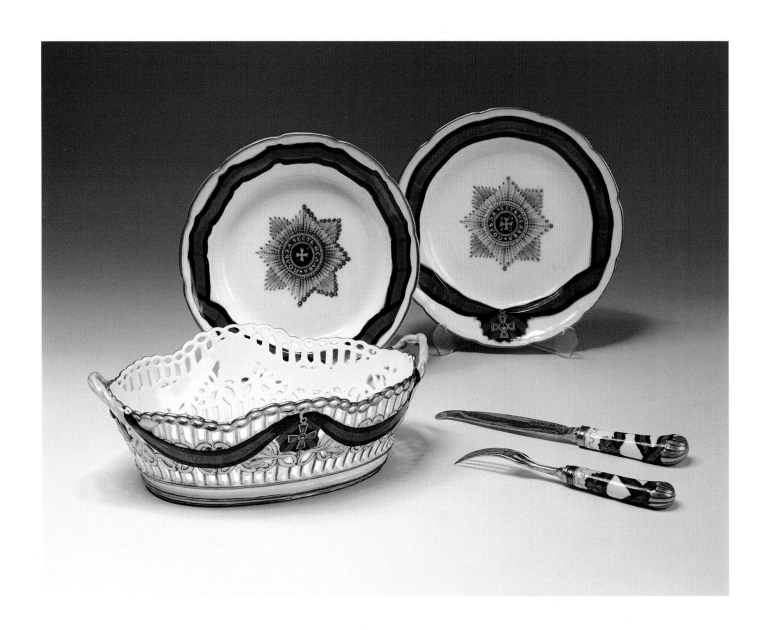

Catherine II, the Collector

"*I have just concluded a very important affair. It is the acquisition of the Crozat collection, added to by his descendants and known today by the name of the Baron de Thiers Gallery. It includes works by Raphael, Guido, Titian, Carracci, Le Sueur, Poussin, Van Dyck, Schidon, Carlo Lotti, Rembrandt, Wouwerman, Teniers etc., to the number of around 500 pieces. This is costing Her Majesty 460,000 pounds.*"

Letter to Falconet, April 17, 1772,
Correspondance, éd. Laffont, coll. Bouquins,
vol. V, p. 1106

There was no tradition of art collecting in Russia until the reign of Peter I. The first Russian museum, the *Kunstkamera*, was founded just after Peter's trip to Europe. Peter visited Paris in 1717: it was there that he discovered the work of the Palais de la Monnaie, as well as tapestry manufacturing. He went to the Académie Française and admired the paintings at the Palais Royal. But it was his visit to the Luxembourg Palace where he saw a series of paintings by Rubens, recounting Marie de Médicis's life, which made the most vivid impression upon him. Peter was given gifts of tapestries and bought paintings and upon his return to his new capital, following the example of the European monarchs, he founded the *Kunstkamera*. It held a collection of natural history exhibits as well as a small collection of paintings of great masters, mostly Dutch and Flemish. The selection of these works still owed very little to their aesthetic value. The goal was primarily educative: outside of works which, for example, showed an anatomic collection, the other paintings, presented by theme, were hung to familiarize the public with the different genres of painting.

At the same time, an artistic collection was beginning to be put together in the country residence of Peterhof. The collections were acquired with a specific goal in mind and the choice fell particularly upon the paintings of the Dutch and Flemish masters, small format paintings which reflected the Czar's taste. It was not yet a collection in the strict sense of the term. During the following decade, Peter acquired small-scale paintings for his personal pleasure and to decorate his beloved Mondesir Palace, the little Marly and the Hermitage Pavillion. The Czar's infatuation rapidly became a fashion.

This fashion developed even more during the reign of Peter's daughter, Elisabeth, who made some important acquisitions, notably the collection purchased in Prague in 1745 by the intermediary of the court painter G. K. Groot, which brought together mostly paintings by French and Italian masters. A "Paintings Room" was especially created in the Grand Palais of Tsarskoye Selo, the country residence of the Russian Czars, to show the works. The paintings covered the walls from top to bottom, creating an original decorative effect.

It was undoubtedly during the reign of Catherine II that the building up of a real collection of art works was begun.

Catherine, who married the Grand Duke Peter Fedorovitch, Peter the Great's grandchild from the matrilineal side, had the first "room of paintings" built in the Oranienbaum Palace outside of Petersburg, where she lived for almost twenty years. This collection was mostly made up of acquisitions which had been randomly collected and which were ultimately given to the Fine Arts Academy.

After her accession to the throne, Catherine created her own collection with a precise goal in mind, to make it one of the most important collections in Europe. If Peter I had acquired paintings for his own pleasure, Catherine was guided to a certain extent by political and state aims. Her wish was to create, in the Imperial Palace, a gallery as valuable which as the European ones, thus increasing the prestige of the Russian state and appearing as an enlightened ruler.

She succeeded brilliantly. In just 20 years, she created the Winter Palace gallery of paintings, made up of remarkable works, both for their artistic significance and their quality of execution.

The founding of the Hermitage dates from 1764, that is, from the moment when the collection belonging to the Berlin merchant Johann Ernest Gotskovsky entered the

1
Gerrit van Honthorst
The Musician, 1624

2
Gerrit van Honthorst
The Entertainer, 1624

Winter Palace, the imperial residence.[1] This collection included 225 remarkable paintings mostly by Dutch and Flemish masters, although it also included some French and Italian works, equally valuable. The circumstances surrounding the acquisition of this collection are interesting: it was initially destined for the Prussian king, Frederick II, a famous collector who had created the Sans-Souci Gallery in Postdam. But financial problems due to the Seven Years' War prevented him from making the acquisition. Vladimir Sergueievitch Dolgoroukov (1717–1803) who was the Russian ambassador at the Prussian court informed Catherine of the opportunity. Being a shrewd politician, she could not miss such an occasion: the collection served to pay off Prussia's debt to the Russian treasury.

This first collection acquired for the Hermitage, which was the base of the whole collection to come, is represented in the exhibition by a pair of paintings by Gerrit van Honthorst, *The Entertainer* (fig. 2) and *The Musician* (fig. 1), both of them dated 1624, and by a painting by Niccolò Cassana, *Nymphs and Satyr* (1585) (fig. 4).

This purchase which came about by chance seems to have encouraged Catherine to put together a major artistic collection. The Russian ambassadors at their respective European courts were given the mission to systematically seek out paintings to be acquired by the imperial painting gallery.

The prince Dmitri Alexeievitch Golitsyn (1734–1803) played a predominant role in this undertaking. He was the Russian ambassador to Paris from 1765 to 1768, and then, from 1769 to 1797 at The Hague. The diplomat Golitsyn was a very cultivated and talented man who left his imprint in a number of fields: he was a man of letters and a historian but he was also the author of works on mineralogy, economy, medicine, and art history. He was elected to a number

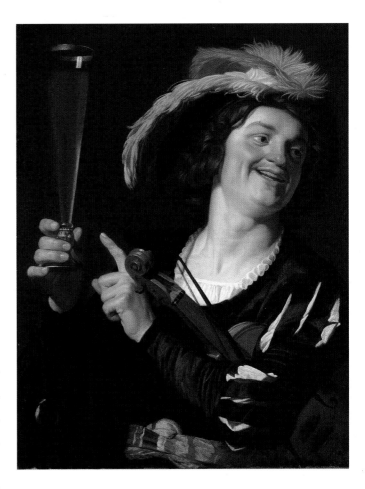

of European academies and was member of honor of the St. Petersburg Fine Arts Academy. He purchased some of Catherine's first important acquisitions in the Parisian auction sales.

He acted as intermediary in 1767 for the purchase of Jean de Julienne's collection of paintings (1686–1767).[2] Jean de Julienne was a friend of Antoine Watteau's and connoisseur of paintings. He was director of the Gobelins Manufacture. He was an amateur engraver, a patron of the arts and collector, but his fame came primarily from the publication of engravings made from Watteau's paintings. His collection was essentially made up of works from the first half of the 18th century which had been purchased in Parisian auction

3
Peter Patel, the Elder
*Landscape with Christ
and a Centurion*, 1652

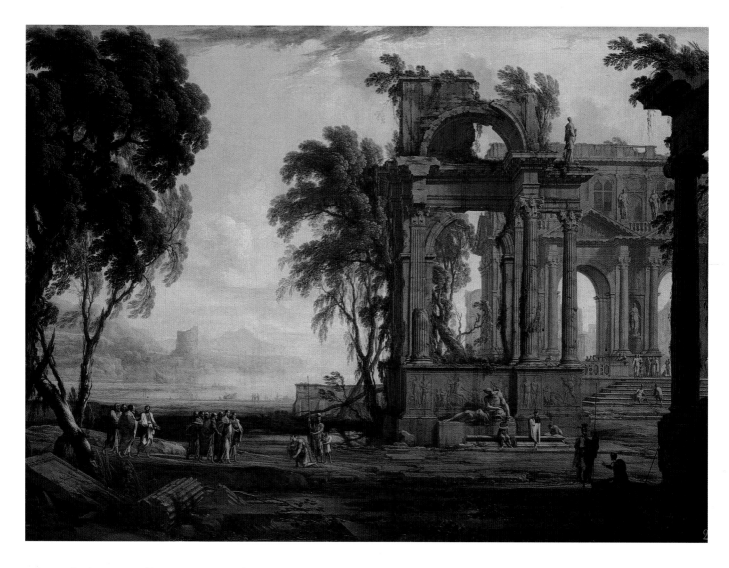

sales: paintings as well as engravings, drawings, sculptures, and applied works of art. The whole was of an exceptional quality. It was probably because of such quality that the auction sale of the collection was held in the Louvre, in the building usually reserved for exhibitions. Golitsyn bought several works, among them a landscape by Peter Patel, the Elder, *Landscape with Christ and a Centurion* (1652) (fig. 3).

Two years later, in 1769, came a new important acquisition, in Saxony this time, thanks to another Russian diplomat, Alexander Mikhaïlovitch Beloselski-Belozerski

(1752–1809). It concerned the very famous collection belonging to Count Henry von Brühl (1700–1763)[3] which was bought in its entirety from his heirs. Von Brühl, who was one of August III's ministers at the Saxony Court was also in charge of buying for the Dresden painting gallery. Benefiting from the opportunities given him by this mission, von Brühl had built up his own personal collection at the same time. It consisted primarily of more than six hundred paintings by Dutch and Flemish masters, but the French and Italian schools were also represented. And so it was that these

remarkable jewels of French painting entered the Hermitage, paintings such as *An Embarrassing Proposition* (1716) (fig. 5) by Antoine Watteau and *Christ appearing to Mary-Magdelene* by Charles de Lafosse (fig. III). A remarkable still life by Jan Davidsz de Heem, *Flowers and fruits* (1655), was included also to complete the Flemish collection.

The whole of the engravings and drawings of the von Brühl collection was the starting point for the Hermitage's exhibition room of graphic works.

The Empress's interest in building up the collections increased in the 1770s and this activity gathered a new momentum. The Empress devoted a great deal of time and energy to it. She mentions in her correspondence with the Baron Melchior Grimm that she had learned a great deal through "the assiduous reading of collection catalogues." But Catherine did not rely only on her own taste and knowledge in her choice of paintings to purchase but also on the considered advice of connoisseurs. She was corresponding with Voltaire and Diderot during this time, and the Parisian art market afforded her the opportunity to make new acquisitions. Outside of the important collections destined for the Hermitage, she also bought isolated works from private collectors or antique dealers. Diderot kept her regularly informed about the collections and paintings of quality which were up for sale in the Parisian auction sales. Catherine also sought the advice of Etienne Maurice Falconet, a sculptor she had invited to Russia and given the commission for the monument for Peter I. It was on the advice of Falconet that in 1771 she bought from an unknown merchant a landscape by Claude Gellée called Le Lorrain, *Christ on the Road to Emmaus* (1660) (fig. 9). But the source of a number of paintings which entered the collection during those years remains obscure. This is the case of such important works as *The Holy Family in the Center of*

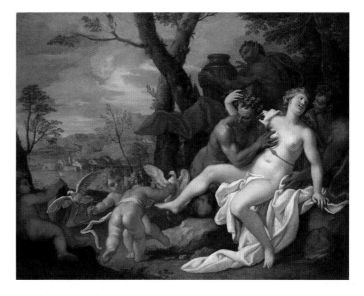

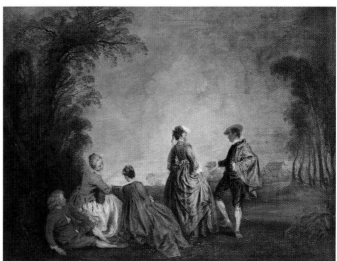

a Crown of Flowers by Nicolas Loir (fig. 7), *The Resurrection of Christ* (fig. VII) by Paolo Veronese or *The Adoration of the Magi* (small format) by the Bolognese master, Giovanni dal Sole (fig. VI).

1774 saw the first printed catalogue of the new collection. It included an assessment of all the acquisitions Catherine II had made in the past ten years.[4] It was an impressive record: in that short time, 2084 paintings had been

6
Anton Raphael Mengs
*St. John the Baptist Preaching
in the Desert*

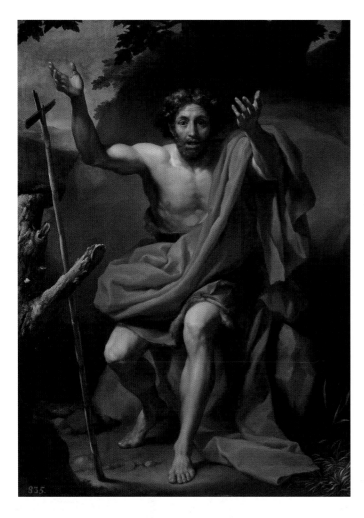

acquired, among them some genuine masterpieces and many paintings of excellent quality.

But this was not enough for the Empress and she continued her quest for treasures. She made another major acquisition which caused a great stir in the European capitals, comparable by its importance only to the acquisition of the Crozat collection. It was the former English Walpole collection. Sir Robert Walpole, first count of Orford (1676–1745) had been England's prime minister under George I and George II. He was a fervent collector and had amassed a remarkable collection of paintings in the family house, Houghton-Hall in Norfolk. This collection had been creat-

ed at the beginning of the 18th century and was made up of works of the highest quality from the Italian, Flemish, and French schools. It was considered one of the best collections in England and in Europe. His son, Horace Walpole (1717–1797), a famous writer, wrote and published an inventory of this collection in 1747.[5] Catherine was informed by the intermediary of the Russian ambassador to London, Alexeï Semienovitch Moussine-Pouchkin (1732–1817), about the chance to acquire this collection from the heir to it, Sir Robert's grand-nephew George Walpole (1676–1791). The latter, crippled by debt, was forced to sell his collection, which was then added to that of the Empress's. These 198 paintings, all of an exceptional quality, came to enhance the glory of the collection, enriching in particular the collection of Flemish painters. The Walpole collection is represented in the exhibition by a work of Carlo Maratta, *Madonna and Child and John the Baptist* (fig. 8).

Another remarkable collection was to be acquired, this time in Paris. Catherine heard in 1780, through Baron Grimm's considered advice, of a handwritten catalogue about Count Baudoin's art collection in Paris. She acquired that collection for her favorite, Count A.D. Lanskoï. He died soon after that however, and the collection entered the Hermitage. The Baudoin collection[6], considered one of the best in Paris, included 119 paintings of exceptional quality from several schools. *The Holy Family and St. John the Baptist* by Benedetto Caliari (fig. V) comes from this collection. The Baudoin Collection was the last major acquisition of the 18th century.

Catherine was also interested in the painting of her time and she bought directly from the studios. This is how one of the best collections of the work of the German painter Anton Raphaël Mengs (fig. 6) entered the Hermitage. The Empress particularly admired his work and his name was frequently quoted in her letters to Grimm. Af-

7
Nicolas Loir
The Holy Family in the Center
of a Crown of Flowers

8
Carlo Maratta
Madonna and Child
and John the Baptist

ter the artist's death, in 1780, she ordered to acquire a large number of Mengs' works which had remained in his Rome studio. The drawings were given to the Fine Arts Academy, the paintings to the Hermitage.

By the middle of the 1780s, the selection of the Hermitage gallery was practically complete. There were fewer and fewer purchases. In her letters from this time, Catherine frequently mentions that she has bought practically nothing. Her goal had already been accomplished. The Hermitage, created in just twenty years, had become one of the jewels of the Russian capital, first of all its immense gallery of paintings, well renowned all over Europe. On the Empress's order, an inventory of all the paintings was drawn up in 1783–1785. Ernst Münich was put in charge of the project. He drew up a hand-written catalogue in three volumes which contained the description of the 2658 paintings.[7] Near the end of Catherine's reign, the prestigious art gallery contained more than three thousand paintings and was one of the best court collections in the Old World.

The artistic life of St. Petersburg during the second half of the 18th century was particularly rich. Along with the Imperial Museum, there were many among the nobility who built up their own collections: it was not just the fashion, as but a real passion.

During the years 1770–1790, private Russian art collections flourished, with the works being purchased on trips to foreign countries or at St. Petersburg art auction sales. There were a number of art galleries in the city, the most famous among them being the Klosterman shop on Nevsky Prospect. The Empress herself visited it, to buy paintings or engravings for the Hermitage. The palaces of the Russian aristocracy overflowed with inestimable treasures.

The 19th century saw no major change in the state of affairs of the collection. Purchases were rare and occasional.

9
Claude Gellée, known
as Le Lorrain
Christ on the Road to Emmaus,
1660

There were however a few truly excellent acquisitions which, while not especially adding to the glory of the present collection, did complete it. One of these was the acquisition of the Barbarigo collection[8], under the auspices of General A.V. Khvostov, consul in Venice. It was a unique collection in the sense that it included paintings by Titian which had been bought by Cristoforo Barbarigo from the son of the artist, Pomponio Vecellio, in 1581. For almost three hundred years, the *Christ carrying the Cross* by Titian (fig. VIII) had remained in this famous Venetian collection. In 1845, at the death of the last representative of the Barbarigo family, a catalogue was drawn up and the collection sold. This was how in the 19th century the Russian imperial family continued the tradition begun by Peter I and brilliantly carried on by Catherine II.

By the middle of the century, the Hermitage had little by little ceased to be a court gallery forbidden to the public and was transformed into a museum open to all. Nicolas I ordered the construction of an independent building where the impressive collection of paintings collected by his grandmother could be shown.

The Imperial Museum which was built under the direction of the Munich architect Leo von Klenze was inaugurated in 1850. At the same time, a scientific study of the collection was begun. Beginning in 1863, catalogues on the different schools of painting began to be published, studies that continued through the end of the century.

N. Serebriannaïa

[1] The inventory of this collection, established by I. Chtéline, *Vornehste Stücke aus dem Ihro Kays. Maj. Verkauften Gotzkowsky Cabinet aus Berlin*, is kept in the Hermitage Museum Archives.

[2] *Catalogue raisonné of paintings, drawings, engravings and other curious items after the death of M. de Julienne, squire, Chevalier of Saint-Michael and Honorary member of the Royal Academy of Paintings and Sculpture by Pierre Remy*, Paris, 1767; *P.G. Catalogue of paintings by Mr. de Julienne. Connaissance des Arts*, April, 1956.

[3] *Collection of engravings, from the paintings of the Gallery and of the Cabinet of S.E. Monsieur the Count of Brühl*, Dresden, 1754.

[4] [Munich, E.] *Catalogue of paintings from the St. Petersburg Galleries and Imperial Rooms* [Saint-Petersburg], 1774. The contents of this catalogue were incorporated into the work of Johann Bernulli, who visited the Hermitage in 1778: Bernulli, J., *Reisen durch Brandenburg, Pommern, Preussen, Curland, Russland und Poland in der Jahren 1777 und 1778*, Leipzig, 1780, vol. 4, p. 169–284; republished in 1861 by Paul Lacroix in the "Revue universelle des Arts", 1861, vol. 13, p. 164–179, vol. 14, p. 212–225; 1862; vol. 15, p. 106–123.

[5] *Aedes Walpolianae: Or a Description of the Collection of Pictures at Houghton-Hall in Norfolk. The Seat of the Right Honourable Sir Robert Walpole, Earl of Orford. The Second Edition with Additions*, London, MDCCLII, First Edition, 1747. *A Set of Prints Engraved after the Most Capital Paintings in the Collection of Her Imperial Majesty, the Empress of Russia, lately in the Possession of the Earl of Orford at Houghton in Norfolk*, publ. by John and Josiah Boydell, London, vols. 1–2, 1788.

[6] *Description of paintings from the Cabinet of M. le Baudoin 1780 Count of Baudoin, Brigadier of the King's Armies, Captain commanding a battalion of the French Guards*, 1780, Hermitage Museum Archives.

[7] Münich, E., *Catalogue raisonné of paintings from Galleries, Salons and Cabinets of the Saint Petersburg Imperial Palace, 1773–1783*, vol. 1, 2; 1783–1785, vol. 3, from the Hermitage Museum Archives.

[8] *Insigne pinacoteca della nobile Veneta famiglia Barbarigo della Terrazza, Descritta ed illustrata da G.C. Bevilacqua*, Venezia, 1845.

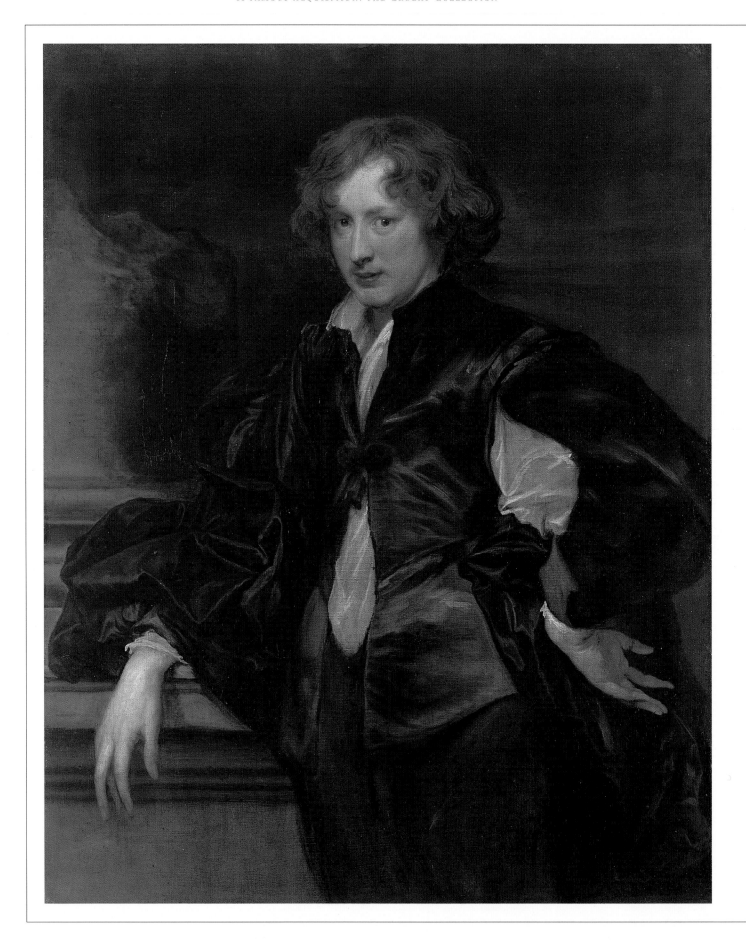

A famous acquisition: the Crozat Collection

In 1770 the Hermitage already owned a significant collection of valuable paintings, but the most important event in the building up the collection was the acquisition in Paris in 1772 of one of the richest and most famous private collections of the 18th century, the Crozat collection.[1] The one responsible for this collection, the Parisian financier Pierre Crozat (1661–1740), treasurer to Louis XV, was a great connoisseur of painting. He had devoted his whole life to art collection, sinking a great part of his fortune into this passion, and had built up an exceptional collection, reputed to be one of the best in Europe. It included not just paintings, but also a unique body of drawings, engravings, sculpture, porcelain and a room devoted to sculpted stones. Pierre Crozat was also the owner of a library of more than 20,000 volumes which was in his home on the rue Richelieu, a place where artists and art connoisseurs would frequently gather. Antoine Watteau and Charles de Lafosse even lived there for a time. In 1740, at the death of the banker who had no direct heirs, his will designated his nephews as heirs to the collection. In 1751, Louis-Antoine Crozat, Baron of Thiers, inherited the greatest part of this collection. Like his uncle, he too was a fervent collector of paintings and he considerably increased the volume of the collection which he had inherited. In 1770 at his death, financial problems forced his heirs to sell. By then, the collection included nearly 500 paintings from different schools.

The acquisition of this collection for the Hermitage was carried out by the intervention of Denis Diderot and François Tronchet, councilor to the Geneva magistrate, friend of Voltaire, and himself a famous collector. Tronchet advised Grimm and Golitsyn to buy the whole collection. Diderot sent a catalogue to Catherine. Tronchet went to Paris to appraise the collection. The negotiations lasted more than a

Page 276
a
Anthony van Dyck
Self-portrait, around 1630

Page 277
b
Nicolas Poussin
Venus, Faune and Putti,
around 1630

c
Giulio Cesare Procaccini
Madonna and Child

year. Catherine acquired the collection in January 1772 for the sum of 480 thousand pounds: the collection arrived in St. Petersburg in the autumn.

This sale caused a sensation in Paris and throughout Europe, particularly as it took place during a very costly war between Russia and Turkey.

The entry of the Crozat collection into the Hermitage gallery considerably raised the level of the Imperial collection. Every department of the gallery was enriched by exceptional works. A notable example, *Self-portrait* by Anthony van Dyck (fig. a), the jewel of the Flemish collection. Most of the paintings in the French section were small-format pictures in which the artist revealed all his mastery of color. Poussin is represented by the painting *Venus, Faune and Putti* (fig. b) a work from the short period at the beginning of the year 1630, period when the artist was intensifying his research on color. Today many of the paintings from this collection are on display in the permanent collection of the Hermitage: *Darius opening the Tomb of Nitocris* by Eustache Le Sueur (fig. VI),

Concert in the Park by Nicolas Lancret (fig. II), *Cupid sharpening his Arrow*, (1750) by Charles Joseph Natoire (fig. I). The collections were also enriched by the entry of a number of Italian paintings, among them *Madonna and Child* (fig. c) by the master of Bologna Giulio Cesare Procaccini.

The acquisition of the Crozat collection completed a collection begun ten years before. More than two thousand paintings had been acquired during that period: the modest gallery of its beginning had become one of the most important court collections of Europe. At the beginning, the collections were housed in two galleries of a building located next to the Winter Palace and linked to it by the covered passageway of the Little Hermitage. That was where Catherine had her library and where she enjoyed moments of solitude in one of the two lateral pavilions whose windows gave out onto the River Neva, and that is how the Hermitage Museum got its name (name formerly given to the Empress's private apartments). Later, this building was given the name of Gallery of Imperial Art. The galleries

gave out onto a roof garden, decorated with marble statues. The exhibition of the paintings was purely decorative: they were hung by several rows on the wall, many of them in beautiful gilded frames, but even with this "squeezed-in" exhibition, there was soon no longer any room. In 1783, the construction of a new palace building was completed, the Old Hermitage, and a part of the collection was transferred into these new and richly decorated rooms. At that time, the exhibition was not a permanent one: the arrangement of the paintings was often changed. According to the account of Jacob Stählin, a court historiographer and author of *Notes on the Arts in Russia* (a first account of the history of Russian art), Catherine herself would go almost daily to the new gallery to rearrange the hanging of the paintings. Unfortunately, the plans of the various ways in which the paintings were hung have been lost. Only the Empress's guests were allowed into the gallery and a special code of behaviour was drawn up which they were expected to follow.

N.S.

[1] *Catalogue of paintings from the Cabinet of M. Crozat, baron of Thiers*, Paris, 1755. Stuffmann, M., *The paintings of the Pierre Crozat collection. History and destiny of a famous collection, established from an inventory after death (1740)*, GBA, 1968, vol. 72, July–September, p. 11–43.

I
Charles Joseph Natoire
Cupid sharpening his Arrow, 1750

II
Nicolas Lancret
Concert in the Park

III
Charles de Lafosse
*Christ appearing
to Mary-Magdalene*

IV
Giovanni dal Sole
The Adoration of the Magi

V
Benedetto Caliari
*The Holy Family and
St. John the Baptist*

Pages 286–287
VI
Eustache Le Sueur
Darius opening the Tomb of Nitocris

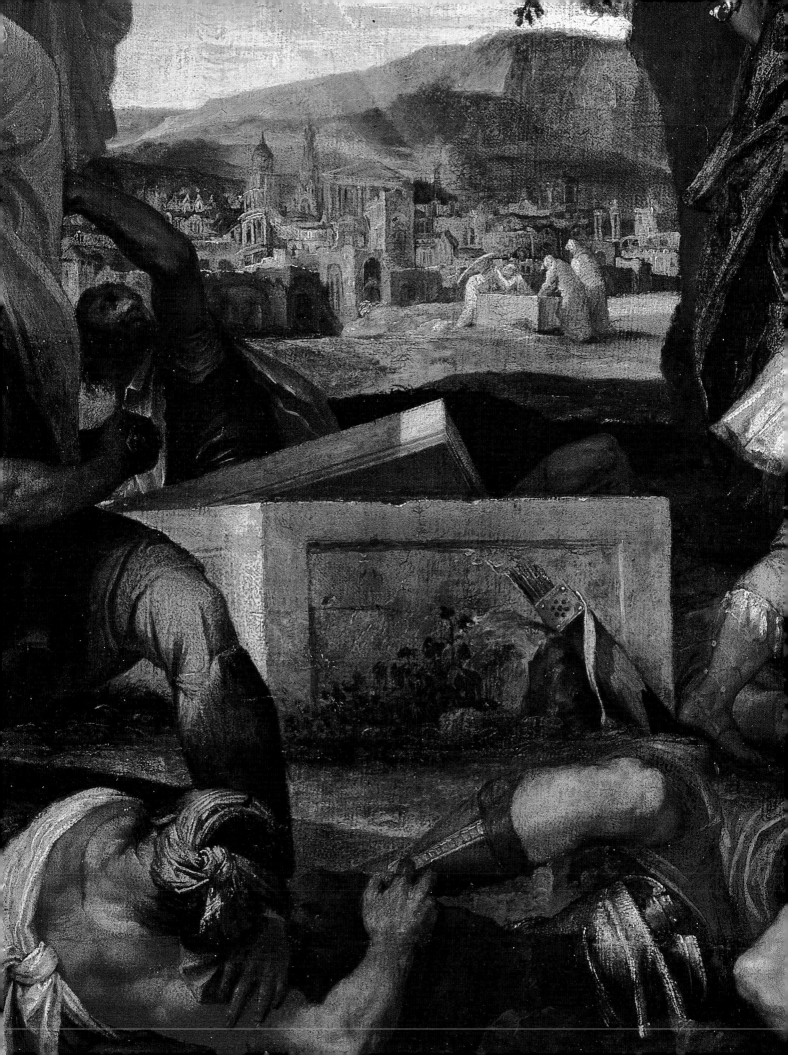

Pages 288–289
VII
Paolo Caliari, known as Veronese
The Resurrection of Christ

VIII
Tiziano Vecellio, known as Titian
Christ carrying the Cross

Appendix

Comparative Chronology

This comparative chronology was written by Claude de Grève for
Le voyage en Russie, Anthologie des voyageurs français aux XVIII^e et XIX^e siècles,
Paris, Laffont, coll. Bouquins, 1990

From Peter I's (the Great) accession to the breaking off of relations with France (end of Catherine II's reign)

In Russia		In France	
1689:	Peter I maneuvers the regent Sophie out of power. Period of new territorial expansion, economic and cultural opening toward Europe, various and controversial reforms. Development of metal-working industry (Urals), improvement of river transport.	1689:	Summit of French art: Paris becomes the artistic capital of Europe.
1696:	Taking of Azov.		
1698:	*Streltsy* revolt (Officers of the Guard). Peter develops a dislike of Moscow.		
1699:	Peter replaces dating from the creation of the world by the Julian calendar, beginning in 1700.		
1700:	Great Northern War begins (particularly against Sweden).		
		1702–13:	War of Succession in Spain.
1703:	Founding of St. Petersburg.		
1704:	Taxation on beards.	1704:	A. Galland. Translation of "A Thousand and One Nights."
1705–06:	Astrakhan revolt.		
1707–08:	Agrarian uprising (Bulavin)		
1709:	Victory at Poltava over the Swedes. Creation of provinces (*gubernii*)	1709:	Famines, high mortality.
1711–13:	War against the Ottoman Empire.		
1711:	The Senate is established.		
1712:	St. Petersburg becomes the Russian capital.		
		1713:	Treaties of Utrecht, Rastadt and Basel. France gives up Newfoundland and Arcadia to England.
1714:	Peter sets up public education. Victory over Finland.		
		1715:	Death of Louis XIV. Philip of Orleans becomes regent.
1717:	Peter I travels to France. Beginning of a myth for numerous French philosophers.		
1717:	Creation of the first Masonic Lodge.	1717–43:	Regency.
1718:	Setting up of "assemblies", required meetings for the upper classes.		
		1719:	War between France and Spain.
		1719–20:	Financial collapse.

In Russia		In France	
1720:	Founding of a church called a "French" church whose ministers are from Geneva.		
1721:	Nystad Peace. Conquered territories include a large part of the Baltic countries (Estonia, Latvia, part of Karelia) . Peter I is proclaimed emperor "Peter the Great" and Russian an "empire." Creation of the Saint Synod and suppression of the Patriarchate.	1721:	Montesquieu writes *Lettres persanes*.
1722:	The Table of Ranks codifies nobility ranks. Skvornik-Pisariev: first mechanics manual.	1722:	Cardinal Dubois's ministry.
1722–23:	Campaign against Persia. Annexation of the Western littoral of the Caspian Sea.		
1724:	The Academy of Science is founded. Inauguration at the end of 1725, after the death of Peter.		
1725:	Death of Peter the Great.		
1725–27:	Catherine I (Peter the Great's wife).		
		1726–43:	Fleury Ministry.
		1726:	Founding of the St. Thomas Scottish lodge. Works by Falconet, Watteau, Marivaux. Saint-Simon writes his *Mémoires*.
1727–30:	Peter II (Peter the Great's grandson).	1727:	Treaty of Paris with Spain.
1730–40:	Anna (Peter the Great's niece) devotes her time more to her German favorites than to her people. Increasing discontent among farmers (Kharkov, Vladimir etc.).		
		1731:	The death penalty for witchcraft is abolished. Works by Fragonard, Voltaire, the Abbot Prévost. Beginning of an economic boom (mercantilism and protectionism). Works by Boucher, Hubert Robert, Couperin, Rousseau, the younger Crébillon.
		1734:	Voltaire writes *Lettres Philosphiques*.
		1734–38:	Poland's War of Succession. French intendance in Lorraine.
1735–39:	War against Turkey, re-conquest of Azov.		
		1740–48:	Austrian War of Succession. Works by Boucher, Chardin, Houdon, Grétry.
1741–61:	Reign of Elisabeth (Peter the Great's second daughter). Progress in cultural, and judicial fields (abolition of the death penalty). Growing rapprochement with France.		
		1743–74:	Reign of Louis XV.
		1744:	Development of big mining companies. Liberty of Masonic lodges.
1747–52:	Peterhof is built (actual Petrodvorets).		
		1748:	Aix-la-Chapelle peace. France wins nothing from it, unpopularity of the king. Voltaire writes *Zadig*. Montesquieu writes *De l'Esprit des lois*.
1749–56:	Tsarskoye Selo is built.		

In Russia		In France	
		1751:	The Sèvres manufacture is built. *L'Encyclopédie* begins to be published. Works by d'Alembert, Diderot, Maupertius, Buffon, Quentin de la Tour....
1755:	At the initiative of the scholar Lomonossov, the University of Moscow is founded.		
1756:	Founding of a theater in St. Petersburg (director: the dramatist Sumarokov.)	1756–70:	Choiseul reorganizes the army and the navy.
1756:	Beginning of the Seven Years' War: France, Russia, Austria against Prussia and England.		
1758:	The Fine Arts Academy is established in St. Petersburg (with French artists). French is the language of high society and the Court.		
		1759:	*L'Encyclopédie* is banned by order of the State Council.
		1760:	Voltaire moves to Ferney.
		1761:	The Jesuit colleges are closed.
		1761–62:	Rousseau, *Emile, Julie or La nouvelle Héloïse, Le Contrat Social.* Works by Lemoyne, Greuze, Glück.
1762:	Brief reign of Peter III, deposed and assassinated. His wife, the princess of Anhalt-Zerbst (suspected to be at the very least responsible for his deposition) succeeds him.		
1762–96:	Reign of Catherine II. The Empress calls herself a "citizen of Europe" and an "enlightened despot", disciple of the French philosophers. Era of reforms which enlarge the power and prestige of the nobility.		
1763-64 :	Secularization of church property.	1763:	Condemnation by the Sorbonne of Freemasonry.
1764:	The Smolny Institute is created for young girls of the nobility.	1764:	Expulsion of the Jesuits. Voltaire's *Dictionnaire philosophique.*
1765:	Use of the potato starts to become more widespread.		
1765:	Catherine buys Diderot's library, leaving him the use of it. The philosophers express enthusiasm for the Empress.		
1766:	Denis Fonvizin writes *The Brigadier* (comedy). Works by Tchulkov, Kantemir (satires), Sumarokov, Gatchina.	1766:	Stanislas Leczinski dies. Lorraine is returned to France.
1766–78:	Falconet sculpts the famous statue of Peter the Great at St. Petersburg.		
1767–68:	Great legislative commission (not very effective).		
1768:	Posthumous publication of Tatichtchev's *History of Russia.* Translation of the works of the philosophers.		
1768–74:	War against Turkey to gain access to the shores of the Black Sea.		
		1769:	Diderot: *Le rêve d'Alembert.*
		1770:	Parliamentary revolts which result in the abolition of the royal parliaments by Chancellor Maupéou. Increasing riots, strikes.
		1771:	Beginning of a grave economic crisis.

In Russia		In France	
1772:	First partition of Poland.		
1773:	Farmers' revolt led by the Cossack Pougatchev extending from Western Siberia to the middle and lower Volga. The rebels set up their own government. First works by Novikov.		
1774:	Kuchuk-Kainarji Treaty: Russia establishes itself on the Black Sea.	1774-89:	Reign of Louis XVI. Turgot is Finance Minister. Parliaments recalled.
1775:	Pougatchev and his supporters are crushed.		
1776:	Creation of the Bolshoi in Moscow.	1776:	Turgot dismissed (through Marie-Antoinette's influence).
		1776-81:	Necker becomes Finance minister: plan of austerity.
		1776-83:	The steamship is invented by Jouffroy.
		1781:	Necker dismissed (through the Queen's influence). The army is reorganized by the Marquis of Ségur (the bourgeoisie are excluded from command.
1782:	The Czarevich Paul visits France to great success.		
1782:	Fonvizin, *The Miner*.	1782:	Laclos writes *Les liaisons dangeureuses*. Work by Lavoisier.
1782-86:	The Pavlosk palace is built.		
1783:	The Crimea is annexed. Serfdom is extended to the Ukraine. An Academy for the perfecting of the Russian language is founded.	1783-87:	Calonne is Finance minister. Squanders state funds.
		1784:	Beaumarchais, *Le Mariage de Figaro*. Bernadin de Saint Pierre, *Études de la nature*.
1785:	Charter of the Nobility which reinforces nobility privileges and maintains serfdom.	1785:	Works by Florian, Restif, Chénier.
1786:	Treaty between Russia and France. Opening of the Black Sea to trade with Marseilles (the Count of Vergennes is Foreign Affairs Minister).		
1787-91:	Russian-Turkish War.	1787:	Calonne's disgrace. Suppression of corvée. Paris Parliament revolt against the royal power.
		1788:	Suppression of torture. Convocation of the general states by the king. Return of Necker.
1789-92:	Catherine II passes a suspects law regarding French language foreigners, then against liberals, Freemasons and Russian "illuminated ones." Novikov arrested.	1789:	Revolution.
1790:	Radishchev writes *Voyage from St. Petersburg to Moscow* (against serfdom and despotism, in favor of a republic). Arrested.		
1791:	Peace of Jassy with Turkey. Annexation of Moldavia.	1791:	Flight and arrest of Louis XVI.
1792:	Rupture of diplomatic relations between Russia and France.		

From the rupture to the Quintuple-Alliance

In Russia		In France	
1792:	Russia invades Poland. Second partition (with Prussia and Austria). Annexation of the Courlande, Lithuania, Byelorussia, and the part of Ukraine located on the right bank of the Dnepr River.	1792:	Taking of the Tuileries. Fall of Louis XVI. Proclamation of the Republic.
1792–97:	Russia participates in the first coalition against France.		
1793:	Catherine II welcomes the Count of Artois, after the aborted campaign of 1792. Six months of mourning for Louis XVI.	1793:	Execution of Louis XVI. Beginning of The Terror.
		1794:	Execution of André Chénier.
1795:	Third partition of Poland.	1795:	Bonaparte crushes a royalist revolt.
		1795–99:	The Directory.
1796:	Death of Catherine II.		
1796–1801:	Reign of Paul I. Paul I offers asylum to Louis XVIII in Courlande (Mittau). Big wave of French immigration to the Court.		
1798–1802:	Paul I heads the second coalition.		
1799:	Victory of Souvorov in Milan against Bonaparte's troops.		
		1799:	Coup d'État of the 18th-Brumaire.
		1799–1804:	Consulate.
1800:	Tale of Ihor's Campaign, an ancient national text, published by Mussin-Pushkin.	1800:	Madame de Staël, *De la littérature*.
1800–1801:	Good relations between Paul I and the (authoritarian) Bonaparte.		
1801:	Paul I assassinated (conspiracy by Count Pahlen).		

List of works

Jean-Marc Nattier
Portrait of Catherine I, 1717
Oil on canvas
142.5 × 110 cm
Signed and dated bottom left: *Painted
at La Hague by Nattier the Younger in 1717*
The State Hermitage Museum, inv. ERJ-1857
(repr. on p. 107)

Louis Caravaque
Portrait of the future Empress Elisabeth Petrovna,
end of the 1720s (1726?)
Oil on canvas
78 × 63 cm
The State Hermitage Museum, inv. ERJ-3268
(repr. on p. 50)

Anonymous
Portrait of the emperor Peter III, 1762
Oil on canvas
132.5 × 99 cm
The State Hermitage Museum, inv. ERJ-562

Anonymous
Portrait of the Empress Catherine II,
end of 18th century
Oil on canvas
79 × 65 cm
The State Hermitage Museum, inv. ERJ-3262
(repr. on p. 147)

Stepan Semenovitch Chtchoukin
Portrait of the Emperor Paul I, 1797-1798
Oil on canvas
154 × 116 cm
The State Hermitage Museum, inv. ERJ-1733
(repr. on p. 138)

Anonymous
*Portrait of Anna Petrovna Cheremetieva (1744–1768)
in "carrousel" costume by Bellone*, around 1766
Oil on canvas
138 × 87 cm
The State Hermitage Museum, inv. ERJ-1872

Ivan Iakovlevitch Vichniakov (1699–1761)
Portrait of Mikhaïl Savvitch Iakovlev, after 1756
Oil on canvas
90 × 72 cm
The State Hermitage Museum, inv. ERJ-340

Ivan Iakovlevitch Vichniakov
Portrait of Stepanida Stepanovna Iakovleva,
after 1756
Oil on canvas
90 × 72 cm
The State Hermitage Museum, inv. ERJ-341

Anonymous
Portrait of Mikhaïl Vassilievitch Lomonossov,
2nd half of 18th century
(copy based on the portrait by G. Brenner [1750s])
Oil on canvas
87 × 70 cm
The State Hermitage Museum, inv. ERJ-2646
(repr. on p. 114)

Anonymous
*Portrait of Alexeï Grigorievitch Bobrinsky
in masquerade costume*, 1790
Oil on canvas
81.5 × 665 cm
The State Hermitage Museum, inv. ERJ-791

Karl Ludwig Christinek (1732 [?]–1792–1794 [?])
Portrait of Sara Alexandrovna Greyg, 1770
Oil on canvas
90,5 × 73,5 cm
The State Hermitage Museum, inv. ERJ-1064

Anonymous
View of Peter I's Summer Palace
Oil on canvas
71 × 120 cm
The State Hermitage Museum, inv. ERJ-2591
(repr. on p. 111)

Anonymous
*View of the Empress Elisabeth Petrovna's
Summer Palace*, after 1753
Oil on canvas
71 × 119 cm
The State Hermitage Museum, inv. ERJ-1865
(repr. on p. 51)

Johann Georg de Mayer (1760–1816)
*View of the Palace quay from the tip
of Vasiliesky Island, 1796*
Oil on canvas
76 × 117 cm
Signed and dated to the left on the stone:
De Mayr Pinx // St Peterpolis // 1796
The State Hermitage Museum, inv. ERJ-2219
(repr. on p. 54)

Benjamin Patersen
(1750, Varberg, Sweden–1815, St-Petersburg)
*View of the Palace Square and the Winter Palace from
the beginning of Nevsky Prospect*, 1801
Oil on canvas
64 × 99 cm
Signature and date illegible at lower right:
Paterssen [1800]
The State Hermitage Museum, inv. ERJ-1902

Benjamin Patersen
(1750, Varberg, Sweden–1815, St-Petersburg)
View of Sennaia Square, "haymarket square",
around 1800
Oil on canvas
57.5 × 89.5 cm
The State Hermitage Museum, inv. ERJ-1904
(repr. on p. 122–123)

Benjamin Patersen
(1750, Varberg, Sweden–1815, St-Petersburg)
The Neva gate of Peter and Paul Fortress,
around 1800
Oil on canvas
68.5 × 85 cm
The State Hermitage Museum, inv. ERJ-1671
(repr. on p. 124)

Benjamin Patersen
(1750, Varberg, Sweden–1815, St-Petersburg)
View on Smolny monastery from Okhta,
around 1800
Oil on canvas
68 × 85 cm
The State Hermitage Museum, inv. ERJ-1674
(repr. on p. 154)

Anonymous
Portrait of Catherine II in a traveling outfit,
after 1787
Oil on canvas
52.2 × 65.8 cm
The State Hermitage Museum, inv. ERJ-2702
(repr. on p. 245)

Benjamin Patersen
(1750, Varberg, Sweden–1815, St-Petersburg)
Vassiliesky Island Quay near the Fine Arts Academy,
around 1799
Oil on canvas
64 × 100 cm
The State Hermitage Museum, inv. ERJ-1901
(repr. on p. 125)

Benjamin Patersen
(1750, Varberg, Sweden–1815, St-Petersburg)
*View of the St. Petersburg surroundings near
the porcelain factory, 1798*
Oil on canvas
64.5 × 102 cm
Signed and dated lower left: *Benj: Paterssen 1798*
The State Hermitage Museum, inv. ERJ-1676
(repr. on p. 120)

Benjamin Patersen
(1750, Varberg, Sweden–1815, St-Petersburg)
View of the Tauride Palace, around 1800
Oil on canvas
57.5 × 89.5 cm
The State Hermitage Museum, inv. ERJ-1903
(repr. on p. 116)

Johann Baptiste Lampi, the Elder (1751–1830)
Portrait of G.A. Potemkin, Prince de Tauride,
around 1790
Oil on canvas
73.5 × 60.5 cm
The State Hermitage Museum, inv. ERJ-1879
(repr. on p. 146)

Ivan Petrovitch Argounov (1727–1802)
Portrait of Peter Borissovitch Cheremetiev
(1713–1787), 1753
Oil on canvas
135 × 103 cm
Signed and dated lower right: *N. Argounoff 1753*
The State Hermitage Museum, inv. ERJ-1867

Andreï Matveev (1702 [?]–1739)
Portrait of Peter I
Oil on canvas
78.5 × 61 cm (oval)
The State Hermitage Museum, inv. ERJ-3298
Painting based on the original by C. Moor
painted from life at The Hague in 1717
(place of conservation unknown)
(repr. on p. 92)

Anonymous
View of the Neva with the Winter Palace
and the Academy of Science, after 1753
(based on a drawing by M.I. Makhaïev)
Oil on canvas
81.5 × 139.5 cm
The State Hermitage Museum, inv. ERJ-2238

Johann Friedrich August Tischbein
(1750, Maastricht, Holland–1812, Heidelberg)
Portrait of the Saltykov family, 1782
Oil on canvas
115 × 147 cm
The State Hermitage Museum, inv. GE-5771

Giulio Cesare Procaccini
(1570, Bologna–1625, Milan)
Madonna and Child
Oil on canvas
55.5 × 40.5 cm
The State Hermitage Museum, inv. GE-144
Entered in 1772, from the Pierre Crozat collection
(repr. on p. 279)

Giovanni dal Sole (1654, Bologna–1719, Bologna)
The Adoration of the Magi
Oil on canvas
42.5 × 31.5 cm
The State Hermitage Museum, inv. GE-129
Entered between 1774 and 1783
(repr. on p. 284)

Nicolas Poussin (1594, Paris–1665, Rome)
Venus, Faune and Putti, around 1630
Oil on canvas
72 × 56 cm
The State Hermitage Museum, inv. GE-1178
Entered in 1772, from the Pierre Crozat collection
(repr. on p. 279)

Claude Gellée, known as Le Lorrain
(1600, Champagne–1682, Rome)
Christ on the Road to Emmaus,
signed and dated 1660
Oil on canvas
99 × 132 cm
The State Hermitage Museum, inv. GE-1229
Entered in 1771. Purchased in Paris from
an unknown art dealer
(repr. on p. 274)

Peter Patel, the Elder (1605–1676, Paris)
Landscape with Christ and a Centurion,
signed and dated 1652
Oil on canvas
76.5 × 1135 cm
The State Hermitage Museum, inv. GE-1198
Entered in 1767, from the J. de Julienne collection
in Paris
(repr. on p. 270)

Eustache Le Sueur (1617, Paris–1655, Paris)
Darius opening the Tomb of Nitocris
Oil on canvas
163 × 112 cm
The State Hermitage Museum, inv. GE-1242
Entered in 1772, from the Pierre Crozat collection
(repr. on p. 286)

Nicolas Loir (1624, Paris–1679, Paris)
The Holy Family in the Center of a Crown
of Flowers
Oil on canvas
59 × 70,5 cm
The State Hermitage Museum, inv. GE-1774
Entered between 1763–1774
(repr. on p. 273)

Marie Louise Elisabeth Vigée Le Brun
(1755, Paris–1842, Paris)
Portrait of the Count G.I. Tchernychev,
holding a mask, 1793
Oil on canvas
56 × 44 cm
The State Hermitage Museum, inv. GE-7459

Antoine Watteau (1684, Valenciennes–1721, Paris)
An Embarrassing Proposition, around 1716
Oil on canvas
65 × 84,5 cm
The State Hermitage Museum, inv. GE-1150
Entered before 1774, likely acquired in 1769, from
the G. von Brühl collection in Dresden
(repr. on p. 271)

Nicolas Lancret (1690, Paris–1743, Paris)
Concert in the Park
Oil on canvas
61.5 × 51.5 cm
The State Hermitage Museum, inv. GE-16
Entered in 1772, from the Pierre Crozat collection
(repr. on p. 281)

Charles de Lafosse (1636, Paris–1716, Paris)
Christ appearing to Mary-Magdalene
Oil on canvas
81 × 65 cm
The State Hermitage Museum, inv. GE-1215
Entered before 1774, likely acquired in 1769, from
the G. von Brühl in Dresden
(repr. on p. 282)

Charles Joseph Natoire
(1700, Nîmes–1777, Castel Gandolfo)
Cupid sharpening his Arrow,
signed and dated 1750
Oil on canvas
55.5 × 42.5 cm
The State Hermitage Museum, inv. GE-7653
Entered in 1772, from the Pierre Crozat collection
(repr. on p. 280)

Veronese (Paolo Caliari, known as Veronese)
(1528, Verona–1588, Venice)
The Resurrection of Christ
Oil on canvas
130 × 95 cm
The State Hermitage Museum, inv. GE-2545
Entered between 1773 and 1785
(repr. on p. 289)

Johann Baptist Lampi, the Elder
(1751, Romeno–1830, Vienna)
Portrait of Catherine II, 1794
Oil on canvas
290 × 208 cm
The State Hermitage Museum, inv. GE-2755
(repr. on p. 133)

Anton Raphael Mengs (1728, Aussig–1779, Rome)
St. John the Baptist Preaching in the Desert
Oil on canvas
208 × 153 cm
The State Hermitage Museum, inv. GE-1332
Entered between 1780 and 1783
Among the works purchased in the artist's studio
in Rome by Catherine II
(repr. on p. 272)

Gerrit van Honthorst
(1590, Utrecht–1656, Utrecht)
The Entertainer, signed and dated 1624
Oil on canvas
84 × 665 cm
The State Hermitage Museum, inv. GE-717
Entered in 1764, from the I.E. Gotzkowsky
collection in Berlin
(repr. on p. 269)

Gerrit van Honthorst
(1590, Utrecht–1656, Utrecht)
The Musician, signed and dated 1624
Oil on canvas
84 × 66.5 cm
The State Hermitage Museum, inv. GE 718
Entered in 1764, from the I.E. Gotzkowsky
collection in Berlin
(repr. on p. 268)

Benedetto Caliari (1530, Verona–1596, Venice)
The Holy Family and St. John the Baptist
Oil on canvas
150 × 95 cm
The State Hermitage Museum, inv. GE-1485
Entered in 1781, from the Baudouin collection
in Paris
(repr. on p. 285)

Jan Davidsz de Heem
(1606, Utrecht–1684, Antwerp)
Flowers and fruits, signed and dated 1655
Oil on canvas
95 × 124.3 cm
The State Hermitage Museum, inv. GE-1107
Entered before 1774, likely acquired in 1769, from
the G. von Brühl collection in Dresden

Anthony van Dyck
(1599, Antwerp–1641, London)
Self-portrait, around 1630
Oil on canvas
116,5 × 93,5 cm
The State Hermitage Museum, inv. GE-548
Entered in 1772, from the Pierre Crozat collection
in Paris
(repr. on p. 276)

Niccolò Cassana (1659, Venice–1713, London)
Nymphs and Satyr, 1585
Oil on canvas
115 × 150 cm
The State Hermitage Museum, inv. GE-158
Entered in 1764, from the I.E. Gotzkowsky
collection in Berlin
(repr. on p. 271)

Carlo Maratta (1625, Camerino–1713, Rome)
Madonna and Child and John the Baptist
Oil on canvas
100 × 84 cm
The State Hermitage Museum, inv. GE-1560
Entered in 1779, from the R. Walpole collection in
Hougthon Hall
(repr. on p. 273)

Titian (Tiziano Vecellio)
(around 1488, Pieve di Cadore–1576, Venice)
Christ carrying the Cross
Oil on canvas
89 × 77 cm
The State Hermitage Museum, inv. GE-115
Entered in the Hermitage in 1850, from the
Barbarigo collection in Venice
(repr. on p. 290)

Icon *"The Trinity of the Old Testament"*
Northern Russia, 1705
Wood, distemper
70.5 × 60 × 3 cm
The State Hermitage Museum, inv. ERI-511
(repr. on p. 18)

Icon *"The Prophet Elijah ascending in the flames"*
Russia, end of 17th century
Wood, distemper
106 × 76 × 4 cm
The State Hermitage Museum, inv. ERI-525
(repr. on p. 36)

Icon diptych *"The Miracle of Saint-George
vanquishing the dragon"* and *"The Miracle of Flor
and Lavr"*
Northern Russia, end 17th century,
beginning of 18th
Wood, distemper
138.5 × 78, 5 × 4 cm
The State Hermitage Museum, inv. ERI-446
(repr. on p. 37)

Benjamin Patersen
(1750, Varberg, Sweden–1815, St-Petersburg)
*The Nevsky Prospect at the level of Gostinnyi Dvor
("The merchants' courtyard")*, 1799–1800
Paper, watercolor, Indian ink
60.4 × 95.5 cm
The State Hermitage Museum, inv. ERR-3334

Andreï Efimovitch Martynov
Peter I's Palace in the Summer garden, 1809-1810
Paper, watercolor, Indian ink
61.5 × 87 cm
Signed in lower left: "drawn by A. Martinoff."
Inscription on the back: view of the St. Petersburg
fortress and a part of the Fontanka Summer
Garden
The State Hermitage Museum, inv. ERR-5553
(repr. on p. 48)

Carl Joachim Beggrow
(1799 Rig–1875 St. Petersburg)
*Neva Quay near the Old Hermitage
and the Hermitage Theater*, 1824
62.5 × 84.6 cm
The State Hermitage Museum, inv. ERR-7188

Johann Wilhelm Gottfried Barth (1779–1852)
*Dacha of the Counts Laval Apterkarsky Island
in St. Petersburg*, around 1816
Paper, gouache, Indian ink
58.7 × 79 cm
The State Hermitage Museum, inv. ERR-8009
(repr. on p. 117)

Johann Wilhelm Gottfried Barth (1779–1852)
*Krestovsky Island Quay at St. Petersburg
from the side of the Small Neva*, around 1816
Paper, gouache, Indian ink
57.5 × 78 cm
The State Hermitage Museum, inv. ERR-8008

Benjamin Patersen
(1750, Varberg, Sweden–1815, St-Petersburg)
The English Quay near the Senate, 1801
Paper, watercolor, Indian ink
60 × 94.8 cm
Signed and dated in lower right: *B. Paterssen 1801*
The State Hermitage Museum, inv. ERR-3335

Anonymous
*Catherine II, surrounded by the Court on the Winter
Palace balcony greeting the Guard and the people
on the day of her "coup d'État"*, end of 18th century to
first third of 19th century
Carton, watercolor, gouache
25.6 × 34.5 cm
The State Hermitage Museum, inv. ERR-8033
Copy based on a original by I.K. Kestner done in
the 1760s. Catherine II had ordered a series of five
gouaches from him evoking the "coup d'État"
of June 28, 1762 and her accession
(repr. on p. 134)

Anonymous
*Catherine II on the steps of Our Lady of Kazan church
greeting the clergy on the day of her "coup d'État"*,
end of 18th century
to first third of 19th century
Carton, watercolor, gouache
25.7 × 35 cm
The State Hermitage Museum, inv. ERR-8035

Giacomo Quarenghi (1744–1817)
St. Michael's Castle. View from the southeastern side,
1801
Paper, watercolor, Indian ink
46 × 63.3 cm
The State Hermitage Museum, inv. ERR-3328
(repr. on p. 156)

Alexeï Fedorovitch Zoubov (1682/1683–1751)
Panorama of St. Petersburg, 1716–1717
Etching, burin
75.6 × 244.5 cm
Above in a cartouche: "St-Petersburg"
Signed in lower left: "Engraved by Alexeï Zoubov
at St Petersburg in 1716."
The State Hermitage Museum, inv. ERG-17079
(repr. on p. 75)

Grigori Anikievich Katchalov (1711/1712–1759)
(based on a drawing by Mikhail Makhaïev
[around 1717–1770])
*View of the Fontanka near the Grotto and the Court
storage warehouse*, 1753
Etching, burin
53 × 71.5 cm
Under the picture to the left, signature:
"Supervised by G. Valeriani. Drawn by the
apprentice Mikhail Makhaïev"
Under the picture to the right, signature:
"Engraved by Master Grigori Katchalov"
Under the picture the inscription, to the left of
the blazon in Russian, to the right in French:
"View made on the Fontanka River around noon,
between the Grotto and the Court storage
warehouse"
The State Hermitage Museum, inv. ERG-31452

Yakov Vassilievitch Vassiliev (1730–1760/1780)
(based on the drawing by Mikhail Makhaïev
[around 1717–1770])
*View of the Nevsky Prospect from the Anitchkov Palace
from the Moïka side*, 1753
Etching, burin, watercolor, Indian ink
51.5 × 71.5 cm
Under the picture to the left, signature:
"Supervised by G. Valeriani. Drawn by the
apprentice Mikhail Makhaïev"
Under the picture to the right, signature:
"Supervised by the master Ivan Sokolov.
Engraved by the Master Yakov Vassiliev"
Under the picture, the inscription, to the left of
the blazon in Russian, to the right in French:
"View of the New Palace near the Anikschky
triumphal gate toward the east with a part of the
city and of the road of the Alexander Nevksy
Monastery from the Fontanka side"
The State Hermitage Museum, inv. ERG-29263

Ludwig Gabriel Lory I (1763, Bern–1840, Bern) and
Mathias-Gabriel Lory II (1784, Bern–1846, Bern)
View of the Bolshoï Theater (St. Petersburg),
around 1800
Stroke engraving, watercolor
46.3 × 73 cm
The State Hermitage Museum, inv. ERG-20048

Ludwig Gabriel Lory I (1763, Bern–1840, Bern) and
Mathias-Gabriel Lory II (1784, Bern–1846, Bern)
*View of the Palace Quay and Winter Palace from
Vassiliesky Island*, 1804
Sketched engraving, watercolor
44.6 × 74 cm
Signature in lower left: "Lory fecit. 1803" and
on the stone, the initials, "I W"
Inscription below, in the middle, "The Imperial
Palace at St. Petersburg"
The State Hermitage Museum, inv. ERG-20053

Ludwig Gabriel Lory I (1763, Bern–1840, Bern) and
Mathias-Gabriel Lory II (1784, Bern–1846, Bern)
*Alexander I reviewing the troops
on the Palace Square*, 1800s
Stroke engraving, watercolor
55 × 80.5 cm
The State Hermitage Museum, inv. ERG-20045

Alexeï Fedorovitch Zoubov (1682/1683–1751)
*Ceremonial arrival in St. Petersburg of the frigates
taken from the Swedes*, 1720
Etching, burin
59 × 61 cm
Signature lower left: "Engraved by Ale. Zoubov"
Inscriptions: Above on the ribbon,
"St. Petersburg", below right, "Ceremonial arrival
in St. Petersburg of the frigates taken from
the Swedes"
Below: Key to the letters appearing in the
engraving
The State Hermitage Museum, inv. ERG-21018
(repr. on p. 69)

Thomas Malton (1726, London–1801, Dublin)
(based on the drawing by Joseph Hearn [England])
*View of the Vassiliesky Island near
the Academy of Science*, 1789
Aquatint, watercolor
33.7 × 50.8 cm
Signatures: lower left, "Drawn by Joseph Hearn",
lower right, "Engraved by Thos Malton", lowest
signature, "Publish'd Oct 1789 by Joseph Hearn
St. Petersburg. London"
The State Hermitage Museum, inv. ERG-29344
(repr. on p. 112)

Alexeï Kiprianovitch Melnikov (1803–1855)
Inauguration of the monument of Peter I,
middle of 19th century
(based on the drawing by A.P. Davydov, 1782)
Paper, burin
65 × 83.7 cm
Lower left: "Engraved by A. Melnikov, engraver
at the Academy of Science", right: "Work by
Davydov, student at the Fine Arts Academy",
in the center: "Inauguration of the monument
of Peter I, 1782"
The State Hermitage Museum, inv. ERG-6802
(repr. on p. 136)

Anonymous, Germany
Map of St. Petersburg, 1717
Established by Johann–Baptiste Homann
Etching, burin, watercolor
50.5 × 59.5 cm
Inscriptions upper right: *"Topographische
Vorstellung der Neuen Russischen Haupt-Residenz und
See-Stadt St.Petersburg samt ihrer zu erst aufgerichten
Vestug welche von Ihro Czaar Maj. Petro Alexiewitz
aller Russen selbst Erhalter, etc. etc. etc. An 1703 an
der Spitze der Ost-See auf etlichen Insuln bey dem
Aussflus des Neva Stroms erbaut, und zur Aufnahm
der Handelschafft und Schiffarth fur die Russische
Nation mit einer machtigen Flotte versehen worden.
herausgegeben von Ioh. Baptist Homann. Der Rom.
Kays. Majt Geographo in Nurnberg"*
To the left: key to the numbers used in the map.
To the right below the view of Kronchlot, "Crohn
Schlot"
The State Hermitage Museum, inv. ERG-32148
(repr. on p. 59)

Alexeï Fedorovitch Zoubov (1682/1683–1751)
Marriage of Peter I and Catherine, 1712
Etching, burin
54 × 63.3 cm
Inscriptions below: "Marriage of His Majesty Peter
I, emperor of all the Russias, 1712", lower: key to
the figures used in the engraving
The State Hermitage Museum, inv. ERG-29460
(repr. on p. 70)

Efim Terentievitch Vnoukov
(1723/1725–1762/1763)
(based on the drawing by Mikhail Makhaïev
[around 1717–1770])
The perspective near the Twelve Colleges building,
1753
Etching, gouache, watercolor
54.6 × 71.5 cm
Under the image to the left, signature:
"Supervised by G. Valeriani. Drawn by the
apprentice Mikhail Makhaïev"
Under the image to the right, signature:
"Supervised be Master Ivan Sokolov. Engraved
by Efim Vnoukov"
Under the image, the inscription to the left of the
blazon in Russian to the right in French: "View of
the Imperial College buildings and a part of the
Storage Warehouse looking east"
The State Hermitage Museum, inv. ERG-29453
(repr. on p. 58)

Ludwig Gabriel Lory I (1763, Bern–1840, Bern) and
Mathias-Gabriel Lory II (1784, Bern–1846, Bern)
*View of the Neva and of the Bezborodko
dacha*, beginning of the 1800s
Stroke engraving, watercolor
47 × 73 cm
The State Hermitage Museum, inv. ERG-20059

Ludwig Gabriel Lory I (1763, Bern–1840, Bern) and
Mathias-Gabriel Lory II (1784, Bern–1846, Bern)
*View on the Marble Palace from Peter and Paul
Fortress*, beginning of the 1800s
Stroke engraving, watercolor
48.5 × 72 cm
The State Hermitage Museum, inv. ERG-20052
(repr. on p. 121)

Ludwig Gabriel Lory I (1763, Bern–1840, Bern) and
Mathias-Gabriel Lory II (1784, Bern–1846, Bern)
View of the Stroganov dacha from Kamenny Island,
beginning of the 1800s
Stroke engraving, watercolor
46 × 73 cm
The State Hermitage Museum, inv. ERG-20060
(repr. on p. 118)

Benjamin Patersen
(1750, Varberg, Sweden–1815, St-Petersburg)
View of Isaac Bridge from Vasiliesky Island, 1799
Stroke engraving, watercolor
50.5 × 64 cm
The State Hermitage Museum, inv. ERG-20072

Benjamin Patersen
(1750, Varberg, Sweden–1815, St-Petersburg)
*View onto the Summer Garden from the other shore,
known as "Peterbourgskaia Storona"*, 1799
Stroke engraving, watercolor
50 × 65 cm
Signature below: "Painted by B. Paterssen –
engraved by the same, 1799"
Inscription below: "The garden of St. Michael's
Palace next to the Neva" as well as a dedication
to Paul I
The State Hermitage Museum, inv. ERG-29285

Benjamin Patersen
(1750, Varberg, Sweden–1815, St-Petersburg)
Panorama of the English Quay, first part, 1799
Stroke engraving, watercolor
47.5 × 63.5 cm
Signature below: "Painted by B. Paterssen –
engraved by the same, 1799"
Inscription below: "View of the first part of
Galeeren Hof" as well as a dedication to Paul I
The State Hermitage Museum, inv. ERG-29281
(repr. on p. 126)

Benjamin Patersen
(1750, Varberg, Sweden–1815, St-Petersburg)
Panorama of the English Quay, second part, 1799
Stroke engraving, watercolor
50 × 64.5 cm
Signature below: "Painted by B. Paterssen –
engraved by the same, 1799"
Inscription below: "View of the second part of
Galeeren Hof" as well as a dedication to Paul I
The State Hermitage Museum, inv. ERG-27233
(repr. on p. 127)

Benjamin Patersen
(1750, Varberg, Sweden–1815, St-Petersburg)
Panorama of the English Quay, third part, 1799
Stroke engraving, watercolor
48.5 × 64 cm
Signature below: "Painted by B. Paterssen –
engraved by the same, 1799"
Inscription below: "View of the third part of
Galeeren Hof" as well as a dedication to Paul I
The State Hermitage Museum, inv. ERG-27234
(repr. on p. 127)

Benjamin Patersen
(1750, Varberg, Sweden–1815, St-Petersburg)
View onto the Winter Palace from Vassiliesky Island,
1799
Stroke engraving, watercolor
49,5 × 64,7 cm
The State Hermitage Museum, inv. ERG-27227

Thomas Malton (1726, London–1801, Dublin)
(based on the drawing by Joseph Hearn [England])
*View of Vassiliesky Island quay near
the Fine Arts Academy,* 1789
Aquatint, watercolor
34 × 52 cm
Signatures: Lower left, "Drawn by Joseph Hearn",
lower right, "Engraved by Thos Malton", lowest
signature, "Publish'd Oct 1789 by Joseph Hearn, St.
Petersburg. London"
The State Hermitage Museum, inv. ERG-30516
(repr. on p. 152)

Nicolas Martin de Larmessin (1684–1755)
(based on a painting by P.D. Martin the Younger)
The battle of Lesnaïa, 1722-1724
Paper, etching, burin, watercolor
53.8 × 75.2 cm
Inscription below: *Representation of the battle
between a part of the Russian troops under the
command of His Imperial Highness, and the Swedish
troops under the command of the general Count
Levengaupt, at Lesnaia, located two miles from
Propoisk, September 28, 1708*
The State Hermitage Museum, inv. ERG-23486
(repr. on p. 66)

Jacob van der Schley (1715–1779)
(based on the drawing by I.M. Velten)
*Transporting a massive stone used
for the base of Peter I's monument*
Paper, burin, etching
51 × 76 cm
Below, left: G. Velten del. Right, I.V. Schley sculpsit,
"View of the massive stone being transported, in
the presence of Catherine II, January 20, 1770"
The State Hermitage Museum, inv. ERG-16656

Georg-Friedrich Schmidt (1712–1775)
(based on an original by Louis Tocqué, 1758)
Portrait of Elisabeth Petrovna, 1761
Paper, burin
79 × 51.8 cm
Signatures, lower left: L. Tocqué. 1758, to the right:
Engraved by Geor. Fried. Schmidt in St. Petersburg,
1761, lower in the center, blazon and on either
side of the blazon, "The Empress Elisabeth I,
sovereign of all the Russias"
The State Hermitage Museum, inv. ERG-16667

Benjamin Patersen
(1750, Varberg, Sweden–1815, St-Petersburg)
*View on the Marble Palace from
Peter and Paul Fortress,* 1806
Stroke engraving, watercolor
69 x 79 cm
Signature below: "Painted by B. Paterssen –
engraved by the same, 1806"
Inscription below: "The Marble Palace from the
southern side of the Fortress in St. Petersburg"
as well as a dedication to Paul I
The State Hermitage Museum, inv. ERG-29283

Charles Simonneau (1645–1728)
(based on the painting by P.D. Martin the Younger)
The battle of Poltava (second day), after 1724
Paper, etching, burin, watercolor
53.5 × 75.7 cm
The State Hermitage Museum, inv. ERG-33264
(repr. on p. 44)

Grigori Anikievich Katchalov (1711/1712–1759)
(based on the drawing by Johann-Jacob
Schumacher [1701–1767] and Bono Girolamo
[worked in Russia between 1731–1746])
Cross-section of the Kunstkammer, 1741
Etching, burin
47.5 × 63.2 cm
The State Hermitage Museum, inv. ERG-17143

Christian-Albrecht Vortman (1680–1760)
(based on a drawing by Johann-Jacob Schumacher
[1701–1767] and Bono Girolamo [worked in Russia
between 1731–1746])
Perspective from the Kunstkammer library, 1741
Eau-forte, burin
51 × 64.8 cm
The State Hermitage Museum, inv. ERG-17145
(repr. on p. 108)

Ottomar Elliger (around 1703–1735, worked
in St. Petersburg beginning in 1727)
(based on the drawing by Cristoforo Marcellius
[1656–after 1730])
Panorama of the Palace quay (in three parts),
1728–1729
Etching, burin
51.8 × 210 cm
Under the engraving in three cartouches,
inscriptions and key to the figures used in the
engraving, in Russian and in French
The State Hermitage Museum,
inv. ERG-17137 to 17139
(repr. on p. 76–78)

Anonymous, Russia
*Portrait of Catherine II, holding the Nakaz
(or Instruction),* 1770s
Copper, enamel
8 × 10.7 cm
The State Hermitage Museum, inv. ERR-8014
The *Nakaz,* a judicial and philosophical treatise,
was written by Catherine II in 1767 for the
Commission representatives whose mission was
to establish a new code of laws
(repr. on p. 135)

Andreï Ivanovich Tcherny
(?–after the years 1780)
Portrait of the Empress Catherine II, 1765
Miniature copied from an oil portrait
by F.S. Rokotov en 1763
Copper, enamel
9 × 7 cm (oval)
Signed and dated: 1765 A.T.
The State Hermitage Museum, inv. ERR-8830
(repr. on p. 145)

Andreï Ivanovich Tcherny
(?–after the years 1780)
Portrait of the count G.G. Orlov,
end of the 1760s–beginning of the 1770s
Miniature copied from an oil portrait of
G.G. Orlov on horseback in "carrousel" dress,
done by V. Erichsen at the end of the 1760s
Copper, enamel
7.2 × 5.3 cm
The State Hermitage Museum, inv. ERR-8013
(repr. on p. 144)

Bartolomeo Carlo Rastrelli (1675–1744)
Bust of Peter I, 1723–1730
Bronze
102 × 90 × 40 cm
Signatures: lower left on the festoons of the
breast-plate: "Cte Rastrellij Florentinus F.", in the
center: "Cte Rastrellij Florentinus F.", to the right
on the side of the hand: "assistance. D. R. F Finis,
by St. Mange. 1729"
The State Hermitage Museum, inv. ERSk-162
Bust ordered by Peter I. On the breastplate are
battle scenes and compositions in relief. Peter,
represented as a Roman emperor, is sculpting the
statue of the new sovereign Russia.
(repr. on p. 106)

Johann-Georg-Gaspar Jäger (worked in the second
half of the 18th century)
Portrait of the Great Duke Paul Petrovitch
Bas-relief, marble, slate
24.5 × 19.5 cm (oval)
The State Hermitage Museum, inv. ERSk-111

Jean Antoine Houdon's studio (1741–1828)
Bust of Voltaire, 1778–1779
Marble
Height: 48 cm
The State Hermitage Museum, inv. ERSk-71
(repr. on p. 140)

Jean Antoine Houdon's studio (1741–1828)
Bust of Jean-Jacques Rousseau, 1778–1779
Marble
Height: 50 cm
The State Hermitage Museum, inv. ERSk-72
(repr. on p. 143)

Marie-Anne Collot (1748–1821)
Bust of Denis Diderot, 1772
Marble
Hauteur: 57 cm
Signed and dated: *par MA Collot 1772*
The State Hermitage Museum, inv. NSk.-2
(repr. on p. 142)

F.I. Gardner Factory in the town of Verbilki
near Moscow, 1778
Eleven pieces from the Order of St. George
Project designer, G.I. Kozlov (1738–1791)
Painted and gilded porcelain
Place settings: silver, gilding, porcelain
(repr. on p. 249)

*Oval fruit basket with handles made of intertwined
stems with flowers and an edging of openwork
design, decorated with the ribbon of the Order with
a cross and a garland of bay leaves, on the background,
the star of the Order with the motto, "For service
and for courage"*
Marked in cobalt blue: G.
85 × 37 × 26.2 cm
The State Hermitage Museum, inv. ERF-7341
(repr. on p. 253)

*Small round fruit basket with intertwined
handles and the same decoration*
Marked in cobalt blue: G.
9 × 28 × 25 cm
The State Hermitage Museum, inv. ERF-6867
(repr. on p. 261)

*Fruit bowl in the shape of an elongated leaf, green
background decorated with a ribbon of the Order with
a cross, a garland made of bay leaves and a star of the
Order*
Marked in cobalt blue: G.
6.7 × 23.5 × 30 cm
The State Hermitage Museum, inv. ERF-318

*Fruit bowl in the shape of a vine leaf
with the same decoration*
Marked in cobalt blue: G.
7 × 25.3 × 25.5 cm
The State Hermitage Museum, inv. ERF-317

*Soup bowl with a festooned edge, decorated with a
ribbon of the Order with a cross, background
with a star of the Order*
Marked in cobalt blue: G.
5 × 23.8 cm
The State Hermitage Museum, inv. ERF-4505

Dinner plate with the same decoration
Marked in cobalt blue: G.
3,5 × 23.8 cm
The State Hermitage Museum, inv. ERF-4504

*Salt shaker in the shape of a basket with twisted
handles and a festooned edge, decorated with the ribbon
of the Order with a cross and a star of the Order*
Marked in cobalt blue: G.
3.5 × 10.9 × 8.3 cm
The State Hermitage Museum, inv. ERF-316

*Creamer with a lid topped by a squirrel, decorated by a
circle of leaves and a ribbon of the Order with a cross*
Marked in cobalt blue: G.
7 × 8.8 × 6.8; 4.7 × 7 cm
The State Hermitage Museum, inv. ERF-320 a,b

*Creamer with a lip topped by a rose, decorated by a
circle of leaves and a ribbon of the Order with a cross*
Marked in cobalt blue: G.
7.3 × 8.8 × 6.6; 3.7 × 6.8 cm
The State Hermitage Museum, inv. ERF-321 a,b

*Knife in gilded silver with a porcelain handle,
decorated with a ribbon of the Order with a cross and a
bay leaf garland*
22.1 × 3 × 2 cm
The State Hermitage Museum, inv. ERO-7391

*Fork in gilded silver with a porcelain handle,
same decoration*
18.1 × 2.5 × 1.9 cm
The State Hermitage Museum, inv. ERO-7385

F.I. Gardner Manufacture in the town
of Verbilki near Moscow, 1779-1780
*Six pieces of the service of the Order of
St. Andrew the First Called*
Project designer, G.I. Kozlov (1738-1791)
Painted and gilded porcelain
Table Setting: silver, gilding, porcelain
(repr. on p. 257)

*Small round fruit basket with handles made of
intertwining stems with flowers and an openwork
design on the edge, decorated by the chain of the Order,
the star of the Order in the background with the motto,
"For faith and fidelity"*
Marked in cobalt blue: G.
9 × 27 cm
The State Hermitage Museum, inv. ERF-292

*Dinner plate with a festooned edge decorated
with the chain of the Order, the star of the Order in the
background*
Marked in cobalt blue: G.
3.2 × 24.5 cm
The State Hermitage Museum, inv. ERF-289

*Small display shelf in the shape of a leaf, decorated
by the ribbon of the Order with a cross and the star of
the Order on a green background*
Marked in cobalt blue: G.
4.3 × 19.3 × 11.5 cm
The State Hermitage Museum, inv. ERF-295

*Creamer, decorated with a edging of gilded leaves and
the ribbon of the Order with a cross*
Marked in cobalt blue: G.
7 × 8.6 × 6.62 cm
The State Hermitage Museum, inv. ERF-297

*A knife in gilded silver with a porcelain handle,
decorated with the ribbon of the Order with a cross*
22.2 × 2.9 cm
The State Hermitage Museum, inv. ERO-7410

*Fork in gilded silver with a porcelain handle, with the
same decoration*
18.8 × 2.7 cm
The State Hermitage Museum, inv. ERO-7402

F.I. Gardner factory in the town of Verbilki
near Moscow, 1779-1780
*Seven pieces of the service of the
St. Alexander Nevsky's Order*
Project designer, G.I. Kozlov (1738-1791)
Painted and gilded porcelain
Place settings: argent, gilding, porcelain
(repr. on p. 258)

*Large round fruit bowl with handles made of
intertwining stems with flowers and an edging in
openwork design, decorated with the ribbon of the
Order with a cross, the star of the Order with the
motto, "For work and country," on the background*
Marked in cobalt blue: G.
10 × 27.5 × 30.3 cm
The State Hermitage Museum, inv. ERF-280

Dinner plate with a festooned edge decorated with a ribbon of the Order with a cross, the star of the Order on the background
Marked in cobalt blue: G.
4.6 × 22.5 cm
The State Hermitage Museum, inv. ERF-7042

Dinner plate with a festooned edge with the same decoration
Marked in cobalt blue: G.
3.5 × 23.5 cm
The State Hermitage Museum, inv. ERF-273

Creamer with handle and a lid topped by a rose, decorated with the ribbon of the Order with a cross, the star of the Order, flowers and, on the lid, a laurel garland
Marked in cobalt blue: G.
7.9 × 9 × 6.3; 4.3 × 6.6 cm
The State Hermitage Museum, inv. ERF-7097 a, b

Salt cellar in the shape of a basket with twisted handles and an embedded festooned edge, decorated with a ribbon of the Order with a cross and the star of the Order on the background
Marked in chrome: A II
3.9 × 9.7 × 8.8 cm
The State Hermitage Museum, inv. ERF- 284

Knife in gilded silver with a porcelain handle, decorated with the ribbon of the Order with a cross
21.4 × 2.9 × 2 cm
The State Hermitage Museum, inv. ERO-7427

Fork in gilded silver with a porcelain handle, same decoration
18.2 × 2.6 × 1.8 cm
The State Hermitage Museum, inv. ERO-7417

F.I. Gardner Factory in the town of Verbilki near Moscow, 1783–1785
Twelve pieces from the service of St. Vladimir's Order
Project designer, G.I. Kozlov (1738-1791)
Painted and gilded porcelain
Table setting: silver, gilding, porcelain
(repr. on p. 262)

Small oval fruit basked with handles made of intertwined stems with flowers and an openwork design along the edge, decorated with a ribbon of the Order with a cross, the star of the Order on the background with the motto, "Usefulness, honor, and glory"
Marked in cobalt blue: G.
9.5 × 28.2 × 19.7 cm
The State Hermitage Museum, inv. ERF-249
(repr. on p. 252)

A big fruit bowl in the shape of a leaf, decorated with a ribbon of the Order with a cross and the star of the Order on a green background
Marked in cobalt blue: G.
7.1 × 31 × 24.3 cm
The State Hermitage Museum, inv. ERF-7028

Fruit bowl in the shape of an elongated leaf with the same decoration
Marked in cobalt blue: G.
6.8 × 29.5 × 23.3 cm
The State Hermitage Museum, inv. ERF-261

Fruit bowl in the shape of a vine leaf with the same decoration
Marked in cobalt blue: G.
6.5 × 25.7 × 25 cm
The State Hermitage Museum, inv. ERF-268

Soup bowl with a festooned edge, decorated with the ribbon of the Order with a cross, a cross of the Order is on the background
Marked in cobalt blue: G.
4.5 × 22.5 cm
The State Hermitage Museum, inv. ERF-7055

Dinner plate with the same decoration
Marked in cobalt blue: G.
3.5 × 22.5 cm
The State Hermitage Museum, inv. ERF-7045

Creamer with two handles and a lid topped by a rose, decorated by the ribbon of the Order with a cross and a crown of leaves
Marked in cobalt blue: G.
8.2 × 10.8 × 6.8; 3.5 × 6.4 cm
The State Hermitage Museum, inv. ERF-7024 a, b

Creamer with a handle made of intertwined stems and a lid topped by a rose, decorated by a ribbon of the Order with a cross, the star of the Order and a crown of leaves
Marked in cobalt blue: G.
5.6 × 8.3 × 6.5; 3.7 × 6.7 cm
The State Hermitage Museum, inv. ERF-7061 a, b

Creamer with a handle and a lid topped by a rose, decorated with a ribbon of the Order with a cross and a crown of leaves
Marked in cobalt blue: G.
7.1 × 8.3 × 6.3; 3.7 × 6.7 cm
The State Hermitage Museum, inv. ERF-240 a, b

Salt cellar in the shape of a basket with handles and a festooned edge decorated with the ribbon of the Order with a cross, the star of the Order is represented on the background
Marked in cobalt blue: G.
4.7 × 11.8 × 10.1 cm
The State Hermitage Museum, inv. ERF-247

Salt cellar in the shape of a basket with entwined handles and a embedded festooned edging, decorated with a ribbon of the Order with a cross, the star of the Order is represented on the background
Marked in cobalt blue: G.
3.7 × 11 × 8.2 cm
The State Hermitage Museum, inv. ERF-246

Knife in gilded silver with a porcelain handle, decorated with a ribbon of the Order with a cross
22.5 × 2.9 × 2 cm
The State Hermitage Museum, inv. ERO-7371

Fork in gilded silver with a porcelain handle, decorated with a ribbon of the Order with a cross
18.3 × 2.6 × 1.8 cm
The State Hermitage Museum, inv. ERO-7363

Pieces from the "Cameo Service"
"Catherine II's service"
Sèvres, 1778–1779
Mark: two L's interlaced, dated "AA"
Soft-paste polychrome porcelain with gilding
(repr. on p. 210–219)

Twenty-four dinner plates
Diameter 26 cm
The State Hermitage Museum, inv. GT-51, 54. 65, 67, 87, 91, 100, 102, 103, 111, 142, 163, 185, 193, 195, 210, 211, 212, 214, 221, 240, 241, 244, 255

Four square fruit bowls
Width 20.5 cm
The State Hermitage Museum, inv. GT-359, 360, 363, 364

Four oval fruit bowls
Length 22.5 cm; width 20,5 cm
The State Hermitage Museum, inv. GT-372, 375, 376, 377

Two round fruit bowls
Height 9 cm; diameter 23 cm
The State Hermitage Museum, inv. GT-629, 631

Four sugar bowls with lids and a base
Height 14 cm; length 17 cm
The State Hermitage Museum
Sugar bowls: inv. GT-684, 687, 689, 691
Bases: inv. GT-380, 382, 383, 385

Twelve tea cups with their saucers
Height of the cup, 7 cm;
diameter of the saucer 13.5 cm
The State Hermitage Museum
Cups: inv. GT-451, 454, 457, 458, 460, 467, 473, 480, 481, 482, 485, 468
Saucers: inv. GT-386, 388, 391, 392, 393, 394, 395, 401, 402, 411, 412, 416

Twelve coffee cups with their saucers
Height of the cups, 5.5 cm;
diameter of the saucers 12 cm
The State Hermitage Museum
Cups: inv. GT-486, 488, 489, 490, 491, 493, 494, 495, 496, 497, 498, ЗФ-25195
Saucers: inv. GT-427, 429, 430, 432, 433, 434, 437, 440, 441, 445, 447, 449

Twenty-two small ice-cream cups
Height 8.5 cm
The State Hermitage Museum, inv. GT-509, 511, 519, 522, 525, 528, 536, 539, 541, 544, 546, 551, 552, 553, 557, 564, 569, 570, 571, 577, 580, 590

Four display shelves for glasses
Height 12.5 cm; length 26 cm; width 15 cm
The State Hermitage Museum, inv. GT-604, 609,
612, 617

Two display shelves for bottles
Height 16.5 cm; diameter 16.5 cm
The State Hermitage Museum, inv. GT-620, 621

Two ice-cream makers with their lids
Height 24 cm; diameter 19 cm
The State Hermitage Museum, inv. GT-623, 625

Two display shelves for liqueurs
Height 12 cm; length 26 cm; width 12 cm
The State Hermitage Museum, inv. GT-641, 642

Two trays for seven small ice-cream cups
Height 5.5 cm; diameter 26 cm
The State Hermitage Museum, inv. GT-647, 650

Two trays for four small ice-cream cups
Height 5.5 cm; length 21.5 cm; width 15.5 cm
The State Hermitage Museum, inv. GT-660, 661

Two cream jugs
Height 16 cm
The State Hermitage Museum, inv. GT-672, 673

Two coffee pots with their lids
Height 17.2 cm
The State Hermitage Museum, inv. GT-680, 682

Two 2-jam dish trays with their lids
Height 15.5 cm; length 20.5 cm; width 15.5 cm
The State Hermitage Museum, inv. GT-694, 696

Two 3-jam dish trays with their lids
Height 8.5 cm; diameter 19 cm
The State Hermitage Museum, inv. GT-700, 704

Eight small vases in the form of ram heads
Soft paste porcelain, biscuit
Height 17 cm
The State Hermitage Museum, inv. GT-7213, 7214,
7216, 7217, 7218, 7221, 7227, 7228, 7224, 7219

Two small vases in the shape of craters
Soft paste porcelain, biscuit
Height 12 cm
The State Hermitage Museum, inv. GT-7193, 7211

Two small pear-shaped vases
Soft paste porcelain, biscuit
Height 15 cm
The State Hermitage Museum, inv. ZF-24134,
24135

Two bases shaped like columns
Soft paste porcelain, biscuit
Height 11 cm
The State Hermitage Museum, inv. GT-7206, 7208

Jean-Baptiste Charlemagne's studio,
based on a project by Ch. Cameron, 1784
Armchair
St. Petersburg
Wood, silk, metal
119 × 77 × 73 cm
The State Hermitage Museum, inv. ERMb-1193

Two chairs bearing the arms of August II
Livonia (?), first third of 18th century
Oak
135 × 51 × 52 cm
The State Hermitage Museum, inv. ERMb-1665,
1666

Table
Russia, first quarter of the 18th century
Oak, resiniferous wood
71 × 83 × 70 cm
The State Hermitage Museum, inv. ERMb-856

Armoire-cabinet for casts of engraved stones
London, 1783–1790
Attributed to Roach
Various types of wood
232 × 102 × 37 cm
The State Hermitage Museum, inv. E-57
Arrived in London in 1783-1788 at the same time
as the J. Tassie collection of casts of engraved
stones

Chimney screen
Lyon, 1770–1780
Silk hanging done by Philippe de la Salle in 1771
Sculpted and gilded wood, silk
146 × 85 × 45 cm
The State Hermitage Museum, inv. E-5083
The screen has Catherine II's monogram, and she
herself is represented on the silk hanging
(repr. on p. 204)

Armoire-cabinet for engraved stones
Door: 1786–1787, Germany, Neuwied,
David Roentgen's studio
Armoire: beginning of 19th century, St. Petersburg,
Ch. Meyer, H. Gambs
Mahogany, oak, gilded bronze
Doors: 101 × 56 cm; armoire: 183 × 67 × 67 cm
The State Hermitage Museum, inv. E-155
(repr. on p. 205)

Armoire-cabinet for casts of engraved stones
London, 1783–1790
Attributed to Roach
Various types of wood
128 × 117 × 41 cm
The State Hermitage Museum, inv. E-342

Bean-shaped table
Russia, middle of 18th century
Wood, bronze
73 × 94 × 46 cm
The State Hermitage Museum, inv. E-1276

Catherine II's uniform dress based on the Imperial
Guard dress of the Preobrajensky Regiment
St. Petersburg, 1793
Caftan and silk skirt in green decorated with
gilded trimming and buttons. On the lining is an
inscription in India ink: 1763 N° 35
Length of the back of the outer garment, 194 cm;
of the skirt, 95 cm
Silk, silk and metallic thread, gilded trimming
The State Hermitage Museum, inv. ERT-11013,
11023
(repr. on p. 246)

Catherine II's uniform dress based
on the Horse Regiment Imperial Guard
St. Petersburg, 1773
Outer garment in blue silk. Under garment
in red and blue silk
On the lining is an inscription in India ink: 1773
Silk, silk and metallic thread, gilded trimming
Length of the back of the outer garment, 155 cm;
under garment, 150 cm
The State Hermitage Museum, inv. ERT-11002,
11008
(repr. on p. 246)

Pinafore Dress and Stole
Copies, second half of 19th century
Length of back, 142 cm
Blue velvet, metallic thread, embroidery
The State Hermitage Museum, inv. ERT-15866

Altar frontal "Prince Mikhail Tchernigovsky"
Russia, second half of 16th century
Silk, cloth, silk and metallic thread
41 × 30 cm
The State Hermitage Museum, inv. ERP-919

Altar frontal, "Three Saints" (St. John, St. Nicolas
and the venerable Cyrille Belozersky)
Russia, 17th century
Silk, cloth, silk and metallic thread, pearls
64.5 × 63.5 cm
The State Hermitage Museum, inv. ERP-1380
(repr. on p. 26)

Altar frontal, "St. Vassily the Great"
Russia
Silk, cloth, silk and metallic thread
45 × 38 cm
The State Hermitage Museum, inv. ERP-1076

Peter I's seaman's outfit: jacket, pants, hat
Russia, first half of 18th century
Jacket of dark brown wool, loose-fitting
light-brown woolen-cloth pants. Dutch style
wide-brimmed hat in brown wool
Wool, woolen cloth, cloth
Jacket 82 cm; pants 87 cm; hat diameter 35.5 cm
The State Hermitage Museum, inv. ERT-8545,
8436, 8498
(repr. on p. 42)

Peter's ceremonial dress: caftan, pants, shirt
Berlin workshops, 1710–1720
Caftan and pants of brown woolen cloth, cloth
shirt. Lining of wool and silk
Woolen cloth, cloth, silk, gilded thread
Caftan 114 cm; pants 76 cm; camisole 90 cm
The State Hermitage Museum, inv. ERT-8407,
8408, 8281

Peter I's winter interior dress
Western Europe, 1710–1720
Blue satin decorated with multi-colored
embroidery (flower garlands, bouquets)
Lining in blue silk. Kimono style cut
Satin, silk thread
Length 157 cm
The State Hermitage Museum, inv. ERT-8346

Caftan of an officer of the Dragoons
of the Imperial Regiment
Holstein–Gottorp, 1750s
Woolen cloth, silk
Back 100 cm; size 93 cm
The State Hermitage Museum, inv. ERT-12701

Coat of an officer of the Dragoons
of the Imperial Regiment
Holstein–Gottorp, 1750s
Woolen cloth, silk, gilded trimmings
Back 135 cm; width of bottom edge 334 cm
The State Hermitage Museum, inv. ERT-12700

Uniform of an officer of the Preobrajensky Regiment
of the Imperial Guard, caftan, camisole
Russia, 1762
Length of the back of the caftan, 95 cm;
of the camisole 77 cm
The State Hermitage Museum, inv. ERT-11038,
12702

Uniform of an officer of the Horse Regiment
of the Imperial Guard, caftan, camisole
Russia, 1760s
Woolen cloth, silk, metal, gilded trimmings
Length of the back of the caftan, 104 cm;
of the camisole, 81 cm
The State Hermitage Museum, inv. ERT-11034,
11035

"The supper at Simon le Pharisian's", 1712–1715
Wool, silk
504 × 772 cm
Signed lower right two times: Le Febvre
Gobelins Manufacture, Le Fevre-Sons high warp
workshop
First variant of the border made based on a
cartoon by Blain de Fontaine
In the cartouche of the lower part of the border,
the inscription: Dilexit Multum
The State Hermitage Museum, inv. N° 2902
(repr. on p. 60)

"The miraculous draught of fishes", 1713–1717
Wool, silk
504 × 743 cm
Signed lower right two times: Le Febvre
Gobelins Manufacture, Le Fevre-Sons high warp
workshop
First variant of the border made based on a
cartoon by Blain de Fontaine; in the lower part of
the border, the inscription: Qvia dominus est
The State Hermitage Museum, inv. N° 2898
(repr. on p. 61)

Master C. King
Portrait of Peter I
On the ribbons above the portrait of Peter I:
"PETRUS MAGNUS"
On the cannon, the signature of the
"Master C. KING"
Sculpted and gilded wood, velvet
27 × 27 cm (painting);
42 × 37 cm (dimensions including the frame)
The State Hermitage Museum, inv. ERD-1595
(repr. on p. 89)

Carnival sleigh
Russia, 1760s
Sculpted and gilded wood, metal, leather, velvet
174 × 350 × 116 cm
The State Hermitage Museum, inv. ERRz-6450
(repr. on p. 254)

Holy doors of the Simonov Monastery iconostasis
Moscow, 17th century
Sculpted and gilded wood
277 × 100 cm
The State Hermitage Museum, inv. ERP-1414 a, b
(repr. on p. 20)

St. Nicolas of Mojaïsk
Russia, 18th century
Sculpted and painted wood
128 × 83 × 20 cm
The State Hermitage Museum, inv. ERP-1082
(repr. on p. 24)

Christ, bound
Russia, 18th century
Sculpted and painted wood
125 × 58 × 47 cm
The State Hermitage Museum, inv. ERD-2472
(repr. on p. 25)

Mantle-piece clock
Russia, 18th century
Sculpted and gilded wood, metal, enamel
88,5 × 62 cm
The State Hermitage Museum, inv. ERD-2819

Pair of consoles with Cupid
Russia, first half of 18th century
Sculpted and gilded wood
38 × 36 cm
The State Hermitage Museum, inv. ERD-2382,
2383

Two wall candelabras with five candles
Russia, 18th century
Sculpted and gilded wood
50 × 70 cm
The State Hermitage Museum, inv. ERD-3031,
3012

Two wall candelabras with three candles,
from the Winter Palace
Russia, 18th century
Sculpted and gilded wood
43 × 23 cm
The State Hermitage Museum, inv. ERD-2861,
2862

Pair of wall mirrors with a candle
Russia, middle of 18th century
Sculpted and gilded wood, glass
51 × 25 cm
The State Hermitage Museum, inv. ERD-1753,
1754

Bas-relief "Angel in the clouds," with the right
arm raised
Russia, 18th century
Sculpted and gilded wood
82.5 × 31 cm
The State Hermitage Museum, inv. ERD-2957

Rules for visitors to the Hermitage established
by Catherine II
Russia, 1760
Wood, lacquer, gilding
78 × 60 × 3 cm
The State Hermitage Museum, inv. ERD-3300

Wall mirror with candle
Russia, 18th century
Sculpted and gilded wood, glass
56 × 30 cm
The State Hermitage Museum, inv. ERD-3153

Two-seated "vis-à-vis" carriage
Paris, around 1761
Oak, beech, ash, iron, steel, bronze, leather,
glass, silk, nacre
500 × 195 × 255 cm
The State Hermitage Museum, inv. KN-13
(repr. on p. 214)

Cane with a length measure inside
Western Europe, first half of 18th century
Wood (Spanish reed), bone, metal
Length, 90 cm
The State Hermitage Museum,
inv. ERD-128 a, b, v

Saw for amputations
Paris, first quarter of 18th century
Stamp in form of needle: "PARIS"
Steel, black wood
Length, 53 cm
The State Hermitage Museum,
inv. ERTkh-1074

Dentist pliers
Western Europe, end of 17th century,
beginning of 18th
Steel, wood
Length, 12.5 cm
The State Hermitage Museum, inv. ERTkh-1117

Three-legged measuring compass
Western Europe, first quarter of 18th century
Brass, steel
18 × 3 × 1.7 cm
The State Hermitage Museum, inv. ERTkh-1194
(repr. on p. 87)

Artillery aiming level
Western Europe, end of 17th century,
beginning of 18th
Brass
Length: 11.3 cm; hauteur 14.9 cm
The State Hermitage Museum, inv. ERTkh-1228
(repr. on p. 85)

Artillery aiming level
Western Europe, end of 17th century,
beginning of 18th
Brass
Length, 17.8 cm; height 15.6 cm
The State Hermitage Museum, inv. EPTkh-1230
(repr. on p. 100)

Geodesic Astrolabe, 1721
London, Master craftsman Edmond Culpeper
(1660-1738), based on a project by Peter I
Signature engraved: "Culpeper Londini"
Brass, glass
68.8 × 24.8 cm
The State Hermitage Museum, inv. ERTkh-1256
(repr. on p. 98–99)

Masters Georg Roll (1546-1592)
and Johann Reinhold (around 1550–1596)
*Astronomical clock with celestial
and terrestrial globe*, 1584
Germany, Augsburg
Alloys of copper, steel, silver, wood, enamel,
glass, gilding
Diameter 31.2 cm; height 49 cm
The State Hermitage Museum, inv. ERTkh-1303
(repr. on p. 56)

Masters Tobias Lengkhardt
and Hans Georg I Brenner
Peter I's Military campaign pharmacy kit,
around 1613–1615
Germany, Augsburg
39.5 × 41 × 32.5 cm
The State Hermitage Museum,
inv. ERTkh-1389–1425
(repr. on p. 101)

Master Pierre Morand
Model of the "Ferney Chateau," Voltaire's house
France, Ferney, 1777
Paper, wood, glass, metal, plaster
48 × 100 × 65 cm
The State Hermitage Museum, inv. ERTkh-2138
(repr. on p. 141)

Bartolomeo Carlo Rastrelli (1670–1744),
Andreï Constantinovich Nartov (1693–1756) (?)
*Medallion with allegoric representation,
"Sculptor chiseling the state of Peter I",*
1723–1729 (?)
Bronze
Diameter 35 cm
The State Hermitage Museum, inv. ERTkh-600

Zinger Franz (?–1723)
*Cylindrical Bas-relief (model) showing the siege
of Riga by the Russian troops*, 1720s
Bronze
Height 23.5 cm; diameter 30 cm
The State Hermitage Museum, inv. ERTkh-639

Stellar clock ("nocturnal")
England, end of 17th century,
beginning of 18th
Wood, copper
Width, 23.3 cm; diameter 10.5 cm
The State Hermitage Museum, inv. ERTkh-702

Universal horizontal sundial, Butterfield type,
1716–1725
St. Petersburg Artisan John Bradlee (?–1725)
Alloys of copper, steel
13.7 × 9.3 × 1.6 cm
The State Hermitage Museum, inv. ERTkh-705
(repr. on p. 96)

Parallel rules
Western Europe, beginning of 18th century
Wood, alloys of copper
Length 30.2 cm
The State Hermitage Museum, inv. ERTkh-763

Mechanical gauge
Western Europe, first quarter of 18th century
Brass, steel
26 × 6.5 cm
The State Hermitage Museum, inv. ERTkh-846

Telescope
France (?), first half of 17th century
Carton, leather, gilding
Length from 77 to 426 cm; diameter
of the tubes from 4.1 to 7.3 cm
The State Hermitage Museum, inv. ERTkh-891
(repr. on p. 95)

Andreï Constantinovich Nartov (1693–1756)
*Medallion with allegoric representation
of the Nystadt Peace (August, 30, 1721)*
Bronze
Diameter 35.5 cm
The State Hermitage Museum, inv. ERTkh-587
(repr. on p. 93)

Azimuthal ship's compass,
beginning of 18th century
London, Master Edmond Culpeper (1660–1738)
Alloys of copper, magnetic iron, wood, paper
47 × 74.4 × 38 cm;
diameter of the face, 35.6 cm
The State Hermitage Museum,
inv. ERTkh-1306
(repr. on p. 97)

*Armillary sphere representing the solar system
based on the geocentric theory*
England (?), beginning of 18th century
Brass
Diameter 40.4 cm; height 78 cm
The State Hermitage Museum, inv. ERTkh-1307
(repr. on p. 94)

Telescope binocular "BISNOG"
Paris, Master craftsman Vesdy,
first quarter of 18th century
Carton, parchment, leather, gilded bronze,
glass, wood
Length, 118 to 180 cm; section 11.8 to 24 cm
The State Hermitage Museum,
inv. ERTkh-1273 a, b, v
(repr. on p. 95)

Folding square
Paris, Master Michael Butterfield
(?–1724, first quarter of 18th century
Brass
17 × 16.4 × 4 cm
The State Hermitage Museum, inv. ERTkh-731
(repr. on p. 84)

Protractor
Western Europe
Brass
13.8 × 8.4 cm
The State Hermitage Museum, inv. ERTkh-728

Graduated ruler
Western Europe
Brass
38 × 3.5 × 0.3 cm
The State Hermitage Museum, inv. ERTkh-1201

Astrolabe plane table
Paris, Craftsman Louis Chapotot
Brass, glass
40 × 27 × 14 cm
The State Hermitage Museum, inv. ERTkh-697

Handsaw
Western Europe, end of 17th century,
beginning of 18th century
Steel, wood
72.5 × 16 cm
The State Hermitage Museum, inv. ERTkh-675

Plane
Western Europe, beginning of 18th century
Wood
9.5 × 4.3 cm
The State Hermitage Museum, inv. ERTkh-1288

Hatchet
Western Europe, beginning of 18th century
Steel, wood
38 × 12 × 2.7 cm
The State Hermitage Museum, inv. ERTkh-1302

Speculum
Paris, end of 17th century,
beginning of 18th century
Stamp in form of a needle, inscription: "PARIS"
Steel
19.2 × 5.8 × 10.3 cm
The State Hermitage Museum, inv. ERTkh-1093

Bartolomeo Carlo Rastrelli (1670–1744),
Andreï Constantinovich Nartov (1693–1756) (?)
*Bas-relief commemorating the founding
of St. Petersburg (May 16, 1703),* 1720s
Bronze
Diameter 35 cm
The State Hermitage Museum, inv. ERTkh-560
(repr. on p. 88)

Folding chessboard,
beginning of 18th century
Leather, cloth
48.5 × 36 × 0.3 cm
The State Hermitage Museum, inv. ERRz-1294

Beer tankard with lid, 1789
Silver, gilding
42.3 × 40.8 × 25.5 cm
The State Hermitage Museum, inv. ERO-4759
(repr. on p. 186)

Pieces of the D.I. Tchitcherin service, 1774–1775
Tobolsk
Silver, gilding, niello work
Teapot 18 × 6.2 × 19.5 cm;
tea box 18.8 × 8.8 × 8.8 cm;
finger bowl 18 × 18 × 18 cm;
cream jug 20.9 × 8.7 × 24 cm;
goblets 3.5 × 6.2 × 8.7 cm
The State Hermitage Museum, inv. ERO-5094,
5090, 5089, 5091, 5085, 5084
(repr. on p. 182)

Tray, 1774
Stamps: anonymous master, MN; stamp
of master's guarantee Ivan Savelev (S/1774);
City of Moscow
Silver, gilding
5.8 × 68 × 53 cm
The State Hermitage Museum, inv. ERO-4819
(repr. on p. 190–191)

Cup with lid
St. Petersburg, end of 18th century
Stamps of master's guarantee A. Yachinov (AI);
City of St. Petersburg
Silver, gilding
32 × 12.2 × 12.2 cm
The State Hermitage Museum, inv. ERO-4051

Watch in the form of an Easter egg, 1764–1769
Nijni Novgorod
Silver, metal, glass
9.5 × 5.6 × 5.6 cm
The State Hermitage Museum, inv. ERO-7318

Dish, "Catherine II's Triumph"
St. Petersburg (?), 1870s
Below, in the center, inscription:
"KATHARINA II,
Nata 1729 morta A. 1796 coronata A. 1762."
Silver
104.5 × 77.5 cm
The State Hermitage Museum, inv. ERO-8203

Goblet, 1706
Moscow
Inscription on the edge: Jan Sapega 1721
Gilded silver
10.1 × 9.2 cm
The State Hermitage Museum, inv. ERO-3569

Goblet, 1720
Stamps: Master of the monogram ЕΘ;
Master of the guarantee M. Moïseev (MM);
City of Moscow
Silver
13 × 11.2 × 11.2 cm
The State Hermitage Museum, inv. ERO-4579

Goblet, 1720s
Stamps: Anonymous master ЕΘ with initials
of Master of the guarantee M. Moiseev (MM)
Inscriptions: "Vivat! Vivat! Vivat the Czar Peter
Alexeevitch!..."
Gilded silver
13.1 × 11.2 × 11.2 cm
The State Hermitage Museum, inv. ERO-4580

Tray, 1720s
St. Petersburg
Stamps of master's guarantee G. CH/1736
Gilded silver
Diameter 49 cm
The State Hermitage Museum, inv. ERO-4596
(repr. on p. 189)

Goblet with lid, 1734
Moscow
Master Ivan Mikhaïlov, stamp I.M.
Gilded silver
30.5 × 12.8 × 12.8 cm
The State Hermitage Museum, inv. ERO-5171
(repr. on p. 176)

Kovsch
Moscow
Gilded silver, without stamp,
dated on the edge, 1718
10 × 28.4 × 18.5 cm
The State Hermitage Museum, inv. ERO-6905
(repr. on p. 196)

Kovsch, 1720s
Moscow
Gilded silver, without stamp
10 × 26.3 × 16.2 cm
The State Hermitage Museum, inv. ERO-7672
(repr. on p. 199)

Kovsch, 1730s
Moscow
Gilded silver, without stamp
9.6 × 29 × 17 cm
The State Hermitage Museum, inv. ERO-5179
(repr. on p. 198)

Kovsch, middle of 18th century
Moscow
Gilded silver, without stamp
10.2 × 28.3 × 15 cm
The State Hermitage Museum, inv. ERO-4556
(repr. on p. 185)

Kovsch, 1761
Moscow
Stamps: Master Ia. Maslennikov, stamp IaM;
Master of guarantee VA; City of Moscow; 1761
Gilded silver
11 × 30 × 16.5 cm
The State Hermitage Museum,
inv. ERO-4616
(repr. on p. 197)

*Three-legged beer tankard,
bowl and lid,* 1750s
Moscow
Stamps: Masters A. Guerasimov (AG)
and Yacob Grigoriev (IG), City of Moscow;
date incomplete 175...
Gilded argent
19 × 19 × 13.1 cm
The State Hermitage Museum, inv. ERO-4618
(repr. on p. 52)

Master I.F. Kepping
Soup bowl, 1750s
St. Petersburg
Silver
35 × 24 × 24 cm
The State Hermitage Museum, inv. ERO-5153
(repr. on p. 53)

Beer tankard, middle of 18th century
Moscow
Stamps of the Master VAO; City of Moscow
Gilded silver
14 × 8.8 × 8.8 cm
The State Hermitage Museum, inv. ERO-5147

Oval plate, 1762
Moscow
Stamps: Masters A. Guerasimov (AG)
and A. Polozov (APV); City of Moscow; 1762
Gilded silver
58 × 46 cm
The State Hermitage Museum, inv. ERO-5058
(repr. on p. 194)

Bratina (friendship cup), 1660s
Moscow
Gilded silver
9.5 × 11.4 × 11.4 cm
The State Hermitage Museum,
inv. ERO-6895
(repr. on p. 188)

Chalice, 1796
Moscow
Stamps: Master ΘA; stamp of guarantee Alexeï
Ivanovich Vikhliaev (AV); City of Moscow; 1796
Gilded silver, glass, enamel
31.7 × 12.3 × 18.5 cm
The State Hermitage Museum, inv. ERO-8198
(repr. on p. 181)

Censor, 1649
Moscow
Silver, 24.3 × 14.5 cm;
length of chain, 55 cm
The State Hermitage Museum, inv. ERO-8181
(repr. on p. 22)

Triptych, end of 17th century
Moscow
Wood, distemper, silver, enamel
12 × 9.5 cm (closed)
The State Hermitage Museum, inv. ERO-767
(repr. on p. 30–31)

*Evangelistary with medallions in enamel
and niello*
Bible, Moscow, 1787; covering, Moscow, 1789
Gilded silver, glass, enamel
48.5 × 33.5 cm
Stamps: Master of guarantee Alexeï Ivanovich
Vikhliaev (AV); city of Moscow, 1789
The State Hermitage Museum, inv. ERO-5706
(repr. on p. 192)

Reliquary cross, 1654
Moscow
Gilded silver, pearls
40.5 × 26 cm
The State Hermitage Museum, inv. ERO-7783
(repr. on p. 19)

Snuff-box in the shape of a boat, end of 17th century
Russia
Gold, wood, nacre
3.2 × 2.9 × 12.2 cm
The State Hermitage Museum, inv. E-3676
(repr. on p. 90)

Snuff-box with view of St. Petersburg, 1719–1725
St. Petersburg
Gold, tortoise-shell, miniature, glass
1.8 × 8.9 × 6.4 cm
The State Hermitage Museum, inv. E-4006

Beauty-mark box with embossing decoration
St. Petersburg, middle of 18th century
Jasper, gold, glass
2.6 × 5.8 × 6.8 cm
The State Hermitage Museum, inv. E-3958
(repr. on p. 177)

Beauty-mark box with embossing decoration
St. Petersburg, middle of 18th century
Gold, lapis lazuli, rock crystal, glass
2 × 6 × 5.2 cm
The State Hermitage Museum, inv. E-3987
(repr. on p. 207)

Jean Pierre Ador
Snuff-box with a portrait of Paul Petrovich, 1774
St. Petersburg
Gold, silver, diamonds, enamel
3.3 × 7.1 × 5.5 cm
The State Hermitage Museum, inv. E-4498
(repr. on p. 208)

Master Alexandre Lang
Snuff-box with allegoric composition, 1776
St. Petersburg
Gold, silver, diamonds, enamel, garnets
3.5 × 7.5 × 5.3 cm
The State Hermitage Museum, inv. E-4462
(repr. on p. 208)

Master Pierre Etienne Teremen
*Snuff-box with the portrait of the Grand Duke
Alexander Pavlovich*, 1799
St. Petersburg
Gold, enamel, glass, porcelain
Height 3.2 cm; diameter 8 cm
The State Hermitage Museum, inv. E-4062
(repr. on p. 209)

Snuff-box with representation of Peter I's monument,
1780s
Switzerland
Stamp of the master
Gold, enamel, miniature, glass, hair
Height 2.3 cm; diameter 7.5 cm
The State Hermitage Museum, inv. E-4025

Master Ch. Cabrier
Pair of clocks on columns
England, 1770s
Gold, silver, precious stones, enamel, glass,
metallic alloys
Height 42.8 cm; base 11.9 x 11.9 cm
The State Hermitage Museum, inv. E-2006, E-2007

Master Jean-François-Xavier Bouddé
Snuff-box with the portrait of Catherine II
St. Petersburg
Around 1780
Gold, silver, diamonds, enamel
Diameter 7.3 cm; height 1.5 cm
The State Hermitage Museum, inv. E-4706
On the lid, a portrait of Catherine II based
on a original by F. Rokotov
(repr. on p. 209)

Two statuettes of "Swiss Guards"
Germany, Saxony, first quarter of the 18th century
Silver, diamonds, pearls, enamel, garnets,
cornelian, gilding
14.7 × 6.9 × 7.5 cm
The State Hermitage Museum,
inv. E-2617, 2618

Statuette, "The Knife Grinder"
Germany, Saxony, first quarter of 18th century
Silver, diamonds, pearls, rubies, emeralds,
cornelian, marble, glass, garnets, enamel, gilding
8.8 × 8.4 × 5.9 cm
The State Hermitage Museum, inv. E-2620
According to the legend, Peter I bought this group
during his journey to Saxony

Anonymous
Chalice with medallions in enamel, 1795–1799
St. Petersburg
Stamps: St. Petersburg, 179… (illegible);
master of guarantee "A 3"; initials for gold "Ch"
Gold, silver, diamonds, enamel
Height 23 cm; diameter 12 cm
The State Hermitage Museum, inv. E-9756
(repr. on p. 181)

Reliquary cross with a sliver of the Holy Cross,
beginning of 19th century
St. Petersburg
Gold, diamonds, enamel, wood, mica
6.2 × 5.4 cm; length of the chain, 92 cm
The State Hermitage Museum, inv. E-9723

*Twenty-four dessert tableware settings with Catherine
II's monogram*
*Dessert spoons, forks and knives, teaspoons
and ice cream spoons*
Paris, Master Claude-Auguste Aubry
(worked from 1758 to 1791)
Stamps: Paris, master, year:
on the spoons, 1768–1769 and 1777–1778;
on the other silver-ware, 1778–1779
Gilded silver
Length: desserts spoons, 18.8 cm;
teaspoons, 14.5 cm;
forks, 18.5 cm;
ice cream spoons, 15 cm;
knives, 20.6 cm
The State Hermitage Museum
Spoons: inv. E-8076, 8077, 8078, 8079, 8080, 8081,
8082, 8083, 8084, 8085, 8086, 8087, 8088, 8089,
8090, 8091, 8092, 8093, 8094, 8095, 8096, 8097,
8098, 809
Forks: inv. E-8163, 8164, 8165, 8166, 8167, 8168,
8169, 8170, 8171, 8172, 8173, 8174, 8175, 8176,
8177, 8178, 8179, 8180, 8181, 8182, 8183, 8184,
8185, 8186
Knives: inv. E-8255, 8256, 8257, 8258, 8259, 8260,
8261, 8262, 8263, 8264, 8265, 8266, 8267, 8268,
8269, 8270, 8271, 8272, 8273, 8274, 8275, 8276,
8277, 8278
Teaspoons: inv. E-8470, 8471, 8472, 8473, 8474,
8475, 8476, 8477, 8478, 8479, 8480, 8481, 8482,
8483, 8484, 8485, 8486, 8487, 8488, 8489, 8490,
8491, 8492, 8493
Ice cream spoons: inv. E-8497, 8498, 8499, 8500,
8501, 8502, 8503, 8504, 8505, 8506, 8507, 8508,
8509, 8510, 8511, 8524, 8525, 8526, 8527, 8528,
8529, 8530, 8531, 8532
Silverware made for the Cameo Service

Table, 1744
Tula, Chansky factory
Steel, brass, wood
74 × 69 × 47 cm
The State Hermitage Museum, inv. ERM-5059
(repr. on p. 225)

Folding armchair, 1744
Tula
Steel, brass, leather
88 × 69 × 47 cm
The State Hermitage Museum, inv. ERM-5058
(repr. on p. 224)

Table-screen, 1785
Tula
Steel, bronze, copper
66 × 66 × 66 cm
The State Hermitage Museum, inv. ERM-2186
(repr. on p. 230)

Dressing table, around 1801
Tula
Steel, gilded bronze
77 × 55.5 × 38
The State Hermitage Museum, inv. ERM-7497
(repr. on p. 239)

Foot-stool, end of 18th century
Tula
Steel, gilded bronze, silk
17 × 34.5 × 25.5 cm
The State Hermitage Museum, inv. ERM-7535
(repr. on p. 239)

Small decorative cushion, end of 18th century
Tula
Pearls, steel, velvet
41 × 22.5 cm
The State Hermitage Museum, inv. ERM-2336

Armchair, 1790s
Tula
Steel, bronze, silk
92 × 58.5 × 47.5 cm
The State Hermitage Museum, inv. ERM-2185
(repr. on p. 239)

Chest, end of 18th century
Tula
Steel, gilded bronze, velvet
17 × 26 × 17.5 cm
The State Hermitage Museum, inv. ERM-7503
(repr. on p. 238)

Umbrella, 1780s
Tula
Steel, bronze, silk, glass
105.5 × 12 × 10 cm
The State Hermitage Museum, inv. ERM-2164

Chest, end of 18th century
Tula
Master craftsman Rodion Leontiev (signature
on the base: Tula M./ master craftsman/Rodion
Leontiev)
Steel, gilded bronze, velvet
18.5 × 27.5 × 19.2 cm
The State Hermitage Museum, inv. ERM-2170
(repr. on p. 228)

Pair of candelabras with four candles,
last quarter of 18th century
Tula
Steel, gilded bronze
26.5 × 12 × 12 cm
The State Hermitage Museum, inv. ERM-981, 982
(repr. on p. 237)

Perfume and incense burner, end of 18th century
Tula
Steel
12.5 × 25.5 × 9 cm
The State Hermitage Museum, inv. ERM-2136
(repr. on p. 228)

Spool, end of 18th century
Tula
Steel, gilded bronze
25 × 17 × 10.7 cm
The State Hermitage Museum, inv. ERM-2183
(repr. on p. 229)

*Writing set with ink well, sand recipient and candle
holder on an oval base*,
end of 18th century
Tula
Steel, bronze
16 × 20 × 17.3 cm
The State Hermitage Museum, inv. ERM-7701
(repr. on p. 238)

Pierre Fromeri (?)
Box-safe having belonged to Peter I
Berlin, first third of 18th century
Steel, gilded bronze, enamel
20 × 31.5 × 21.5 cm
The State Hermitage Museum, inv. ERM-5054
Monogram "PA" (Peter Alexeievich) under
an imperial crown

Box
Russia, 1727
Brass, enamel
38 × 43 × 32 cm
The State Hermitage Museum, inv. ERM-4701

Eleven pieces of a chess game, 1780s
Steel, bronze
Tula
The State Hermitage Museum

King	inv. ERM-4591, 4579	10.5 × 3.4 × 3.3 cm
Queen	inv. ERM-4592, 4580	9.5 × 3.3 × 3.3 cm
Pawns	inv. ERM-4584, 4596	5 × 2.1 × 2.1 cm
Knights	inv. ERM-4590, 4608	5.8 × 2.5 × 2.5 cm
Castle	inv. ERM-4607	4 × 3.7 × 2.5 cm
Bishop	inv. ERM-4581, 4593	7.9 × 2.7 × 2.7 cm

(repr. on p. 234–235)

Ink-well in the shape of a globe,
beginning of 19th century
Tula
Steel
23.5 × 11.5 × 11.8 cm
The State Hermitage Museum, inv. ERM-2129
(repr. on p. 232)

Triptych *"Deisis"*, 18th century
Russia Vygovsky Monastery (?)
Copper, enamel
17.4 × 15.3 cm
The State Hermitage Museum, inv. ERP-332
(repr. on p. 34–35)

Triptych *"Deisis"*, 18th century
Russia Vygovsky Monastery (?)
Copper, enamel
18.2 × 15.7 cm
The State Hermitage Museum, inv. ERP-333

Patriarchal altar cross, 18th century
Russia
Copper, enamel
38.8 × 22.5 cm
The State Hermitage Museum, inv. ERP-22
(repr. on p. 29)

Mirror, second half of 18th century
Russia
Engraved and gilded wood
104 × 40.5 cm
The State Hermitage Museum, inv. ERD-2645

The Emperor's ukaze, middle of 18th century
Bronze and glass
67 × 37 × 50 cm
The State Hermitage Museum, inv. ERD-2055
(repr. on p. 43)

Antoine Lossenko
Statue of Peter I by Falconet in St. Petersburg, 1770
84 × 106 cm
Black stone, graphite, and highlights in white
chalk
Fine Arts Museum, Nancy, inv. 370
(repr. on p. 137)

B.L. Enriquez
*Head of the statue of Peter I based on a drawing
by Lossenko*, 1772
32.9 × 22.2 cm
Paper, burin engraving
Scientific Research Museum of the Russian
Fine Arts Academy, inv. G-9634

Antoine Lossenko
*Equestrian statue of Peter I based on the model
by Falconet*, 1770
64.3 × 49 cm
Red chalk on paper
Scientific Research Museum of the Russian
Fine Arts Academy, inv. R-4366

Ivan Eliakov
*View of the Neva toward the East between the Galleys
Shipyards and the 13th line of Vassiliesky Island*,
1716/29–1770
Left: 50.4 × 68.4 cm; right: 50.4 × 71.6 cm
Paper, burin engraving in two parts
Scientific Research Museum of the Russian Fine
Arts Academy, inv. G-10036
(repr. on p. 163)

Yakov Vassiliev
View of the Neva toward the West between
St. Isaac's Cathedral and the Cadet Corps buildings,
18th century
Left: 50.6 × 69.2 cm; right: 50.5 × 70.7 cm
Paper, burin engraving in two parts
Scientific Research Museum of the Russian
Fine Arts Academy, inv. G-10037
(repr. on p. 47 and 163)

Grigori Anikievich Katchalov
View of the banks of the Neva in going down the river
between Her Majesty's Winter Palace and the
Academy of Science buildings, 1716/29–1770
Left: 54.5 × 72.5 cm; right: 54.5 × 72.5 cm
Paper, burin engraving in two parts
Scientific Research Museum of the Russian
Fine Arts Academy, inv. G-10738
(repr. on p. 162)

Efime Grigorievitch Vinogradov
View seen from the banks of the Neva in going up the
river toward the Admiralty and the Academy of
Science, 1716/29–1770
Left: 54.8 × 72.5 cm; right: 54.7 × 72.5 cm
Paper, burin engraving in two parts
Scientific Research Museum of the Russian
Fine Arts Academy, inv. G-10737
(repr. on p. 162)

Anonymous, based on the project by V. Brenna
Model of half of the west façade and of the
church of St. Michael's Castle
(Scale: 1/33), end of 1790
Wood, oil painting, wax, plaster
127 × 183 × 163.5 cm
Scientific Research Museum of the Russian
Fine Arts Academy, inv. AM-38
(repr. on p. 157)

Group of artists under the direction
of Y. Lorents (Jacob Lorenzo)
Model of the Smolny Monastery based
on a project by F.B. Rastrelli
(Scale: 1/62), 1750–1756
Wood, oil painting, gilding
272 × 526 × 550 cm
Scientific Research Museum of the Russian
Fine Arts Academy, inv. AM-2
(repr. on p. 168–171)

Group of artists directed by A. Vist
based on a project by A. Rinaldi
Model of St. Isaac "The Dalmatian's" Cathedral
(Scale: 1/33), 1766–1769
Wood, oil painting, gilding, plaster, gypsum
260 × 237 × 250 cm
Scientific Research Museum of the Russian
Fine Arts Academy, inv. AM-7
(repr. on p. 158, 164–167)

Bibliography

A

Album du comte du Nord, preface Jean Babelon. Published by Monelle Ayot, Paris 2001.

Algarotti, *Lettres du comte Algarotti sur la Russie avec l'histoire de la guerre de 1735 contre les Turcs et des observations sur la mer Baltique et la mer Caspienne*, (Letters from Count Algarotti to Lord Hervey and the Marquis Scipio Maffei), London and Paris 1769.

Ancelot Jacques, *Six mois en Russie* in *Œuvres complètes*, Paris, 1838.

Arlincourt, Victor d', *Le Pèlerin. L'Etoile polaire*, Paris, Dumont, 1843.

Audouard, Olympe, *Voyage au pays des boyards. Étude sur la Russie actuelle*, Paris, 1881.

B

Batowsky, Zygmunt, *Architekt Rastrelli o swych pracach, Relation générale de tous les édifices, palais et Jardins que moy Comte Rastrelli, Ober Architecte de la Cour, a fait construire pendant tout le tems que j'ai eu l'honneur d'être au service de Leurs Majestés Imp.^{les} de toutes les Russies, à commencer depuis l'année 1716 jusqu'à cette année 1764* Lwow, Zaklad Narodowy Imiena Ossolinskich, 1939.

Berelowich, Vladimir and Medvedkova Olga, *Histoire de Saint-Pétersbourg*, Paris, Fayard, 1996.

Biais, Emile, *Les Pineau, sculpteurs, dessinateurs des bâtiments du Roy, graveurs, architectes (1652-1886) d'après les documents inédits concernant des renseignements nouveaux sur J. Hardouin Mansart*, Paris, published by Morgand 1891.

Bridges, J, *History of Northants*, 1791

Brodsky, Joseph, *Less than One* (essay "A Flight from Byzantium.") (*Loin de Byzance*, French translation, Paris, Fayard, 1988).

C

Catherine II et l'Europe, Actes du colloque, edited by Anita Davidenkoff, Paris 1997.

Caulaincourt, Armand, Marquis of Caulaincourt, Duke of Vicence, *Mémoires*, Paris, 1934.

Cracraft, James, *The Petrine Revolution in Russian Architecture*, The University of Chicago Press, 1988.

Curtis, Mina, *A forgotten empress, Anna Ivanovna and her era, 1730-1740*, New-York, 1974.

Custine, Astolphe de, *La Russie en 1839*, Paris, Amyot, 1843.

D

Daschkoff, Princess, *Mémoires de la princesse Daschkoff, dame d'honneur de Catherine II*, ed. Presented and annotated by Pascal Pontrémoli, Paris, Mercure de France, 2001

De Grève, Claude, *Le voyage en Russie, Anthologie des voyageurs français aux XVIII et XIX^e siècles*, Paris, Laffont, 1990.

Dezallier d'Argenville, Antoine–Joseph, *Théorie et pratique du jardinage*, published by Mariette, Paris 1709.

Diderot, Denis, *Correspondance*, June 1773–April 1774, Paris, Mouret, 1966.

Ducamp, Emmanuel, *Vues des palais impériaux des environs de Saint-Pétersbourg ; Gatchina, Pavlovsk, Peterhof, Tsarskoïe Selo*, Paris, Alain de Gourcuff, 1991.

Dumas, Alexandre, *Voyage en Russie*, Paris, Hermann, 1960, re-edition of *Impressions de voyage en Russie 1858-1859*, Paris, 1865.

F

Ferro Marc, *Nicolas II*, Paris, Petite Bibliothèque Payot,1991.

Frotier de la Messellière, Louis-Alexandre, *Voyage à Pétersbourg ou Nouveaux mémoires sur la Russie*, Paris 1803.

Führing, Peter, *Design into art. Drawings for Architecture and Ornament. The Lodewijk Houthakker collection*, London, 1989, 2 vol.

G

Gallet Michel:
- *Ledoux*, Paris, Picard, 1980.
- *Les architectes parisiens du XVIII^e siècle, dictionnaire biographique et critique*, Paris, Mengès, 1995.

Gautier, Théophile
- *Trésors d'art de la Russie ancienne et moderne. Ouvrage publié sous le patronage de Sa Majesté l'empereur Alexandre II, dédié à Sa Majesté l'impératrice Marie Alexandrovna*, Paris, Gide 1859.
- *Voyage en Russie en 1859*, Paris, Le Moniteur, 1865-1866.

Georgel, (Abbé), *Voyage à Saint-Pétersbourg en 1799-1800*, Paris 1818.

Grey, Marina, *Paul I^{er}*, Paris, Perrin, 1998.

Gurlitt, Cornelius, *Andreas Schlüter*, Berlin, 1881.

H

Hamilton, G.H., *The Art and Architecture of Russia*, re-edition, Baltimore, 1975.

Harris, John, *Sir William Chambers*, London, 1996.

Hautecoeur, Louis, *L'architecture classique à Saint-Pétersbourg à la fin du XVIII^e siècle*, Paris, Honoré Champion, 1912.

Heller, Michel, *Histoire de la Russie et de son empire*, Paris, Plon, 1997.

J

Julvécourt, Paul de, *Autour du Monde*, Paris, Hivert, 1834.

K

Kaganov, Grigori, *Images of space, Saint Petersburg in the visual and verbal arts*, Stanford, (Calif.) 1997.

Kennett, Victor and Audrey, *The Palaces of Leningrad*, London, Thames and Hudson, 1973.

Kirikov, Boris, *Saint-Pétersbourg, Guide de l'architecture*, Paris, Canal Editions 1997.

Kraft, Gueorg, *Description authentique et circonstanciée de la maison de glace construite à Saint-Pétersbourg au mois de janvier 1740... par Gueorg Kraft, membre de l'Académie impériale des Sciences et professeur de physique*, St. Petersburg, 1741.

L

Lavedan, Pierre, *Histoire de l'urbanisme, Renaissance et Temps modernes*, Paris, Henri Laurens, 1959.

Lepautre, Pierre, *Recueil des plans généraux des jardins de Versailles, de Trianon et de la Ménagerie... les plans en grand de tous les bosquets... etc.*, Peter the Great Library in the Academy of Science Library, St. Petersburg.

Leroy-Beaulieu, Anatole, *L'Empire des tsars et les Russes*, Paris Hachette, 1881, re-edition Paris, Laffont, 1990.

Lister, Raymond, *Decorative wrought ironwork in Great Britain*, London 1957, re-edition Ch. Tuttle, 1970.

Lo Gatto, Ettore, *Le Mythe de Saint-Pétersbourg*, French translation, Paris, Editions de l'Aube, 1995.

Lossky, Boris, "J.-B.-A. Le Blond, Architecte de Pierre le Grand, son œuvre en France", *Bulletin of the Russian Association for Scientific Research in Prague*, n° 16, Prague, 1936.
- "Deux livres sur l'art russe du XVIIIème siècle et de la première moitié du XIX^e siècle", *Gazette des Beaux-Arts* (Fine Arts Gazette), May-June 1985, Paris.
- "Un architecte français en Russie à l'aube du XIX^e siècle : J.-F. Thomas dit de Thomon", *Revue des Études slaves* (Review of Slavic Studies), t. LVII, fasc. 4, Paris, 1985.
- "Formation artistique et premières étapes de la carrière de l'architecte Jean-François Thomas, dit de Thomon (1759-1813)", *Bulletin de la Société de l'Histoire de L'art français* (History Society Bulletin of French Art), Paris, 1986.
- "Consécration internationale de l'art de Giacomo Quarenghi", *Gazette des Beaux-Arts* (Fine Arts Gazette), Paris, June 1986.
- "Pour saluer la première monographie de Vincenzo Brenna, Architecte du Tsar Paul I^{er}", *Gazette des Beaux-Arts* (Fine Arts Gazette), Paris, May-June 1987.
- "En attendant la première monographie de J.-B.-M. Vallin de la Mothe (1729-1800)", *Gazette des Beaux-Arts* (Fine Arts Gazette), Paris, May-June 1988.
- "Dessins et manuscrits de J.-B. Michel Vallin de la Mothe (1729-1800) dans les collections françaises", *Bulletin de la Société de l'Histoire de l'Art français* (History Society Bulletin of French Art), Paris, 1988.
- "Vallin de la Mothe à travers les collections de la S.A.H.C.", *Bulletins et Mémoires, Société archéologique et historique de la Charente*, Angoulême (Bulletins and Memoirs, Archeological and History Society of Charente), 1989.

M

Madariaga, Isabel de, *Russia in the Age of Catherine the Great*, 1982 (*La Russie au temps de la Grande Catherine*, translated from English by Denise Meunier, Paris, Fayard, 1987)

Mérimée, Henri, *Une année en Russie. Lettres à Saint-Marc Girardin*, Paris, Amyot, 1847.

Montclos, Brigitte de:
- *Splendeurs de Russie*, exhibition, Petit Palais Museum, Paris 1993.
- "Le mobilier en acier de Toula", in *L'Estampille/L'Objet d'art*, n° 268, April 1993.
- *Introduction à l'architecture de Saint-Pétersbourg* in *Le Défi architectural des tsars*, Saint-Pétersbourg, Loire-Atlantique Regional Council, 1995.
- *Un palais d'Hiver pour les rois du Nord*, in Muséart, *Saint-Pétersbourg impérial*, n° 56, December 1995–January 1996.
- *Moscou, Patrimoine architectural* (scientific advisor), Paris, 1997.
- *Civilisation de Saint-Pétersbourg*, Paris, Mengès, 2001
- *Rivières et canaux, La Construction de Saint-Pétersbourg, Résidences de campagne* in *Saint-Pétersbourg*, coll. Bouquins, Laffont, Paris, 2003.

Mottraye, Aubry de La, *Voyages en Anglais et en Français en diverses provinces*, The Hague, 1732.

N

Nolhac, Pierre de, *La résurrection de Versailles, Souvenirs d'un conservateur, 1887-1920*, p. 151–168, Paris, Perrin/Amis de Versailles (Friends of Versailles), 2002

P

Percier, Charles, and Fontaine, Pierre, *Résidences de Souverains. Parallèle entre plusieurs résidences de souverains de France, d'Allemagne, de Suède, de Russie, d'Espagne et d'Italie*, Paris, published by the authors, 1833.

Perelle, Gabriel *Vues des plus beaux endroits de Versailles*, Paris 1679.

Pérouse de Montclos, Jean-Marie:
- *Les Prix de Rome*, Paris, Berger-Levrault, 1984.
- *Principes d'analyse scientifiques, Architecture, Vocabulaire*, second edition, Paris, Imprimerie nationale, 1988.
- *Histoire de l'Architecture française, De la Renaissance à la Révolution*, Paris, Mengès, 1989.
- *Etienne-Louis Boullée*, second edition, Paris, Flammarion, 1994.

Perrault, Charles, *Le Labyrinthe de Versailles, présenté par Charles Perrault avec des gravures de Sébastien Leclerc*, Paris, Imprimerie Royale, 1677, chap. XXXIX.

Pingaud, Léonce, *Les Français en Russie*, Paris, 1886.

Q

Quarenghi, Jacques (Giacomo):
- *Edifices construits à Saint-Pétersbourg d'après les plans du chevalier de Quarenghi et sous sa direction*, St. Petersburg, 1810.
- *Théâtre de l'Hermitage de Sa Majesté l'Impératrice de toutes les Russies*, St. Petersburg, 1787.
- *Le nouveau Bâtiment de la Banque Impériale de Saint-Pétersbourg* St. Petersburg, 1791.

R

Raeff, Marc, *Politique et culture en Russie, XVIII^e-XX^e siècles*, Paris, 1996.

Réau, Louis:
- *Saint-Pétersbourg*, Paris, 1913.
- *L'Art russe*, Paris, 1921.
- *Correspondance de Falconet avec Catherine II, 1767-1778*, Paris, 1921.
- *Correspondance artistique de Catherine II avec Frédéric-Melchior, baron de Grimm*, Paris, 1922.
- *Etienne-Maurice Falconet*, Paris, 1922.
- *Histoire de l'expansion de l'Art français moderne, le Monde slave et l'Orient*, Paris, 1924.
- *L'Europe française au siècle des Lumières*, Paris, 1938.

Reichard, Hans Ottokar, *Guide de la Russie et de Constantinople*, Weimar, 1793.

Riasanovsky, Nicolas V., *Histoire de la Russie des origines à 1984*, French translation, Paris, Laffont, 1987.

Roche, Denis, *Les dessins de Nicolas Pineau pour la Russie*, Starye Gody, St. Petersburg, 1913.

Rowan, Alistair, *Robert Adam, Catalogue of Architectural Drawings in the Victoria and Albert Museum*, London, 1988.

Rykwert, Joseph, *Adam, Nascita di uno stile*, Electa, Milan, 1984.

S

Ségur, Louis-Philippe, Cte de, *Mémoires ou Souvenirs et anecdotes*, Paris, 1824-1826.

Soloviova, Tatiana, *Po Angliiskoï naberejnoï*, (On the English Quay), bilingual edition, St-Petersburg, Euro-cultures, 1995.

Staël, Germaine de, *Dix années d'exil*, Brussels, 1821.

Summerson, John, *Architecture in Britain, 1530-1830*, The Pelican History of Art, sixth edition, 1970.

T

Thacker, Christopher, *Histoire des jardins*, Paris, 1979.

Troyat Henri:
- *Catherine la Grande*, Paris, 1977.
- *Pierre le Grand*, Paris, Flammarion, 1979.
- *Alexandre I^{er}*, Paris, Flammarion, 1981.
- *Alexandre II*, Paris, Flammarion, 1990.

V

Versini Laurent, *Diderot, Œuvres*, vol. III and V, Paris, Laffont, coll. Bouquins, 1995.

Viardot, Louis, *Les musées d'Angleterre, de Belgique, de Hollande et de Russie*, Paris, Paulin and Lechevalier, 1851.

Vicat, Louis-Joseph, *Recherches expérimentales sur les chaux de construction, les bétons et les mortiers ordinaires*, Paris, 1818.

Vigée-Lebrun, Elisabeth-Louise, *Souvenirs*, Paris, 1835-1837.

W

Weber, F.C., *Nouveaux mémoires sur l'état présent de la Grande Russie ou Moscovie par un Allemand résidant en cette cour, avec la description de Pétersbourg et de Kronshlot*, translated from the German by Father Malassis, Paris, 1725.

Z

Zanella, Vanni, *Giacomo Quarenghi, Architetto a Pietroburgo, Lettere e altri scritti*, Venice, Albrizzi, 1988.

Exhibition Catalogues

Istoritcheskaïa vystavka arkhitektury, St. Petersburg, 1911, bilingual captions.

Charles De Wailly, peintre architecte dans l'Europe des Lumières, Paris, 1979.

La France et la Russie au siècle des Lumières, Grand Palais, Paris, 1986.

L'ordre de Malte et la France, National Museum of the Legion of Honor, Paris, 1988.

Les Architectes de la Liberté, École nationale supérieure des Beaux-Arts, Paris, 1989.

Catherine the Great, Centennial Building, Fair Park, Dallas (USA), 1992.

Splendeurs de Russie, Petit Palais Museum, Paris, 1993.

Balzac dans l'Empire russe, Balzac House, Paris, 1993.

Saint-Pétersbourg vu par ses architectes, dessins d'architecture des XVIII^e-XIX^e siècles du musée de l'Académie des Beaux-Arts de Saint-Pétersbourg, Mona Bismark Foundation, Paris, 1993.

Domenico Trezzini e la costruzione di San Pietroburgo, Museo cantonale d'Arte, Lugano, 1994.

Giacomo Quarenghi, architettura e vedute, Palazzo della Ragione, Bergamo, 1994.

Charles-Louis Clérisseau (1721-1820). Dessins du musée de l'Ermitage, Saint-Pétersbourg, Louvre Museum, RMN (Réunion des Musées Nationales), Paris, 1995.

Betancourt, los inicios de la Ingeneria Moderna en Europa, Real Jardin Botanico, Pabellon Villanueva, Madrid, 1995.

Le Défi architectural des tsars, Saint-Pétersbourg, La Garenne-Lemot, Clisson, Loire-Atlantique, 1995.

Splendeur et intimité à la cour impériale de Russie, Collections du musée national du palais de Pavlovsk, Museum of the Dukes of Wuremberg castle, Montbéliard, 1995.

Les Russes à Paris au XIX^e siècle, Carnavalet Museum, Paris, 1996.

Hubert Robert (1733-1808) et Saint-Pétersbourg, Valence Museum, RMN (Réunion des Musées Nationaux), 1999.

Rastrelli i Elisaveta. Epokha barokko (Rastrelli and Elisabeth. The Baroque Period), Smolny Monastery, St. Petersburg, 2000.

Italianskie arkhitektory dlia Rossii, XV-XX vv (Italian architects for Russia, 15th to 20th centuries), Schusev Museum, Moscow, 2000.

Stroganoff, The Palace and collections of a Russian noble family, Portland Art Museum, 2000, Carnavalet Museum, Paris, 2002.

Osnovateliou Peterbourga, English version *Homage to the founder of St. Petersburg*, St. Petersburg, Hermitage Museum, 2003.

Dal mito al progetto, la cultura architettonica dei maestri italiani e ticinesi nella Russia neoclassica, Accademia di Architettura, Mendrisio, Museo cantonale d'Arte, Lugano, October 2003-January 2004.

Russian Bibliography

B

Barteneva., M. I. *Nicolaï Benois*, St. Petersburg, Stroïizdat, 1994.

Benois, Alexander Nikolaïevich, *Moi Vospominania*, Moscow, 1980.

Bergholtz, F.V., "*Dnievnik*" (Dnievnik kammer-junker F.V. Bergholtsa 1721-1725 – journal of the kamer-junker Bergholts), translated from German into Russian by I.F. Ammon and published in Rousskii Arkhiv, Moscow, 1902-1903.

Bobrova, E.I., *Biblioteka Pietra Piervovo, oukazatiel-spravotchnik*, (Peter I's Library), Leningrad, 1978.

C

Court Archives in Zapiski imperatorskogo moskovskogo arkheologuitcheskogo instituta imieni imperatorskogo Nikolaïa II, volume XXIII, Moscow 1913.

D

Derjavin, G.R., *Opissanie prazdnika, byvchevo po sloutchaiou vziatia Izmaïla*, (Description of the celebration given on the occasion of the taking of Izmail), St. Petersburg, 1792.

Diatchenko, L.I., *Tavritcheski dvorets* (The Tauride Palace), St. Petersburg, Almaz, 1997.

E

Ermitage, istoria stroitelstvo i arkhitektury (The Hermitage: history of its construction and architecture), a collective work edited by Boris Piotrovsky, Leningrad, Stroïizdat, 1989.

Ermitage, istoria i sovremennost (The Hermitage, history and contemporaneity), edited by Boris Piotrovsky, Moscow, Iskousstvo, 1990.

Exacte relation von der von Sr. Szarschen Majestät Petro Alexiowitz an dem grossen Newa und der Ost-See neue erbauten Vestung und Stadt St. Petersburg... von H.G., Leipsig, 1713 (translated into Russian and published in Rousskaïa Starina with the title *Opissanie Sankt Peterburga i Kronshchlota*, St. Petersburg, October and November 1882.)

Evsina, N.A., *Arkhitekturnaïa teoria v Rossii XVIII vieka* (Architectural Theory in Russia in the 18th century), Moscow, 1975.

G

Grabar, I.G., *Istoria rouskogo iskousstva*, volume III, *Peterbourg v XVIII i XIX viekakh* (History of Russian Art, Vol. III, Petersburg in the 18th and 19th centuries), St. Petersburg, 1913.

Gueïrot, Alexandre, *Opissanie Petergofa 1501-1868* (Description of Peterhof), St. Petersburg, Imperial Printing House of the Academy of Science, 1868.

I

Istoria rousskoï arkhitektoury pod redaktsieï akademika I.E. Grabaria (History of Russian architecture edited by Igor Grabar), second edition, Moscow, 1956.

K

Kaliazina, N.V., *Dvoriets Menchikova* (The Menshikov Palace), Moscow, Sovietski khoudojnik, 1986.

Korchounova, M.F., *Iouri Felten*, Leningrad, Lenizdat, 1988.

Kioutchariants, D.A.
- *Gatchina*, Leningrad, Lenizdat, 1990.
- *Antonio Rinaldi*, St. Petersburg, Stroïizdat, 1994.
- *Ivan Starov*, St. Petersburg, Stroïizdat, 1997.

Kozmian, G.K., *K.B. Rastrelli* in *Zodchie Peterbourga XVIIIeme vieka* (K.B. Rastrelli in *The St. Petersburg Architects*) St. Petersburg, Lenizdat, 1997.

L

Luppov, S.P., *Istoria stroïtelstva Peterbourga v piervoï tchetvierti XVIII vieka* (History of the construction of Petersburg in the first quarter of the 18th century), Moscow-Leningrad, Izdatielstvo Akademiï SSSR, 1957.

M

Matveiev, A., *Rastrelli*, Leningrad, 1938.

P

Pamiatniki arkhitektoury prigorodov Leningrada (Architectural monuments in the Leningrad surroundings) edited by V.I. Piliavsky, Leningrad, Stroïizdat, 1983.

Peterbourg v 1720, Zapiski poliaka-otchevitsa (Petersburg in 1720, notes by a Polish observer), published in *Rousskaïa Starina*, volume XXV, St. Petersburg, June, 1879.

Piliavsky, V.I., *Stassov Arkhitektor* (The architect Stassov), Leningrad, National publications on construction, architecture and architectural studies, 1963.

Piliaiev, M.I., *Stary Peterbourg* (Old Petersburg), St. Petersburg 1889, re-edition Titoul, Leningrad, 1990.

Polnoïe sobranie zakonov Rossiiskoï Imperii (Complete collection of the laws of the Russian empire), volume V.

Putchkov, Vladimir and Khaïkina, Liudmilla, *Mikhaïlovskii Zamok* (St. Michael's Castle), St. Petersburg, Palace Editions, 2000.

R

Raskin, A., *Petrodvorets*, Leningrad, Lenizdat, 1988.

Rousskaïa koultoura piervoï tchetverti XVIII vieka, dvorets Menchikova, (Russian culture in the first quarter of the 18th century, the Menshikov Castle), collective work, St. Petersburg, Hermitage publication, 1992.

Rousskaïa architectura piervoï poloviny XVIII° vieka, pod redactsieï akademika I. E. Grabar, Moscow, 1954 (Russian architecture in the first half of the 18th century, edited by the Academician Igor Grabar).

S

Severnaïa ptchela (l'Abeille du Nord), 1850, n° 79.

Soloviova, Tatiana, *Po Angliiskoï naberejnoï* (On the English quay), bilingual edition, St. Petersburg, Euro-cultures, 1995.

Stählins, Jacob, *Zapiski ob iziachtchnykh iskousstvakh v Rossii* (1735-1785), Moscow, Iskousstvo, 1990.

Starye Gody (*The Old Years*)
- 1912, n° 2, Igor Grabar, *Alexandrovski klassitsism i evo frantsouzskie istotchniki* (Alexander's Classicism and its French sources), p. 68-97.
- 1913, *Denis Roche Les dessins de Nicolas Pineau pour la Russie*
- 1916, April-June, A. Troubnikov *Piervye pensioniery imperatorskoï Akademii khoudojestv* (The first residents of the Imperial Fine Arts), p. 67–88.

T

Tchekhanova, O.A., *Auguste Monferrand*, St. Petersburg, Stroïizdat, 1994.

Trofimov, V., *Petropavlovski sobor* (Peter and Paul Cathedral), St. Petersburg, Bieloïe i Tchernoïe, 1998.

V

Viedomosti vremieni Petra Vielikovo, 1703-1707, Moscow, 1903.

Viguel, Philippe Philippovich, *Zapiski* (Notes at the beginning of the 19th century–1856), First Moscow edition 1928, second edition, Moscow, Zakharov, 2000.

Voronov, M.G. and Khodiassevich, G.D., *Arkhitektourny ensembl Kamrona v Pouchkine*, Leningrad, Lenizdat, 1990.

Vseobchtchaïa istoria architektury, (General History of Architecture), Volume 12, Moscow, 1975.

Z

Zabielin, I. *Istoria goroda Moskvy*, volume I, Moscow 1902.

Zapiski poliaka-otchevitsa, Peterburg v 1720 in *Rousskaïa Starina*, volume XXV, St. Petersburg, June 1879.

Zodtchie Sankt-Peterbourga, 300 liet Sankt-Peterburgou 1703-2003 (The St. Petersburg architects, three hundred years of St. Petersburg), collective work, volume I: *Zodtchie Sankt-Peterbourga XVIII vieka*, St. Petersburg, Lenizdat, 1997.